W9-AVZ-213

Art in Seattle's Public Places

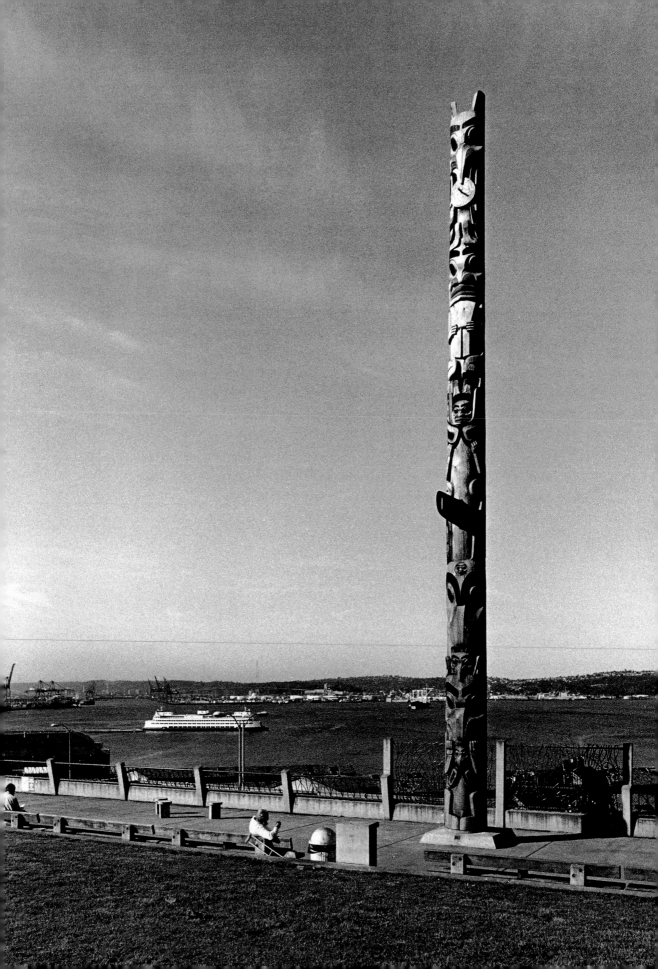

Art in Seattle's Public Places

An Illustrated Guide

JAMES M. RUPP

Photographs by Mary Randlett

University of Washington Press *Seattle & London*

5.27 Totem pole, James Bender and Marvin Oliver

The publication was jointly funded by major grants from Burlington Northern Foundation and US West Communications.

Copyright © 1992 by the University of Washington Press
Printed in Japan by Nissha
Designed by Audrey Meyer
All rights reserved. No part of this publication may be reproduced or transmitted in any form or by any means, electronic or mechanical, including photocopy, recording, or any information storage or retrieval system, without permission in writing from the publisher.

7.4 *Great Gull*, G. Alan Wright

Library of Congress Cataloging-in-Publication Data

Rupp, James M.
 Art in Seattle's public places : an illustrated guide / James M. Rupp : photographs by Mary Randlett.
 p. cm
 Includes bibliographical references.
 ISBN 0-295-96988-1 (alk. paper).—ISBN 0-295-97100-2 (pbk.: alk. paper)
 1. Public art—Washington (State)—Seattle—Guidebooks.
I. Title
N8845.S43R87 1991
708.197′772—dc20 90-32846
 CIP

The paper used in this publication meets the minimum requirements of American National Standard for Information Sciences—Permanence of Paper for Printed Library Materials, ANSI Z39.48-1984.

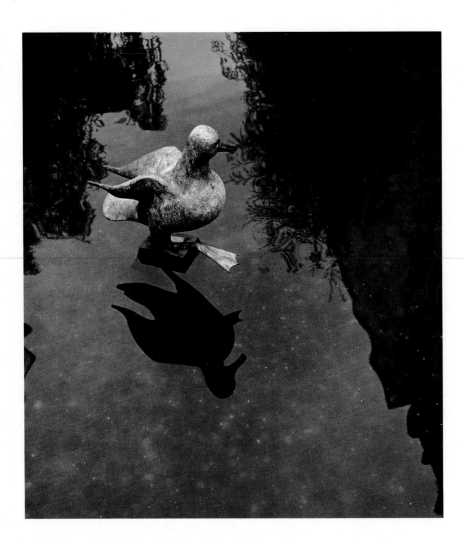

To Maxine Cushing Gray, 1909–1987

3.8 *Seattle Tulip*, Tom Wesselmann

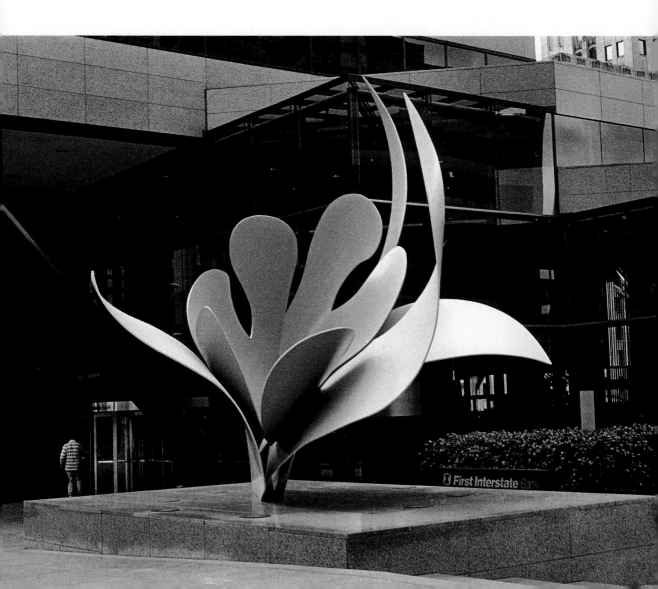

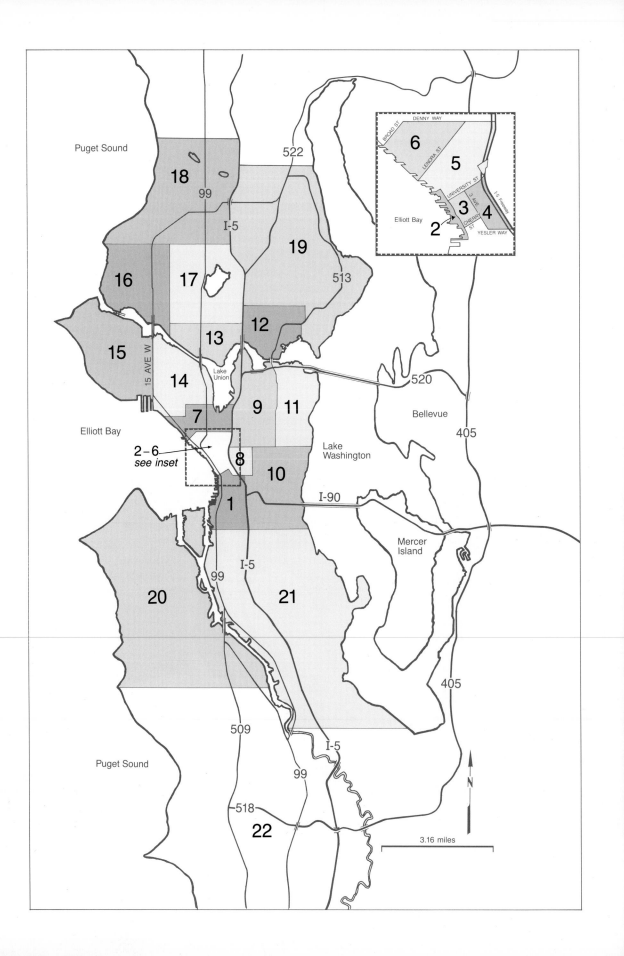

Puget Sound

522

18

99

I-5

19

513

16

17

12

15 AVE W

15

13

Lake
Union

14

520

7

9

11

Bellevue

405

Elliott Bay

2–6
see inset

8

10

Lake
Washington

1

I-90

Mercer
Island

405

99

I-5

20

21

509

I-5

Puget Sound

99

518

22

3.16 miles

N

DENNY WAY

BROAD ST

LENORA ST

6

5

UNIVERSITY ST

3 AVE

3

I-5 Freeway

Elliott Bay

2

4

CHERRY ST

YESLER WAY

Contents

Foreword

One of the most frustrating experiences for the culturally curious is to discover an unidentified work of art in a public place without being able to find out when, why, and by whom it was created. As works of public art proliferate, this frustration will increase. Not so in Seattle, however, thanks to the publication of this comprehensive guide by James M. Rupp and the accompanying handsome photographs by artist Mary Randlett.

The stunning photographs are a special and insightful bonus to the interesting and informative text. The total package should be a reference book much appreciated by the citizens of Seattle and the city's many visitors.

Seattle is a leader in providing for all of its citizens a vast collection of artworks in public places, proving once again that the city deserves its forward-looking reputation. Considering the breathtaking natural beauty of the area, it is even more to the city's credit that it is not resting on its laurels. As we know, great civilizations of the past excelled in incorporating public art with their major construction activities, urban plazas, and parks. Cities following in that tradition offer a particularly democratic opportunity for all citizens to experience such cultural achievements without ever having to pay the price of an admission ticket.

Public art is a one-time investment that increases in value, both economically and culturally, for present and future generations to enjoy. The best works frequently challenge us to question, think about, and rethink issues affecting our social structure and our physical environment. The artworks will also tell future generations something about our present society in a way the printed word and other art forms cannot.

The early commemorative works, for example, tell us about America's need to affirm its heroes, its need to formalize its identity, and its need to document major events of this young country. Although most Americans do not realize it, the United States captured the coveted title of "World Capital of Art" from France, where it had rested until shortly after the end of World War II. Since then, the majority of world-class artists have been living and working in the United States, primarily in New York but recently and increasingly in other parts of the country, including the Pacific Northwest.

Seattle's cultural legacy is rich and varied. With the publication of this book, the legacy is beautifully documented for Seattle's residents and visitors as they explore the city's public art heritage.

Donald W. Thalacker
Former Director, Art-in-Architecture Program
U.S. General Services Administration
Washington, D.C.

14.1 *Changing Form*, Doris Totten Chase

Hatch cover, Anne Windus Knight

Acknowledgments

Publication of this book was made possible by substantial grants from U.S. West Communications and the Burlington Northern Foundation. Special thanks go to Andrew V. Smith of U.S. West Communications and to Christopher Bayley of Burlington Northern Corporation, who recognized the value of a guide to art in Seattle's public places and provided the impetus for those grants.

Over the ten years it took to create and publish this book many individuals provided their thoughts, knowledge, and moral support. There are too many to name here, but all can rest assured that their support was gratefully received and that without it the project would not have succeeded. A few people deserve special recognition. Maxine Cushing Gray, to whom *Art in Seattle's Public Places* is dedicated, gave her usual devoted support to, and lobbied for, an idea she thought should succeed. She also provided valuable editorial advice. Donald Ellegood and Anne Gould Hauberg were two others who gave valuable advice and whose moral support never wavered throughout the project. Richard Andrews, Steven Huss, and Betsy Fulwiler also provided helpful assistance and editorial advice on several occasions. Of special importance was the continuing and immeasurable support of John and Libby Rupp.

Mary Randlett offered her services as photographer early into the project. In addition to providing an outstanding collection of photographs, she has contributed enthusiasm and creative ideas. Her achievement would not have been possible without the long and constant support of Elizabeth Bayley Willis, Betsy Lawrence, Pam Price, Skippy Younger, and Peggy Enderlein. Other friends who helped her in various ways include Dorothy Anthony, Jean Russell, Brent Goeres, Guy Anderson, Dori and Jolly Miller, Anne and Philip McCracken, Ruth and Ibsen Nelsen, and Barbara and Clayton James. Special thanks must also be given to Hugh Stratford for technical advice over the years and to Sue Olsen for devising an orderly method for photographing the many works of art.

Research, photographs, money, and advice will not by themselves create a book. The skill of editors and designers is necessary for that, and special thanks go to the staff of the University of Washington Press, especially the splendid editorial talents of Julidta C. Tarver and Naomi Pascal, and the exceptional designing skill of Audrey Meyer. I also want to recognize the work of Pamela J. Bruton, whose outstanding editing skills vastly improved a raw manuscript.

James M. Rupp
Seattle, Washington

Hatch cover, Nathan P. Jackson

A Historical Overview

There has always been art in public places. It began with cave paintings and evolved into the artistic flourish of Renaissance Europe. Inspirational religious subjects have been depicted in public art throughout the history of religion. Bronze and stone images of heroes and heroines and monuments commemorating great events have been erected for centuries.

Seattle is outstanding among American cities for the abundance of art in its public places. No city of comparable size can match Seattle's collection, which runs the gamut of artistic media and styles. It includes the realism of traditional heroic statues, the impressionism of Auguste Rodin, and the minimalism of Ronald Bladen and Tony Smith. The somber realism of depression-era painting can be observed in several locations, and in others the mysticism of the "Northwest School" of painting, which evolved from the same period.

Public places, as defined in this guide, include public and private building lobbies and other spaces readily accessible for public viewing. As a result, the public is exposed to a varied collection of works of all sizes and media. Outdoor sculpture abounds and includes colorful ceramic murals in addition to the many bronze, stone, and metal creations that withstand the elements. Paintings are usually reserved for indoors and have been placed in many building lobbies throughout Seattle, but several external building walls in the city have also been graced with painted murals. Some were commissioned through a city-sponsored downtown wall project, while others were privately commissioned. Many fine examples of exterior architectural adornment can be seen in Seattle, especially on the University of Washington campus (chap. 12).

The majority of artists represented in Seattle's collection live or have lived in the Pacific Northwest. Some are successful midcareer artists, others are young and relatively unestablished, some are deceased, and the reputations of many extend far beyond the region. A substantial number of artworks were created by artists of international prominence, including Henry Moore, Alexander Calder, Isamu Noguchi, Louise Nevelson, Frank Stella, and Sam Francis. Women are well represented in the collection, beginning with Alice Robertson Carr's 1924 bas-reliefs in Woodland Park and dramatically increasing in numbers in the past two decades.

The recognition of landscape design as art is relatively new, and Seattle and surrounding areas have been leaders in incorporating it in new or renovated parks and open spaces. Glass art has experienced a renaissance in the past few decades. Works by Dale Chihuly, one of the world's leading contemporary glass artists, are on display in several places in Seattle, and Paul Marioni's glass walls have achieved wide acclaim.

Seattle also has an unusually large number of fountains, most of which are abstract designs rather than the formal, European-style fountains predominant elsewhere in this country and in Europe. This is in part the result of Seattle's comparative youth. At the time fountains in older cities, such as New York, Chicago, and Kansas City, were being commissioned by an established wealthy class, Seattle was young and less sophisticated, and large fortunes were less common. By the time Seattle began spending money for public art, traditional fountain design was passé. At the same time local artists George Tsutakawa and James FitzGerald were available to build their welded bronze fountains, which have achieved national recognition for their unique and innovative designs.

Perhaps the city's comparative youth gave it the vigor to amass its collection and be innovative in its selection and placement of art in public places; or perhaps Seattle was lucky enough to have a group of art supporters who laid a vital foundation at a time when the government and public were most receptive. Whatever the case may be, Seattle's collection is a product of evolutionary, rather than revolutionary, growth. Although two major events fostered many of the public artworks, the evolutionary growth of art in Seattle's public places is similar to the growth of art in most large American cities. However, in the past decade the citizens and local governments around Seattle have led unusually energetic and successful programs to encourage and support the arts in general and, in particular, to install artworks to grace the urban environment.

For the most part, the history of urban art has been concerned with art created for special events and special people. Elsewhere in the country, cities have monuments to those who died in the Civil War. However, Washington was a territory far removed from that conflagration, and no Civil War generals or battles are immortalized here. Soldiers who fought in the Spanish-American War are honored with a small statue in Woodland Park (17.3); but it was a peacetime event that first fostered a significant amount of public art in Seattle.

In 1909 Seattle held its first world's fair, the Alaska-Yukon-Pacific Exposition, on the campus of the University of Washington. It was a banner year for public art. On the site of the world's fair one could see commissioned bronze sculptures of George Washington (12.7), commissioned in 1905 by the Daughters of the American Revolution before planning for the fair had begun, William H. Seward (9.4), Edvard Grieg (12.22), and James J. Hill (12.27). Governor John H. McGraw's statue was placed in downtown Seattle (5.22) and the bust of Chief Seattle was dedicated in Pioneer Square (1.2). All of those statues remain, although many citizens have no idea whom they depict.

The First World War was the next impetus for the commissioning of public art in this country. In 1921 a public subscription for donations was begun to commission Alonzo Victor Lewis to create a statue to honor those Washingtonians who fell in that catastrophe. No art had been installed in Seattle since 1909, but the controversy surrounding the design of *American Doughboy Bringing Home Victory* (7.14) delayed its installation until 1932.

A lesser known historical event inspired a memorial in 1923. In the summer of that year, Warren G. Harding stopped in Seattle on his way to Alaska and made a speech to the local Boy Scouts. It was his last public speech. He became ill on his return trip and died in San Francisco. That speech was commemorated by a large concrete memorial erected in Woodland Park in 1925. Over fifty years later it was torn down to make room for zoo expansion, the only "permanent" memorial sculpture erected in Seattle that no longer stands. In 1925 the death of Judge Thomas Burke, one of Seattle's most prominent citizens, resulted in the construction of a now-forgotten monument to his memory, commissioned with funds donated by his many admirers (9.2).

Architectural decoration was another form of public art. It flourished in the early 1900s with terra-cotta creations such as the Indian heads on the White-Henry-Stuart Building (5.5) and the relief sculptures on the Chamber of Commerce (now the TRA) Building (3.1). New buildings at the University of Washington were graced with a wide variety of sculptural relief (see chap. 12). From 1928 through 1931 Seattle experienced a building boom and, through it, art deco reached Pacific Northwest architecture. That style replaced the ornamental cornices and high relief friezes, which were typical additions to the older buildings, with low relief or inscribed designs. Major examples in downtown Seattle are the Seattle Tower, the Exchange Building, and the Colman Building redesign of 1932.

All in all, however, the first half of the century was fairly unproductive in terms of both public art and architecture. The Great Depression, war, and the philosophic outlook of the day were not conducive to inspiring the commissioning of public art. Comparing the activity of today, it is clear that the absence of government involvement in the arts was a significant reason for the inactivity.

One must remember that until the 1930s the role of federal, state, and local government in America was far less extensive than that to which we are now accustomed. In almost every case the artworks erected in Seattle from 1899 through the 1950s were privately commissioned by nonprofit corporations or citizen groups. Supporting the arts was simply not considered a proper government function.

On the national level the growth of government support for the arts began during the Great Depression. In 1933 Franklin Roosevelt's New Deal created the Federal Art Project of the Works Progress Administration (the WPA) and the lesser known Section of Fine Arts of the U.S. Treasury Department. For the next ten years the federal government would pay over one thousand artists, craftsmen, and art teachers to teach art and create artworks for public buildings. The WPA enabled many of the Northwest's most prominent artists, such as Mark Tobey, Morris Graves, Guy Anderson, Carl Morris, William Cumming, and Louis Bunce, to pursue their artistic careers and create works for public enjoyment.

The WPA implanted seeds for further growth, but its programs were a historical aberration. Local government and industry support for the arts remained comparatively rare. Both pursued their traditional roles. Support of the arts was not included.

The late fifties and early sixties saw a gradual change in Seattle and the country. Seattle's awareness of art's place in a healthy (both economically and spiritually) community was heightened through the efforts of Allied Arts of Seattle, founded in 1954. This energetic group of

arts advocates and cultural organizations pledged that it would bring the arts to a position of prime importance in Seattle, thereby ensuring that the city would "increase in beauty as it increases in size." One of its major goals was the creation of a Municipal Art Commission to champion public art and other civic improvements to enhance the quality of urban life.

The time was ripe to lobby for such a commission. On the federal level Dwight Eisenhower had already urged the creation of an advisory commission to encourage the arts and other cultural activities. There had been some debate over the extent to which governments could spend public money for civic beautification. However, in 1954 the U.S. Supreme Court ruled that it is permissible to do so. Nevertheless, the concept of active government support was still radical. Eisenhower was recommending an *advisory* body, not a budgeted commission. The New Deal's WPA projects were still criticized by some as boondoggles, and the postwar period was a quiet period rather than one of change. Although some citizens were becoming more receptive to the concept of local government support for the arts, it was not a belief held by a majority, and local governments were not going to lead the way.

In 1955 the Seattle City Council did create a Municipal Art Commission. Unlike today's arts commissions, this was purely an advisory body. It had no budget. Its power was limited to the persuasive talents of its members and supporters, principally those in Allied Arts.

The Municipal Art Commission lobbied for city beautification projects such as planting trees and burying utility lines. Historical preservation and improved facilities for the city's performing arts were other prominent issues. It also recommended that a "reasonable percentage" of the project cost for major public buildings be budgeted for "interior design, painting, sculpture, landscape, architecture and other arts." That recommendation was not accepted.

The commission and Allied Arts also began promoting cultural expansion to encourage Seattle's economic growth because it had become apparent that the arts and the city's prosperity were related. Cultural backwaters and weak economies do not attract enlightened businesses and investment.

One way to show the world that Seattle was robust and sophisticated was to have some sort of exposition, something to show that the economy was strong and that culture and natural beauty were prominent features of the Seattle lifestyle. The idea of a world's fair was formed in the midfifties, and the resulting event became a

milestone in the history of public art in Seattle. The Century 21 Exposition of 1962 was Seattle's second unique event to foster art in its public places.

Two years before, the city had created a General Donation and Gift Trust Fund to allow city acceptance of private gifts of art and money to purchase art, and the world's fair became the focal point for gifts of art by artists with regional and international reputations. Commissioned fountains, paintings, murals, and sculptures were made possible through donations of over $750,000 from private citizens, businesses, the World's Fair Corporation, and local and federal government sources. Several other works were loaned for the event. The Seattle World's Fair was a great success and accomplished its economic goals. At the same time it increased awareness in Seattle that artworks can create inspirational settings and break the standard urban monotony of bare walls and concrete.

All this is not to say that public art in Seattle was unheard of in the fifties. In 1958 Seattle had taken its first major step in acquiring art for art's sake when the Seattle Public Library Board of Trustees commissioned artworks for the new Seattle Public Library downtown. George Tsutakawa's *Fountain of Wisdom* (4.18), Ray Jensen's *Pursuit of Knowledge* (4.20), and Glen Alps's *Activity in Growth* (4.21) were placed on the new building's Fifth Avenue side. James FitzGerald's decorative screen was placed in the Fourth Avenue lobby below. The following year the city commissioned Everett DuPen and Glen Alps to create artworks for its new Municipal Building (4.8 and 4.9). The expenditures for these commissions were more than the government had allocated for public art up to that point, having limited itself to funding statues or busts of Chief Seattle or providing partial funding for statues of other prominent citizens. However, the funding pales in comparison to government involvement in subsequent decades.

The latter part of the fifties also introduced Seattle to the first allocation of corporate profits for art in public places. In 1959 the Norton Building was the first large office building to be built in Seattle since the Exchange Building in 1930. It was also the first business building in Seattle to have commissioned nonarchitectural art for its public places. The building's public places had two sculptures: Philip McCracken's *Restless Bird* (3.2) and Harold Balazs's *Totem* (removed after remodeling in 1984). The Logan Building, also completed in 1959, became the second office building to have commissioned public artwork. Archie Graber's *Morning Flight* was placed in its lobby (5.11).

Despite those efforts by a venturesome few, it was the Seattle World's Fair of 1962 that ushered in a new age. In the larger scheme of things, it was an early example of a national trend. The Kennedy administration, spurred by the president's personal interest in culture, recognized the value of government support for the arts and attempted to broaden the federal government's involvement. In 1962 the U.S. General Services Administration implemented an art program requiring allocation of one-half of one percent of federal building renovation and construction budgets for artworks. That program lasted only a few years, but the principle would later become typical of local and federal programs.

In 1966 the federal government created the National Endowment for the Arts, which has since provided assistance to programs and projects throughout the country in all areas of the arts. Its public art program has provided partial funding for public artworks throughout the land. Indeed, some of Seattle's most important sculptures, including Isamu Noguchi's *Black Sun* (9.1), Tony Smith's *Moses* (7.11), and Ronald Bladen's *Black Lightning* (7.7), were made possible by the National Endowment for the Arts.

Washington State became an early leader in government support for the arts with its creation of the Washington State Arts Commission in 1961. Like the Seattle commission before it, the state entity was merely advisory and was a far cry from the budgeted, influential body of today. Nevertheless, it was part of the groundwork laid for the next decade of activity in the arts.

The late sixties ushered in the most vibrant era for public art, both in Seattle and throughout the nation, and that era continues today. Charitable institutions, such as the Rockefeller and Ford foundations, had been increasing their support of the arts in general. However, it was a growing recognition of art as a worthwhile investment by American corporations that made a major difference. Some businesses also believed that they should actively support the arts because they could afford to do so in a manner that could measurably improve the quality of urban life.

As the Medici family financed the artistic growth in the city-state of Florence, major corporations have become the Medicis of the modern age, supporting the arts and collecting artworks on a grand scale. Seattle's most prominent corporate collector throughout the sixties and seventies was Seattle–First National Bank, led by its chairman, arts patron William

Jenkins. When Seafirst's office building (Seattle's first modern skyscraper) was completed in 1968, its Fourth Avenue plaza and lobby had more public art per square foot than those of any other building in the city. New works by regional artists such as George Tsutakawa, Guy Anderson, and James Washington, Jr., were on permanent display with sculptures by world-renowned Henry Moore and Emile-Antoine Bourdelle (Bourdelle's bronze sculpture *La Grande Penelope* was removed in the late eighties).

Seafirst was joined by other corporate collectors, notably Rainier (now Security Pacific) Bank, Pacific Northwest Bell (now U.S. West Communications), and SAFECO Insurance Company; but only SAFECO placed more than a few artworks in its public places. Although these large corporate collections are available for public tours by appointment, they are closed to unrestricted public viewing.

In recent years real estate developers have invested in public artworks. Martin Selig, Richard Hedreen, and Wright Runstad & Company have been the leaders in this area. Selig, Seattle's most prolific developer, quietly led the way with installations of paintings and sculptures by artists such as Paul Horiuchi, Kenneth Callahan, Jonn Geise, and Phillip Levine. His acquisitions of works by Alexander Calder (6.2) and Anthony Caro (4.10) are but the latest purchases over a long career of collecting art for public display. Richard Hedreen included major works within the three hotels he built on Sixth Avenue (the Seattle Hilton, the Crowne Plaza, and the Stouffer Madison). Although some were removed when he sold the buildings, a notable exception is James Rosati's *Loo Wit* (4.25). Wright Runstad, a comparative newcomer to placing art in public places, has begun a fine collection including works by Robert Graham (3.14), Beverly Pepper (3.6), and Tom Wesselman (3.8).

Many are unaware of the private contributions to public art in Seattle because they are overshadowed by the results of local government commitments. The government's outlook, like that of the business community, came full circle by the early seventies. Public art for purposes other than commemorating people and events is now deemed necessary to a city and therefore worthy of government support. However, government officials did not decide to support the arts in order to test the public's view on the subject. Elected officials were as hesitant initially as they are with accepting any radical idea. Legislation does not result until issues, whether they concern seatbelts in cars or military spend-

ing, are widely considered and debated by legislators and their constituents. No bold steps to provide government support of the arts were taken until citizen groups had pushed and prodded for a decade.

Continuous lobbying and a gradual change in philosophic outlook, together with economic prosperity, brought enlightenment. In 1967 King County created its arts commission, which was the nation's first publicly funded county arts agency. Seattle's earlier unfunded Municipal Art Commission died quietly in 1969 and was replaced in 1971 with a budgeted entity, the Seattle Arts Commission. That same year the commission began working with the Seattle Water Department in a process that selected Ted Jonsson's fountain design for the department's Operations Control Center on Airport Way South (21.1). Although the city did not have a 1% for Art program at that time, funds for the fountain were set aside from the building's construction budget, and the commission directed a statewide competition to select a suitable design. A jury of artists and art supporters selected design finalists, and the commission, the Water Department, and the building's architect selected Jonsson's design. That selection process became the model for future Seattle Arts Commission projects.

Commissioned artworks became the norm after Seattle's 1% for Art ordinance (105389) was enacted on June 30, 1973. The Seattle City Council recognized that the "development of the visual and aesthetic environment is a fundamental responsibility of civic government." It provided that one percent of funds appropriated for municipal construction projects in the city's Capital Improvement Program be set aside for the "selection, acquisition and installation of artworks in public places." The Seattle Arts Commission was given the responsibility of carrying out those goals by working with city departments whose budgets contain 1% funds, selecting artworks, and maintaining the city's art collection. Its Art in Public Places Committee was given the task of overseeing the Art in Public Places Program, including selection procedures and long-range planning.

Once a city department has a construction project, it now works with the arts commission in selecting interior and exterior artworks. If a project is small, the department can have its funds set aside in a Municipal Arts Fund until additional department funds accumulate to permit purchase of an artwork. Seattle City Light, the Water Department, the Department of Parks and Recreation, and the Building Department have the largest construction budgets. Collections accumulated through their funds have grown considerably since the statute's enactment in 1973.

As local governments became larger and more sophisticated art collectors, the processes used to select art became more innovative. A common procedure was to hold design competitions in which the selections of the jury were subject to confirmation by the commission. However, until relatively recently, artworks were commissioned or selected only after a building or improvement project was designed or construction was either all or nearly completed. Art was not included in the overall design, other than designating a spot for possible placement of art. The selection of that art was a totally separate process.

Many objected to treating art as an unrelated attachment or afterthought to projects. They argued that by allowing artists to participate in the initial project design a wide range of artistic possibilities would be considered and implemented. In the mid-1970s Seattle first added artists as members of construction project design teams, and it was quickly discovered that artists working with architects and engineers often stimulated their colleagues into departing from the customary restraints of their disciplines. What were initially considered impractical ideas of an artist became well-received parts of a larger whole.

The first design team artists worked on Seattle City Light's Viewland-Hoffman Electrical Substation (18.4) and integrated folk art windmills and colorful geometric shapes into what would otherwise have been a dreary gray electrical complex. Since the dedication of that award-winning substation design in 1979, the creations of many successful design teams in the Seattle area have been widely acclaimed. Seattle's design team concept has since been used as a model for cities throughout the United States.

By far the largest design team effort to date in Seattle is the Metro Downtown Seattle Transit Project, in which five artists worked with project architects and incorporated their artworks and those of sixteen other artists into both functional and decorative elements for underground transit stations and street improvements (1.8, 1.13, 5.7, 5.19, and 5.25). A few of the many other examples include the Creston-Nelson Electrical Substation (21.17), Paul Marioni's glass wall at the North Seattle Police Precinct Station (18.2), James Schoppert's I-90 tunnel entrance (10.9), Bob Maki's *Westlake Star Axis* in Westlake Park (5.24), and Vicki Scuri's tire tread wall design for the Boren Avenue Garage (8.11).

Although Seattle is the predominant source of public art innovation in the region and its efforts are studied by many throughout the country, its 1% for Art ordinance is neither unusual nor unique. In fact, it was preceded by King County's 1% for Art ordinance of February 1973. Other cities, including Bellevue, Everett, Portland, and San Francisco, have similar statutes. Tacoma enacted one; then its citizens voted to suspend it in 1985 after its arts commission installed a neon artwork in its sports dome that, although critically acclaimed, was disliked by the citizenry. In 1974 the state of Washington enacted a one-half of one percent for art statute. All are vital sources of support for the arts of their regions.

Unfortunately, it is impractical to include in this book the fine collection of publicly and privately owned artworks in public places outside Seattle. Portions of King County's collection within Seattle are included in this book, but that is only a small part of the county collection. Bellevue's collection has grown rapidly with the increased development of its business center and the increased activity of its arts commission. Although formed in 1978, that commission had an initial burst of activity and then lay dormant into the early eighties after public support dwindled.

In 1979 King County held an international symposium, titled "Earthworks: Land Reclamation as Sculpture," to investigate artistic designs for rehabilitating such eyesores as surface mines and gravel pits. That event resulted in two important local reclamation projects. In 1979 the county funded Robert Morris's reclamation of an abandoned gravel pit in the Kent Valley, and two years later the city of Kent funded Herbert Bayer's innovative design for a floodwater retention basin in Mill Creek Canyon Park. Both are well worth seeing, although the Morris work has had a history of abuse and vandalism due to its placement in a secluded area.

Art in public places throughout the Seattle area, and everywhere in the world, continues to foster debate and criticism. Art is by its very nature controversial. A recent traditional statue such as that of Leif Eriksson at Shilshole Bay (16.6) can inspire as much debate as a modern work such as *Adjacent, Against, Upon* (7.40). Some people like more traditional illustrative art. Others prefer contemporary abstract approaches. Some critics argue that art should not be designed as an integral part of architectural surroundings, such as the design team creations for the Metro Downtown Seattle Transit Project. Rather, they believe it should stand on its own to make its own independent statement, as is true of Henry Moore's *Three-Piece Sculpture: Vertebrae* (4.13) and Alexander Calder's *Big Crinkly* (6.2). It is also argued that landscape architecture, such as that created for NOAA's Seattle facility (19.2–19.6), is not art but decoration. Those who disagree argue that landscape architecture is a distinctive art medium. The issues can, and will, be argued forever between equally intelligent forces. In the end it is all a matter of taste, and taste is often affected by education and sophistication.

Oscar Wilde wrote that "art is the most intense form of individualism." And so it is. Throughout Seattle there are countless works of art by individuals expressing their thoughts and emotions about life and art. The artworks are not products of uniform mental exercises. Rather, they are as varied as their creators and elicit a wide range of emotional reaction from viewers. But whatever the reaction, the art in our public places provides an energy to the urban environment and counteracts the mundane concrete repetition surrounding it.

Seattle's prominent program to foster art in public places has arisen from a policy that developed slowly and expanded gradually under the nurturing influence of relatively few citizens. Art in Seattle's public places has now become commonplace. The city and county, their arts commissions, and their citizens now have the burden of ensuring continuing quality and protecting what exists from normal wear and tear and from the increasing dangers of graffiti and other vandalism.

It is the author's hope that this guide will inspire its readers to admire and investigate the artworks around them, wherever they may be. The enjoyment of one's surroundings, whether familiar or foreign, is always enhanced by learning more about it and observing more than the immediate, ground-level scene. It is also hoped that local commissions will take it upon themselves to provide more detailed and readily available information so that citizens and visitors can enjoy the collections as much as those few individuals who have done the collecting.

Using This Book

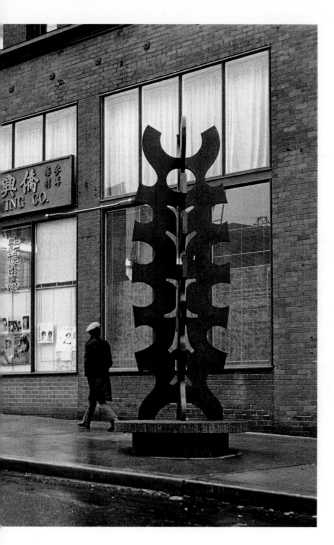

1.10 Untitled street sculpture, George Tsutakawa

Seattle prides itself on having a fine collection of art in its public places; but where is it? What is it? Who created it and why? Complete maps have never been prepared. No publication has ever provided more than a glimpse of the art in Seattle's public places. This book does.

Art in Seattle's Public Places divides Seattle into twenty-two zones and devotes a chapter to each. Because the heaviest concentration of artworks is in downtown Seattle, downtown has been divided into six zones. The boundaries of each were drawn to create the easiest areas to tour, or envision if one wishes to sit back and read in the comforts of home.

The first zone starts in Pioneer Square, which is appropriate since the city began there. Subsequent zones follow the northerly growth of downtown Seattle. The artworks have been marked on splendid maps, and readers can design their own routes, perhaps starting from a favorite bistro or convenient parking place.

The measurements provided for artworks are listed by height (H), length (L), width (W), and diameter (dia.). The use of length and width varies in different art texts. Here, length is a measurement of the artwork's face, or in some cases the longer surface. Width measures the distance perpendicular to the length.

Short biographies of most of the artists mentioned can be found in the back of the book. Whether touring or engaged in scholarly study, or both, do not forget the Index, which lists not only artists and titles of artworks but also various topics of interest. The Index is a very useful tool if you wish to compare a particular artwork with the artist's creations elsewhere in the city.

The art in Seattle's public places was placed there for all to enjoy. The purpose of this guide is to increase that enjoyment manyfold. So, enjoy!

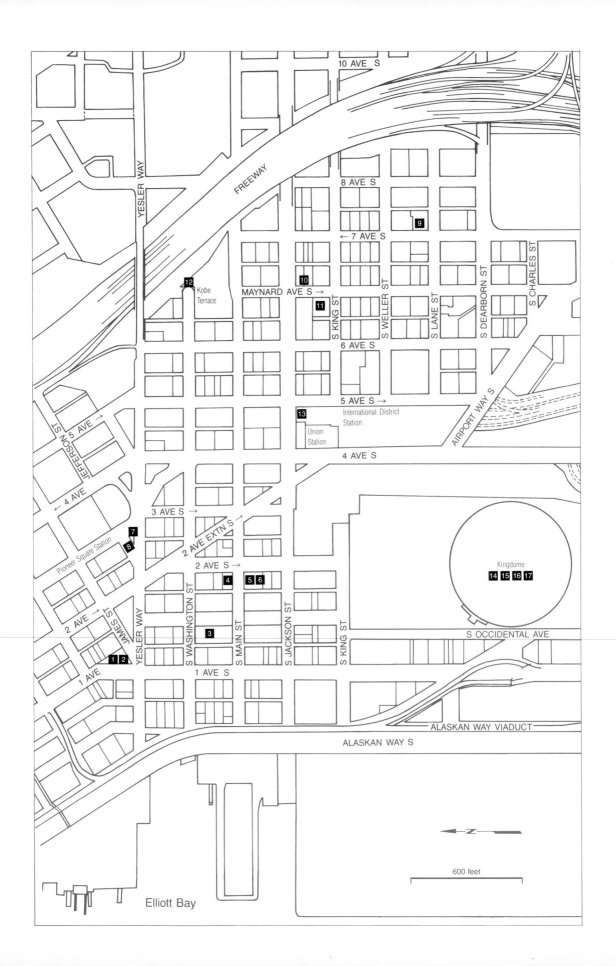

10 AVE S

FREEWAY

YESLER WAY

8 AVE S

← 7 AVE S

■9

S CHARLES ST

S DEARBORN ST

■10

MAYNARD AVE S →

S KING ST

S WELLER ST

S LANE ST

■12 Kobe Terrace

■11

6 AVE S

5 AVE S →

AIRPORT WAY S

JEFFERSON ST

5 AVE →

■13

International District Station

Union Station

4 AVE →

4 AVE S

3 AVE S →

2 AVE EXTN S →

Pioneer Square Station

■7
■8

2 AVE S →

Kingdome

■14 ■15 ■16 ■17

2 AVE →

S WASHINGTON ST

■4

■5 ■6

S MAIN ST

S JACKSON ST

S KING ST

■3

JAMES ST

YESLER WAY

■1 ■2

1 AVE →

1 AVE S

S OCCIDENTAL AVE

ALASKAN WAY VIADUCT

ALASKAN WAY S

← N →

600 feet

Elliott Bay

Chapter 1

Pioneer Square,
the International District,
and the Kingdome

*As a house is the home of a family, so is a city the home
of its inhabitants and should be furnished with works
of art, just as you would furnish your own home.*

Sir Henry Moore 1898–1986

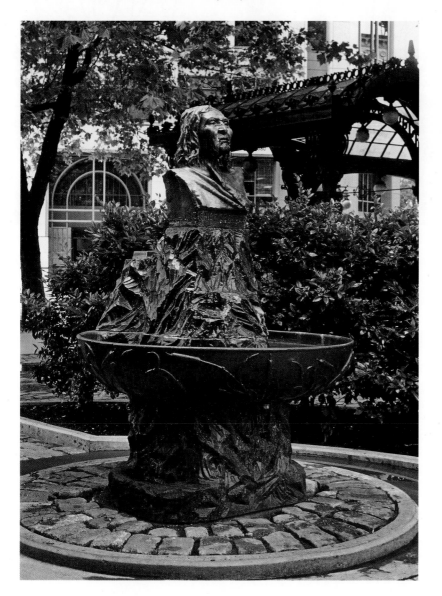

1.2 Bust of Chief Seattle, James Wehn

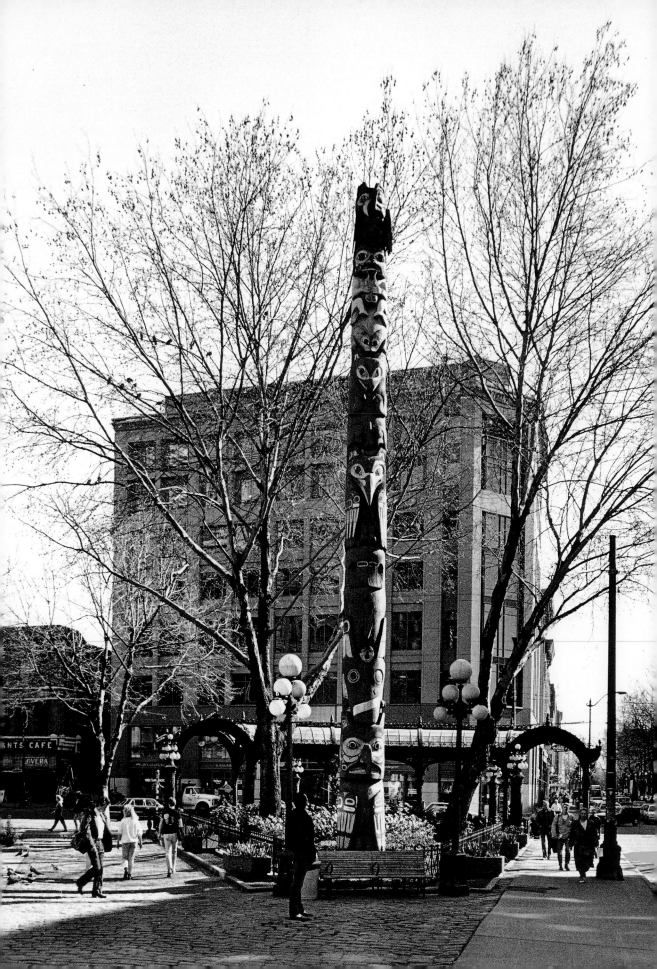

Pioneer Square

1.1 Totem pole, 1940

Charles Brown and William H. Brown, with James Starfish, William Andrews, James Andrews, and Robert Harris

Carved cedar; H 50 ft.
Gift to the city from the U.S. Government
Near Pioneer Square at intersection of First Avenue S, James Street, and Yesler Way

The first work of art in a public place in Seattle was a fifty-foot-high totem pole erected in 1899 in Pioneer Square. The pole originally stood in the Tlingit village of Tongass, Alaska, but was removed in 1899 by a group of touring Seattle businessmen who decided to take it home as a souvenir. The "donors" were fined for their theft, but the stolen property was never returned and "Seattle's" totem pole became a city landmark. The existing cedar pole is a replica of the original, which was discovered to have dry rot in 1938. A year later the U.S. Forest Service sponsored the carving of a replacement, and this pole is primarily the work of Charles Brown and his father, William H. Brown, with assistance from other Tlingit Indian craftsmen.

Totem poles are a three-dimensional art form generally associated with the Tlingit of southeastern Alaska, the Haida of the Queen Charlotte Islands, and the Tsimshian and Kwakiutl of western British Columbia. No Indian tribes in the Seattle area practiced this advanced and detailed art.

Totem poles were made as memorials or grave posts, or as architectural supports, and the designs usually consisted of figures representing myths and legends of the native people. The figures on this pole depict, from the top, Raven, holding a crescent moon in his beak; Woman holding her frog child; her frog husband; Mink; Raven; Whale, with a seal in its mouth; and Grandfather of Raven, a major mythical being also called "Raven-at-the-Head-of-Nass." The pole represents the Indian legend of how Raven stole the sun and moon from Raven-at-the-Head-of-Nass and brought light to the world. A similar story is illustrated in Duane Pasco's nearby *Sun and Raven* totem pole (1.3). For a description of the legends commemorated here, and a brief history of the rich tradition of totem pole carving, see *The Seattle Totem Pole* by Viola E. Garfield (see Sources and Suggested Reading).

1.2 Bust of Chief Seattle, 1909

James Wehn

Bronze; H 2 ft.
City of Seattle collection
In front of totem pole

In 1908 Seattle was sprucing itself up for its first world's fair, the Alaska-Yukon-Pacific Exposition set to open in 1909. One desired improvement was an ornamental watering fountain for animals in Pioneer Square. At that time, Seattle sculptor James Wehn was completing the clay model for his large statue of Chief Seattle for Tilikum Place (6.5). The head of the city's Street and Sewer Department asked him to make a bronze cast of that head for the new watering fountain. This bust became the first sculpture of the city's namesake to be placed in Seattle (see page 19).

The Victorian pergola in Pioneer Square was another city improvement for the Alaska-Yukon-Pacific Exposition of 1909. It was designed by Julian F. Everett and served as both a shelter for trolley passengers and as the entrance to a large underground public comfort station. For several decades the pergola was in a state of disrepair, and by 1958 the convenience station had become such a deteriorated hazard that it was closed. In the early 1970s Everett's cast iron and glass pergola was refurbished (as was the area around it) and returned to its original grandeur.

1.1 Totem pole, Charles Brown and William Brown

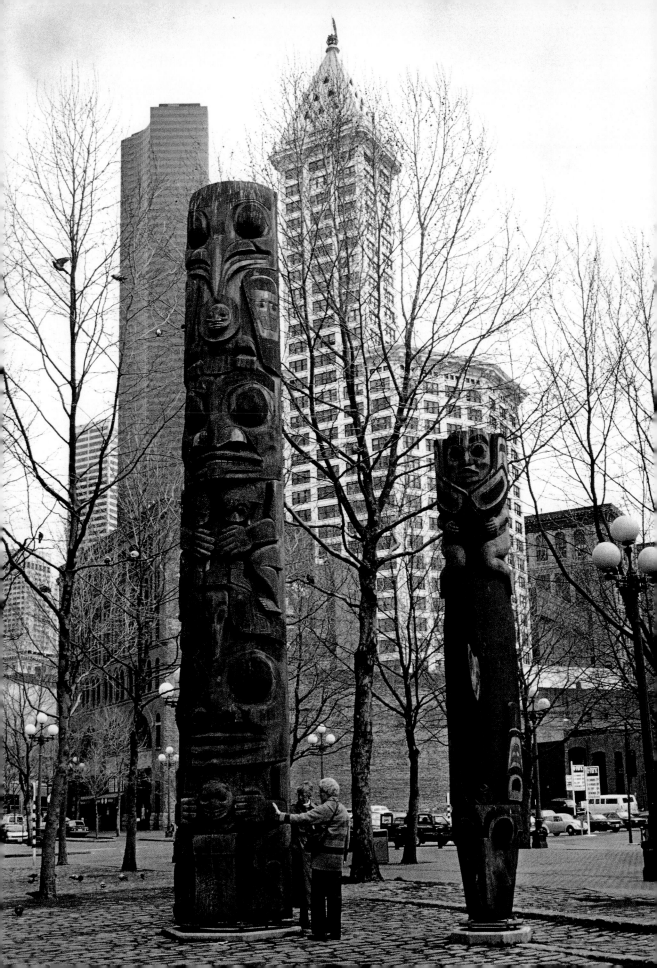

1.3 Northwest Coast Indian carvings

Duane Pasco

Sun and Raven, 1973, H 32 ft.
Man Riding on Tail of Whale, 1971, H 20 ft.
Bear, 1974, H 12 ft.
Tsonoqua, 1973, H 12 ft.

Carved cedar
Gift of Richard White to the Pioneer Square Association
Occidental Park

Duane Pasco's four sculptures in Occidental Park are some of the city's finest examples of carving in the Northwest Coast Indian style. *Sun and Raven* was carved for the 1974 world's fair in Spokane, Washington, and refers in part to the Indian legend about Raven's bringing light to the world. At the pole's base the sun is held above the box in which it was stored before Raven stole it. At the top portion Raven holds the moon. Part of the same legend is depicted in Seattle's Pioneer Square totem pole (1.1).

The nearby human figure with arms outstretched depicts Tsonoqua, a mythical giant of the deep forest. She is usually shown with lips pursed to utter a cry. In some stories her cry could bring supernatural power, good luck, or great wealth. In others she is a terrifying figure, threatening to eat children, and referred to by parents to frighten children into obedience. In some versions of the Tsonoqua myth she is called "the nightmare bringer."

Except for the *Sun and Raven* pole, the carvings were created under a commission from Richard White, a local entrepreneur and arts patron. All four works originally stood with several other Pasco works at White's Kiana Lodge, a restaurant and meeting center located across the sound on the Kitsap Peninsula. White sold the lodge and donated these four to the Pioneer Square Association. The pieces were refurbished at Pasco's studio in Poulsbo, Washington, and installed in 1987 and 1988.

The large red-orange steel sculpture in Occidental Place, in the next block south of Pioneer Square, is *Anawog II* by Jan Evans. The piece was given to the city in 1978 by the Seattle Foundation after an anonymous donor gave funds to that organization for that expressed purpose. Unfortunately, the piece is placed in such a way that it looks like a temporary placement. A nearby cor-ten steel sculpture by Portland artist Lee Kelly is similarly placed, but it belongs to the artist and has been there "temporarily" for over a decade.

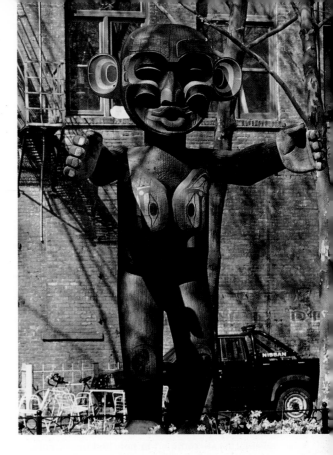

1.3 *Sun and Raven* and *Man Riding on Tail of Whale (left)*, *Tsonoqua (top)*, and *Bear (bottom)*, Duane Pasco

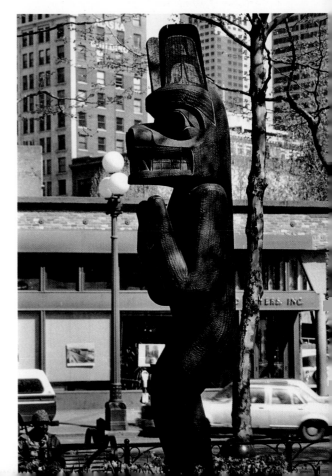

1.4 **Waterfall Garden,** 1977
Designed by Masao Kinoshita

Gift of Annie E. Casey Foundation
Second Avenue S and S Main Street, just east of Occidental Park and across Main Street from the fire station

This corner park was constructed on the site where United Parcel Service was founded in 1907. Seventy years later that company's founder, James Casey, had this park built for the enjoyment of Seattle citizens. It is owned and maintained by the Annie E. Casey Foundation, a private entity named for his mother.

The park was designed by Masao Kinoshita of Sasaki Associates, Inc., Watertown, Massachusetts. The natural-looking waterfall was constructed in an ancient Japanese fashion. Granite slabs stand at each end of the upper walkway and water passes between them in a granite streambed. Drinking fountains and trash receptacles are outlined in polished brass. Per square foot, this park is said to have been the most expensive in the country to create.

1.5 **Firefighters,** 1988
Tom Askman

Bronze over zinc
Seattle 1% for Art Program
Seattle Fire Department headquarters, corner of Second Avenue S and Main Street

The corners of the fire department headquarters building are graced with three heroic silhouettes of firefighters created by Spokane artist Tom Askman. Each is accentuated with lighting for dramatic emphasis at night. He made similar designs in aluminum for the tower of the University District fire station.

Askman, Seattle artist Ellen Ziegler, and Kenny Schneider of Miami were selected by the Seattle Arts Commission to create artworks for several fire station renovation projects. Ziegler's *Firefighters Memorial* can be seen in the building's lobby (1.6). Askman and Ziegler collaborated on *Lightning Bolts* at Twenty-third Avenue S and E Yesler Street. Schneider created *Hot Cha Cha* at the Magnolia fire station (15.4), and Ziegler created an untitled work at the Beacon Hill station (21.2).

1.6 **Firefighters Memorial,** 1988
Ellen Ziegler

Colored terrazzo and brass mosaic;
H 9 ft. 3 in. × W 6 ft.
Seattle 1% for Art Program
Seattle Fire Department headquarters lobby, Second Avenue S and Main Street

The drab lobby of the fire department's headquarters building is brightened considerably by the colored terrazzo in this mural. A firefighter is shown directing a fire hose at billowing smoke and flames. The lines of the design and the frame around it are inlaid brass. The frame includes a dedication in brass letters: "In memory of the brave men & women who gave their lives in the line of duty."

1.7 **Prefontaine Fountain,** 1926
Designed by Carl F. Gould

Bequest of Father Francis X. Prefontaine
Prefontaine Place, Yesler Way and Third Avenue

Two blocks up the hill from the pergola and the totem pole in Pioneer Square, in a triangular piece of land created by Yesler Way, Jefferson Street, and Third Avenue, is Seattle's first public fountain. It was given to the city by Father F. X. Prefontaine, a prominent Jesuit priest in Seattle who built the city's first Catholic church in 1870. When Father Prefontaine died in 1911, he left the city the then princely sum of five thousand dollars for a fountain "sparkling with clear water to beautify the city." Fifteen years later his wishes were fulfilled. The park and Prefontaine's fountain were designed by Carl F. Gould, one of Seattle's leading architects at the time.

The colored lights that originally accented this fountain at night are now gone, and the fountain has been treated rather roughly by local denizens. In 1970 it was extensively refurbished through funding by the Committee of 33, a group of Seattle philanthropists, who also gave the city the Chief John Wallace totem pole (11.1).

1.8 **Metro station artworks,** 1990

Garth Edwards, Kate Ericson, Jim Garrett, Brian Goldbloom, Laura Sindell, and Mel Ziegler

Mixed media
Metro collection
Pioneer Square station, Third Avenue at Jefferson Street

Although Metro does not have a percent for art program, it dedicated $1.5 million of its Downtown Seattle Transit Project's $420 million budget to a program to commission public art for the transit tunnel stations and street-level entrances. The program, completed in mid-1990, is the largest public art project in Northwest history. An advisory arts committee selected the artists and artworks and monitored the fabrication and installation of the artworks. It also appointed a design team of five artists, Alice Adams, Kate Ericson, Sonya Ishii, Jack Mackie, and Vicki Scuri, who worked with architects on incorporating artworks into the project. Their works and those of fifteen other artists and a poet grace the tunnel's five stations (1.13, 5.7, 5.19, and 5.25).

Surface artworks at all stations include unique cast-iron grates for the bases of the five species of trees planted on Third Avenue and Pine Street. Norway maple leaf shapes make up Maren Hassinger's maple tree grate design. The linden leaf is included in Garth Edwards's design for linden tree grates, and Dyan Rey incorporated ginkgo leaves in her grate design for those trees. Birds, acorns, and oak leaves are in Susan Point's classical design for the oak tree grates. Virginia Paquette's linear art deco–inspired design incorporates serrated zelkova leaves, Z-shapes, and references to a high-heeled shoe, water, and people, all of which might come in contact with the grate.

Each station also has an eight-foot granite marker with an inlaid silhouette of a noted Northwest citizen, and the stair risers from the mezzanine to the street level display a quote from that person. The design is a collaborative effort of Kate Ericson and Mel Ziegler.

The entrance to the Pioneer Square station at Prefontaine Place is graced with an eleven-by thirty-foot steel gate by Seattle artist Garth Edwards. It consists of six sections of steel grillwork, each mounted with a group of human, cartoon-like figures similar to those on Edwards's

1.8 Untitled mural, Laura Sindell

cast-iron hatch covers at various locations downtown. The design was inspired by figures on gates of European cathedrals and a bus driver's comment to Edwards that such figures reminded him of people lined up waiting for a bus.

The major artwork in the Pioneer Square station is an eight- by fifty-foot ceramic tile mural by local artist Laura Sindell. It combines a landscape and a soundscape with two technical drawings of an Indian dugout canoe, the artist's reference in the modern transit station to a past mode of travel.

Two unique clocks by Kate Ericson and Mel Ziegler stand at each end of the station. The face of the southern clock is made of masonry remnants dug up during tunnel construction. The face of the northern clock is made of remnants from the tunnel project. The numbers on the clocks are tools donated by tunnel workers.

At the station's James Street entrance, Brian Goldbloom's addition of rough granite to the struts and beams along the stairway and escalator transform them into massive, tilting and moving shapes.

1.9 **Dragon play sculpture,** 1981

Gerard K. Tsutakawa

Silicon bronze and stainless steel;
H 6.5 ft. × L 12 ft.
Funded by the city and private sources
International Children's Park,
Seventh Avenue S and S Lane Street

The dragon in this small park is the first public commission for Seattle sculptor Gerard K. Tsutakawa, the son of artist George Tsutakawa. Made almost entirely of light and durable silicon bronze, this creature's undulating form culminates with the contrasting brightness of stainless steel eyes. Tsutakawa was careful to make his dragon as safe as possible to play on. Edges are rounded and it is filled with sand to absorb heat from the metal on hot days.

Tsutakawa's dragon was commissioned by the Seattle Parks Department.

1.9 Dragon play sculpture, Gerard K. Tsutakawa

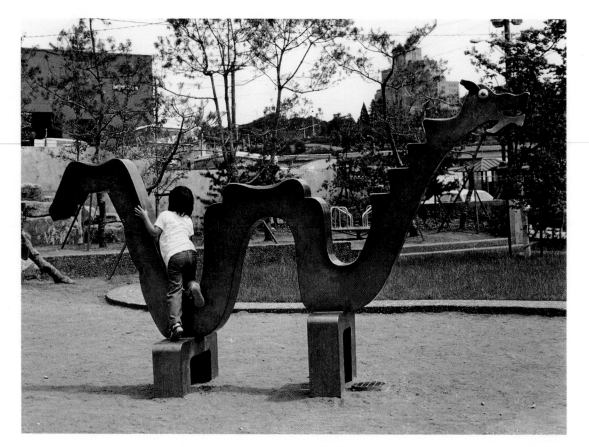

1.10 **Untitled street sculpture,** 1978

George Tsutakawa

Silicon bronze; H 12 ft. 2 in. × W 2 ft. 9 in.
Funded by the Seattle Arts Commission and private sources
Corner of S Jackson Street and Maynard Avenue, one block north of Hing Hay Park

With the exception of two gates (11.2 and 19.9) all of George Tsutakawa's public works produced before he created this street sculpture (see page 17) were fountains. "This work," he explains, "is closely related to my other themes . . . to totemic designs and *obo*s [the piled rock memorials placed on mountain trails in Tibet], but without the use of water I had to be more careful with proportion and concentrate on the scene from different angles. Sculpture, not water, became the most important aspect."

An unusual aspect of Tsutakawa's design is the inclusion of three stylized characters of Chinese calligraphy. Heaven, Man, and Earth are symbolized here. However, Tsutakawa explains that these elements will be detected only by those who have studied Chinese. "Only the old Chinese will see them," he concludes. "The young ones haven't studied Chinese much."

1.11 Untitled mural, John Woo

1.11 **Untitled mural,** 1977

John Woo

Seattle Walls Project, funded by the city and private sources
Overlooking Hing Hay Park,
Maynard Avenue S and S Jackson Street

John Woo's dragon mural on the south side of the Bush Hotel depicts the struggle of Asian Americans after their arrival here as laborers in the nineteenth century. The figures shown include Chinese railroad workers, Filipinos working in local canneries and farms, and Japanese-Americans in World War II detention camps. Also pictured are local residents taking part in Asian festival celebrations and a view of the International District with the Kingdome in the background. The mural's central dragon figure is a symbol of good luck.

In 1975 the Downtown Seattle Development Association and the Seattle Arts Commission sponsored the Seattle Walls Project to have murals painted on walls of selected downtown buildings. John Woo submitted this design for a Seattle Walls Project competition in 1976, just after his graduation from Evergreen State College.

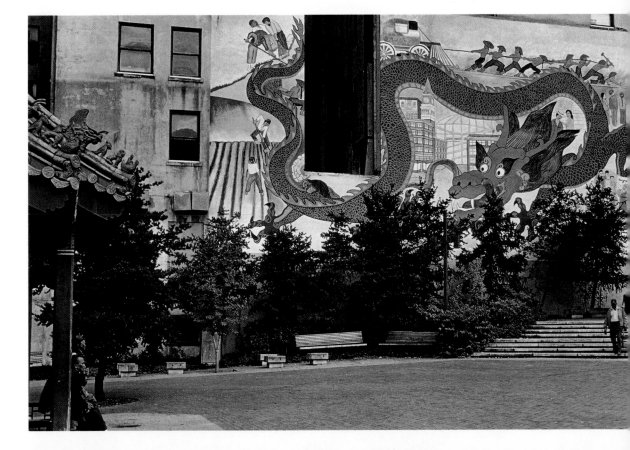

1.12 Yukimidoro lantern, 1976

Anonymous Japanese craftsmen

Carved granite; H 9 ft. × W 5 ft. 10 in.
Gift of the city of Kobe, Japan
Kobe Terrace Park, east end of S Washington Street

This large granite lantern was given to the city of Seattle by the city of Kobe, Japan, on June 19, 1976, to commemorate both the U.S. bicentennial and the completion of Kobe Terrace Park. Included with the gift were the Mount Fuji flowering cherry trees located nearby.

Kobe is Seattle's "Sister City" in Japan. A commemorative plaque installed across the path, south of the lantern, says, "May the lantern shed light on the friendship between the peoples of Seattle and Kobe forever."

1.13 Metro station artworks, 1990

Sonya Ishii and Alice Adams, with architect Gary Hartnett

Mixed media
Metro collection
International District station, Jackson Street, between Fourth and Fifth avenues

The southern terminus of Metro's transit tunnel includes artworks by local artist Sonya Ishii and New York sculptor Alice Adams, some of which reflect the Asian character of the district. Both artists collaborated on the twelve, colored-brick figures of the Chinese calendar in the station's brick plaza entrance. Each figure is approximately 7.5 feet square. Adams and Ishii worked with station architect Gary Hartnett on designs for steel trellises on the station's plaza level. Etched on stainless steel on the overhead beams of the trellis walkway is poetry by Laureen Mar.

At the Jackson Street entrance, visitors are welcomed by 200 tiles made by students of Gatzert and Beacon Hill elementary schools.

The plaza level also includes a 17.5-foot-square performance and seating platform by Alice Adams constructed of heavy timbers and supported in the front by two large stones.

The east station wall includes Sonya Ishii's nine 16- by 16-foot stainless steel sculptures showing different stages in the creation of two origami designs. Origami is the ancient art of Japanese paper folding, and the figures are male and female guardian figures included in a book of origami designs dating back to the seventeenth century.

1.13 Tiles, students of Gatzert and Beacon Hill elementary schools

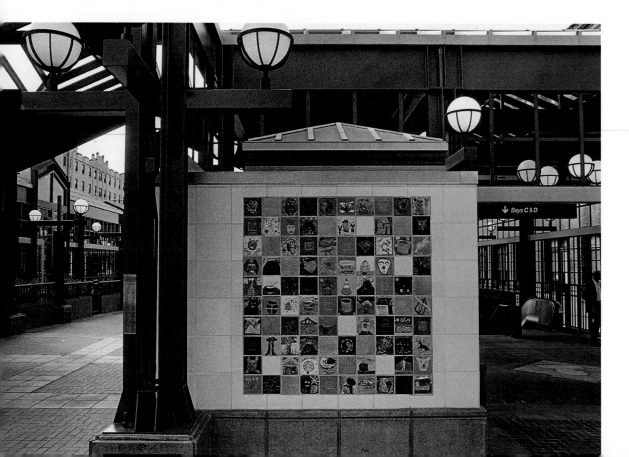

Kingdome

The majority of works discussed in this book are readily available for viewing during normal business hours. However, normal business hours do not apply to the Kingdome, and one cannot get in at all times. It is worth planning ahead to do so, because within its walls are several large commissioned artworks by eminent artists in the Northwest. All were created for the Kingdome and purchased with King County 1% for Art funds.

1.14 **Kingdome Bronzes,** 1978

Philip McCracken

Five bronze plaques; each, H 26 in. × W 25 in.
King County 1% for Art Program
Kingdome, exterior north wall,
facing the parking lot

These five bronze bas-reliefs are typical of the birds portrayed by Pacific Northwest artist Philip McCracken. They are stylized creations rather than illustrations and have been praised for their subtle depiction of spirit and inner strength. Only the far right and left plaques show a single bird. The three central reliefs portray the serenity and intimacy of family life, an important theme in many of McCracken's works.

Although created in 1978, these panels are the culmination of an inspiration McCracken received in 1955, when he spent a year in England working with renowned British sculptor Henry Moore. Moore had suggested that his young protégé view certain works in the British Museum. There, McCracken was profoundly impressed with limestone relief sculptures of birds and animals done by Greek sculptors around 450 B.C.

"In the summer of 1977 we were in England again essentially for two reasons—one to visit the Moores, and the other to research in a broad sense two upcoming sculpture commissions . . . [one of them] these relief sculptures. . . . I was very restless about settling on what I was going to do here," McCracken reports. "But on visiting the British Museum and those old friends there I did feel something stirring. One morning in Sussex I awoke early . . . very restless, but feeling good—beautiful morning—flowers blooming—larks rising from the fields. I sat down and did the drawings for these pieces in perhaps five or ten minutes. None of them changed except a slight change in gesture of the last one on the right. Well, I was elated of course. I knew I had them right then, but on further reflection I also realized that they had been germinating since 1954 when that young sculptor was awed by the presence of those masterworks looking out of their stone and bronze lives into, through, and beyond my own" (Graham, *Philip McCracken*, 126).

1.14 *Kingdome Bronzes*, Philip McCracken

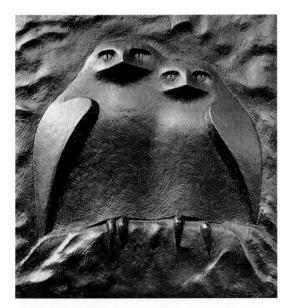 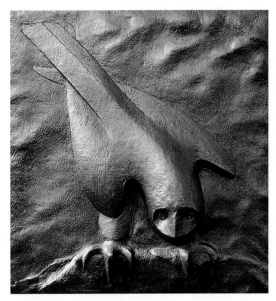

1.15 **Untitled mural,** 1979

Harold Balazs

Vitreous enamel on steel; H 34 ft. × W 8 ft.
King County 1% for Art Program
Kingdome, interior entrance perimeter

Harold Balazs does not believe that his art needs to have a message. It is sufficient simply to "take one corner of the world and make it more beautiful than another." When he saw the colorless concrete area where his work would be placed, he said to himself, "My God. What a nice place for a bouquet of flowers. . . . a little gentleness to these gray surroundings." What he created is this large colorful mural of flowers.

Its location required a sturdy material, so he chose a baked-on vitreous enamel, the same material used by Jacob Lawrence in his nearby mural. Balazs's work is sometimes referred to as "Rhododendrons." Balazs reports that although owners sometimes feel a need to provide a name, he seldom names his works and did not name this one.

1.16 **Tumbling Figure: Five Stages,** 1979

Michael C. Spafford

Painted aluminum; H 70 ft.
King County 1% for Art Program
Kingdome, interior entrance perimeter

Rather than painting these figures on the elevator shaft, Seattle artist Michael Spafford took durability and maintenance into account and attached seventeen black-painted aluminum sections flush against the bare concrete walls. The sections create a seventy-foot-high mural outlining a falling figure at five points in its plunge. The design makes it seem that the figures were painted on the walls, or perhaps attached as paper cutouts. Unfortunately, Spafford's work has been partially covered by new construction, and he has denied requests to designate a new location for it, arguing that it was designed only for placement in this specific space.

1.15 Untitled mural, Harold Balazs

1.16 *Tumbling Figure: Five Stages,* Michael C. Spafford

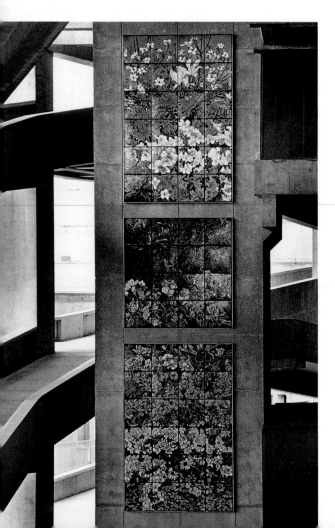

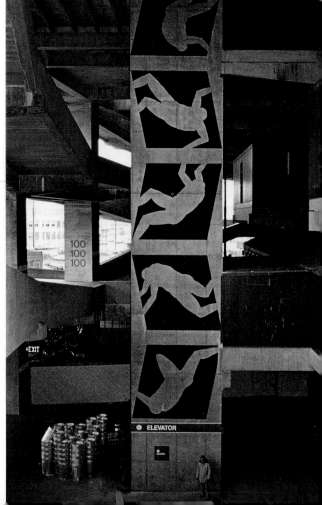

1.17 **Games,** 1979

Jacob Lawrence

Vitreous enamel on steel; H 9 ft. × L 18 ft.
King County 1% for Art Program
Kingdome, interior entrance perimeter,
second-level entry bridge ramp

As in the case of Michael Spafford, painter Jacob
Lawrence used a durable material to create his
huge mural for the new Kingdome in 1979. Here,
the design is typical of Lawrence's boldly colored
works, but the material is hard-fired vitreous
enamel on steel. This mural is his first venture
with this medium. A second in Seattle was
created in 1985 for the University of Washington's
Meany Hall (12.8).

No specific sport is represented in this mural.
Rather, Lawrence vividly portrays the excitement
and action of sports in general. "I've always been
attracted to the human figure in motion," he
explains. "I grew up in an eastern city [New York]
teaming with life, a very exciting experience. I
don't particularly draw upon the scenes I saw,
but I still draw upon that experience."

Here, the work abounds with athletic activities
and physical competition. This aspect is similar
to the themes of many of Lawrence's other works,
where physical and psychological struggle
dominate. "I deal overall with the content of
struggle," he has said. "Always working against
something. . . . Having a push. . . . If we don't
have it we atrophy. . . . That's my philosophy.
That's my temperament."

1.17 *Games,* Jacob Lawrence

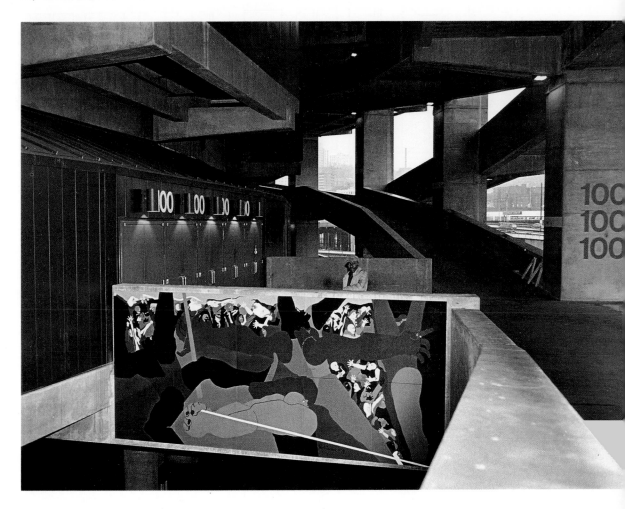

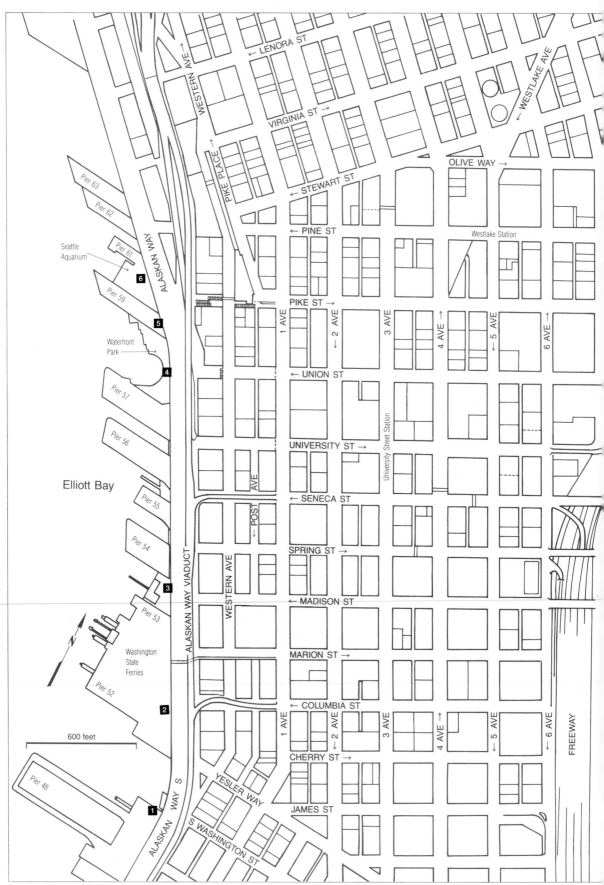

LENORA ST ←

WESTERN AVE

WESTLAKE AVE →
← WESTLAKE AVE

VIRGINIA ST →

Pier 63

Pier 62

OLIVE WAY →

PIKE PLACE

← STEWART ST

ALASKAN WAY

Pier 61

Seattle
Aquarium

6

← PINE ST

Westlake Station

Pier 59

5

PIKE ST →

Waterfront
Park →

4

1 AVE

2 AVE ↓

3 AVE

4 AVE ↑

5 AVE ↑

6 AVE ↑

Pier 57

← UNION ST

Pier 56

Elliott Bay

Pier 55

UNIVERSITY ST →

University Street Station

Pier 54

POST AVE ↓

← SENECA ST

SPRING ST →

3

Pier 53

ALASKAN WAY VIADUCT

WESTERN AVE

← MADISON ST

N

MARION ST →

Washington
State
Ferries

Pier 52

2

← COLUMBIA ST

600 feet

1 AVE

2 AVE ↓

3 AVE

4 AVE ↑

5 AVE ↓

6 AVE ↓

FREEWAY

CHERRY ST →

Pier 48

1

ALASKAN WAY S

YESLER WAY

JAMES ST

S WASHINGTON ST

Chapter 2

The Waterfront District

*Art does not lie in copying nature. Nature furnishes
the material by means of which to express a beauty still
unexpressed in nature. The artist beholds in nature
more than she herself is conscious of.*

HENRY JAMES 1843–1916

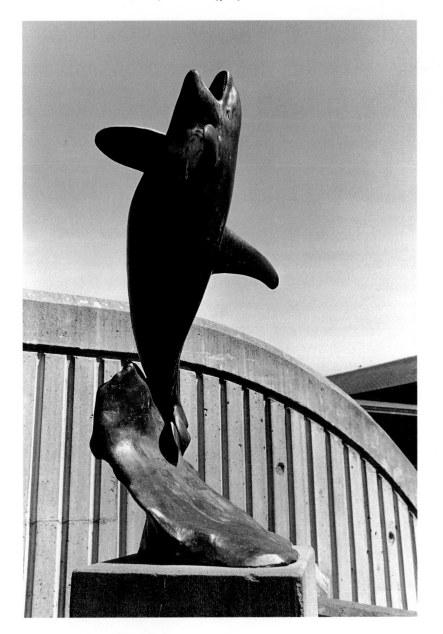

Orca sculpture, Tony Angell (*see page 37*)

2.3 *Ivar Feeding the Gulls*, Richard Beyer

2.4 *Christopher Columbus*, Douglas Bennett

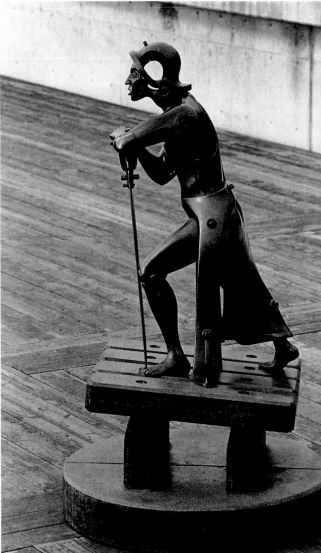

2.1 Totem pole, 1975

John Hagan, Ed Kasko, and Cliff Thomas

Carved cedar; H approx. 35 ft.
Port of Seattle collection
Alaska Square, adjacent to
Washington Street boat ramp

This totem pole was commissioned by the Port of Seattle to stand as a reminder of the importance of Alaska to Seattle. The plaque in front of the pole calls Seattle Alaska's "southern seaport." The pole is a collection of symbols of the forty-ninth state. Eagle stands at the top, symbolizing the main clan of the Tlingit tribe of southwestern Alaska. Below is Brown Bear holding a money piece, symbolizing the great size and wealth of Alaska. Next are Killer Whale, symbolizing tenacity and strength; Hawk, with its sharp eyesight and perception of the state's future; Grizzly Bear, typifying bravery but, as stated on the plaque, "holding a mosquito to warn people that all is not easy." At the bottom of the pole is Strong Boy, symbolizing Alaska's youthful strength. He is holding a sea lion by the tail after it has eaten his uncle. According to legend, Strong Boy was ridiculed for being weak, but he built up his strength and was able to tear the sea lion in half and rescue his uncle.

This pole was created at Alaska Indian Arts, a well-known art center in Haines, Alaska.

2.2 Joshua Green Fountain, 1966

George Tsutakawa

Silicon bronze; H 6 ft. × L 9 ft. × W 7 ft.
Gift to the city from Joshua Green
Washington State Ferry Terminal

This bronze fountain is a gift to the city from the late Joshua Green, an early Seattle shipping magnate and founder of Peoples National Bank (now U.S. Bank). The design of this fountain-sculpture is best viewed from above. Tsutakawa regrets that people usually view it only from street level.

One commentator has suggested that Tsutakawa's design has a flower or nature theme. The artist suggests otherwise: "I suppose you could see a flower theme, but there was a lot of abstract work in the sixties and I think I was probably working with abstract design when I made this fountain."

2.3 Ivar Feeding the Gulls, 1988

Richard Beyer

Cast bronze and aluminum; H 5 ft. 8 in. × W. 5 ft.
Gift to the city from the Friends of Ivar Haglund
Foot of Madison Street in front of Ivar's Acres of Clams restaurant

This memorial to the late Ivar Haglund is the first statue of a Seattle citizen to be placed in a public location in Seattle since James Wehn's statue of Chief Seattle was installed in 1912 (6.5). Haglund was a successful restaurant owner and entrepreneur who was admired for his unassuming devotion to the city and its people. After his death, a group of his friends (whose names are listed on the bronze captain's chair) donated money to create a memorial. Ivar is shown wearing a seaman's coat and captain's hat and engaged in one of his favorite pastimes at his Acres of Clams restaurant, feeding french fries to the local gulls. One gull reaches beneath the chair to catch a bronze clam running away. The gulls are oversized to allow children to sit on them.

2.4 Christopher Columbus, 1978

Douglas Bennett

Bronze; H 6.5 ft.
Gift to the city from the Italian American Hall
Waterfront Park

In designing this memorial to Christopher Columbus, Douglas Bennett intended to show a man who had been through the torment of a long and dangerous journey with a mutinous crew only to discover the wrong continent. Bennett's concept was to depict the tenacity and courage of this man who endured so much. Columbus stands on his ship's deck (granite planks in this case) and gazes out over the water.

Unfortunately, Bennett's creation is not best known in the history of Seattle's public art for its artistic merit. Rather, it is remembered for the uproar surrounding its creation and the controversy that ensued before its acceptance by the city. The work was a gift from members of the Italian American Hall to commemorate one of Italy's most famous citizens. The Seattle Arts Commission, which accepts such gifts for the city, deemed the sculpture unacceptable. It was an abstract rendition rather than a traditional statue, such as the Leif Eriksson statue at Shilshole Bay (16.6), but both pieces sparked similar debates. Commission members believed that the work

failed to meet "artistic standards" and to show the determination and emotional appeal its creator intended to represent.

Seattle's Italian community disagreed. After considerable debate and publicity, Seattle's mayor rejected the commission's arguments and accepted Bennett's sculpture. It was finally installed in 1978.

2.5 Waterfront Fountain, 1974

James FitzGerald and Margaret Tomkins

Bronze; H 16.5 ft. × W 18 ft. × L 21 ft.
Gift to the city from Helen Harrington Schiff
Waterfront Park

The *Waterfront Fountain* is the last of five James FitzGerald fountains created for Seattle's public places. Made of cast and welded bronze, FitzGerald designed it only a few months before his death in October 1973. His wife, noted Northwest painter Margaret Tomkins, executed the commission from her husband's bronze scale model. She was assisted by sculptor Terry Copple and welder Art Sjodin. Sjodin had worked with FitzGerald on past commissions.

This last fountain does not have the craggy and eroded shapes of FitzGerald's earlier works at the IBM Building (4.29), Plymouth Congregational Church (4.30), Intiman Playhouse (7.15), and Jefferson Terrace Retirement Home (8.2). This is a combination of cubical structures with comparatively little surface treatment.

Waterfront Fountain was given to Seattle by Helen Harrington Schiff in memory of her parents, Edward M. and Margaret J. Harrington. The Harringtons came to Seattle from Delaware in 1921 after his retirement from the DuPont Company and maintained an undying love for Seattle. Mr. Harrington died in 1931. Mrs. Harrington was an active philanthropist in this area until her death in 1966.

2.5 *Waterfront Fountain,* James FitzGerald
 and Margaret Tomkins

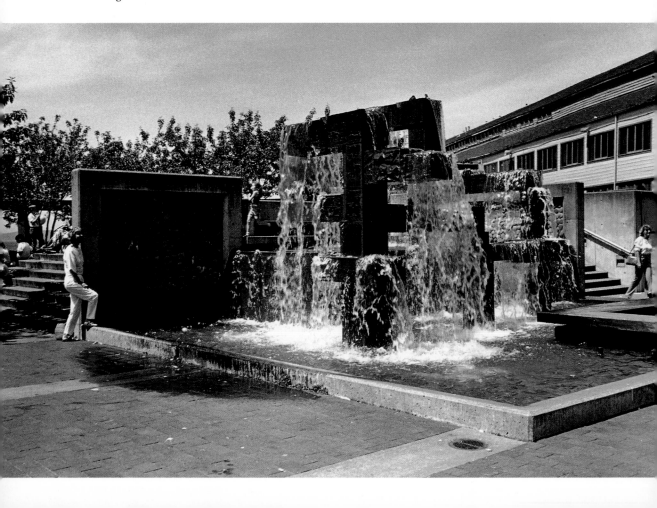

2.6 Untitled painting, Jay Kohn

2.6 **Untitled paintings,** 1977–79

Jay Kohn

Acrylic in Plexiglas; each, H 5 ft. × W 6 ft.
Seattle Arts Commission (Artist in the City Program)
Seattle Aquarium, just north of the entrance

Jay Kohn's colorful marine life paintings displayed outside the aquarium's main entrance are far away from the sidewalk and are thus missed by many passersby. This is unfortunate, for each of the eight works is a skillful rendition of marine life. Those farther from the entrance depict fish and various other forms of underwater marine life. Those closer to the entrance feature seals and sea otters and, second from the entrance, a sea bird called a tufted puffin.

Kohn's subjects are painted on separate sheets of Plexiglas and inset as different layers into wooden frames. In so doing he creates the illusion of three dimensions. In the tufted puffin painting, tinted Plexiglas was placed over the lower third to create an underwater scene. Kohn's subjects are all residents of the aquarium.

These works were made possible by the Seattle Arts Commission through its federally funded Comprehensive Employment and Training Act (CETA) Artist in the City Program, in which artists are employed to execute individual projects.

Jay Kohn's oil on canvas painting *Beyond the Reef* (1982) is located inside the aquarium.

Inside the aquarium are two other notable artworks. In the first building is an impressive display of glass creations by Dale Chihuly, an international leader in the world of glass sculpture. The work is dramatically displayed in a case designed by Chihuly, and the shapes, all inspired by sea forms, are displayed at different levels against mirrored and black backgrounds. This sculpture was commissioned by the King County Arts Commission under its annual Honors Award Program. Chihuly was the 1985 recipient and was chosen to create an artwork for any public place in King County. His choice of location was a logical one. Sea forms have influenced his work for many years. Another example of his work with sea forms is displayed in the lobby of the Stouffer Madison Hotel (4.11).

Upstairs near the aquarium office and accessible to the public is a bronze orca (killer whale) sculpture by Tony Angell, one of the Northwest's finest sculptors and painters of wildlife (see page 33). The great whale is shown as the artist has often seen them from his property in the San Juan Islands. It is jumping straight out of the water with only its tail touching the surface. The sculpture was commissioned by Pacific Search Press in 1977 and given to the city. It is Angell's second bronze work.

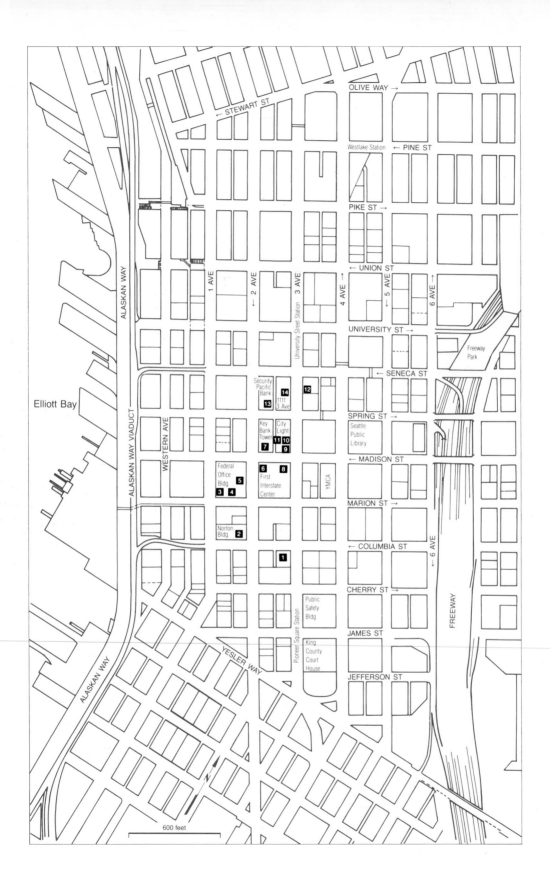

Elliott Bay

OLIVE WAY →

← STEWART ST

Westlake Station ← PINE ST

PIKE ST →

← UNION ST

UNIVERSITY ST →

Freeway
Park

← SENECA ST

Security
Pacific
Bank 14

13 1111
3 Ave

12

SPRING ST →

Key City
Bank Light
Tower 11 10

7 9

Seattle
Public
Library

← MADISON ST

Federal 6 8
Office
Bldg 5
3 4

First
Interstate
Center

YMCA

MARION ST →

Norton 2
Bldg

← COLUMBIA ST

1

6 AVE

CHERRY ST →

Public
Safety
Bldg

FREEWAY

JAMES ST

King
County
Court
House

JEFFERSON ST

YESLER WAY

ALASKAN WAY

ALASKAN WAY VIADUCT

WESTERN AVE

1 AVE

2 AVE

University Street Station 3 AVE

4 AVE

5 AVE

6 AVE

Pioneer Square Station

600 feet

Chapter 3

West of Third Avenue Between Cherry and University Streets

For me, a painting is a dramatic action in the course of which reality finds itself split apart.

PABLO PICASSO 1881–1973

3.4 *Freedom*, Philip McCracken

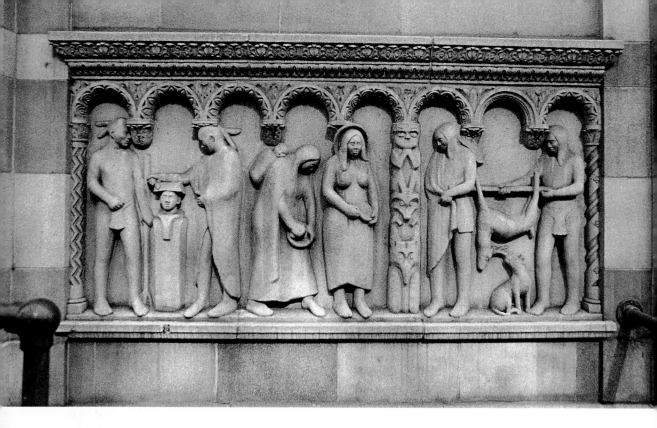

3.1 Relief sculpture, Morgan Padelford

3.3 Untitled sculpture, Harold Balazs

3.1 Relief sculptures, 1924

Morgan Padelford and Mildred Stumer

Cast stone; H 5 ft. 8 in. × L 11 ft.
Commissioned by the Seattle Chamber of Commerce
219 Columbia Street (Second Avenue and
Columbia Street)

The sculptured panels at both sides of the
entrance to the Seattle Chamber of Commerce
Building (which is now owned and occupied
by TRA, a Seattle-based architectural and
engineering firm) were designed by Morgan
Padelford as part of his master's degree program
at the University of Washington. The left-hand
panels, executed by Padelford, depict scenes of
native Northwest residents engaged in various
pursuits, including hunting and wood carving.
The right-hand group was executed by Mildred
Stumer. Her group is engaged in more modern
technological and industrial pursuits.

3.2 Restless Bird, 1959

Philip McCracken

Concrete aggregate; H 9 ft. × L 5.5 ft.
Commissioned by the Northwest Corporation
Norton Building, 801 Second Avenue

When the Norton Building was built in 1959, its
architects, Skidmore, Owings, Merrill & Johnson,
urged the owner to include artworks in the
building's public areas. Acting on that advice, the
Northwest Corporation (a Norton Clapp family
enterprise) commissioned two artworks. The
Norton Building thus became the first private
office building in Seattle to have commissioned
artworks in its public areas.

The selected artists were Philip McCracken and
Harold Balazs. The works of these two young
artists impressed the owner as "being contem-
porary expressions of the Pacific Northwest and
compatible with the elegance of the building's
design." Unfortunately, Balazs's copper sculp-
ture, *Totem,* was removed when the building's
west plaza was turned into office space in the
mid-1980s.

Restless Bird was the first public commission
for Philip McCracken. Still one of McCracken's
largest works, this four-ton sculpture is a fierce-
looking bird of prey, a recurring subject in many
of McCracken's creations. The stance is similar
to that of a bird in one of McCracken's later
Kingdome panels (1.14).

3.3 Untitled sculpture, 1976

Harold Balazs

Welded copper; H 8 ft. × L 11.5 ft. × W 2.5 ft.
*Commissioned by the U.S. General Services
Administration (Art in Architecture Program)*
Jackson Federal Office Building, First Avenue
and Marion Street

In 1959 Harold Balazs created a vertical collection
of welded-copper abstract shapes for the nearby
Norton Building and called it *Totem.* Seventeen
years later he used similar symbols in this
untitled work but without the vertical totemic
design of his earlier sculpture. Balazs points out
that although we are accustomed to vertical
totem poles, totems are symbols that need not
be shown only vertically. Here, the interlocking
symbols grow in all directions, independent of
any post or plane.

"I have always been fascinated with totemic
ideas and combinations of disparate figures," he
explains. "They show that we are all different, but
combined together. . . . This work is a collection
of contemporary forms and elements which refer
to both that idea and my fascination with com-
binations of anthropomorphic and mechanical
shapes."

Balazs used similar forms in bas-relief panels at
the University of Washington (12.32) and Seattle
Pacific University (14.5).

3.4 Freedom, 1976

Philip McCracken

Cast bronze; H 23.5 in.
*Commissioned by the U.S. General Services
Administration (Art in Architecture Program)*
Jackson Federal Office Building,
Marion Street side

Next to the brick stairs, close to the building, and
about halfway up the hill, is Philip McCracken's
fourth commission for Seattle's public places (see
page 39). It is among his first sculptures since
1966 to return to the bird subjects for which he is
best known. In the period between 1966 and 1976
he worked with subjects unrelated to his more
familiar nature themes, incorporating such
things as broken light bulbs and saber saw
blades. In *Freedom,* McCracken has portrayed a
bird of prey ready to escape from the restrictions
of its bronze cage. With a look of rage it stands
poised and ready to lunge forward to freedom.

McCracken points out that although his sculpture describes the act of becoming free, it "is not intended to represent a specific religious or political condition, but is meant to be translated into the terms each viewer personally sees as representing his own freedom" (Graham, *Philip McCracken*, 115).

Two blocks north of the Jackson Federal Office Building is a collection of curious sidewalk inserts created in 1983 by Seattle artist Charles Greening. At the corner of Second Avenue and Spring Street and appearing again downhill toward Western Avenue, the careful observer will see bronze duck feet imprints that wander about and disappear into a manhole.

3.5 **Landscape of Time,** 1975
Isamu Noguchi

Carved granite boulders
Commissioned by the U.S. General Services Administration (Art in Architecture Program)
Jackson Federal Office Building, Second Avenue entrance

One of the city's most controversial sculptures, because of its simple design and $100,000 cost, *Landscape of Time* was commissioned by the federal government for its then-new office building. It is the second of two major works in Seattle by Isamu Noguchi. (The first is *Black Sun* in Volunteer Park [9.1].) In designing this setting, Noguchi refers to a Japanese landscape garden. Its time-worn boulders are meant to inspire thoughtful repose. In fact, these boulders initially stood in the artist's studio garden on the island of Shikoku in Japan. *Landscape of Time* is intended to tie centuries together by combining ancient boulders and modern man-made materials. Noguchi could not place the boulders amidst raked gravel or sand, as he might have in a traditional Japanese garden. Here they are surrounded by natural materials and trees. No chrome or metal here.

These boulders are fine examples of Noguchi's opinion that natural stones are "ready-made sculptures for the eyes of connoisseurs." He points out that with proper placement anything can become a sculpture. Here, Noguchi supplemented the natural shapes with only a few grooves. In 1975 Noguchi described this sculpture as the "ultimate step" in his artistic works so far.

On the southeast corner of this Second Avenue plaza is a stone arch, and along the Marion Street side can be found architectural decoration in red terra-cotta. These are remnants of the Burke Building, which originally stood on that portion of the block. Built in 1890 by Thomas Burke (whose memorial stands in Volunteer Park [9.2]), it was demolished in 1971 to make way for the new Jackson Federal Office Building. These elements were saved by Seattle architect Fred Bassetti and incorporated into the new plaza.

3.6 **Moline Markers: Claudio Column II, Deere Split Column, Triangle Sentinel I, Lima Marker III, and Mauro Column II,** 1981
Beverly Pepper

Cast iron; H 114–127 in.
Wright Runstad & Company collection
First Interstate Bank Building, Second Avenue side

Across the street from Noguchi's "natural" boulder sculptures at the Jackson Federal Office Building are sculptures at the other end of the artistic spectrum: Beverly Pepper's five iron columns. These abstract creations are unusual among the outdoor works by this renowned American sculptor. Pepper's prior public works were monumental, seventeen to sixty feet high; and *Moline Markers* are related to her four steel columns placed in Todi, Italy, which range from twenty-eight to thirty-six feet high and weigh five to eight tons. Here, the works are studio-sized creations. The columns have been praised as intimate additions to a pedestrian-oriented setting. The decision to place smaller, more intimate works on the building's western steps was made by Wright Runstad & Company, the building's developer.

Across Madison Street, on the wall of Warshal's Sporting Goods Store, is a forested scene of western mountains titled *Mountain Landscape Mural*. It was designed by Teresa Goins and painted in 1984 by Jerry Lee.

Fifteen Northwest Coast Indian designs of birds and animals, sculpted in bronze bas-relief by Seattle artist Everett DuPen, decorate the entrance archway of the building at the corner of Second Avenue and Seneca Street (1117 Second Avenue).

3.5 *Landscape of Time*, Isamu Noguchi 3.6 *Moline Markers*, Beverly Pepper

3.7 **Rain Forest,** 1986

Gaylen Hansen

Oil painting; H 6 ft. × L 7 ft.
Private collection
Key Bank Building lobby, First Avenue between
Madison and Spring streets

In the lobby of this new building is the only work
in Seattle's public places by Washington artist
Gaylen Hansen. This colorful oil on canvas
painting brings to the urban environment a
scene of Pacific Northwest evergreens, ferns,
delicate trilliums, and other native flowers.

 Another public work in the area by Gaylen
Hansen is a mural at the Renton Public Library.
That work was commissioned in 1987 by the
King County Arts Commission.

3.8 **Seattle Tulip,** 1989

Tom Wesselmann

Painted aluminum; H 18 ft. × L 20 ft.
Wright Runstad & Company collection
First Interstate Bank Building, Second Avenue
and Madison Street

This colorful flower (see page 5) is one of the rare
sculptures, and the largest public work, by New
York artist Tom Wesselmann. Wesselmann estab-
lished his place in American art history in the
1960s as a pop artist whose works incorporated
paintings of faceless nudes with real objects such
as clocks or television sets, photomontage effects,
and sounds. The painted background often
included a tulip. Here his tulip bends and curves
as if cut from paper.

 Wesselmann had long been working on ideas
for a colorful tulip sculpture when Wright
Runstad & Company, the building's owner,
began searching for an important work to place at
this corner. His design for *Seattle Tulip* was readily
accepted and this commissioned sculpture adds
needed color to its neighborhood. The three-ton
green and red tulip is constructed of flat, three-
quarter-inch aluminum sheets. Appropriately,
it was installed on May Day 1989.

3.9 **Seattle City Light Promenade,** 1987

Alden Mason

Acrylic on canvas; each, H 4.5 ft. × L 12–13.5 ft.
Seattle 1% for Art Program
Seattle City Light Building lobby,
1015 Third Avenue, corner of Third Avenue
and Spring Street

Each of Alden Mason's four large paintings in
the Seattle City Light Building lobby is a flurry
of colorful acrylic paint squiggles and lines from
which comical humans and animals emerge.
Rather than using a brush, Mason applied his
paints directly from squeeze bottles; after stir-
ring the paints together, he added slashes and
squiggles. The technique adds texture and
vitality, brings out colors from lower layers of
paint, and allows a wide variation of shades and
colors. The paintings show a further stage in the
evolution of Mason's unique style. His earlier
squeeze bottle works, such as *Noah on a Forty-Year
Cruise* (22.8), have precise thick lines of paint with
no crossing of defined limits or stirring. *Seattle
City Light Promenade* was commissioned for this
location by the Seattle Arts Commission.

3.10 **That Man May Use It Freely as the Air He Breathes, the Waters of the Rivers, the Winds of Heaven,** 1958

Jean Cory Beall

Glass mosaic; H 8 ft. × L 32 ft.
Seattle City Light collection
Seattle City Light Building,
1015 Third Avenue, between Madison
and Spring streets

When the Seattle City Light Building was
designed in 1957, the utility and its architects
decided that thirty-four sculptured metal plaques
from the original City Light Building should be
displayed in its new lobby (3.11). However, doing
so left a blank thirty-two-foot exterior wall near
the building's entrance. Rather than leave it bare,
they commissioned Jean Cory Beall to create a
mosaic mural for the site.

 This brightly colored mural was made in
Venice, Italy, in 1958 according to Beall's
instructions and consists of 177, almost square-
foot sections of inlaid glass. The design and title
were inspired by these words of French novelist
Emile Zola: "The day will come when electricity

3.9 *Seattle City Light Promenade*, Alden Mason

3.10 *That Man May Use It Freely as the Air He Breathes, the Waters of the Rivers, the Winds of Heaven,* Jean Cory Beall

will be for everyone as the waters of the rivers and the winds of Heaven. It should not merely be supplied, but lavished, that men may use it at their will as freely as the air they breathe."

3.11 **Evolution of Lighting,** 1935 and 1958

Albert E. Booth and John Elliott

Britannia metal; each, H 23 in. × L 35 in.
Seattle City Light collection
Seattle City Light Building lobby,
1015 Third Avenue, between Madison and Spring streets

On a wall just inside the Seattle City Light Building is a collection of bas-relief plaques depicting scenes in the evolution of knowledge about and ability to create light. All are made from Britannia metal, a material similar to pewter.

Thirty-four were designed by Albert E. Booth and executed by John Elliott in 1935. They formed a frieze in the lobby of City Light's original building. In 1958, Elliott created two additional plaques for the new building.

The historical incidents illustrated here include the witnessing of fire created by lightning (in the first panel) and light-creating inventions from candles and liquid-fueled lamps to Thomas A. Edison's perfection of the incandescent light in 1879. The collection ends with an illustration of the twentieth-century invention of the air traffic beacon. In designing the first set of panels, Albert Booth spent considerable time researching period fashions and settings to ensure an accurate portrayal of the periods depicted.

Elliott created these panels using silversmithing techniques called chasing and repoussé. With the former he inscribed the design into the thin metal sheet. With the latter, he pressed the design out from the back of the sheet.

3.11 *Evolution of Lighting,* Albert E. Booth and John Elliott

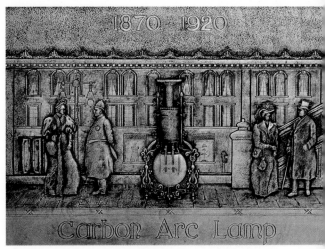

3.11 Individual plaques from *Evolution of Lighting,*
Albert E. Booth and John Elliott

3.12 **Untitled sculptures,** 1972

Jan Zach

Cast aluminum; H 10 ft. ×L 2.5 ft.
U.S. West Communications collection
U.S. West Communications Building,
Third Avenue, between Seneca and Spring streets

Among the lesser-known artworks in downtown
Seattle are the ten-foot-high sculptures attached
to the U.S. West Communications Building on
Third Avenue. Created by Czechoslovakian-born
artist Jan Zach, these rough gray abstract forms
refer to "organic formations of the Pacific
Northwest," subjects Zach considered ideal for
offsetting the straight lines of the building.
 Jan Zach's sculptures can be found in many
public places in Oregon, but these are his only
works displayed in Seattle.

In the next block, at the corner of Third Avenue
and University, is the twenty-seven-story Seattle
Tower, an important example of art deco archi-
tecture in Seattle. When it was built in 1928 it was
one of the earliest art deco buildings on the West
Coast. Its lobby is elaborately decorated with the
low relief and incised designs typical of the style
and, in this case, the decoration was influenced
by the Mayan, Chinese, and Pacific Northwest
cultures.
 Other examples of early art deco architecture
are the Exchange Building at Second Avenue and
Marion Street, just south of the Jackson Federal
Office Building, and the lobby of the Colman
Building at First and Marion.

3.12 Untitled sculpture, Jan Zach

3.13 **Untitled mural,** 1981

Richard Haas

Acrylic paint
Seattle Walls Project, funded by the city
and private sources
Building to the west of the 1111 Third Avenue
Building, on Spring Street

After completion of the 1111 Third Avenue
Building, the Seattle Arts Commission, the
Downtown Seattle Development Association,
Howard S. Wright Development Company, and
Security Pacific Bank combined their resources
and commissioned Richard Haas to paint a mural
on the adjacent building to the west (owned
by Security Pacific Bank) as part of the Seattle
Walls Project. Haas had two major objectives in
painting this wall. He wanted to imitate the
terra-cotta decoration on the building's front and

then create a "fantasy reflection" as a backdrop
for the new plaza. The imitated decoration is
more detailed than is apparent from Third
Avenue. Viewed from Spring Street or the alley
between the two buildings, one can see a detailed
"entrance" below the large window.

This wall illustrates Haas's belief that "there is
always room for play and fantasy." Inspired by
Seattle's impressive landscapes, he created a
mural of Mount Rainier viewed from an imagi-
nary window on Queen Anne Hill. Although
the viewer faces west, the view through the
window is to the south.

Richard Haas considers many buildings "blots
on the landscape" and has earned considerable
recognition for his architectural supplementation
of blank, boring urban walls throughout the
United States. The end result, he explains, is
to "help make the city alive . . . and add to
the fabric of city life."

3.13 Untitled mural, Richard Haas

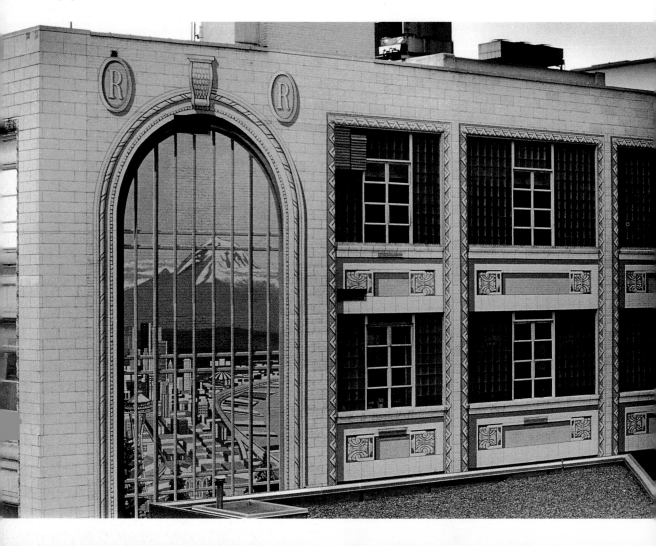

3.14 **Dance Columns I & II,** 1982

Robert Graham

Bronze; H 11 ft.
Wright Runstad & Company collection
1111 Third Avenue Building plaza
(removed in 1990; reinstallation uncertain)

In most cases, bronze sculptures in Seattle's
public places can stand as principal points of
interest because of their size alone. California
sculptor Robert Graham's two bronze columns
are exceptions. Many sets have been created,
initially for use as sculptures for private
residences. Graham later began placing them
in public settings, as small but energy-packed
sculptures able to compete with large buildings.

The two nude dancers standing atop the two
eight-foot-high columns are classically detailed
and, at first glance, classically posed. Graham is
considered by many to be the premier American
realist sculptor, and these figures are typical of
the sensuous female nudes for which he has
become famous. Hilton Kramer, an art critic for
the *New York Times,* has hailed Graham for his
ability to create "a vivid sculptural presence"
while simplifying it to a "statement of emotion."

Graham created the controversial (some
thought too sensual) *Olympic Gates* for the
entrance to the 1984 Olympic Games in Los
Angeles and is one of four artists (with George
Segal, Leonard Baskin, and Neil Estern) commis-
sioned to create works for the Franklin D.
Roosevelt Memorial in Washington, D.C.

Dance Columns I & II are Graham's only
sculptures in Seattle's public places. They were
purchased by Wright Runstad & Company, an
owner of the 1111 Third Avenue Building.

3.14 *Dance Columns I & II,* Robert Graham

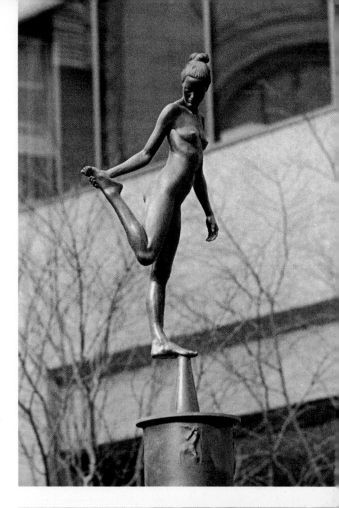

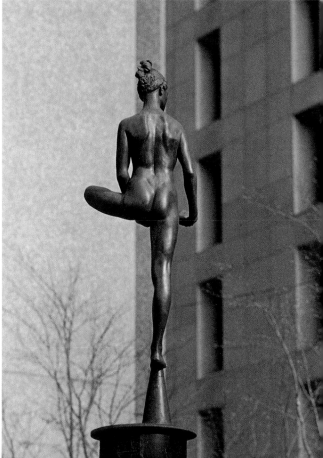

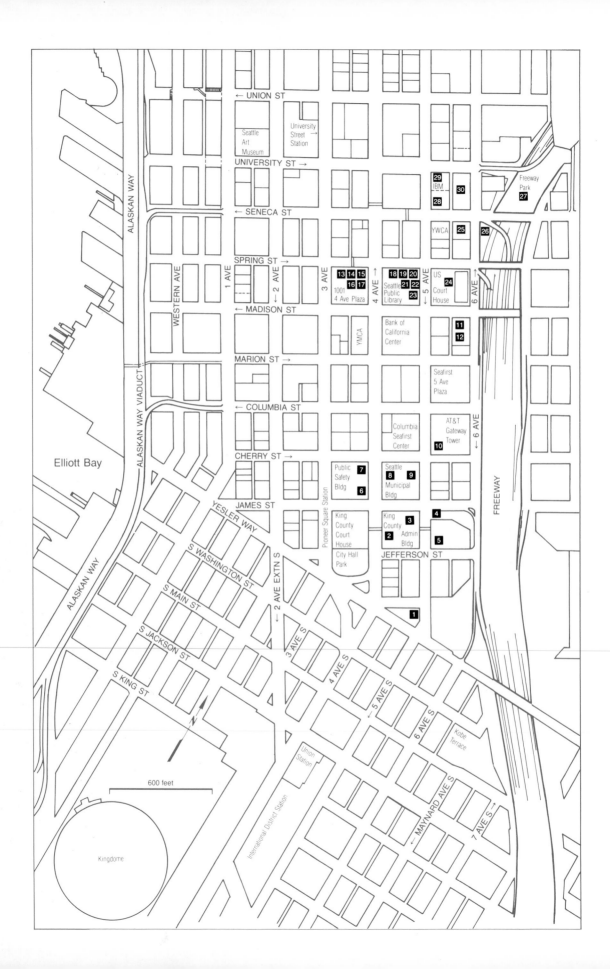

Chapter 4

East of Third Avenue Between Cherry and University Streets

The First (Principle of Painting) is, that through a vitalizing spirit, a painting should possess the movement of life.

HSIEH HO A.D. 500

4.20 *Pursuit of Knowledge*, Ray Jensen

4.1 *Covert Ensemble*, Michael Fajans

4.2 *Untitled #625*, Robert Sperry

4.1 Covert Ensemble, 1979

Michael Fajans

Painted mural
Seattle Arts Commission (Artist in the City Program)
Yesler Building, Yesler Way entrance

When Michael Fajans was commissioned to create a mural through the Seattle Arts Commission's Artist in the City Program, he chose to alter the ambience of the Yesler Building's south lobby with a multisurface mural. The work consists of 16 rectangular panels of varying sizes. Fajan explains that there is no simple description for the end result. His design intends to attract the viewer's attention with realism and then startle with illusion.

At first inspection, one sees realistic and unified scenes in *Covert Ensemble;* but logic soon escapes. Rooms are unrelated. Stairs lead nowhere. In one panel, the Yesler Building actually looks in upon itself. In other panels, figures fade away or appear as if captured in an unposed photograph. Several of the figures are portraits of persons living in the Yesler area when Fajans painted *Covert Ensemble.* Their inclusion is his tribute to people displaced by urban development.

4.2 Untitled #625, 1985

Robert Sperry

Ceramic; H 10.5 ft. × L 30 ft.
*King County Arts Commission
(Honors Award Commission)*
King County Administration Building,
Fourth Avenue lobby

Robert Sperry's ceramic mural is a monumental example of his innovative skill in ceramic art. A combination of sculpture and painting, it is composed of 176 black panels painted with a thick white slip (semifluid clay) and then fired. The result is a collection of geometric shapes and abstract images, accentuated by a crackled white surface. In 1983 *New York Times* critic Ruth J. Katz spoke of Sperry's technique: "The cracked and crater-like surface of this black-and-white volcanic landscape evokes images of relentless geological activity. The blistered and mottled crust periodically dissolves into tranquil plains."

This mural was commissioned by the King County Arts Commission as part of its annual Honors Award Program, which salutes outstanding local artists. The award has been presented annually since 1975 and requires that the selected artist create an artwork for a site within King County. Sperry received the award in 1983 and spent two years designing and constructing this mural. It is Sperry's largest work to date. Two smaller works can be seen in the lobby of the Sheraton Hotel (5.14).

4.3 Sand Worm, 1986

George Tsutakawa

Stainless steel; H 3 ft. 6 in. × L 8 ft. 5 in. × W 7 ft.
*King County Arts Commission
(Honors Award Commission)*
King County Administration Building,
Fifth Avenue plaza

This undulating stainless steel sculpture by Seattle artist George Tsutakawa was commissioned by the King County Arts Commission through its annual Honors Award Program (discussed in the Robert Sperry article above). The sculpture is different from many of Tsutakawa's other public artworks; few use stainless steel. It was originally created as a play sculpture for children and placed in Luther Burbank Park on Mercer Island. It was very popular with the children, but unfortunately, stainless steel's ability to retain heat from the sun made its surfaces too hot. Liability concerns resulted in its transfer to this location.

4.3 *Sand Worm*, George Tsutakawa

4.4 *Jail House Garden*, Martha Schwartz

4.4 Jail House Garden, 1987

Martha Schwartz

Ceramic tile
*King County 1% for Art Program
and National Endowment for the Arts*
King County Correctional Facility,
north entry plaza off Fifth Avenue

The colorful plaza on the correctional facility's
north side is a surreal version of a formal
European garden. Instead of the topiary shrubs
of such gardens, Martha Schwartz has used
geometric shapes made of a rich dark green tile.
The same tile is used for the "shrubbery" border
surrounding live plantings near Fifth Avenue.
Inlaid throughout this imaginary garden are
colorful ceramic pathways in yellow, mauve,
blue, and shades of green. The building's walls
are tiled in similar colors, and one path seems
to lead through a huge arched hedge.

The artist explains that, like any other garden
design, her *Jail House Garden* was designed with
the goal that it "entertain, amuse, and yet impart
a sense of mystery."

This colorful addition to a beige complex, as
well as Benson Shaw's *Torus Torum* (4.5) at the
south entrance, was commissioned by the King
County Arts Commission with funds from the

facility's construction budget and additional
funds from the National Endowment for the
Arts. Only one-quarter of one percent of the
construction budget was allocated for these
artworks (and several others inside). The King
County Arts Commission decided that one
percent ($600,000) would be too extravagant.

4.5 Torus Torum, 1984

Benson Shaw

Cast concrete panels; each section,
H 8 ft. 11 in. × L 17 ft. 8 in.
*King County 1% for Art Program
and National Endowment for the Arts*
King County Correctional Facility,
south entry plaza off Fifth Avenue

Benson Shaw's *Torus Torum* is a relief sculpture
placed within two bays of the south entry plaza
of the King County Correctional Facility. One
bay contains a symmetrical collection of smooth
curves and circles. The other bay displays a
disassembled version of the former. Shaw gave
his creation what he describes as "a snooty Latin
title." *Torus*, he explains, is Latin for a doughnut
shape. *Torum* is his made-up word referring to
the "torn up version" of the torus.

4.5 *Torus Torum*, Benson Shaw

Each sculpture consists of eight cast concrete panels (each appearing to consist of four panels) created using a method invented by the artist. The material used is glass-fiber-reinforced concrete, referred to in the construction industry as GFRC. The panels were made by spraying a slurry of sand, cement, and chopped glass fibers onto the sculpture mold. After several sprayings a sufficient thickness accumulates and a steel frame is permanently attached to the back of the still-wet material.

In 1984 this procedure was relatively new to the construction industry and had been used to create the "skins" of buildings such as the Stouffer Madison Hotel in downtown Seattle. Shaw improved on the process by devising a way to make raised, curved designs. His method has received considerable attention from artists, architects, and the construction industry.

Torus Torum is beige, and Shaw lightly textured its surface by sandblasting. The end result softens the plaza's concrete angles.

4.6 Gold Star Mother, 1950
Dudley Pratt

Marble; H 13.5 ft. × L 4 ft.
Washington Memorial Plaza, Fourth Avenue, between James and Cherry streets

Gold Star Mother is the last work created in Seattle by Dudley Pratt, one of the city's best known artists and a long-time professor at the University of Washington. He designed the work in a half-scale model and then had it executed in full scale by stonecutters at the Seattle Monument Company.

Carved in Carrara marble, the same Italian marble used by Michelangelo, this ethereal figure stands above the engraved names of Seattle residents who died fighting in World War II and, on the street-level walls, in Korea and Southeast Asia. A gold star mother is one who lost a son in World War II. Each was presented with a four-inch-square flag with a gold star in its center. The flag was often displayed in the window of the family home.

Dudley Pratt was one of the most prominent sculptors of this area in the first half of the century. The largest collection of his public works is at the University of Washington (chap. 12).

4.7 Nine Spaces, Nine Trees, 1983
Robert Irwin

Plum trees and blue mesh fencing
Seattle 1% for Art Program
and National Endowment for the Arts
Seattle Public Safety Building, northeast plaza
(just north of *Gold Star Mother*)

California artist Robert Irwin is among a group of American artists who attempt to redefine the requirements of what public art should be. Their work is sometimes considered closer to landscape design. Like Siah Armajani, Scott Burton, and George Trakas, whose creations at the National Oceanic and Atmospheric Association facility in Seattle are discussed in chapter 19, he does not believe in a clear distinction between art and landscape. Rather, he seeks to create a functional, aesthetic place and disdains the idea of "plopping" a sculpture onto a site.

Here Irwin took an empty, unused plaza and created a geometric pattern of blue fencing. The fencing creates nine spaces, each twenty-two feet square, which are accessible from one another. In the middle of each is a concrete planter with a dark red plum tree and ground cover. The lip of each planter serves as a bench.

In designing the setting, Irwin studied the possible uses for the site, the lighting in the area, and the surrounding colors and textures. He then sought to create a work with an "aesthetic presence" that responds to its environment. The blue fencing material was carefully selected to properly react to the light from different angles. The colors of the trees relate to the nearby plaza walls and interact with the fencing color and its aluminum framing. It is best to view this work from as many angles as possible. In fact, one of the most interesting views is from above.

4.6 *Gold Star Mother*, Dudley Pratt

4.7 *Nine Spaces, Nine Trees*, Robert Irwin

4.8 Sculptural screen, 1962

Everett DuPen

Carved walnut and bronze; H 7 ft. × L 10 ft.
City of Seattle collection
Seattle Municipal Building, Fourth Avenue lobby

When the plans for Seattle's Municipal Building were accepted in 1960, no art was designated for its public places. Art for art's sake in downtown buildings was rare at the time. Only one year before, the Norton Building became the first private building to display commissioned works of art in its public places. The new Seattle Public Library building was the only one of Seattle's municipal structures to have commissioned works. However, in 1961 the Seattle City Council agreed to commission works by two local artists, Everett DuPen and Glen Alps, for the Municipal Building. Both were professors of art at the University of Washington.

The theme of Everett DuPen's carved walnut panels is nature's fertility, in this case, Pacific Northwest plant life. On the left, the three-inch-thick walnut was carved into undulating sea-weed. On the right, buds are unfolding from growing land plants. Bronze framing encompasses the entire work.

DuPen, who describes himself as a "thematic artist," wanted something more for this space than a mere divider. He prefers to work with a theme because it gives him "a more personal attachment to each piece. It becomes more of a personal adventure when I relate my art to something more than just space breaking," he explains.

DuPen carved these screens with the help of his friend Elias Schultz.

4.9 Fountain of Waterfalls, 1962

Glen Alps

Concrete aggregate, steel, glass, and stainless steel; H 22.5 ft. × L 7.5 ft. × D 2.5 ft.
City of Seattle collection
Seattle Municipal Building, Fifth Avenue parking plaza

Glen Alps chose an eclectic design for the Municipal Building's parking plaza. Surrounding his large *Fountain of Waterfalls* are his decorative garden lights and concrete aggregate cubical benches that are radically different in style from the central fountain.

The fountain itself has two personalities. On the east side facing the street, Alps placed seventy metal cubes, thirty-nine of which have designs incorporating thick chunks of colored "cathedral" glass and metal tracery, lighted from behind by interior lights. The tracery can be seen repeated on the light boxes in the surrounding pool. Such boxes and round tracery patterns are continuations of Alp's experiments with sculptural collage designs.

The fountain's west side is composed of three stainless steel sculptures placed over leaf-shaped cutouts. After the designs were cut from metal sheets, they were bent and twisted to create three-dimensional works. The same approach was used in his sculpture at Jefferson Terrace Retirement Home (8.1).

4.10 Untitled, 1990

Parks Anderson

Bronze and stainless steel; H 44 ft.
Sarkowsky Investment Corporation
AT&T Gateway Tower, Fifth Avenue and Cherry Street, entrance to southwest corner plaza

This sculpture, Parks Anderson's largest, stands one floor above Fifth Avenue and straddles the top of the stairway to the southwest corner plaza. Its two stainless steel legs form an equilateral triangle with the top landing, and three over-lapping bronze forms attached to the apex swing randomly as the winds blow through the plaza. Each form is twenty feet in diameter and consists of spokes of bronze tubing radiating from a central point of balance, with a longer set of pendulum spokes extending sixteen feet from the center to a point twelve feet above pedestrians passing below. Anderson notes that the three forms are "just off balance enough to turn slightly and create a balletic rocking with an interaction of the spokes, then return to their original point by force of gravity."

Anderson creates kinetic sculpture because he says static sculpture would bore him after a while. "I like the ambivalence. . . . the kinetic aspect brings a random aspect to each piece. You just can't design it to please your eye, you have to deal with the reality of the surroundings and the randomness of the wind and the way light plays on each piece. . . . It isn't a form that I can fully control. . . . Here I was after a shape that would use the episodic winds generated by both the shape of the building and the canyon effect created by it and the building across the street."

The physical parameters of this location required some unusual planning by Anderson. Due to the design of the structure beneath the plaza, the primary anchor point for this sculpture is the more elaborate "moment-resisting leg" on the northwest side. It is attached to a wall and a structural beam beneath it and carries most of the wind load on this eight-ton creation. The opposite leg is less securely anchored and serves only as gravity support.

study of glass art. Chihuly's works have been featured in exhibits throughout the United States as well as in Canada, Europe, Australia, and Japan.

These sea form sculptures are part of a series of works inspired by aquatic creatures. A later work inspired by the same subject can be seen at the Seattle Aquarium.

4.11 **Sea Form Group,** 1983

Dale Chihuly

Glass
Stouffer Madison Hotel collection
Stouffer Madison Hotel lobby,
Sixth Avenue and Madison Street

Glass was relatively unimportant as an art medium in the twentieth century until the 1970s. One of the major names in the international studio glass movement is Dale Chihuly, who established the Pilchuck School, an independent school in Stanwood, Washington, devoted to the

4.12 **Turning Point,** 1980

Hilda Morris

Bronze; H 5 ft. × L 4 ft. 2 in.
Stouffer Madison Hotel collection
Stouffer Madison Hotel,
Fifth Avenue and Madison Street

Turning Point stands in the lower level of the Stouffer Madison Hotel and is a splendid example of the evolution of Hilda Morris's sculptural style. This is less skeletal than her 1962 sculpture *Muted Harp* at the Opera House (7.28), and although it too appears to have been shaped by natural erosion, it is a more refined, curvilinear form.

4.11 *Sea Form Group,* Dale Chihuly

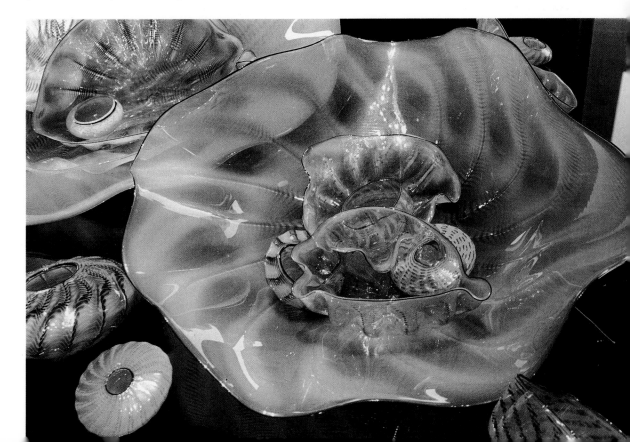

4.13 Three-Piece Sculpture: Vertebrae, 1968

Henry Moore

Bronze; H 9 ft. × L 24 ft. × W 10 ft. 7 in.
Seattle Art Museum collection
1001 Fourth Avenue Building plaza
(former Seafirst Bank Building)

When Seattle–First National Bank began plans to build the city's first modern skyscraper at 1001 Fourth Avenue, it also began collecting art to grace its future headquarters building. One-half million dollars was budgeted for artworks: two hundred thousand dollars for art in the office areas and three hundred thousand for art in the building's public places. Nothing like it had been done before in Seattle. The resulting collection of works by locally, nationally, and internationally known artists took its place with the finest corporate collections in America. Twenty years later financial catastrophe required that Seafirst sell its headquarters building. Happily, most of the public artworks remained.

In 1986 Moore's *Vertebrae* was sold to a Japanese collector, but the public outcry over the secret sale and planned removal of this important work resulted in its repurchase and donation to the Seattle Art Museum. If the museum wishes to remove it after an agreed number of years, it must provide a suitable replacement for the site.

Vertebrae was one of three choices originally considered for the Seafirst building's Fourth Avenue plaza. The other two were Barnett Newman's *Broken Obelisk,* now at the University of Washington (12.10), and Michael Heizer's *Adjacent, Against, Upon,* now at Myrtle Edwards Park (7.40). The bank officials, architects, and art collectors who were selecting the public artworks chose Moore's curvilinear sculpture to offset the stark lines of the building.

Some have remarked that Moore's creation "just looks like bones." They are correct. It was intended to. The history of sculpture is replete with representations of human and animal forms, but Henry Moore took a step further. Although the subjects of his earlier works were stretched and hollowed human forms, he was also attracted to other natural forms such as shells

4.13 *Three-Piece Sculpture: Vertebrae,* Henry Moore

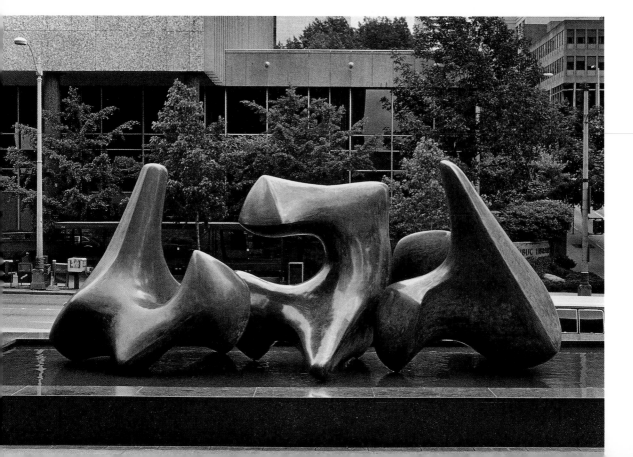

and bones. He did not believe sculptural subjects had to be limited to animate objects and chose to portray smooth, graceful, and rhythmic inanimate forms.

Seattle's *Vertebrae* is the only Moore sculpture in the state. It belongs to a series of three sculptures. One *Vertebrae* can be found on the grounds of Moore's estate in England. Another sits outside the Jerusalem Museum in Israel. However, each is unique in that the three sections of each sculpture are positioned differently. Moore did not believe that a single arrangement was required.

4.14 **Untitled painting,** 1979

Sam Francis

Oil on canvas; H 20 ft. × L 40 ft.
Private collection
1001 Fourth Avenue Building (former Seafirst Bank Building), Fourth Avenue lobby

The huge painting facing Fourth Avenue from the main lobby is the only public work in this area by Sam Francis, one of the leading figures in American abstract painting. Painted in 1979, it is part of his "grid," or "matrix," series, which evolved from his unique approach to space and color on canvas.

As American abstract art developed in the 1950s, artists such as Mark Rothko and Clyfford Still covered their entire canvases with thick paint. Sam Francis took a different approach and incorporated bare white canvas into his work. Initially his paintings included clumps or organic shapes of color divided by space. In the late 1960s his works deemphasized color, and the void became primary. Forms appeared at the sides of his canvases, and ultimately, color was used merely to stain the paintings' edges.

Francis's works in the 1970s began to use color once again; not clumps, but imprecise, linear shapes used sparingly to divide his canvas. In this later Seafirst painting, Francis created a grid, or matrix, of color. One definition of "matrix" is the "intercellular substance in which tissue cells are imbedded." Neither is independent of the other. Such is the case here.

This is an unusually large work for Francis, but others of comparable size do reside in Berlin, Basel, Tokyo, and New York.

4.14 Untitled painting, Sam Francis

4.15 Hanging light fixture sculptures, 1968

Harry Bertoia

Stainless steel
Private collection
1001 Fourth Avenue Building (former
Seafirst Bank Building), banking lobby

A contrast to the natural forms of Henry Moore's *Vertebrae* are the twenty hanging light fixtures designed by Harry Bertoia. A premier sculptor and graphic and furniture designer, Bertoia believed that sculptors should take advantage of the industrial age in which they live. His preference for technologically inspired art is evident in these designs.

The umbrella-shaped lights were created by attaching one end of each of thousands of strands of stainless steel industrial wire and allowing the opposite ends to freely extend upward and be bent downward by their own weight. The resulting curves are not created by forcing the wires into shape. Rather, gravity bends each into a natural curve.

The light fixtures are arranged in seven rows. The most elaborate portions are eight-foot-high combinations of three umbrellas, and the simplest are single umbrellas. The others are double groups.

In the lobby below Bertoia's lights is a large bronze sculpture of a polar bear created by Alaskan artist Melvin Olanna. This is one of Olanna's larger works and is a splendid example of his modern approach to a common subject of traditional Eskimo art.

Polar bear sculpture, Melvin Olanna

4.15 Hanging light fixture sculptures, Harry Bertoia

4.16 Series in Creation, Numbers 7, 8, 9, and 10 (four benches), 1968–69

James W. Washington, Jr.

Carved granite;
each, H 1 ft. 4 in. × L 7 ft. × W 3 ft.
Private collection
1001 Fourth Avenue Building (former Seafirst Bank Building), north side of Fourth Avenue lobby

These four black granite benches are fine examples of the unique sculptural style of Seattle artist James W. Washington, Jr. In each he seeks to express his thoughts about the creation of life and the interrelationship between all creatures. The theme, which he calls the "kinship of all life," has been emphasized in many of his works since 1968 (10.4).

Washington's subjects include a crocodile and chicks emerging from eggs, a human head, a rabbit, a lamb, young birds of prey, sea horses, and a coelacanth (a rare prehistoric fish once thought extinct). These simply carved figures show the influence on Washington of Mexican carvings that he first saw during a tour of Mexico in the early 1950s. Only the essential form is carved. Detail is left to the viewer's imagination.

4.17 Fountains, 1968

George Tsutakawa

Polished bronze; each, H approx. 4.5 ft.
Private collection
1001 Fourth Avenue Building (formerly Seafirst Bank Building), north side of Fourth Avenue lobby

Between Washington's benches are two sculptures by Seattle artist George Tsutakawa. They were created as fountains and originally placed on the building's south side. High winds prohibited their use as fountains, and when they were moved to this location, they were placed as sculptures.

Most of George's Tsutakawa's fountain-sculptures are organic shapes of silicon bronze with a rich brown patina. These are polished geometric shapes with precise, hard edges.

4.18 Fountain of Wisdom, 1960

George Tsutakawa

Silicon bronze; H 9 ft. × W 5.5 ft.
Seattle Public Library collection
Seattle Public Library, Fifth Avenue entrance

Fountain of Wisdom is George Tsutakawa's first fountain-sculpture and marks the beginning of a successful career as an internationally known creator of such works. This creation displays the central idea in the design of all Tsutakawa fountains: that water should be integrated into the sculpture, not just sprayed at it. "Water is *part* of the sculpture—that's one of my strong beliefs," Tsutakawa explains. "The old European, so-called Roman, fountains used cast bronze figures . . . women, horses, fish, with water either squirting onto them or pouring out of an urn or squirting out of a mouth. The water and sculpture are unrelated. I started to think of water as another element of the work. . . . It had to function as part of the total design. One way to do that was to have the water forced out to become part of the design. By doing that, the water can dominate and command the total space around the sculpture . . . not to mention the color, sound, and deflection of the water, which are all tremendously exciting things. Water is the most exciting element we have."

Unlike most of his subsequent works, this fountain is named and abounds with specific symbolism. "The gushing water," Tsutakawa explains, "represents knowledge, the material source. . . . The library is the source of that knowledge. The total representation is of the universe. The top curved dish represents heaven; the round form beneath it represents earth. Beneath it all is the five-fingered basin representing man. Knowledge is flowing down to him. . . . He's trying to catch knowledge to obtain wisdom, but no matter how much knowledge he catches, so much is lost." However, that which is lost, he explains, will be recirculated, as the water in this fountain recirculates.

The larger, immobile pieces in the library are described here, but other, portable works are displayed on each floor. The artworks are well identified and readers are encouraged to explore.

4.18 *Fountain of Wisdom*, George Tsutakawa

4.19 **Alice,** 1966

James Wegner

Laminated and carved pine; H 3 ft. 10 in.
Seattle Public Library collection
Seattle Public Library, inside Fifth Avenue
entrance

Outside the Children's Library is James Wegner's
rendition of Alice in Wonderland, the immortal
creation of Lewis Carroll (Charles Lutwidge
Dodgson). Given to the library in 1967 by an
anonymous donor, Alice stands slightly over
three and a half feet tall and holds a ball. Inscribed
on the sculpture's base is part of the last verse of
Carroll's introductory poem for *Alice's Adventures
in Wonderland:* "Alice! a childish story take, / and
with a gentle hand, / Lay it where Childhood's
dreams are twined, / In Memory's mystic band."

4.20 **Pursuit of Knowledge,** 1960

Ray Jensen

Bronze; H 4 ft. 8 in. × L 7 ft. 7 in. × W 6 ft.
Seattle Public Library collection
Seattle Public Library, inside Fifth Avenue
entrance, in outside courtyard

Pursuit of Knowledge is local artist Ray Jensen's
expression of humanity's constant striving to
obtain knowledge (see page 51). The joining of
these three figures alludes to the fact that we all
contribute in our unique ways to obtaining
knowledge for the good of all. Jensen placed the
subjects at slightly different levels and heading in
slightly different directions to symbolize "that
knowledge takes different directions and is
obtained at different levels." This sculpture was
Jensen's first public commission, and it evolved
from his earlier series of three-figured works
based on events in track competition.

4.21 **Activity in Growth,** 1960

Glen Alps

Sheet metal and steel rod;
H 5 ft. 6 in. × L 9 ft. 10 in.
Seattle Public Library collection
Seattle Public Library, inside Fifth Avenue
entrance, to the right

Glen Alps's *Activity in Growth* is made of cut out
pieces of flat metal that were twisted, bent, and

embossed and then accented with steel-rod
filigree and a rich brown color. His twisting and
swirling shapes imitate growing and moving
natural forms. Twisting, flat metal shapes were
also used in his next public commission in
Seattle, the *Fountain of Waterfalls* at the Seattle
Municipal Building (4.9).

4.22 **Sculptural screen,** 1960

James FitzGerald,
with Margaret Tomkins

Bronze, enamel on brass, and colored glass;
H 8 ft. 2 in. × L 27 ft.
Seattle Public Library collection
Seattle Public Library, inside Fourth Avenue
entrance

James FitzGerald's sculptural screen is an array
of 125 panels created from sand-cast bronze,
etched brass, and fused layers of colored glass.
Surrounded by a frame of polished brass, the
work presents a multitude of shapes and visual
effects and colors.

This work holds an important place in
FitzGerald's successful career. It was his first
major public commission since he designed the
tunnel reliefs for the Mercer Island Floating
Bridge (10.7) and it was the cause of a fire that
destroyed his studio and many of his works and
those of his wife, painter Margaret Tomkins. This
screen is actually FitzGerald's second one because
much of the original was destroyed in that fire.

4.23 **In Transition Is Unity,** 1978

Rita Kepner

Carved granite; H 3 ft. × L 3.5 ft. × W 1.5 ft.
Seattle Public Library collection
Seattle Public Library, outside the Fourth Avenue
entrance adjacent to the bus shelter

Rita Kepner's granite sculpture is her study
of different shapes and textures within one
encompassing shape. The surface changes from
shiny black to rough gray, and the form curves
inward to a circle in its center. The theme of
Kepner's design is the interrelationship of all
things. The theme is referred to in her statement
on the sculpture's base: "Rough to smooth—Hard
to soft—Man to woman—In transition is unity."
Unfortunately, the location of Kepner's sculpture
prohibits an adequate view of its shape.

4.24 The Effects of Good and Bad Government, 1985

Caleb Bach

Paint on canvas; each, H 8 ft. × L 4.5 ft.
*Commissioned by the U.S. General Services
Administration (Art in Architecture Program)*
U.S. Court House, Fifth Avenue, between
Madison and Spring streets, inside main entrance

Colorado artist Caleb Bach's two paintings at the
U.S. Court House are an allegorical work contrasting the effects of good and bad government
upon society. These very detailed works, with
over 150 figures, were inspired by fourteenth-century murals painted by Ambrogio Lorenzetti
on government buildings in Sienna, Italy.

The right-hand scene deals with the
well-governed society. Hovering just above the
landscape are figures representing the following
qualities (which are labeled in Latin): Justice,
Fortitude, Prudence, Common Good, Magnanimity, Temperance, and Peace. Above them
are the virtues: Hope, Faith, and Charity.

The panel's lower two-thirds contains what
Bach describes as a "dense 'Brueghelesque' scene
of a strong united family as the building block
of society surrounded by a broad range of
wholesome, productive forms of activity such
as harvesting fruit, fishing, wine making, bee-keeping, and milling." There are also scenes
of a market, teachers and students, and artisans.
A major portion of the lower area is devoted to a
wedding scene with a feast and a dance. At the
bottom of the work, just above the Latin words
for "Heaven on Earth," "departed ancestors rest
in peace in a graveyard treated with respect."
The words at the top of this panel are Latin
for "Effects of Good Government."

"Effects of Bad Government" runs across the
top of the left-hand work. Bach explains that this
panel is "ruled by negative forces such as Avarice,
Vanity, and Pride, as well as War, Treachery,
Discord, Tyranny, Fury, Fraud, and Cruelty. In
place of a wedding, there is a large, somewhat
fanciful battle scene (vaguely reminiscent of
Uccello's *The Battle of San Romano*)." Bach also
included references to "various forms of antisocial
behavior such as banditry, smuggling, brawling,
and drunkenness." At the center of the negative
panel, Bach has included a poverty-stricken
fragmented family. Their ancestors do not rest
in peace. In general, he concludes, "there is a
general tone of chaos and anarchy." Below are
the Latin words for "Hell on Earth."

4.24 *The Effects of Good Government*, Caleb Bach

Just north of the U.S. Court House, in the lobby
of the Kennedy Hotel, is a six-panel painted
screen by noted Seattle artist Paul Horiuchi. This
work is typical of the collages for which Horiuchi
has become so noted. Horiuchi's work is
discussed in more detail in relation to his large
mural at the Seattle Center (7.3).

4.25 Loo Wit, 1980

James Rosati

Welded aluminum; H 16 ft.
Holiday Crowne Plaza Hotel collection
Holiday Crowne Plaza Hotel, Sixth Avenue
and Seneca Street, in outside courtyard

4.25 *Loo Wit*, James Rosati

Loo Wit, a major work by American sculptor James Rosati, is composed of three painted aluminum sections that are delicately balanced on top of one another. The largest section, at the top of this sixteen-foot-high sculpture, is twisted and balanced in a tension-creating way. Rosati refers to his design as "counterpoint," the technique of musical composition in which two or more melodies are blended together. "What first may seem dissonant or unbalanced," he explains, "reveals itself to be harmonious." In addition, the placement of each piece creates the varied shadows that Rosati considers an important aspect of his sculpture. The shadows add a certain sense of power to the work.

Rosati's work has no specific meaning or message to offer. "If you tell me what a rose means," Rosati comments, "I will tell you what my sculpture is."

No name was intended or thought necessary for this work. However, its arrival in Seattle was delayed for several days by ash fallout in Montana from the 1980 eruption of Mount St. Helens. In recognition of that eruption, Rosati named his sculpture *Loo Wit*, the Klickitat Indian name for the volcano.

This sculpture was purchased and brought to Seattle by Richard Hedreen, the hotel's developer.

4.26 **Naramore Fountain,** 1966

George Tsutakawa

Welded silicon bronze; H 15 ft.
Gift to the city from Floyd Naramore
Sixth Avenue and Seneca Street

In 1966 Floyd Naramore, a prominent Seattle architect, commissioned George Tsutakawa to create this fountain (the artist's twentieth) for presentation to the city. It may be the fountain admired most often in Seattle. Tsutakawa created it with two purposes in mind: to please its viewers and to make water an integral part of its form. Tsutakawa's primary innovation here is the forcing of water onto and against curved bronze shapes, thereby creating flared sheets of water that extend the bronze forms. "As a design without water, it's a more conventional work," he explains, "but the water forced up against the sides and over the leaves is unique. Not many fountains have that."

Naramore Fountain is also unusual for the manner in which it is displayed. Rather than placing it at eye level, Tsutakawa and Perry Johanson, the Seattle architect who designed the setting, placed it on a concave rock aggregate platform above eye level. Rocks quarried from the Cascades were added to the platform to give the effect of a flowing mountain stream.

Looking west from *Naramore Fountain*, on the side of the YWCA Building just beyond the hotel, is one of the few remaining good views of the YWCA's mountain mural. It was painted in 1976, four years before the hotel was built, as a YWCA bicentennial project. The artists were Seattle sign painters Peter Steimel and Jerry Lee. Their design is based on a photograph taken on the North Cascades Highway.

4.27 **Freeway Park waterfalls,** 1976

Lawrence Halprin & Associates

Concrete
Freeway Park, Sixth to Eighth avenues, between University and Spring streets

When Interstate 5 was cut through Seattle in the 1960s, the environmental planning we know today was not a predominant influence. Thus, suggestions that the freeway be covered over to create usable space were quickly dismissed. However, by the end of that decade Seattle voters passed the city's Forward Thrust bond issue, which included plans for a small park at the edge of the freeway between Seneca and University streets.

That idea grew to encompass this much grander 5.4-acre park built over the freeway. The central portion is devoted to three waterfalls designed by the San Francisco landscape architecture firm of Lawrence Halprin & Associates. The three waterfalls, which recirculate a combined total of 27,000 gallons a minute, are the *Central Plaza Canyon*, the *East Plaza Water Display*, and the *Central Plaza Cascade*. These roaring waterfalls effectively drown out the sounds of the freeway below.

4.26 *Naramore Fountain*, George Tsutakawa

The firm of Lawrence Halprin & Associates was also the principal landscape designer of the Seattle World's Fair and designed the *Joseph Drumheller Fountain* at the University of Washington (12.24). The firm also designed the two popular waterfalls in downtown Portland, Oregon. In a 1977 interview with *Newsweek* magazine, Halprin commented that the rushing waterfalls "affect us in the same way as does a wild animal in the zoo, pacing back and forth in his cage, beautiful and quietly desperate, controlled, but with implications of wild danger."

The principal architect on this project was Angela Danadjieva, a Bulgarian-born architect who has achieved considerable recognition for her work on this and similar projects. She has since formed her own landscape architecture firm. She also designed the extension to the Washington State Convention and Trade Center and the earlier one-half-acre addition to the park across the freeway and above the city parking garage. Funds for the first addition were given to the city by the PACCAR Foundation in memory of Paul Piggott, former chief officer of PACCAR Corporation. The more recent addition was constructed with federal funds authorized in 1984 by the Federal Aid Highway Act.

4.28 **Wind on Water,** 1971

Norman Warsinske

Steel with gold leaf; H 5 ft. × L 10 ft.
UNICO Properties collection
IBM Building lobby, Fifth Avenue,
between Seneca and University streets

The only artwork in the IBM Building's white marble lobby is Norman Warsinske's *Wind on Water*. Standing above the elevator bay, his sculpture portrays the motion created by wind upon the sea, a force that, Warsinske comments, "creates a feeling of joy for those who observe it." That common, simple theme was translated into this simple, yet elegant, sculpture. It is the largest of the works in Warsinske's "Wind Series," the subject of two of his exhibitions.

4.29 **IBM Fountain,** 1964

James FitzGerald

Cast bronze; H 6 ft. 10 in. × L 18 ft. 6 in.
UNICO Properties collection
IBM Building, lower plaza,
corner of Fifth Avenue and University Street

The late James FitzGerald is one of the most represented sculptors in Seattle's public places and the fountain he created for IBM is one of his major downtown works. Made of welded sections of cast bronze, its craggy, eroded shapes are similar to those of his nearby fountain at Plymouth Congregational Church (4.30), which is visible from IBM's fountain, as well as his sculpture a few blocks away at Puget Sound Plaza on Fourth Avenue (5.6) and the fountain at Intiman Playhouse at Seattle Center (7.15).

4.30 **Pinkham Fountain,** 1967

James FitzGerald

Cast bronze; H 9 ft. × L 4 ft. 10 in.
Gift of the James E. Pinkham family
Plymouth Congregational Church, Sixth Avenue and Seneca Street, west side, overlooking IBM Building courtyard (access is from the interior of the church)

The *Pinkham Fountain* was created by James FitzGerald three years after he created the fountain next door at the IBM Building. This is the vertical complement to that earlier work and is composed of similar craggy and eroded bronze shapes. This fountain was given in memory of Ada and James E. Pinkham by their son and daughter.

The eighteen-foot-high clock at the northwest corner of Fifth Avenue and University Street was commissioned by UNICO Properties, owner of the Security Pacific Bank Building and surrounding properties, to honor James Ryan, its chairman for many years. The white marble and stainless steel clock, accented after sunset with blue neon lighting, was designed by the NBBJ Group, a Seattle architectural firm.

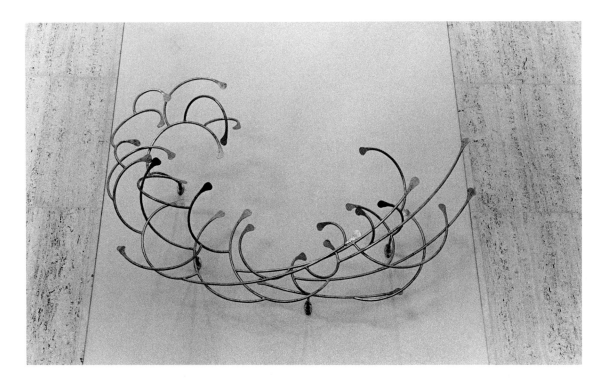

4.28 *Wind on Water*, Norman Warsinske

4.29 *IBM Fountain*, James FitzGerald

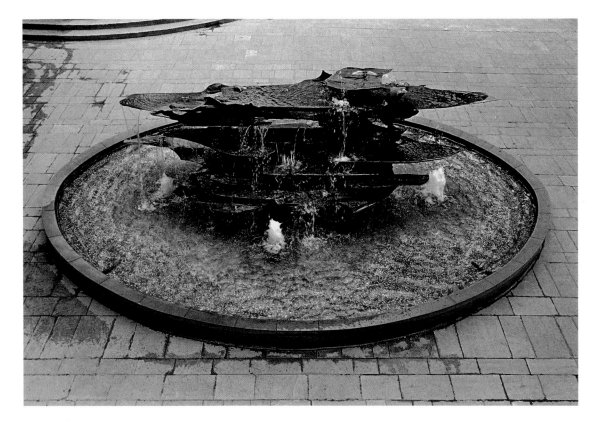

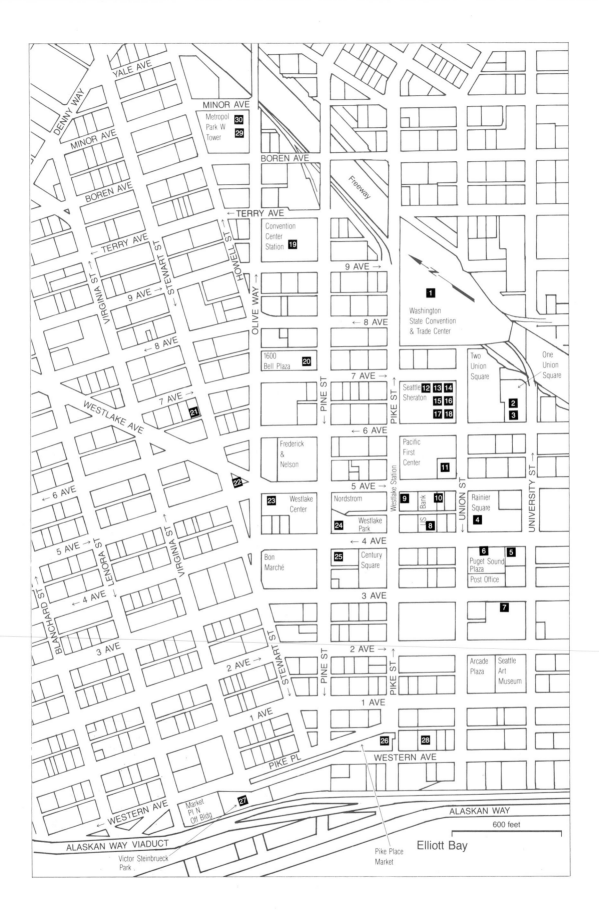

Chapter 5

University Street
to Lenora Street

*Painting is the only bridge linking the painter's mind
with that of the viewer.*

Eugène Delacroix 1798–1863

Hammering Man, Jonathan Borofsky *(photo by Susan Dirk)*
(see page 95)

5.1 *Washington State Centennial Bell Garden,*
David Mahler

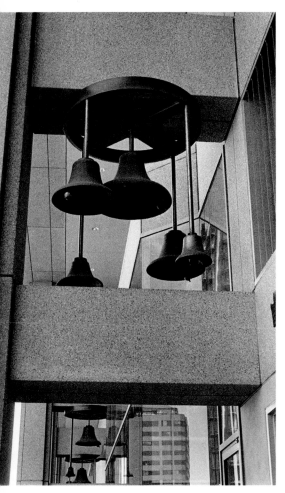

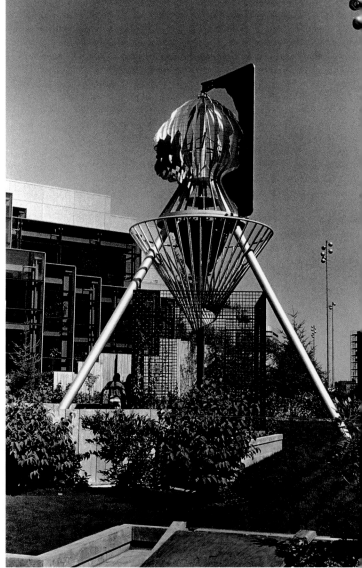

5.1 Untitled mural, Alden Mason

5.1 *Seattle George Monument,* Buster Simpson

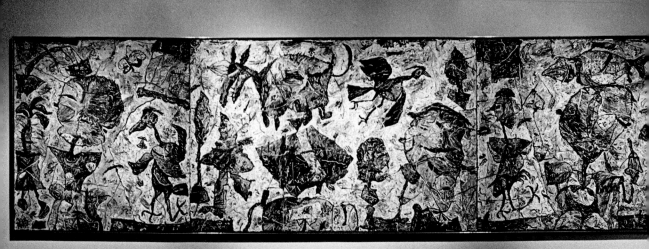

5.1 Washington State Convention and Trade Center works, 1988

David Mahler, Lewis ("Buster") Simpson, Jackie Ferrara, and Jenny Holzer

Mixed media
Washington State Arts Commission
Washington State Convention and Trade Center, north of Seventh Avenue between Union and Pike streets

Five major artworks in Seattle's new convention center were purchased with $329,000 from the state's One-half of One Percent for Art Program. The four artists who created these works were selected in 1985 by a special selection committee consisting of architect David Rutherford, former Seattle City Council member Phyllis Lamphere, Mary Jane Jacobs, curator of the Museum of Contemporary Art in Los Angeles, San Francisco artist Douglas Hollis, and Seattle arts professional Anne Focke.

Seattle composer David Mahler created the *Washington State Centennial Bell Garden,* a collection of thirty-nine bells, one for each county in the state. The bells were contributed by local centennial committees and commemorate Washington's centennial in 1989. Each bell is unique, and sizes range from church and school bells, to small sheep bells, to a little glass bell created at the Pilchuck School in Snohomish County. Most of the bells are located on the center's Pike Street side in between columns along an outside walkway above street level. They are fitted with clappers and rung in computer-programmed sequences on special occasions. Other smaller bells, including the Pilchuck bell, are located inside.

The large bronze Japanese temple bell in the center's northwest courtyard is not part of Mahler's collection. Installed in May 1990, it was presented to the Weyerhaeuser Company as a gift to the state from Yomiuri Shimbun, publisher of Japan's largest newspaper. The 4-foot-tall, 827-pound bell symbolizes the long relationship between Washington and the Pacific Rim and commemorates the state's centennial and the first visit to the Northwest by Y. Kobayashi, president of Yomiuri Shimbun and Japan Television Network Corporation.

On the south side of the convention center, in the fourth-level Freeway Park plaza, is Seattle artist Buster Simpson's *Seattle George Monument.* His twenty-eight-foot-high creation consists of a steel mesh cube topped with twenty-four aluminum profiles of Chief Seattle's head. The wind vane that turns around these profiles is cut in the shape of a profile of George Washington's head. Eventually Seattle's profile will be covered with ivy, and as the wind vane turns it will trim the ivy to the shape of Washington's profile. Chief Seattle will eventually be lost from view. Simpson's sculpture includes a supporting cone and tripod, in reference to Washington's career as a surveyor, and the sculpture is placed on a grid aligned to the Willamette Meridian, the main survey line of Washington and Oregon. Simpson reports that the cone and tripod also refer to the shape of an inverted Indian lodge.

Two other artworks were created by New York artists Jackie Ferrara and Jenny Holzer. Ferrara's design is a geometric pattern of green, black, and red slate tiles for the 7,000-square-foot floor of the International Meeting Place. Holzer designed at least ten electronic signboards that flash "one-line statements expressing diverse and often contradictory points of view." The signs are located on the upper balcony around the International Meeting Place, and what Holzer describes as the changing "truisms" are in different languages.

A twenty-foot-long mural by Seattle artist Alden Mason is located near the escalator corridor. The work is the result of Mason's selection in 1988 as the King County Arts Commission Honors Award artist, which requires the recipient to create an artwork for placement somewhere in the county. Mason reports that his colorful parade of figures includes many inspired by birds observed on trips to tropical locales and is designed to convey a sense of the interaction of birds, animals, and humans.

In 1987 Guy Anderson received the county's Honors Award and created two large paintings, one of which was *Sisyphus,* now located at the end of the same level and to the left of Mason's mural. *Sisyphus* and the Mason mural will remain at the center on long-term loan from King County.

5.2 **Torana Gateway,** 1982

Lee Kelly

Stainless steel
UNICO Properties collection
One Union Square, Sixth Avenue
at University Street

Torana Gateway is Lee Kelly's first stainless steel
sculpture in Seattle's public places. His other
works in Seattle have the rich brown color of
cor-ten steel. However, Kelly found that cor-
ten's color "soaked everything up" in Pacific
Northwest surroundings, unlike stainless steel,
which takes on and reflects surrounding colors.

The sculpture's title is the Sanskrit word for
"arch." Kelly took several arches, cut them, and
fitted them together backwards. This architectural
theme is typical of Kelly's work and is indicative
of his belief that sculpture is "alternative
architecture." Many of his works have been
commissioned for architectural settings. Kelly
received the commission for this sculpture after
One Union Square was completed, and he chose
this curved design to soften the flat surrounding
area. He also painted the edges of each section a
lavender tone and textured the surfaces slightly
by sanding to further lessen the harshness of the
plaza.

5.2 *Torana Gateway,* Lee Kelly

5.3 **Newari I** and **Newari II,** 1982

Lee Kelly

Stainless steel;
each, H 7 ft. 9 in. × W 5 ft.
UNICO Properties collection
One Union Square, Sixth Avenue
at University Street, elevator lobbies

These sculptures are named in honor of the
indigenous people of the region of Katmandu,
Nepal, which Lee Kelly visits regularly to hike,
mountain climb, and create small polished bronze
sculptures cast by Newari artisans. Both are
accentuated with white neon backlighting.

5.4 **The Earth** *(La terre),* 1884

Auguste Rodin

Cast bronze; H 18.5 in. × L 6.5 ft.
Security Pacific Bank collection
Security Pacific Bank Tower lobby, Fourth
Avenue, between University and Union streets

The Earth is the only work on public display in
Seattle by Auguste Rodin, a revolutionary artist
of the latter half of the nineteenth century who
helped begin the "post-realistic" era of modern
sculpture. It is, by the popular standards of his
day, a partially completed sculpture. It consists

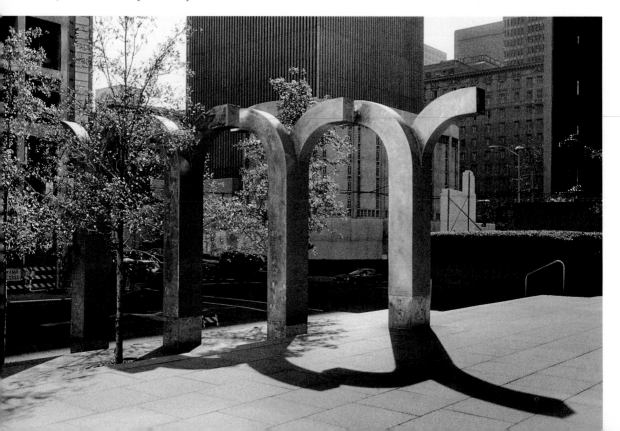

of a faceless human figure stretched out on the ground. The surface texture differs little from that of the soil depicted beneath it. Although small, *The Earth* is a fine example of Rodin's monumental style.

Critic Gustav Geffroy, a contemporary of Rodin's, praised the artist's approach to sculpture. Geffroy's comments about *The Earth* are quoted in *Rodin Rediscovered*, edited by Albert E. Elsen: "It is a body stretched out on its stomach, a powerful piece . . . and it is a woman in hovering movement, the legs bent back, the arms extended, the body thrown forward. How can it be that in this . . . statue with its accentuated movement, its limbs projecting in such a manner, there is no bristling or mangling, but, on the contrary, force and equilibrium? It is because, in fact, all movements, all aspects of life are possible in sculpture and the great truth that matters is the realization of modelling in light" (p. 265).

The Earth was purchased by the bank in 1976 and is the fourth of twelve castings of the work authorized by Rodin to be made after his death. That authorization was part of an agreement with the French government made in 1916, the year before his death. The artist gave France all his works and rights to copyright in return for its promise to support him until his death, at which time his Paris home and studio would become (and became) the Musée Rodin.

5.5 **Indian head,** ca. 1909

Victor Schneider

Terra-cotta; H 8 ft. 2 in. × L 3 ft. 6 in.
Seattle–First National Bank Metropolitan Branch, 1309 Fourth Avenue (across Fourth Avenue from Security Pacific Bank)

This large terra-cotta Indian head was one of many that used to decorate the White-Henry-Stuart Building, which stood across Fourth Avenue where the Security Pacific Bank Tower and Rainier Square now stand. Prior to the building's demolition in 1976, several were removed and preserved for future viewers to see how Seattle's grand old buildings were decorated. Similar heads can still be seen intact on the upper portions of the Cobb Building, just south of this location, at the corner of Fourth Avenue and University Street.

Although no records exist to tell who created these sculptures, they were probably executed by Victor Schneider, a Seattle artisan whose expertise was creating the terra-cotta architectural decoration so popular in the early 1900s. Each head weighs about 800 pounds and consists of eighteen parts.

An identical head stands at eye level on the east end of the Rainier Concourse, the tunnel under Fifth Avenue from Rainier Square. Another was placed at the Museum of History and Industry in Montlake, and a third stands in front of the Daybreak Star Arts Center in Discovery Park.

5.4 *The Earth (La terre)*, Auguste Rodin

5.5 Indian head, Victor Schneider

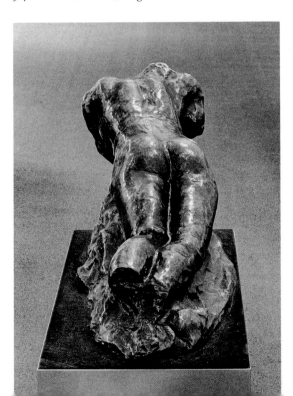

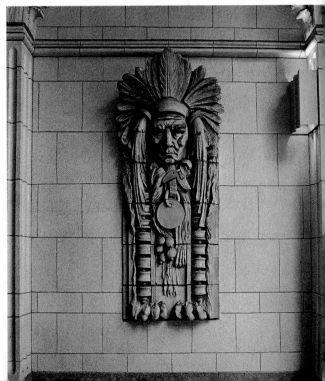

5.6 **Wall sculpture,** 1960

James FitzGerald

Cast bronze; L 32 ft.
Puget Sound Plaza (formerly Washington
Building) lobby, Fourth Avenue,
between University and Union streets

James FitzGerald's bronze wall sculpture is a
splendid complement to his two fountains a few
blocks away at the IBM Building and Plymouth
Congregational Church (4.29 and 4.30). With
its craggy cast forms, the work seems to have
naturally eroded over thousands of years.

5.7 **Metro station artworks,** 1990

Bill Bell, Robert Teeple, and Vicki Scuri, with station architect Mark Spitzer

Mixed media
Metro collection
University Street station,
Third Avenue and University Street

Mezzanine-level artworks in the University Street
station are the most high-tech creations of the
Metro tunnel project. Boston artist Bill Bell
installed twenty-four 16- by 32.5-inch computer-
operated bars of lights that flash on and off
and groupings of light bulbs that flash sequen-
tially to create unexpected patterns of movement,
such as a running animal, across the wall. Bell
embedded the bars into the marble tile wall "in a
random vertical pattern resembling falling red
raindrops." Seattle artist Robert Teeple installed
eight electronically operated light boxes that
have light-emitting diodes flashing schematics
and diagrams of twentieth-century technology, as
well as words and human faces. The walls on the
mezzanine level are also graced with black and
white granite designs by Seattle artist Vicki Scuri.
She has also created computer-etched designs on
stainless steel door panels, which she likens to
braille or circuit board patterns. The reverse of
those designs is etched on nearby black granite
panels on benches.

The University Street station also includes *The
Beltline,* Vicki Scuri's elaborate graphic design
of black, red, and speckled white and brown
granite that covers parts of the walls and creates
tracelike patterns on the floor. The designs
change at doorways and where benches and
information panels are located and continue up
the escalators. Scuri describes her work as "a
kit, with different modules placed in different
manners, . . . made up of asymmetrical designs
for symmetrical spaces, that wrap around the
station like an elastic band, or beltline."

5.8 **Skagit Valley Triptych,** 1974

Richard Gilkey

Oil on canvas; each section, H 6 ft. × L 20 ft.
*U.S. Bank of Washington
(formerly Peoples Bank) collection*
U.S. Bank of Washington Building,
banking lobby, Fourth Avenue,
between Union and Pike streets

At first glance this impressive work by Skagit
Valley artist Richard Gilkey appears to be one
grand scene. Actually it is three separate views
united by composition and theme. Each is typical
of the Skagit Valley north of Seattle, with old,
bleached farm buildings and bright green lichens
accenting the weathered wood.

Using palette knives rather than brushes,
Gilkey lays thick, subtle colors onto his canvas to
create an unmatched, distinctive style. Gilkey's
comments evidence his love for the Skagit Valley,
which has long been a place of inspiration for
many Pacific Northwest artists: "This is a rather
somber country with gray overcast skies much
of the year. The rich flat fields, early barns of
split cedar boards and shakes, the rows of pilings
driven to protect the dikes, all the sloughs,
ponds, and the constant presence of the river
itself, contribute to the quiet beauty."

5.7 Electronic artwork, Robert Teeple

5.8 *Skagit Valley Triptych*, Richard Gilkey
(right-hand painting)

In the southeast corner of the bank lobby, in a stairwell near the door to the adjoining office building, is a large stained glass window created in the late 1920s by Anton Rez (1896–1963). The detailed work depicts people laboring in major areas of regional commerce.

5.9 **Alihtan,** 1984

Susan Singleton

Paper and bamboo, H 7 ft. × L 15.5 ft.
Washington Federal Savings and Loan collection
Washington Federal Savings and Loan Building lobby, corner of Fifth Avenue and Pike Street

In constructing *Alihtan* of bamboo and cream-colored paper, Susan Singleton sought to bring a rustic, lighter complement to the lobby's polished stone and metal surfaces. The delicate-appearing, parchment-like paper is stretched on frames placed at odd angles to further contrast with the lobby's straight lines and ninety-degree angles. This is an approach often taken by Susan Singleton in her many commissioned works for architects and designers. Most of her career has been devoted to textile design, and she typically uses fabric or other natural materials to soften the hard-edged environments created by modern architecture.

5.9 *Alihtan*, Susan Singleton

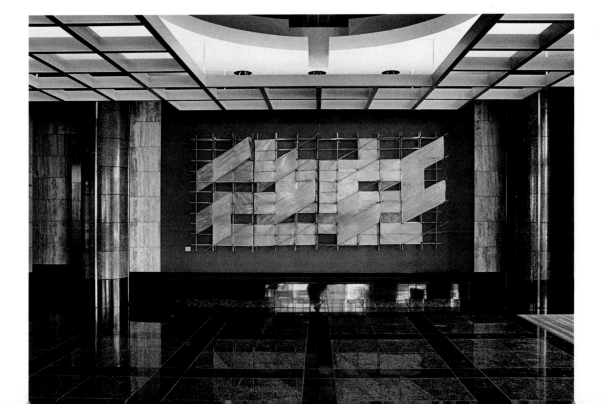

5.10 **Northwest Herbal,** 1979

Harold Balazs

Vitreous enamel on steel;
H 7 ft. 8 in. × L 9 ft. 8 in.
Washington Mutual Savings Bank collection
Washington Mutual Savings Bank,
1401 Fifth Avenue

This colorful rendition of Pacific Northwest plant life is the second of Harold Balazs's enamel-on-steel "paintings" in Seattle. As with his three-part Kingdome mural (1.15), Balazs designed it to add a bit of color to its surroundings.

5.11 **Morning Flight,** 1959

Archie M. Graber

Bronze; H 11 ft. × L 12.5 ft.
Logan Building collection
Logan Building lobby,
Union Street and Fifth Avenue

Archie Graber's *Morning Flight* was the winner in a competition for artwork for the lobby of the Logan Building when it was completed in 1959. At first glance, one may see only swirling lines above marsh reeds. However, those lines form the heads of two ducks flying above the cattails, a common scene where Graber was raised in Montana.

5.11 *Morning Flight,* Archie M. Graber

The Sheraton Hotel Collection (5.12–5.18)

When the Sheraton Hotel opened its doors in 1982, it presented Seattle citizens and visitors with the most elaborate collection of art in any hotel in the region. Over 1,800 limited-edition prints and photographs by contemporary local artists were placed in guest rooms. Photographs by noted Seattle photographer Johsel Namkung were installed in the elevator lobby on each floor.

In the main lobby area is a collection of works by some of the best-known contemporary artists of the Pacific Northwest. In many cases the works on view by the younger artists are their only works in Seattle's public places.

On the west end of the main lobby is Fullers, the hotel's premier restaurant, which has a museum-quality collection of paintings by members of the "Northwest School" and other eminent painters from the Pacific Northwest. At its entrance is a fountain by George Tsutakawa. Above the escalator to the mezzanine level is Parks Anderson's *Reshonta*, a fifteen-foot-high brass and acrylic sculpture given a nonsensical name composed of the letters in "Sheraton."

Works on the mezzanine and second floor include *Latitude Zero*, an eighteen-foot diptych painted in 1980 by William Hoppe; *Big Chief Seattle*, one of Alden Mason's collections of acrylic paint squiggles; Paul Heald's iridescent *Liftoff*; and Mary Ann Peters's energetic collection of forms titled *Veil of the Siren, Disguise of the Mime*.

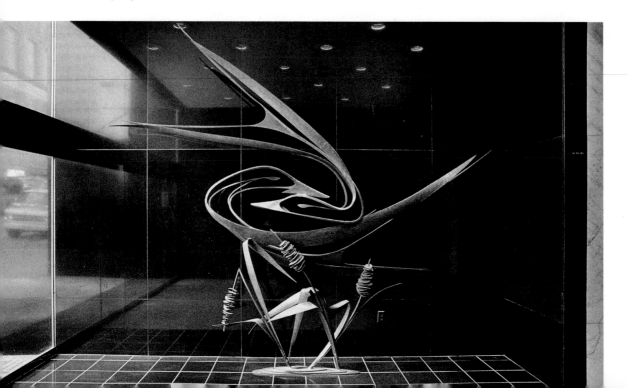

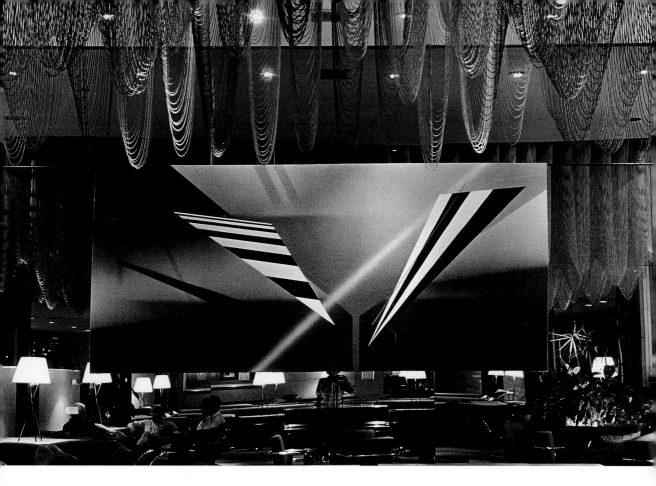

5.12 *Projections 7 (Tides),* Jeffrey Bishop

5.12 **Projections 7 (Tides),** 1982

Jeffrey Bishop

Acrylic on canvas; H 5 ft. × L 11 ft. 8 in.
Sheraton Hotel collection
Sheraton Hotel, Sixth Avenue, between Union
and Pike streets, lobby, southwest corner

Projections 7 (Tides) is one of Seattle artist Jeffrey
Bishop's largest paintings. It is typical of Bishop's
works during this period: brightly colored,
floating geometric shapes that project into a deep,
dark background. Bishop explains that his paint-
ing is a seascape having three or four horizons
with a liquid effect in its lower portion, while the
upper areas are atmospheric. "The painting is not
figurative. It is more about projecting out and
refers to the continuing cycle of atmospheric
absorption." The piece was painted with a spray
gun to help create its atmospheric aura.

Projection 7 (Tides) was designed for placement
on the hotel lobby's east wall. The misguided
efforts of an interior designer resulted in its
subsequent attachment to a large mirror.

5.13 **Lobby ceiling,** 1982

Larry Kirkland

Dyed rayon cord; H 7 ft. × L 40 ft. × W 25 ft.
Sheraton Hotel collection
Sheraton Hotel, Sixth Avenue, between Union
and Pike streets, lobby, south half of lobby

Portland artist Larry Kirkland's goal in designing
his ceiling sculpture in the Sheraton Hotel lobby
was to lessen the lobby's impersonal feeling. "The
building's architecture is undistinguished and
its entry is not designed to make it someplace
you'd be comfortable in," he says. "I wanted to
take part of it and create a special and intimate
setting." He did so by lowering the ceiling with
twenty-five miles of hand-dyed cord that is
curved to create an elaborate undulating effect.
Lighting is directed to the bottom portion of
the sculpture to accentuate its undulations. His
design alludes to Pacific Northwest clouds, which
are so often overhead. As is true of his more than
thirty other sculptures, this is not a heavy work
imposing itself on the viewer. Rather, Kirkland
seeks to have his works "harmonize with the
architectural spaces surrounding them."

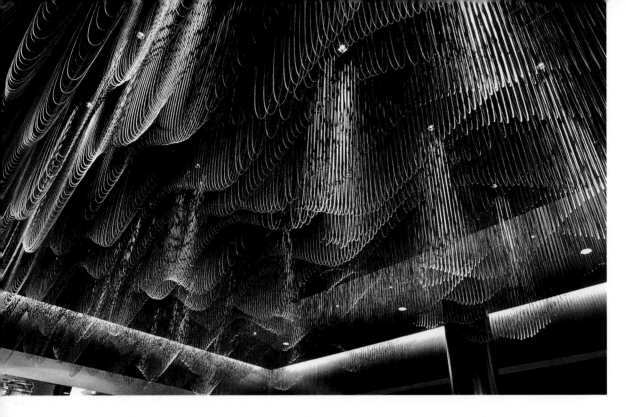

5.13 Lobby ceiling, Larry Kirkland

5.14 **Untitled murals,** 1982

Robert Sperry

Ceramic tiles; each, 64 in. × 64 in.
Sheraton Hotel collection
Sheraton Hotel, Sixth Avenue, between Union and Pike streets, south wall of lobby

These two murals are splendid examples of Robert Sperry's distinctive treatment of ceramic tiles with a thick layer of slip (semifluid clay) to create a crackle glaze. The resulting effect is reminiscent of the surface of a dry lake bed. These two murals are composed of separate panels, as is Sperry's massive mural created for the King County Administration Building in 1985 (4.2).

5.15 **Obelisk with Phoenix and Esoteric Symbols,** 1982

James W. Washington, Jr.

Carved granite;
H 5 ft. 9 in. × L 1 ft. 11 in. × W 1 ft.
Sheraton Hotel collection
Sheraton Hotel, Sixth Avenue, between Union and Pike streets, lobby

This red granite monolith has a fine collection of the esoteric symbols for which James W. Washington, Jr., is known (see 9.14 and 10.4). Creatures on its top include a reclining rabbit and a hatching bird. Designs on its front, back, and sides include a phoenix, symbolizing "period destruction and re-creation or reincarnation"; a loaf and a fish, "symbolizing Christ feeding the multitudes"; and geometric shapes and numbers referring to Washington's personal philosophy. On the wall behind this sculpture is Washington's brief explanation of what the symbols represent.

5.16 **Shapes of Colors from the Past, 2,** 1981

Paul Horiuchi

Casein and paper on canvas; H 4.5 ft. × L 7.5 ft.
Sheraton Hotel collection
Sheraton Hotel, Sixth Avenue, between Union and Pike streets, wall adjacent to Fullers restaurant

Shapes of Colors from the Past, 2, is one of the finest examples of Paul Horiuchi's work on display in a public place in Seattle. The style suggests that of a classic Japanese screen, but it is uniquely

Horiuchi, with the combination of paint and torn-paper collage. The torn paper seems to float at different heights above a field of color. Horiuchi was inspired to pursue this medium in 1956 after seeing rain-soaked and wind-torn posters in Seattle's International District.

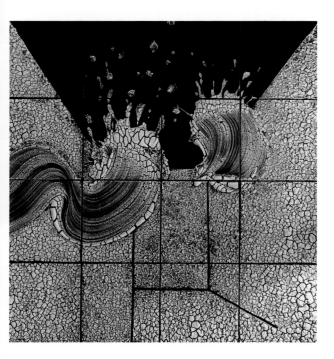

5.14 Untitled mural, Robert Sperry

5.15 *Obelisk with Phoenix and Esoteric Symbols,* James W. Washington, Jr.

5.16 *Shapes of Colors from the Past, 2,* Paul Horiuchi

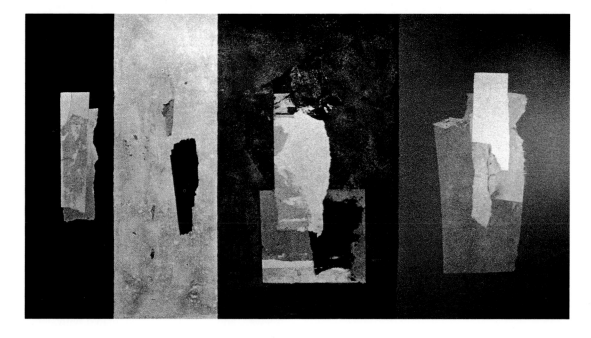

5.17 Phase Four Phosphors, 1982

Norie Sato

Mixed media on paper, and glass;
H 9 ft. 4 in. × L 12 ft.
Sheraton Hotel collection
Sheraton Hotel, Sixth Avenue, between Union
and Pike streets, adjacent to Fullers restaurant

This four-panel screen is a fine example of Seattle
artist Nori Sato's unique style, which stems from
her work in video art and her attraction to
video images. A video image is created by
hundreds of lines of phosphors (substances that
emit light when excited by radiation) that are lit
only one at a time, but so quickly that the human
eye does not see them. Although video and
television allow us to see images, they are merely
electronically arranged patterns of individually
lit phosphors. Sato seeks to paint those rapid
transient single images that make up a minute
part of a picture. *Phase Four Phosphors* was created
for placement near the hotel's Sixth Avenue
windows, so that sunlight would be reflected by
the shards of glass at the bottom and the
horizontal panes of colored glass above.
Unfortunately, its present, inadequately lighted
location hides the work's energy.

5.18 Transition of Venus, 1982

Nancy Mee

Glass and copper; H 6 ft. 10 in. × L 15 ft. 4 in.
Sheraton Hotel collection
Sheraton Hotel, Sixth Avenue, between Union
and Pike streets, northwest corner of lobby level
at entrance to Banners café

A common element of Mee's sculptures is a
vertical column of thick glass shards fused
together and often twisting and contorting.
Mee explains that the continuing theme in her
sculptures is the transition between beauty and
deformity, and the columns refer to deformed
backbones often caused by scoliosis, a spinal
abnormality that occurs in younger women. This
theme is derived from images Mee often saw as a
college student when she worked as a
photocopier at the University of Washington
Medical School library.

5.18 *Transition of Venus*, Nancy Mee

The newest display of art glass in Seattle is the
Prescott Collection of Pilchuck Glass, displayed
on the first three floors of Pacific First Center
across Sixth Avenue from the Sheraton Hotel.
The thirty-five artworks were created at the
internationally known Pilchuck School in
Stanwood, Washington, by artists from around
the world and display a wide range of techniques.
Northwest artists represented in the collection
include Dale Chihuly, William Morris, Norie Sato,
Ginny Ruffner, Dante Marioni, and Dale Kerner.

5.19 Metro station artworks, 1990

Alice Adams, Jack Mackie,
and Maren Hassinger

Mixed media
Metro collection
Convention Place station,
Pine Street and Ninth Avenue

The two marquees at the entrance of this station
relate to the marquee of the Paramount Theatre
across the street. New York sculptor Alice Adams
worked with project architects and engineers to
create the marquees, which are constructed of
white pipe and have glass and neon inserts. This
station connects the Metro tunnel with the
freeway, and Jack Mackie collaborated with
project architects and engineers to create concrete

grid patterns and landscape changes to ease the transition from massive freeway walls to the less-imposing station setting. His design includes a waterfall that cascades down the Pine Street wall to the passenger platform below. Mackie also designed green, white, and safety-orange patterns for the nearby utility poles. Four concrete planters by New York artist Maren Hassinger stand in the station plaza. Each is reminiscent of a Japanese bonsai pot. The design of one was derived from a rock Hassinger saw in Seattle's Japanese Garden, and that of another from the design of the elevator button for the Cloud Room in the nearby Camlin Hotel.

5.20 *San Juan Otters*, Tony Angell

5.20 **San Juan Otters,** 1981

Tony Angell

Cast bronze; life-size
U.S. West Communications collection
1600 Bell Plaza, Seventh Avenue, between Olive and Pine streets, in pool on building's south side

Tony Angell's *San Juan Otters* are bronze depictions of the otters he has admired so often from his property on Lopez Island. They are inquisitive creatures and the upright position of one of the two is a common pose assumed by otters to observe their surroundings. The second otter sits with its paw on a flounder. Angell's

subjects are river otters, which live in the local salt waters. They are not sea otters, which are natives of the Pacific Ocean coast and rarely seen in the Puget Sound area. Angell also works in stone, often steatite, a soapstone native to this area (see 8.6).

Northeast of the U.S. West Communications Building, at King County Medical Blue Shield's building (1800 Terry Avenue), is a bronze fountain created in 1964 by Seattle artist and interior designer Norman Warsinske. Warsinske also created the sculpture *Wind on Water* at the IBM Building (4.28).

5.19 Marquee, Alice Adams

5.21 Cattle Drive and Lumber Mill, 1934 and 1938

Franz Zallinger

Oil on canvas;
H 6 ft. 6 in. × L 6 ft. 4 in.; H 6 ft. 4 in. × L 7 ft.
Vance Hotel collection
Gas Lamp Restaurant, Stewart Street,
between Sixth and Seventh avenues
(removed in 1990 and placed in storage)

These are two largely forgotten works by a prominent artist of his day. Franz Zallinger is also largely forgotten, but in the thirties and forties his works were exhibited at the Seattle Art Museum and he was commissioned to paint several large works for theaters and hotels in the area. He often depicted scenes of the Pacific Northwest and people pursuing commercial endeavors. *Cattle Drive* and *Lumber Mill* are excellent examples of his work.

5.22 Governor John Harte McGraw, 1909

Richard Brooks

Cast bronze
City of Seattle collection,
Alaska-Yukon-Pacific Exposition commission
McGraw Place, Fifth Avenue and Olive Street

John Harte McGraw (1850–1910) was a prominent figure in early Seattle history. A lawyer, businessman, and law enforcement officer, he was also the state's second governor, serving from 1893 to 1897. McGraw served as president of the First National Bank of Seattle and also owned an interest in the *Seattle Post-Intelligencer*.

As King County sheriff, McGraw protected life and property during the Seattle fire in 1889 and was a major figure in keeping the peace during anti-Chinese disturbances in the mid-1880s (see Roger Sale, *Seattle, Past to Present*). As noted in the inscription on the statue's base, McGraw was an avid supporter of plans to build the Lake Washington Ship Canal.

McGraw's statue was one of several created for the city to display in time for the Alaska-Pacific-Yukon Exposition in 1909. Richard Brooks was a prominent New York sculptor in the early part of the century. He also created the William H. Seward statue in Volunteer Park (9.4).

In Times Square Park (the small triangular area across Westlake from the Washington Plaza Hotel) is a small bronze fountain-sculpture created in 1965 by Seattle artist Jean Johanson.

5.23 Sandstone Cliff, 1988

Amanda Richardson

Textiles; H 15 ft. × W 10.5 ft.
Private collection
Westlake Center office building lobby,
1601 Fifth Avenue

Fabric works are some of the rarest seen in public places. An exception is Amanda Richardson's dramatic depiction of a sandstone cliff inspired by visits to Zion Canyon, Utah. From a distance her work looks like a painting or a mural of inlaid stone. In fact, *Sandstone Cliff* is made of over thirty types of applied fabric, including silks, velvets, satins, and brocades, all hand-dyed by the artist and applied in layers to create depth and contrast. The fabric was first glued to bonding paper to allow cutting into desired intricate shapes without fraying. The technique is Richardson's invention and she calls it porphyry (from the Greek word for light and reflected light) tapestry.

Richardson admits that southwestern rock formations are unusual subjects for a lobby in the Pacific Northwest, but she wanted to create a sculptural tapestry to complement stonework in the building's lobby. The building developer liked her concept and selected her design from many entries in a design competition for Northwest artists.

5.24 Westlake Star Axis/ Seven Hills, 1989

Bob Maki

Mixed media
Seattle 1% for Art Program
Westlake Park

Rather than create one sculpture for Westlake Park, Seattle artist Bob Maki and Robert Hanna, of the Philadelphia landscape architecture firm Hanna/Olin, collaborated on incorporating Maki's sculptural elements throughout the setting. At the southern point of the triangular park is a

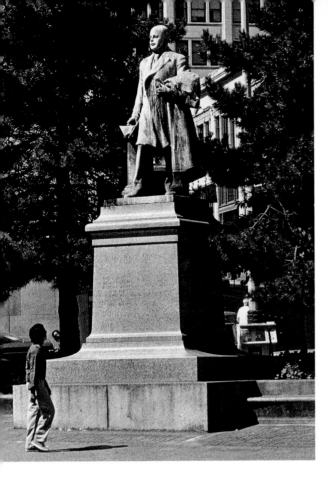

5.22 *Governor John Harte McGraw*, Richard Brooks

5.23 *Sandstone Cliff*, Amanda Richardson

5.24 *Westlake Star Axis/Seven Hills*, Bob Maki

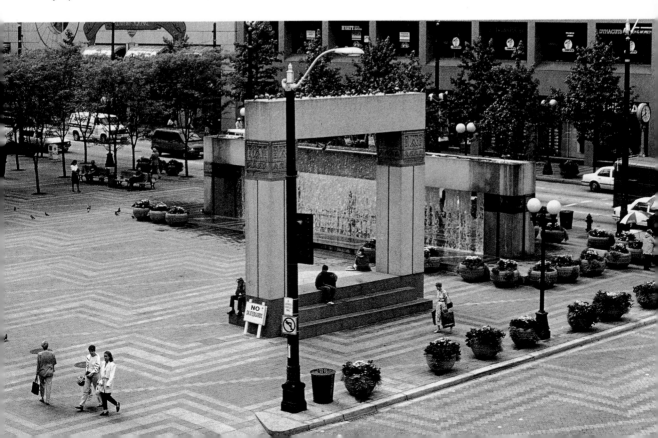

thirty-foot-high pink granite column with smaller cubic pieces nearby. At the northwest corner is a sixty-four-foot-long by twelve-foot-high granite-framed waterfall, and on the north end is a twenty-four-foot-high granite proscenium arch. The entire park is paved with red, gray, and white granite paving blocks arranged in a Salish Indian basket weave pattern. Each element relates to the history of the Westlake Mall vicinity, a subject extensively researched by Maki.

The Westlake Star Axis is the five-point star intersection created at Westlake Mall. "It is an important aspect of the location," Maki explains, "and the city fathers always conceived of this area as being something. I started thinking about all the traffic that's gone through the area and the layering of history. It's a high point from which water runs down to Lake Union. It was a creek bed the Indians used to get to the lake and a narrow gauge railroad was placed there for transporting coal to the waterfront. . . . The columns on the north end refer to the past, things vertical like the trees that used to stand there. The waterfall refers to the important presence of water on the site. The southern element (the granite column) is a point of origin . . . where the water that flowed to Lake Union began." The angled vertical slot carved through that column creates a sight line down Westlake Avenue to Lake Union. That column and six other pieces nearby represent Seattle's original seven hills, with the four-foot-square block representing Denny Hill, removed in the early part of the century to create the Denny Regrade. The bosk of twenty-four trees creates an additional slot for viewing and ties together different aspects of the park.

As is true of Maki's sculptures, "perceptual shifting and alignment" and precise angles are important aspects of the design. All angles in the design follow either the Westlake axis or are parallel or perpendicular to the streets. At different angles new configurations appear, and new relationships with the surroundings become apparent. The different views of the park and its surroundings through the proscenium arch, through the slots created by the waterfall's columns, and through the slot in the southern column are aspects that Maki describes as "variations on a window."

Later additions to the granite paving stones at Westlake Park are one-foot-square brass tiles designed by twenty Seattle schoolchildren. To add something whimsical to the park, the city asked the young artists, from both public and private schools and ranging in ages from five to seventeen, to draw designs of their choice. The tiles include a geometric depiction of downtown buildings (that also includes a hidden math problem), drawings of mazes, fish, and umbrellas, and a series of comic book tiles that lead readers through the park's waterfall.

5.25 Metro station artworks, 1990

Heather Ramsay, Bill Whipple, Roger Shimomura, Fay Jones, Gene Gentry McMahon, Jack Mackie, and Vicki Scuri

Mixed media
Metro collection
Westlake station, Pine Street at Westlake Mall

Two sculptural street clocks were included in the Metro station street decorations. Heather Ramsay's fourteen-foot-high *Pendulum Clock,* installed in 1990 at Third Avenue and University Street, seems delicately balanced on a rounded base and leans at an angle. In designing her clock Ramsay thought of the Leaning Tower of Pisa and "how the passage of time made it lean." Running up each side are little brass mice that Ramsay included to "evoke a nursery rhyme and the relative distance each of us has traveled in time since childhood." Bill Whipple's clock, installed in 1988 at Fifth Avenue and Pine Street, has its face framed by the top portion of a seven-foot-high stainless steel question mark that stnds on a granite base.

Inside the tunnel station are three vivacious ten- by thirty-five-foot murals of vitreous enamel tiles created by three prominent Seattle painters, Roger Shimomura, Fay Jones, and Gene Gentry McMahon. Shimomura (who lives in Kansas but was raised here and considers Seattle his home) created a brightly colored combination of World War II bombers, modern images of contemporary America (including an Andy Warhol portrait of Marilyn Monroe being painted by Donald Duck), and traditional and modern Japanese images (including a samurai warrior, an illustration of a woodblock print, and a Japanese rice cooker). In an effort "to bring sunshine underground" Faye Jones used bright yellow and blue as the principal colors in her mural and depicts a scene of oversized people dancing in front of the waterfront. She explains that her work is a "humorous and theatrical interpretation of Seattle as a waterfront city." Retail sales is the theme of McMahon's

mural and she refers to the bombardment of images one gets from passing retail displays. She depicts men and women in unrelated endeavors all fashionably dressed in designs from past decades, including a couple walking near the Smith Tower, a woman at a perfume counter, a beach scene, and a fashion show.

A 32- by 116-foot section of the south station wall below Westlake Park is covered with over-hanging vines, leaves, and flowers created in terra-cotta tiles designed by Seattle artist Jack Mackie. Mackie also created the designs that were sandblasted into granite benches on the station platform level. Each bench appears to have been draped with patterned cloth.

Vicki Scuri's repeated series of twenty low-relief patterns composed of approximately 25,000 cream-colored, foot-square tiles covers the station's platform-level walls in geometric designs that wrap around corners like fabric. Forty different tile designs, which include shirt designs, portions of Japanese dress patterns and kimonos, zippers, and stitching, are arranged in six-foot-square grids to create the twenty larger patterns. Viewed from different angles, the light upon the impressed forms changes the appearance of the creation. In addition, some tiles are blank and others are cropped, adding to Scuri's effect of a "patterned garment" for the station.

5.25 *Pendulum Clock*, Heather Ramsay 5.25 Untitled mural, Roger Shimomura

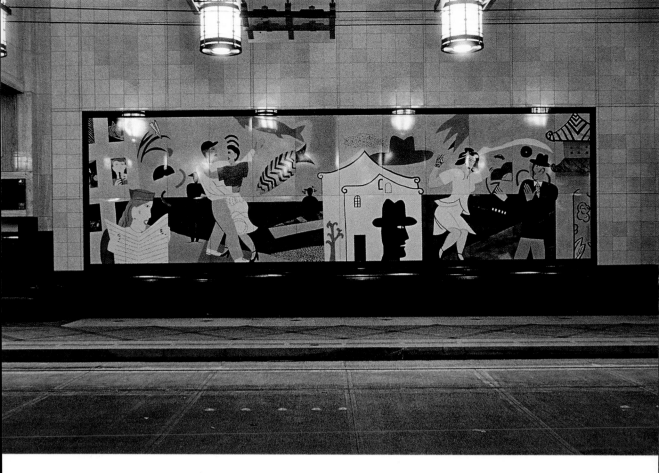

5.25 Untitled mural, Fay Jones

5.25 Untitled mural, Gene Gentry McMahon

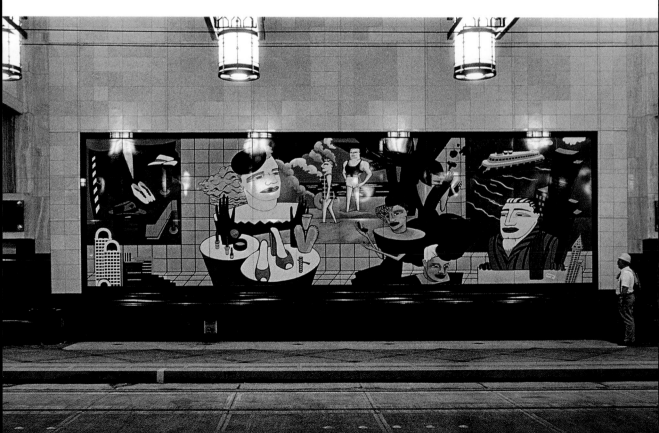

5.26 Market Foundation Piggy Bank (Rachael the Pig), 1986

Georgia Gerber

Bronze; life-size
Gift of Fratelli's Ice Cream Company
Pike Place Market, underneath the market sign and clock

The life-sized bronze pig at the Pike Place Market was chosen through a competition to select a suitable pig for the market's main arcade. She is a piggy bank and gratefully accepts contributions for the Market Foundation, which supports human service agencies in the market. The model for Gerber's sculpture was a friendly old sow that lived near Gerber's home on Whidbey Island.

5.27 Totem poles, 1984

James Bender and Marvin Oliver

Carved cedar; each, H 50 ft.
City of Seattle collection
Steinbrueck Park, north end of Pike Place Market

These totem poles show two approaches to totem pole design; the northern one is a traditional Northwest Coast Indian creation while the southern pole is smooth and topped with two eight-foot-high figures of a farming couple. The traditional pole was inspired by Haida Indian designs and was designed by Jim Bender after a concept developed by Marvin Oliver. Bender designed the adjacent pole with assistance from Seattle architect Victor Steinbrueck. Jim Bender carved both poles from trees Marvin Oliver selected in the Skagit County National Forest and roughed out for carving.

The traditional pole does not depict a legend, although its figures can be interpreted to stand for qualities of strength and abundance and other attributes of the city and the market. From the top, the figures are Raven holding a Salish woman's spinning whorl, Human holding a potlatch copper of prosperity, Little Human (a messenger), Killer Whale or Blackfish, Little Raven, and Bear holding a hawk.

The untraditional southern pole was inspired by an Alaskan pole near Ketchikan, Alaska, that depicts Abraham Lincoln standing at the top of an unadorned pole. The man and woman on the Seattle pole each wear "Honored Farmer—1984" badges that are similar to those presented in 1981 to old-time farmers by the Friends of the Market.

*5.26 Market Foundation Piggy Bank
(Rachael the Pig),* Georgia Gerber

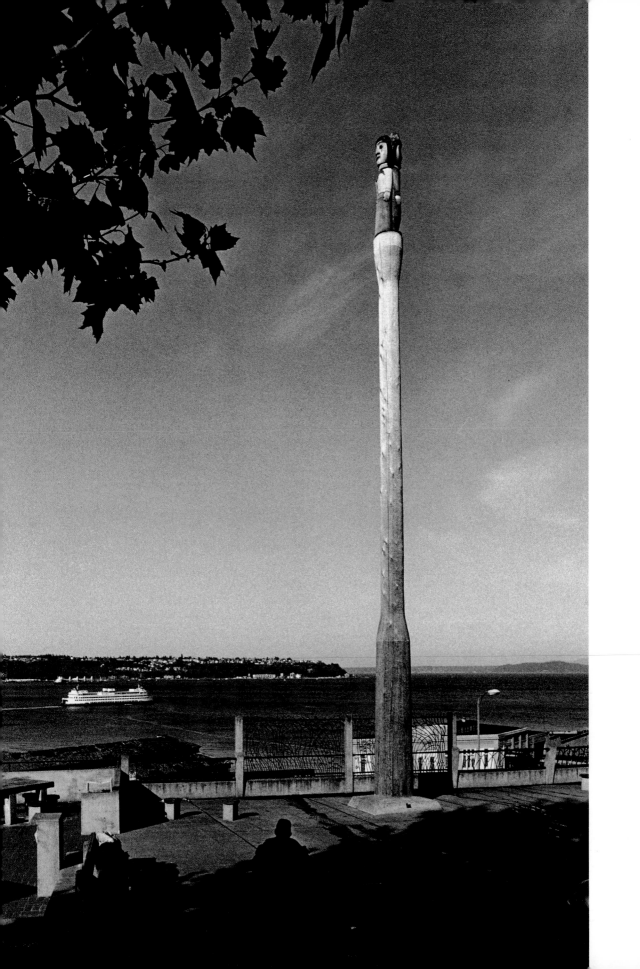

The green wrought-iron fence behind the totem poles was designed by the late Victor Steinbrueck, who designed this park with Seattle landscape architect Richard Haag. After Steinbrueck's death in 1984, the park was named after him, a fitting tribute to the man who led the fight to save the market from destruction and replacement by developers.

5.28 Seattle Garden, 1988

Ann Sperry

Painted galvanized steel; H 4.5 ft. × L 334 ft.
Seattle 1% for Art collection
Seattle City Light Union Street substation, Post Alley and Union Street (from the Market, walk down driveway from Pike Street or walk up from Western Avenue)

New York sculptor Ann Sperry was selected from twenty-five applicants to create an artistic fence atop the low concrete wall around part of the Union Street substation. One of Seattle City Light's goals was to keep transients out of its substation, and Sperry's formidable garden should accomplish the task. She placed a collection of sheet steel plants on top of the wall, each consisting of welded triangular sections topped with round flowers of various sizes. The garden is painted silver and portions of some of the flowers are painted with splotches of subdued hues. These garden flowers have appeared in many of Sperry's works throughout the 1980s, and *Seattle Garden* is one of a series of her public garden works. Two others are *Garden of Delights* at the University of Nebraska and *Winter Garden* in New York City.

One-half block up the hill from Pike Place Market is Post Alley, a charming little route lined with shops and condominiums. In the block between Stewart and Virginia streets are a number of artworks placed by Seattle artist Buster Simpson.

Entering the alley from Stewart Street, the first building on the left is Stewart House. Just beyond it is a courtyard whose west side is bordered by shops and restaurants. Simpson's *Five Headed Crow on a Cherry Limb* stands near that courtyard. Created in 1979, it is a windmill composed of a stationary crow body having five revolving heads.

5.27 Totem pole, James Bender and Marvin Oliver

5.28 *Seattle Garden*, Ann Sperry

Farther down the alley, on the right side, is a curious addition to a downspout made out of plastic sewer pipe. Simpson calls it *Self-Watering Vertical Planter*. Rain coming down the downspout automatically waters whatever vegetation is growing in the pipe's opened portion.

Simpson's *Bench and Braille Rail*, a unique bench made from pipe and part of an old cherry tree, can be found at the corner of Post Alley and Virginia Street. The tree used to grow on a site at the market now occupied by a condominium. The railing was originally supposed to be inscribed in braille.

5.29 **Rape of the Sabines**, 1986

Anthony Caro

Steel; H 7 ft. 4 in. × L 20 ft. 2 in. × D 4 ft. 10 in.
Martin Selig collection
Metropolitan Park, East Tower, 1221 Howell Street

With the death of Henry Moore in 1986, many critics designated Anthony Caro England's most important living sculptor. *Rape of the Sabines* combines approaches he has taken in his abstract sculpture over the last twenty years. The core of this work consists of massive steel beams, which were the sole subjects of his earlier works. Here they are supplemented by objects such as chains and steel plates. *New York City Tribune* art critic James F. Cooper has praised Caro for his ability to take such large industrial objects and meld them into highly imaginative forms. "He shares [Louise] Nevelson's genius in recognizing aesthetic forms and textures among discarded junkyard objects, which when fused with other found objects exude a powerful aesthetic energy and presence."

The title of Caro's sculpture comes from the legend of how Romulus (the founder of Rome about 753 B.C.) solved the problem of a lack of women in the village that became Rome. His simple, brutal, and effective solution was to invite the neighboring Sabines and their wives and daughters to attend a festival. During the festival the Romans attacked their guests and kidnapped and enslaved the women. The ensuing war between the two tribes was ended by the entreaties of the women, who threw themselves between the warring men. The two peoples united and the resulting union allowed Rome to evolve into a state.

Rape of the Sabines is only one of two Anthony Caro sculptures in the region's public places. The other can be seen at Western Washington University in Bellingham.

5.29 *Rape of the Sabines*, Anthony Caro

5.30 Untitled sculpture, Yaacov Agam

5.30 **Untitled sculpture, 1980s**

Yaacov Agam

Metal; H 6 ft. 2 in. × W 7 ft. 4 in.
Martin Selig collection
Metropolitan Park, East Tower, 1221 Howell Street

This eight-sectioned sculpture is a kinetic work by one of the early innovators of optical (also called "op" or retinal) painting in the 1960s. Whereas most op artists, such as Victor Vasarely, used optical illusion to make paintings seem to move, movement in Agam's works was created by viewer movement. In later works he combined painting with sculptural elements, but the aim remained the same: viewer participation was essential and images changed depending on the viewpoint. This sculpture is a further step in Agam's art, both wind and a change in the viewer's position will change its appearance.

Agam's emphasis on displacement, movement, and illusion is part of his strong belief that only a part of reality can be seen at any given moment and relates to his upbringing in the Jewish faith. Jasia Reichart, in her book *Yaacov Agam*, cites the Second Commandment of that faith ("Thou shalt not make unto thee any graven image, or any likeness of anything that is in heaven above or in the earth beneath") and explains that this "is one aspect of philosophy which proposes that one cannot replace reality with an effigy. . . . It implies that the spiritual cannot find its true nature within the concrete form of a finite work of art. To Agam a static picture approximates an idol. As such it cannot be acceptable to him, since it is contrary to the very essence of what he believes. Precariousness and change are the only permanent concepts. . . . The proof of the existence of anything is that it is perceived— what is seen is no more than the measure of the individual."

Seattle Art Museum

Standing at the corner of First Avenue and University Street, at the entrance of the Seattle Art Museum, is *Hammering Man*, a forty-eight-foot-high moving steel silhouette created by California artist Jonathan Borofsky (see page 73). Borofsky's working man holds a hammer in his hand and methodically hammers up and down four times per minute. The artist explains that his sculpture symbolizes "the worker in all of us."

Another, smaller hammering man sculpture stands in Basel, Switzerland. Borofsky's goal is to place others around the world, working simultaneously "to connect all of us together." "At its heart, society reveres the worker. *Hammering Man* is the worker in all of us. . . . Let this sculpture be a symbol for all the people of Seattle working with others on the planet to create a happier and more enlightened humanity." Seattle Arts Commission publications suggested that the piece would "give the down-town pedestrian and motorist the opportunity to reflect upon the contributions of Seattle's working community to the City's history."

Funding for *Hammering Man* was provided by Seattle 1% for Art funds, the Virginia Wright Fund, the Museum Development Authority, and private donations. It was commissioned as part of "In Public: Seattle 1991," a project to celebrate Seattle's public art program. It is the only perma-nent commission of those placed throughout the city for that event.

Dedicated in 1991, the Seattle Art Museum building was designed by prominent American architect Robert Venturi and his Philadelphia architectural firm, Venturi, Scott, and Brown.

Ram, unknown Chinese artisan

Camel, unknown Chinese artisan
(Seattle Art Museum photo)

Civil officer, unknown Chinese artisan
(Seattle Art Museum photo)

Military officer, unknown Chinese artisan
(Seattle Art Museum photo)

Displayed within are major collections of African, Asian, and North Coast native American art and a variety of traditional and contemporary Western art. A visit within the museum is a must, but those with insufficient time for a tour should at least look inside at the grand stairway. Ascending it are six impressive carved marble figures that formerly stood along avenues leading to important Chinese tombs.

The pair of camels and the pair of rams reportedly led to the tomb of Prince Zhu Gaosui near Beijing. The prince, who died in 1436, was the third son of the Yongle emperor, whose reign during the Ming dynasty lasted from 1404 to 1424. The human figures are a civil and a military officer created in the late seventeenth or eighteenth century, during the Qing dynasty. As was the custom, they stood on one side of the avenue and faced identical sculptures on the other side.

The avenue to a Chinese tomb was called the Spirit Path, and statues of real and mythological creatures, as well as warriors and government officials, lined it to guide the soul of the deceased and those paying homage to him or her along the path to the monument. More stood at the entrance and within to serve the deceased and ensure that what comforts existed in life could be enjoyed after death.

These and four other funerary sculptures were brought to Seattle in 1933 by Dr. Richard Fuller, who, with his mother, Mrs. Eugene Fuller, founded the museum. Pairs of tiger and lion sculptures are displayed in the museum's Volunteer Park facility. All were purchased from Gump's in San Francisco and stood in front of the Volunteer Park building. They were removed in 1987 for restorative work after years of deteriorating in the elements. The six downtown figures were placed in their new home in 1990. Because of their size, they were installed before the building's final walls were in place. They were then encased in wooden boxes, and the building was constructed around them.

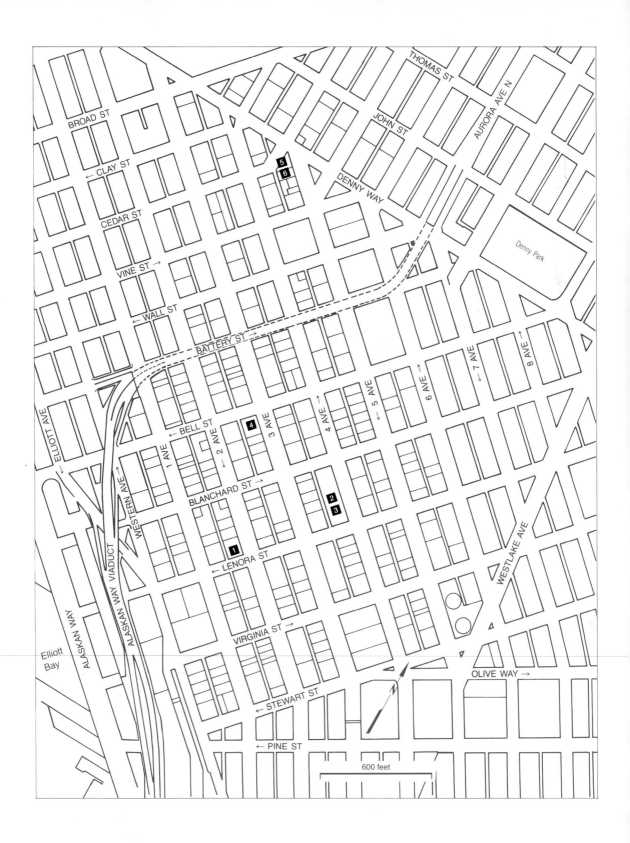

Chapter 6

Denny Regrade

Architecture, sculpture, painting, music and poetry,
may truly be called the efflorescence of civilized life.

HERBERT SPENCER 1820–1903

6.3 *She,* Howard Garnitz

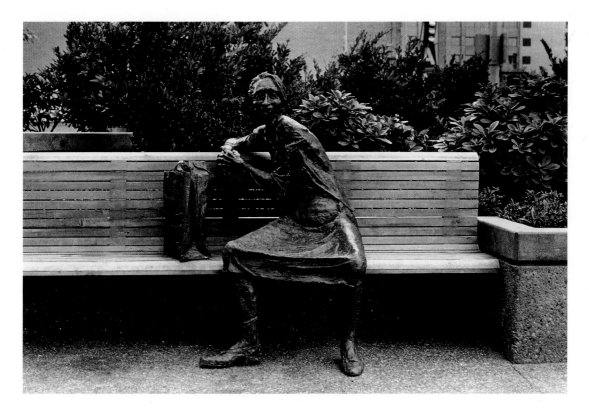

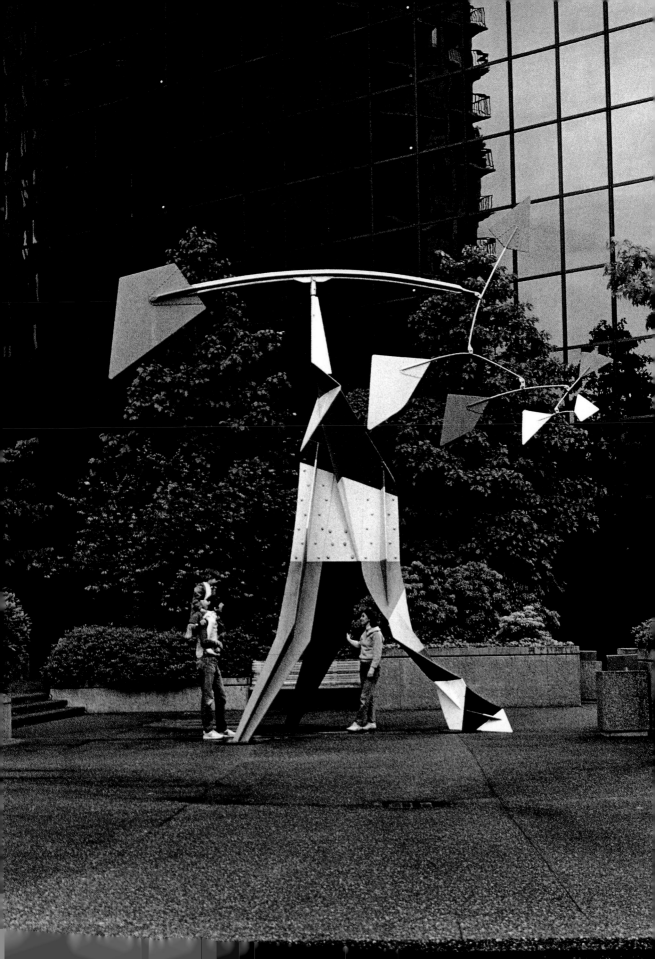

One of the most unusual art in public places projects is *First Avenue Project,* located in the Denny Regrade on both sides of First Avenue between Virginia Street and West Denny Way. Lewis ("Buster") Simpson, Jack Mackie, and Paul and Deborah Rhinehart embarked on this urban renewal art project in 1986 to liven up the dreary stretch of First Avenue with trees, boulders, stone elements, and bus stop benches. The stone elements and benches are made from various sandstone construction remnants and are in a range of shapes, including trapezoids and a cube on four wheels. A few have engraved inscriptions. Many of the trees are evergreen, an unusual choice for urban street plantings, and many are sheltered or supported by unusual materials, including colorful picket fencing, cyclone fencing, and steel bed headboards. The project was funded by the Seattle Arts Commission and the National Endowment for the Arts.

6.1 **Untitled murals,** 1986

Mara Smith

Carved brick
U.S. West Communications collection
U.S. West Communications Building,
Second Avenue and Lenora Street

6.2 *Big Crinkly,* Alexander Calder

The large brick building at the corner of Second and Lenora has few windows because it houses equipment for U.S. West Communications. Rather than leave the walls blank at street level, the company commissioned sculptor Mara Smith to create historical and scenic murals of carved brick. Her six scenes wrap around the building's corner from Lenora to First Avenue. Starting at the Lenora end, Smith has depicted Alexander Graham Bell's invention of the telephone, the growing Seattle waterfront, aviation in Seattle, historic Pioneer Square, bustling Pike Place Market, and the Hiram Chittenden Locks. Each scene was carved before the brick was fired, a technique Smith also used for exterior walls of the First Hill Medical Building (8.10).

6.2 **Big Crinkly,** 1971

Alexander Calder

Painted metal; H 24 ft.
Martin Selig collection
Fourth and Blanchard Building, south plaza

Big Crinkly is the only public artwork in the Pacific Northwest by Alexander Calder, one of the most important names in the history of modern art. It is a combination of his familiar mobile sculptures and his lesser-known, nonmoving "stabiles."

6.1 Untitled murals, Mara Smith

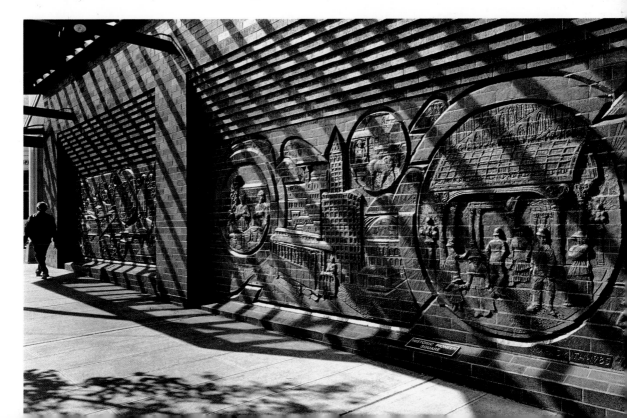

Calder first began working with such designs in the early thirties in an attempt to depict the motion that contemporary artists, such as Calder's friend Marcel Duchamp, were trying to paint. Duchamp named these works of Calder "mobiles."

Although wind moves *Big Crinkly,* Calder provided his earlier, indoor works with motors to give them constant movement. Calder's most famous sculptures hang from ceilings, an approach by which he came closest to reaching his ultimate goal of creating "detached bodies floating in space." Other works were mobiles on large stands painted white to distinguish them from the art they supported.

Other Calder sculptures were similar to the stationary portion of *Big Crinkly* and were dubbed "stabiles" by sculptor Jean Arp, another friend. *Big Crinkly* evolved from Calder's experimentation with these unique approaches to art. The mobile and its supporting stabile combine to make a single sculpture.

This sculpture was originally installed on the Fifth Avenue side of Columbia Seafirst Center, but *Big Crinkly* was no match for the high winds whipping up from Elliott Bay. After repairs, it was moved to the building's Fourth Avenue side. However, there was insufficient wind there to move it, so in 1988 Martin Selig had it moved to his Fourth and Blanchard Building.

6.3 **He** and **She,** ca. 1979

Howard Garnitz

Cast bronze; life-size
Martin Selig collection
Fourth and Blanchard Building, south plaza

The two comfortable-looking senior citizens sitting near Calder's *Big Crinkly* in the Fourth and Blanchard Building plaza are bronze sculptures by East Coast artist Howard Garnitz. Both seem to have paused for a while to relax before joyfully carrying on with their lives (see below and *She* on page 99). Martin Selig reports that when he purchased these sculptures Howard Garnitz was an interior designer living in Washington, D.C. Garnitz has since left that city, and no further information about him was available for this book.

6.3 *He,* Howard Garnitz

6.4 Gyro Jack, 1979

Lloyd Hamrol

Concrete; H 9 ft.
Funded by the Seattle Arts Commission
and private sources
Denny Regrade Park,
Third Avenue and Bell Street

When California artist Lloyd Hamrol was commissioned by the Seattle Arts Commission to create a sculpture for Denny Regrade Park, he first thought of creating a ninety-one-foot tower. That proposal was rejected as too dangerous to playful children. Hamrol then created *Gyro Jack*, a participatory sculpture designed to encourage play, relaxation, and contemplation. The sculpture's four tilted arcs are of graduated sizes, ranging from eight to sixteen feet in diameter, and a narrowing path spirals up the sides. At the top of this eighty-four-ton sculpture is an indentation designed for relaxed viewing of the surroundings.

At its dedication in 1979, Hamrol pointed out that his work is more than a concrete construction. "It moves if you let it. It invites you to explore. It represents a past which is part of the important changes leading to the present." The last comment refers to Hamrol's intention that *Gyro Jack* reflect the history of the Denny Regrade, which is what remains of the west side of Denny Hill after it was regraded and dumped into Elliott Bay in the early twentieth century. His sculpture exemplifies the "rise of the new landscape and the falling of the old."

In the adjacent children's play area is *The Dogs*, a group of carved sandstone dogs created by Richard Beyer in 1978. Each dog crouches and awaits the reappearance of a little rat that hides underneath the bottom step.

6.4 *Gyro Jack*, Lloyd Hamrol

6.5 **Chief Seattle,** 1912

James A. Wehn

Cast bronze with gold leaf, on granite base;
life-size
City of Seattle collection
Tilikum Place, Fifth Avenue and Denny Street

6.5 *Chief Seattle,* James A. Wehn

James Wehn's statue of Chief Seattle (ca. 1790–
1867) is Seattle's first commissioned statue and
stands at Tilikum Place, the historic juncture of
the original land claims of three Seattle pioneers,
Carson Boren, William Bell, and Arthur Denny.
Tilikum is Chinook Jargon (a trade language
based on Indian and European languages) for
"everyone" (friends, relatives, fellow nations)
except chiefs. In the early 1900s the first stage of
the regrade of Denny Hill was being funded, and
the street improvement budget included funds to
commission a statue to mark this site. In 1907 the
commission was awarded to Wehn, Seattle's first
resident classical sculptor and the first chairman
of the University of Washington's Sculpture
Department.

Wehn's rendition is based on the only known
photo of Chief Seattle, chief of the Suquamish
tribe. For his sculpture, Wehn posed the chief
looking out toward Puget Sound with his arm
raised in greeting.

On the granite base are two bronze bear heads
that serve as waterspouts and two bronze plaques
depicting historical events. One shows Chief
Kitsap watching Captain George Vancouver's
ship, the first in these waters, arriving in 1792,
a scene witnessed by the young Seattle. The
other plaque, flanked by salmon, pays tribute
to Seattle, "A firm friend of the Whites."

Wehn's completion of this statue was delayed
by two significant events. First, in 1908 his work
was interrupted to incorporate the head of this
statue into the animal watering fountain in
Pioneer Square (1.2). That work had to be
completed in time for the Alaska-Yukon-Pacific
Exposition of 1909. Second, Wehn became
so furious when he found out that the city
intended to hire an inexperienced local firm
to cast his Chief Seattle statue that he threw
his plaster model into Elliott Bay. It was not
recovered and a second plaster cast was begun
in 1911.

6.6 **Realm of the Seahawks,** 1985

Arturo Artorez

Painted wall mural; H 60 ft. × W 40 ft.
Seattle Walls Project, funded by the city and Ackerley Communications of the Northwest
Edwards Building, 2615 Fifth Avenue (south side of Tilikum Place)

The three-story-high mural covering the north side of the Edwards Building is one of the most colorful public works in the city. Artorez's mural is a collection of symbols representing the past, present, and future of humankind and the Pacific Northwest. The left-hand portion represents air and water and Northwest Indian culture and includes a sea hawk design inspired by a traditional Indian motif. Portions of five fish on the left side further symbolize nature and refer to the role of fish as a cultural symbol. The missing portions of the fish are supplanted in the central section by the building's windows, which is the artist's allusion to urban development. The right-hand portion includes representations of the four elements. The umbrella "represents protection and symbolizes humankind living in peace and harmony with nature and protecting all living things."

The concentric circles at the top of the mural symbolize humankind in the past, present, and future. The center circle represents the simple communicative skills of primitive peoples. The second circle represents the space age of today. The luminescent outer circle symbolizes the illuminated consciousness of people living in harmony with their environment.

6.6 *Realm of the Seahawks,* Arturo Artorez

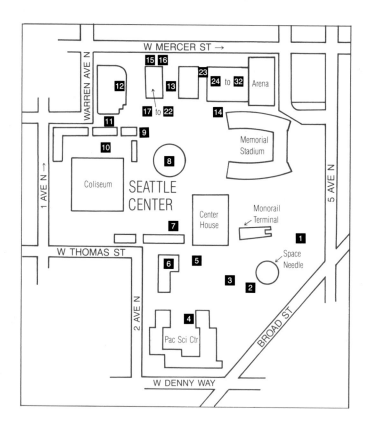

Chapter 7

Seattle Center
and Environs

*Art of any profundity can be appreciated only slowly,
gradually, in leisurely contemplation.*

DANIEL GREGORY MASON 1873–1953

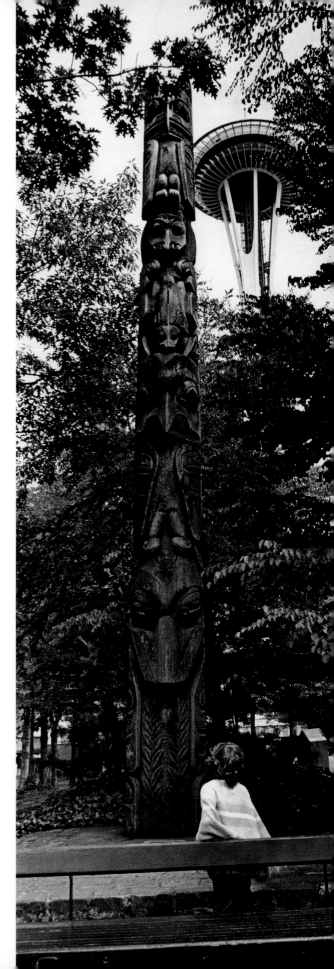

7.5 Totem pole, Duane Pasco

7.1 *The Endless Gate*, Lauren Ewing

7.2 *Olympic Iliad*, Alexander Liberman

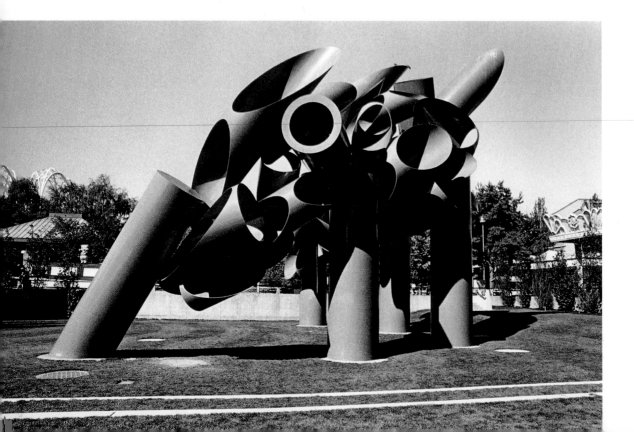

Plans for a substantial renovation of Seattle Center include moving a few of the sculptures from the locations noted in this chapter. However, those artworks are expected to remain at the center, so a little bit of searching will prove fruitful. A few of the artworks in the Opera House were moved to new locations within the Opera House during the preparation of this book. The new locations are given here, but the careful reader will note that to avoid renumbering, some of the entries now appear out of order in the book as one walks through the Opera House.

7.1 The Endless Gate, 1985
Lauren Ewing

Painted steel
Funded by the Seattle Arts Commission
and National Endowment for the Arts
Seattle Center, Fifth and Thomas entrance, near base of Space Needle

This series of small gates and building facades was created by New York sculptor Lauren Ewing to represent the fact that we make many "crossings" in our lives and "there is no one gate through which we go." She describes her five-part work as "large-scale sculptures that use image, form, physical participation, and text to involve the viewer both physically and visually." On each gate she has included part of a continuing text that says, "The gate / a hinge / between the halves / neither one / nor the other."

7.2 Olympic Iliad, 1984
Alexander Liberman

Painted steel; H 45 ft. × L 60 ft.
Gift to the city from private contributors
Seattle Center, at base of Space Needle

The immense red *Olympic Iliad* is one of Seattle's most important public artworks and is Alexander Liberman's largest sculpture. Typical of his work, it was created with industrially manufactured materials and painted a bright red reminiscent of industrial primer paint. The sculpture consists of sections of forty-foot-long cylinders forty-eight and sixty-four inches in diameter. *Olympic Iliad*'s older sibling, *Iliad*, located at the Storm King Art

Center in Mountainville, New York, is made of huge gas storage tanks. *Olympic Iliad* was purchased through the combined efforts of individuals, private foundations, and the Seattle Arts Commission and through goods and services donated by local businesses.

7.3 Seattle Mural, 1962
Paul Horiuchi

Glass tile mosaic; H 17 ft. × L 60 ft.
City of Seattle collection
Seattle Center, west of Space Needle, south of Center House

When the Mural Amphitheatre was designed for the Seattle World's Fair (by Seattle architect Paul Thiry), Paul Horiuchi was commissioned to create a mural for the sixty-foot-long cyclorama behind the stage. Horiuchi had become well known for his innovative use of collages. In this mural his design was transferred by artisans in Venice, Italy, to fifty-four glass tile panels.

In a 1968 interview with *Seattle Magazine*, Horiuchi explained that his collages "are attempts to produce areas of peace and serenity with which to balance the sensationalism—the fast, hard tempo—of our time."

7.4 Great Gull, 1962
G. Alan Wright

Bronze; H 6.5 ft.
Permanent loan from Mr. and Mrs. D. E. Skinner
Seattle Center, Pacific Science Center, to left of entrance

During World War II, Seattle-born sculptor G. Alan Wright was stationed on Johnston Atoll in the South Pacific, where the human population was rivaled by a large colony of albatrosses. These birds, graceful in the air but ungainly on land, captured Wright's interest and admiration. He created this sculpture in 1962 as a tribute to his old wartime friends, which are sometimes called great gulls and referred to by sailors as "gooney birds." Weighing 450 pounds, *Great Gull* is Wright's largest work.

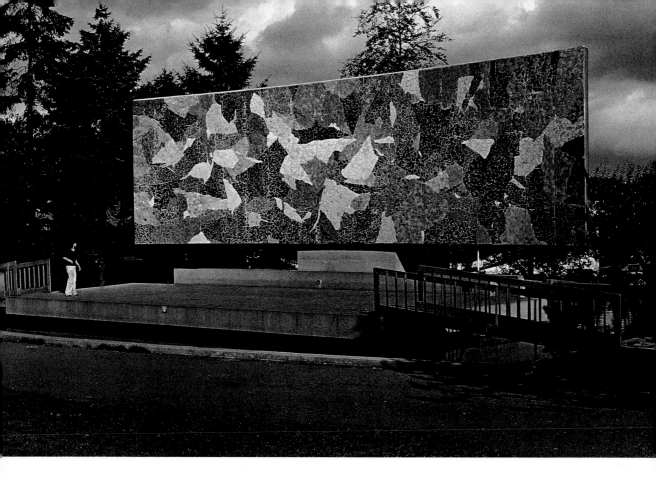

7.3 *Seattle Mural*, Paul Horiuchi

7.4 *Great Gull*, G. Alan Wright

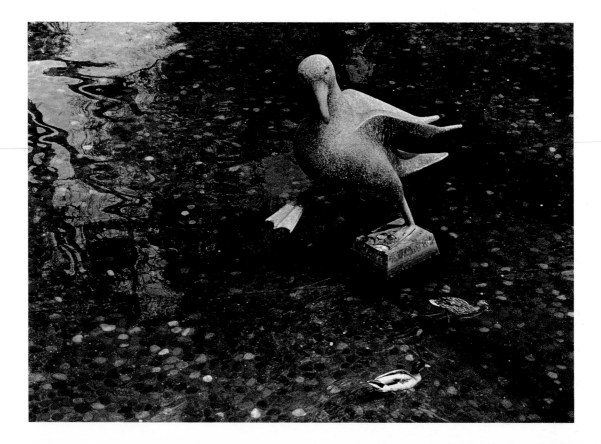

7.5 Totem pole, 1970

Duane Pasco, with Victor Mowatt and Earl Muldon

Carved and painted; H 30 ft.
City of Seattle collection
Seattle Center, north of *Seattle Mural*,
at southwest corner of Center House

This totem pole (see page 107) is one of the finer examples of the unique Pacific Northwest Indian art form of totem pole carving. In this case, the four main figures are, from top to bottom, Hawk, Bear (holding a salmon), Raven, and Killer Whale.

On the lower level of the Center House is Robert Woodward's "dandelion fountain," a round fountain-sculpture resembling a dandelion flower gone to seed. Nearby is a small art gallery, the Public Art Space, which exhibits works from the Seattle, King County, and Washington State art collections. The works on view have been purchased with funds from each government's percent for art program. Those programs are discussed in the introduction to this book, A Historical Overview. Next door to the Public Art Space, in the Center House Theatre, is a large mural by Seattle artist Liza vonRosenstiel. Titled *Setting the Stage*, it is a colorful and whimsical look at life in the theater. The mural was commissioned by the Seattle Arts Commission in 1985 and was funded by 1% for Art funds from the Seattle Center bond issue approved by voters.

7.6 Ceramic mural, 1983

Maggie Smith and others

Ceramic
Seattle Center, Pacific Arts Center,
located southwest of Center House

This ceramic mural is a collection of scenes of China and extends along the center's north entry wall down to its first floor. The mural and the pillar in front of the entrance were created by Seattle schoolchildren working under the guidance of the Pacific Arts Center and Seattle artist Maggie Smith. The Pacific Arts Center is a nonprofit educational institution devoted to bringing young people together with professional artists to explore visual, literary, and performing arts.

7.7 Black Lightning, 1981

Ronald Bladen

Welded steel; H 24 ft. × L 60 ft.
*Funded by the Seattle Arts Commission
and National Endowment for the Arts*
Seattle Center, Flag Plaza Pavilion

Ronald Bladen's *Black Lightning* is the second "minimalist" or "structural" sculpture installed at Seattle Center. As with Tony Smith's *Moses* (7.11), Bladen's creation does not embody a message. Rather, the object itself is the art, and nothing more exists than what each viewer sees or experiences.

In an interview at its dedication, Bladen recognized that many would not enjoy his work when first viewed, but he predicted that "things may start to happen later. . . . You have to be quite open when you see it and deal with the dignity of the form. . . . Trusting your own vision is what art is all about. . . . The viewing is really a learning process and for years *Black Lightning* may be totally alien. But after it becomes familiar, people will grow to love it."

7.8 International Fountain, 1962

Kazuyuki Matsushita and Hideki Shimizu

Steel, white limestone, and concrete aggregate;
dome dia. 32 ft.
City of Seattle collection
Seattle Center

The design for this centerpiece of the Seattle World's Fair and the Seattle Center was selected from over 800 entries in an international design competition sponsored by the American Institute of Architects. The fountain shoots computer-controlled sequences of water jets from 237 nozzles. Although it is impressive, many mourn the fact that lack of funds permitted installation of only a portion of the nozzles included in the design. The musical accompaniment, computer-controlled in synchronization with the water, is supplied by a huge stereo system with speakers set around the fountain basin.

World's Fair literature notes that the young Japanese architect and engineer who designed the fountain intended to create a symbol of humanity's effort to reach out to the heavens and explore outer space.

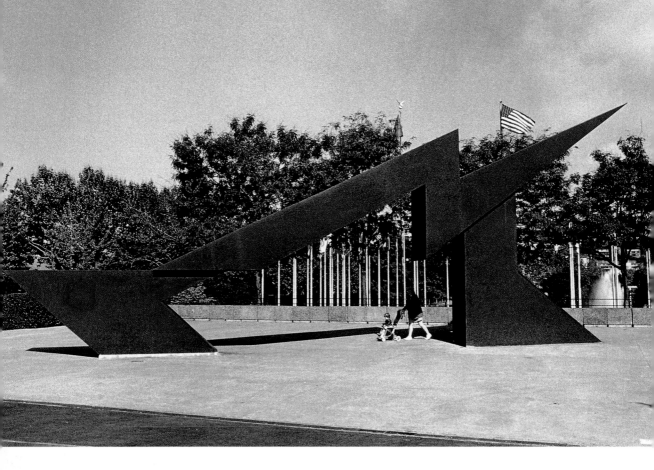

7.7 *Black Lightning*, Ronald Bladen

7.9 *Pool*, Randy Hayes

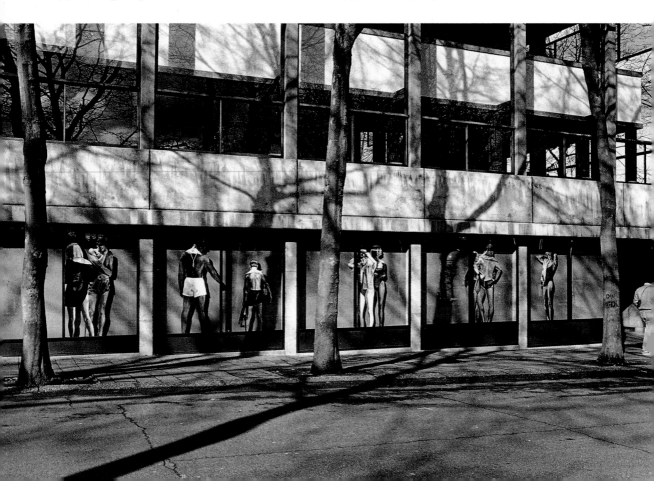

7.9 **Pool,** 1985

Randy Hayes

Oil on plywood; H 6 ft. 7 in. × L 50 ft.
Funded by the Seattle Arts Commission
Seattle Center, on the building south
of Bagley Wright Theatre

Pool is a collection of nine figures standing around an imaginary swimming pool. Randy Hayes was commissioned to create an artwork for this location to replace an ugly concrete wall. The Seattle Center has no swimming pool, but the artist found that the site reminded him of a public pool in his hometown of Jackson, Mississippi. Hayes painted the wall and installed painted plywood figures behind large windows. The subjects seem three-dimensional and realistic from a distance, especially at night with the addition of green fluorescent underlighting. His use of colorful cutouts results from his training in both sculpture and painting.

7.10 **Fountain of Creation,** 1962

Everett DuPen

Cast bronze sculptures on colored concrete relief
City of Seattle collection
Seattle Center, up the stairs from Randy Hayes's
Pool, in basin between Coliseum and conference
rooms

Seattle artist Everett DuPen created his *Fountain of Creation* with a philosophical theme referring to the evolution of life on earth and the concept that water is the basis of all life. The three bronze sculptures placed in this large pool represent life-forms in the sea, in the air, and on land. To the west is a flight of gulls, and to the east, seaweed. The more complicated central sculpture is a tree of life showing the development of life from protozoans to fish, mammals, and humans. "It is not," DuPen has said, "a specific evolutionary column. It is more a celebration of life. . . . The curving shapes outlining the central column represent forces of nature. The concrete base of the pool is a cellular shape, flowing and gently moving." The concrete pool base is an integral part of DuPen's design. It is tinted with subtle earth colors, Indian red, umber, and green, which were chosen to harmonize with the bronze sculptures above.

Surrounding the work are several water jets that originally could shoot water from ten to fifteen feet high. The effect "gave just enough water to complement, but not obliterate, the sculpture," DuPen explains. "I wanted water kept secondary to the sculpture."

On the Coliseum's southwest and northwest sides are cast concrete fountains designed in 1962 by the office of Paul Thiry, the building's architect. Their low-relief designs were inspired by Northwest Coast Indian motifs of clouds, mountains, the sea, and various animals. Other concrete reliefs in and around the Coliseum were designed by the same firm.

On the ceiling inside the Coliseum is a unique fabric artwork by Maine artist and tent maker Bill Moss; it was designed to catch water leaking through the roof. The work was the Seattle Arts Commission's temporary fix for a recurring leak problem until permanent steps could be taken. The waterproof and fireproof sculpture is a hyperbolic paraboloid shape constructed of light nylon taffeta fabric and outlined with black fabric used for seatbelts and backpack straps. Although it is approximately 80 by 100 feet, Moss's work weighs only 147 pounds.

7.10 *Fountain of Creation*, Everett DuPen

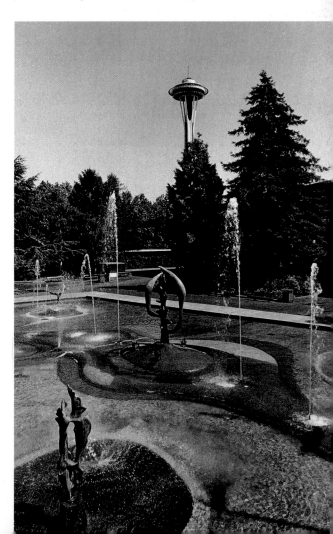

7.11 **Moses,** 1975

Tony Smith

Welded steel; H 11.5 ft. × L 15 ft. × W 7 ft.
*Seattle 1% for Art Program, National Endowment
for the Arts, and private contributors*
Seattle Center, south side of the
Bagley Wright Theatre

Although this 5,500-pound sculpture was
installed in the spring of 1975, a full-size plywood
mock-up, purchased by the Seattle Art Museum's
Contemporary Arts Council, had been displayed
in Seattle since 1968. In the early 1970s that
council, the Seattle Arts Commission, the
National Endowment for the Arts, and the
Virginia Wright Fund (a private foundation in
Seattle) funded the creation of this permanent
steel version. It was the first major expenditure
of funds under the city's new 1% for Art
Program. The same sculpture can be seen at
Princeton University.

Moses is the first large work of sculpture placed
at the center since the Seattle World's Fair of
1962. Like many of Tony Smith's works, it is a
combination of multifaceted forms that seem to
unfold as would a cardboard model. That char-
acteristic resulted from studying and working
with such models in his earlier career as an
architect.

In *Moses,* as with all of his work, Smith's
intention is to offer only a basic form without
sculptural supplementation. He allows viewers
to read his sculpture differently according to the
angle of viewing, sunlight, and shadows. What
initially seems basic becomes quite complex. The
parallel uprights suggest the horns in Michel-
angelo's famous sculpture of Moses. Smith
explains that Michelangelo's peculiar represen-
tation of a horned Moses was the result of
a mistranslation of the Hebrew word "shone,"
derived from the word for "horn," but also used
figuratively to denote rays or flashes of light from
a luminous object, for example, the head of
Moses.

7.12 **Untitled,** 1983

Stephen Antonakos

Red neon
Private funding
Seattle Center, Bagley Wright Theatre

In 1979, five years before completion of the
Bagley Wright Theatre, nationally known neon
artist Stephen Antonakos was selected to design
an artwork for the building's exterior. He worked
with its architects, the NBBJ Group of Seattle, to
incorporate the red neon artwork on the curved
facade. This sculpture is the only large neon work
readily visible in Seattle's public places. The roof
of the Seattle City Light Building in downtown
Seattle has a commissioned work by Cork
Marcheschi, but it has been obscured by new
office buildings since its installation in 1980. An
indoor neon sculpture can be found at Sea-Tac
Airport (22.3).

In the lobby of the Bagley Wright Theatre, below
the Antonakos neon work, is a small sculpture by
George Tsutakawa created in memory of the late
Dr. Solomon Katz. The sculpture consists of two
hollow silicon bronze balls, supported in a "cage"
of vertical and angled rods of the same material.
Its base is a black granite cube into which
Tsutakawa etched words that he and many of
Katz's other admirers associated with their
longtime friend. Tsutakawa's creation sits on a
steel stand, which he also designed.

Solomon Katz was a retired professor of history
and provost emeritus of the University of
Washington who died in 1989. In addition to an
illustrious career as a teacher and administrator at
the university, Katz was widely admired for his
civic involvement. He served as president of the
Seattle Repertory Theatre and PONCHO boards
of directors and on the boards of the Seattle Art
Museum, the Seattle Symphony, Lakeside
School, and the Henry Gallery Association. The
sculpture was commissioned by the Seattle
Repertory Theatre's board of directors.

East of Bagley Wright Theatre near the south
wall of the Intiman Playhouse is a large bronze
bell presented to the city of Seattle by the people
of Kobe, Japan, Seattle's Japanese sister city, for
the world's fair. There is no clapper inside;
Japanese bells are hit on the outside, usually with
a large log suspended from ropes and perpen-
dicular to the bell.

This bell is attached at the top by a large curled
bronze dragon. Bas-relief designs of dragons and
two drum- and flute-playing Japanese gods adorn
its lower portions. The bell is also graced with the
following inscription, in English on one side and
Japanese on the other: "Presented by the People
of Kobe to the People of Seattle as a Symbol of
Friendship. May this bell ring forever signifying
friendship between the nations of the United
States and Japan."

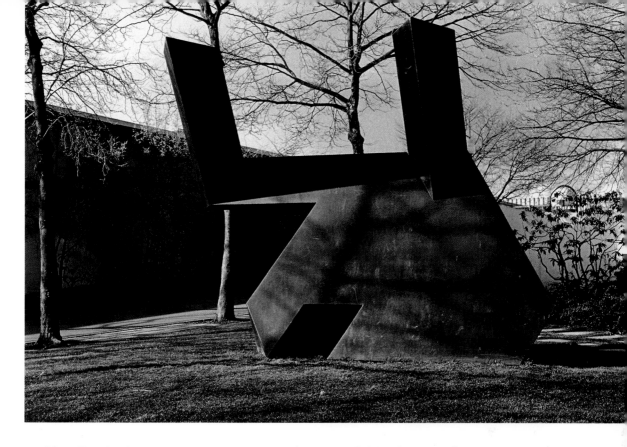

7.11 *Moses*, Tony Smith

7.12 Untitled, Stephen Antonakos

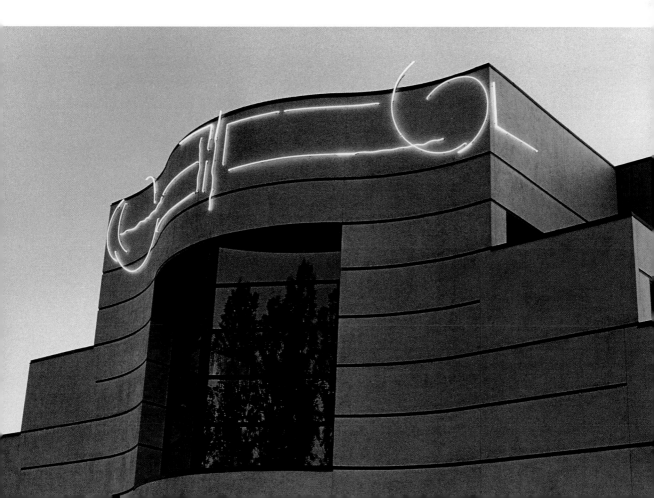

7.13 Julius C Lang Memorial Fountain, 1962

Francois Stahly

Concrete aggregate and carved stone;
H 18 ft. × L 20 ft. × depth 20 ft.
Gift of Mrs. Julius C Lang and Richard E. Lang
Seattle Center, north mall,
east of Intiman Playhouse

The *Julius C Lang Memorial Fountain* is actually a combination of two works by contemporary sculptor Francois Stahly. The stone column was created much earlier as a sculpture for a world's fair in Belgium. At the close of that fair Stahly took his sculpture back to Paris, where it remained until it was brought to Seattle to be incorporated into this larger work.

The concrete aggregate base was designed by Stahly in 1961, when he was a visiting professor at the University of Washington. Unlike many fountains of the time, Stahly's was designed to have a continuous, quiet flow of water over its surfaces. (Its drinking fountain was a design requirement of Mrs. Julius Lang, one of its donors.)

Solomon Katz memorial, George Tsutakawa *(see page 114)*

7.13 *Julius C Lang Memorial Fountain,* Francois Stahly

Julius C Lang was perhaps best known in this area for his ownership in what became the National Grocery Company. Mr. Lang had no middle name, and no period follows his middle initial. When he joined the National Guard in his youth, everyone else seemed to have a middle name, so he simply added a "C" between his two names.

7.14 American Doughboy Bringing Home Victory, 1932

Alonzo Victor Lewis

Bronze; H 12 ft.
Private funding
Seattle Center, south side of Opera House

American Doughboy Bringing Home Victory has one of the most complicated and controversial histories of any artwork in Seattle. It was first commissioned in 1921 as a plaster statue for a military reunion in Seattle and portrayed a soldier returning home with a smile on his lips, a wink in his eye, and German helmets slung over his shoulder. It was named *American Doughboy Bringing Home the Bacon.* Support grew for the idea of using that sculpture as a permanent memorial to World War I soldiers, but the design was widely criticized as inappropriate. The resulting controversy ruined chances of raising funds for commissioning a memorial sculpture within any reasonable time.

In 1932 enough money was raised to have the twelve-foot statue cast in bronze in New York. Certain changes were made in the soldier's appearance to make it more acceptable. When it was dedicated in 1932, the *Seattle Times* called the statue *Armistice.* However, later references to it have been to *American Doughboy Bringing Home Victory* and that name has survived. In recent years the statue has sparked debate over whether its placement (or abandonment) in a dark corner of the center is appropriate for a memorial to fallen American soldiers.

7.14 *American Doughboy Bringing Home Victory,*
 Alonzo Victor Lewis

7.15 Fountain of the Northwest, 1961

James FitzGerald

Bronze; H 20.5 ft. × W 11 ft. × depth 10.5 ft.
Gift of Catherine Gould Chism
Seattle Center, Intiman Playhouse, grand courtyard

Fountain of the Northwest has been hailed by many as the finest example of James FitzGerald's fountain-sculptures. As with his fountains at the IBM Building (4.29) and Plymouth Congregational Church (4.30) in downtown Seattle, its welded bronze forms seem to have eroded naturally through time. The water gushing and cascading from this fountain rushes through numerous channels within the bronze forms. The fountain was given to the city in 1961 for the new playhouse and the world's fair. The same fountain can also be seen, although in a less attractive setting, at Princeton University.

7.16 **Barbet,** 1964

James W. Washington, Jr.

Carved river boulder;
H 1 ft. × L 2 ft. 10 in. × W 2 ft.
Gift of Mr. and Mrs. Paul Roland Smith
Seattle Center, in the southwest garden near
Fountain of the Northwest

This stone sculpture by Seattle artist James W.
Washington, Jr., is typical of his works in the
midfifties and early sixties. It is a simple rendition
of a bird carved out of a local river boulder. A
barbet is a tropical bird, related to the toucan,
that has a stout bill.

7.15 *Fountain of the Northwest,* James FitzGerald

7.17 **Search,** 1962

Kenneth Callahan

Oil on canvas; H 16 ft. × W 8 ft.
Gift of Mrs. Thomas C. Simpson
Seattle Center, Intiman Playhouse lobby,
north wall

Search is a large oil painting by the late Kenneth
Callahan, one of the major names in the history
of Pacific Northwest art. This painting is a fine
example of Callahan's mature style. It is nothing
like his early paintings at Pacific Medical Center
(10.10), Callahan's only other works in a Seattle
public place. While the earlier works are more
traditional portrayals of heroic workers, *Search* is
composed of a swirling universe of more ethereal
depictions, including horses and riders and
children and adults. This later composition
reflects Callahan's belief in an endless life cycle
and the ordered interrelationship of all things.

Callahan spent most of his life in the Pacific
Northwest and his painting was influenced
greatly by the region. A summer spent as a Forest
Service lookout in the isolated forest had a great
impact. There, he saw the swirling clouds and fog
silently envelop, then disclose, the environment.
The experience emphasized to him the continuing
creation and disintegration of natural things.

7.18 **Resurrection,** 1959

Jacob Epstein

Cast bronze; H 1 ft. 10 in. × W 1 ft. 3 in.
Gift of Mr. and Mrs. Norman Davis
Seattle Center, Intiman Playhouse lobby,
west wall

Next to Callahan's work is *Resurrection,* a bronze
sculpture by Sir Jacob Epstein, one of England's
most important twentieth-century sculptors.
Epstein's works ranged from cubist designs to
expressionist portraits of famous and common
people. This work is an example of the latter,
and his model was a London scrubwoman
named Pola Givenchy. She died the year after
this portrait was sculpted.

Resurrection was given to the city by Seattle art
patrons Norman and Amelia Davis for the Seattle
World's Fair of 1962.

7.18 *Resurrection,* Jacob Epstein

7.19 **Kaidan,** 1976

Roger Shimomura

Acrylic on canvas; H 6 ft. × L 12 ft.
Gift of Mrs. John A. McCone
Seattle Center, Intiman Playhouse lobby,
west side

In the west lobby, just beyond Jacob Epstein's
sculpture, is one of Roger Shimomura's unique
paintings incorporating colorful images of
traditional Japanese art, primarily the Ukiyo-e
("pictures of the floating world") style, which
depicts scenes of everyday life in Japan. His
subjects include kimono-clad women, Japanese
samurai, and demons. *Kaidan* is Japanese for
"ghost story" and is the title of a well-known
Japanese movie Shimomura had seen shortly
before painting this work. A later work in
Metro's Westlake station (5.25) incorporates
subjects of twentieth-century America with
those of traditional and modern Japan.

Shimomura first began painting in this style
in the early 1970s after he began teaching at the
University of Kansas. The approach, he reports,
"is really a tongue-in-cheek response to the
typical midwestern idea of what a Japanese
American ought to paint."

Kaidan was given to the city by Mrs. John A.
McCone, a prominent supporter of the arts in
Seattle and the widow of Paul Piggott, former
chief officer of PACCAR.

7.20 **The Chant,** 1974

Frank Okada

Oil on canvas; H 8 ft. × W 6 ft. 8 in.
Seattle 1% for Art collection
Seattle Center, Intiman Playhouse lobby,
southwest wall

At the end of the west lobby is one of the few
paintings on display in a Seattle public place by
abstract expressionist Frank Okada. A Seattle
native, Okada is recognized for his masterful
technique of creating dramatic atmospheres with
color itself, rather than form, and adding vigor
and texture to the painting surface through
skillful brushwork. A field of bright yellow
dominates *The Chant,* with tonal variations of
white and orange at the edges of the canvas.

7.21 **Blue Painting,** 1972

William Ivey

Oil on canvas; H 10 ft. × W 8 ft.
Gift of the Virginia Wright Fund
Seattle Center, Intiman Playhouse lobby, east wall

At the front of the main lobby is a fine example
of the abstract expressionist style of William
Ivey, perhaps the leading exponent of that school
in the region. Ivey has used shades of blue
extensively in his works, often to suggest sky
or space, and this is no exception: the painting's
vibrant colors blend and float over a base of sky
and dark blue. Although influenced by shapes
of nature, Ivey's images are rarely explicit and
remain abstract expressions of color. In her essay
in *William Ivey: An Exhibition of Paintings,* Virginia
Wright notes that unlike other abstract expres-
sionists (such as Clyfford Still, with whom
Ivey studied) Ivey's compositions do not use
harsh, angular lines. Rather, "he prefers the
gentleness of sloping curves, derived from a
shoulder, a rock or a cloud. He clusters sloping
lines which then waft diagonally downward like
the feathery branches of a willow. . . . Curves
and ovoids are often set against a rectangular
block which he uses . . . to give a compositional
stability."

The surface of *Blue Painting* shows Ivey's use
of scrumbling, a painting technique where a color
is layered over a contrasting tone and the latter
shows through at spots, resulting in a rougher,
livelier appearance.

7.22 Untitled sculpture, Doris Totten Chase

7.22 **Untitled sculpture,** early 1970s

Doris Totten Chase

Laminated fir; H 4.5 ft.
Gift of the artist
Seattle Center, Intiman Playhouse lobby, east wall

Near Ivey's painting is a four-part laminated fir sculpture created in the early 1970s while Doris Totten Chase was working on a series of kinetic sculptures commissioned by the Washington State Arts Commission for use in dance and dramatic performances. The onion-shaped sections were designed to rock gently back and forth. Chase presented this previously unexhibited work to the city after the theater was remodeled in 1987 and renamed the Intiman Playhouse.

Upstairs is a wall sculpture by Robert Maki and *Caged Bird,* a wood and welded steel sculpture created in 1958 by Philip McCracken. Other works have been placed in the theater, some of which are part of the city's portable artworks collection, including two large oil on canvas paintings, *Antonia* by Lois Graham and *The Blue Magician* by Harry Widham.

7.23 **Guardian lions,** 1962

Unknown Chinese artisans

Carved concrete;
H 4 ft. 6 in. × L 2 ft. 6 in. × W 1 ft. 20 in.
Gift of the government of Taiwan
Seattle Center, in front of Exhibition Hall

These two sculptures are traditional Chinese guardian lions in centuries-old poses. Both are depicted with a paw resting on an embroidered ball. The female stands with a cub by her other paw. Both were carved by Chinese artisans from Taiwan and presented by Taiwan to the Seattle World's Fair in 1962.

The ball with each lion has age-old significance. In Chinese art it represented the sun, the egg symbol of the dual powers of nature, or a precious stone. It also refers to an ancient Chinese legend that the lion produces milk from its paws. Believing that legend, country people would leave hollow balls in the hills in the hope that lions would play with them and leave some of their milk in the balls.

These renditions are similar to the much older statues that used to stand in front of the Seattle Art Museum in Volunteer Park.

7.24 **Journey of the Opera Star,** 1964

Mark Tobey

Collage on rice paper; H 7 ft. × W 12 ft.
Gift of John and Anne Gould Hauberg
Seattle Center, Opera House entry foyer

Unveiled in 1964, *Journey of the Opera Star* is the only work by the late Mark Tobey on display in Seattle (although he designed the tile masks at the entrance of the Glenn Hughes Playhouse in the University District [12.1], he did not create that minor work). This mural was commissioned in 1962 by John and Anne Gould Hauberg, two of Seattle's most active art philanthropists, because they and Tobey were "dismayed that the artist had no work displayed in a public place in Seattle."

The mural is Tobey's first collage and is a curious collection of pieces from varied sources, including music programs and sports photographs. In the lower right-hand corner Tobey signed his name and included a partially obscured photo of himself with cigarette in hand.

7.23 Guardian lion, unknown Chinese artisans

7.24 *Journey of the Opera Star,* Mark Tobey

Journey of the Opera Star was a controversial piece when it was unveiled because it was unlike any of Tobey's previous works. At the time of its creation Tobey had been working on two other large murals in his more familiar abstract "white writing" style (which consisted of rapid calligraphic strokes). One, titled *Sagittarius Red*, is considered one of his masterpieces. However, Tobey believed the white writing style would not be powerful enough displayed in the mural's original location above the inside lobby's main entrance.

7.25 **A Procession,** 1986

Patti Warashina

Ceramic and mixed media;
H 3 ft. 6 in. × L 10 ft. 2 in. × W 3 ft. 4 in.
Seattle Arts Commission
Seattle Center, Opera House entry foyer

To the right of Tobey's mural, in a large display case, is Patti Warashina's comical collection of well-known Northwest artists in caricature. Some are proceeding across an arched bridge while others frolic around and beneath it, in one case on rafts of broken ceramic plates. The procession is led by a walking can of paint followed by a figure holding a paintbrush. The can and brush are real, and such inclusions are often placed

7.25 *A Procession*, Patti Warashina

with smaller ceramic figures in Warashina's work. Although *A Procession* is not as surreal as many of her sculptures, it gives some evidence of Warashina's admiration of the work of fifteenth-century painter Hieronymus Bosch.

A Procession is one of the first four works created under the Northwest Special Project of the Seattle Arts Commission's Art in Public Places Program, which was established in 1984 to honor "significant achievement in the visual arts by Northwest artists." Warashina, Lois Graham (7.27), Michael Spafford (7.31), and Jack Chevalier (7.32) were each awarded $20,000 to create art for the Opera House. The Opera House was chosen because of its cultural significance to the city and its ability to accommodate larger works.

7.26 **Stained glass windows,** 1962

Max Ingrand

Stained glass; each section, H 3 ft. × L 6 ft.
Gift of the artist
Seattle Center, Opera House entry foyer, south wall

Behind the Tobey mural, above the south doors, are three stained glass panels by French designer Max Ingrand. Ingrand worked on the French Pavilion at the Seattle World's Fair and designed these windows as a gift to the city.

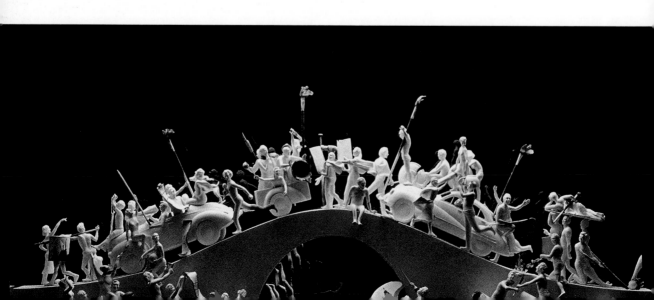

7.27 **Sargasso Stir**, 1985
Lois Graham

Oil on linen; H 19.5 ft.
Seattle Arts Commission
Seattle Center, Opera House, ground floor,
south side

Sargasso Stir is the largest work to date by abstract
expressionist Lois Graham. Its predominant
brilliant green colors are accented with bright
contrasting slashes of reds and oranges. The
work is typical of Graham's style. Glossy paint
is applied thickly with a palette knife or brush
and supplemented with thick strokes of paint
and scratches to create texture.

Behind the Opera House stairways are two
decorative abstract bronze screens by Spokane
artist Harold Balazs. They were commissioned by
the Seattle Civic Arts Committee when the Opera
House was built for the world's fair in 1962.
Although it is sometimes reported that Balazs
also created the grillwork on the stairway and
orchestra-level foyer handrails, they were
designed by one of the building's architects to
incorporate (with Balazs's permission) the screen
designs.

7.28 Muted Harp, Hilda Morris

7.28 **Muted Harp**, 1962
Hilda Morris

Brass, copper, bronze, and cement;
H 5 ft. 8 in. × L 6 ft.10 in.
Gift of Mr. and Mrs. Kenneth B. Colman
Seattle Center, Opera House,
north end of orchestra-level foyer

Muted Harp is a fine example of the predominant
sculptural style of Portland, Oregon, artist Hilda
Morris. It has an eroded, almost skeletal form
that displays delicacy and spontaneity. Such
three-dimensional works have many similarities
to Morris's lesser-known, but equally powerful,
sumi·ink paintings.

7.29 **The Dance,**1962
Ray Jensen

Sheet bronze; H 6 ft. × L 7 ft.
Gift of Mrs. Charles E. Stuart
Seattle Center, Opera House,
south end of orchestra-level foyer

This four-member dance troupe is one of Ray
Jensen's major sculptures in Seattle. *The Dance*
was commissioned for the Opera House and
given by Seattle philanthropist Mrs. Charles

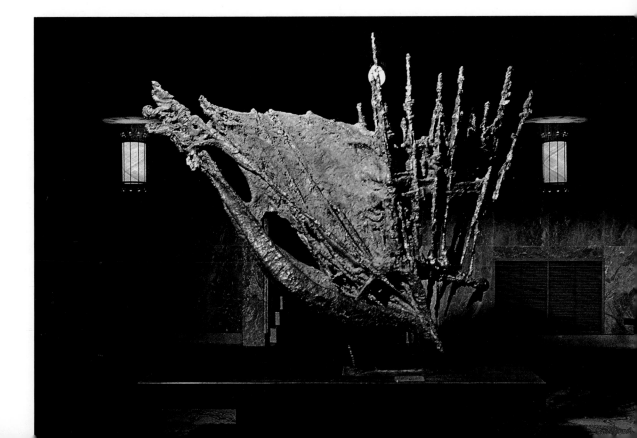

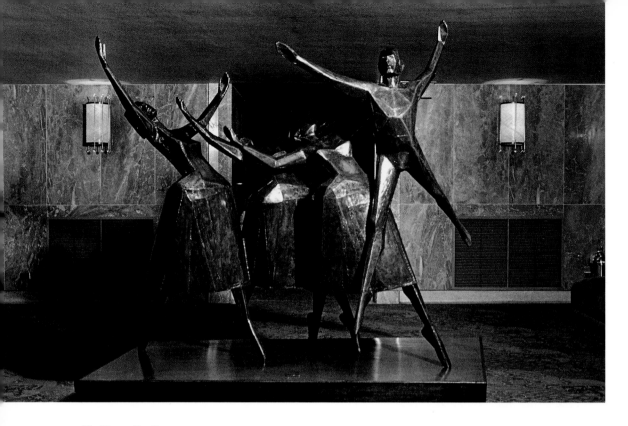

7.29 *The Dance*, Ray Jensen

(DeEtte McAuslan) Stuart. Interestingly enough, this work was created because Mrs. Stuart thought Hilda Morris's *Muted Harp* was too abstract and would not be well received. She requested that a work having a dance theme be commissioned.

Jensen has regretted the fact that the project had to be rushed to ready it for the Seattle World's Fair. His original design was more abstract and fluid. The finished product is, in his words, "more figurative and lacking in detail" than his original intent.

The chandeliers on the orchestra-level foyer and the light fixtures throughout the Opera House were designed by Seattle artist Irene McGowan. The chandeliers, ten feet long and six feet in diameter, were a gift from Mrs. Gustav Schultz, a devoted supporter of the performing arts in Seattle. Her portrait, by Seattle artist Ted Rand, hangs in the Opera House's Celia Schultz Music Room.

7.30 *Cultural Fragments*, Guy Anderson

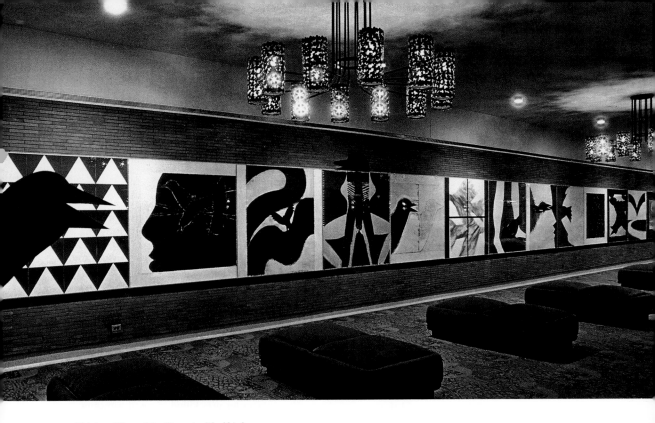

7.31 *Thirteen Ways of Looking at a Blackbird,*
Michael C. Spafford

7.30 **Cultural Fragments,** 1962

Guy Anderson

Oil painting on mahogany; H 5 ft. 9 in. × L 18 ft.
Gift of Mr. and Mrs. William S. Street
Seattle Center, Opera House, first-balcony foyer

Guy Anderson is one of the major names in the
"Northwest School" of painting. The shapes and
earth tones of this painting are typical of his work
and refer to the unity of life-forms. Symbolic,
swirling forms and floating figures are blended
together in a cosmos—not separated but
interrelated. The cellular shapes enclosing his
figures are derived from Pacific Northwest Indian
art. Anderson's work has also been influenced by
Asian philosophies.

7.31 **Thirteen Ways of Looking at a Blackbird,** 1985

Michael C. Spafford

Painted mural
Seattle 1% for Art collection
Seattle Center, Opera House,
second-balcony foyer

This expansive work, which takes up the entire
wall of the second-balcony foyer, consists of
thirteen panels each of which is derived from
a stanza of the Wallace Stevens poem of the
same title. The first stanza is

> Among twenty snowy mountains,
> The only moving thing
> Was the eye of the blackbird.

The thirteenth stanza is

> It was evening all afternoon.
> It was snowing
> And it was going to snow.
> The blackbird sat
> In the cedar limbs.

Spafford's mural is a fine example of his unique
style, which is often reminiscent of black paper
cutouts applied to white paper. At first glance
they appear rather simple, but further study
reveals a combination of energetic and sometimes
sensual forms.

7.32 Transcendental Theatre: Floating Woman and Transcendental Theatre: Crystal Man, 1985

Jack D. Chevalier

Acrylic paint on wood
Seattle 1% for Art collection
Seattle Center, Opera House, ground floor, south side

Jack Chevalier's two scenes are typical of his combined media of painting and sculpture. Natural subjects and energetic forces are depicted with painted wooden forms often supplemented with surface chiseling. These works mark a change in his approach. Prior works consisted of flat interlocking shapes. Here, mountain scenes are constructed as if they were foldout models of stage scenes.

Chevalier reports that these works combine iconography he uses in much of his work and create "transcendental, or natural, operas" for the Opera House. The trees are like an audience, with the ellipse below like a stage and the sky like stage lighting. The sun's rays, converted into triangular shapes, are examples of Chevalier's distillation of natural forms into geometric images.

7.32 *Transcendental Theatre: Crystal Man,*
Jack D. Chevalier

7.33 The Raven and the Salmon Lady, 1973

Morrie Alexander

Carved cedar; H 20 ft.
Seattle Public Schools collection
Seattle Public Schools Administration Building, 815 Fourth Avenue

Master Lummi Indian carver Morrie Alexander carved this pole in the relatively unsophisticated style of the Salish Indians, which include the Lummi, rather than in the classic detailed style of Indian totem carving that developed among the tribes of southeastern Alaska and western British Columbia. The figures represent the Salish legend of how salmon were created when Raven, "the beginner of all things," was searching for food for his people and met Salmon Woman, who created salmon for people to eat.

The Raven and the Salmon Lady was commissioned for the Seattle School District by the Washington State Cultural Enrichment Program. Sadly, Alexander was killed in an automobile accident en route to the pole's dedication in 1973.

7.34 Untitled sculpture, 1977

Jonn Geise

Stainless steel; H 9.5 ft.
Martin Selig collection
100 West Harrison Plaza, north tower

Jonn Geise's untitled stainless steel sculpture is part of a series of his gnomon designs, named after the vertical, shadow-casting portion of a sundial. His earliest work in this series, which has no resemblance to this work, is *Circum-Octo* at the University of Washington's Suzzallo Library (12.13).

7.35 Triad, 1983

Phillip Levine

Bronze; H 14 ft.
Martin Selig collection
Elliott Bay Office Park, 300 Elliott Avenue W

This statue is one of two popular works in Seattle's public places by Seattle sculptor Phillip Levine (see also 12.5). Here, Levine has positioned three bronze figures to form an inverse

7.35 *Triad*, Phillip Levine

7.37 *Moon Song*, George Tsutakawa

triangle. Levine admires this placement for its sculptural "ambiguity"; although the figures are sturdy bronze, their position creates an impression of lightness. *Triad* was commissioned by Seattle real estate developer Martin Selig, who owns Elliott Bay Office Park.

7.36 **Fish at Play,** 1984

Michelle G. Van Slyke

Steel and vitreous enamel; H 4 ft. × L 16 ft.
Privately owned
201 Elliott Avenue W, lobby

In *Fish at Play*, Bainbridge Island artist Michelle G. Van Slyke has created a delightful scene of fish swimming through blue waters and multicolored

vertical waves. A flying fish is shown about to depart the scene. The mural was commissioned by the building's owners and architects. At first it was thought too colorful and whimsical for an office building lobby. However, good sense prevailed and the design remained unchanged. Van Slyke's enameled steel cutout sculpture shows the influence of her studies with Spokane sculptor Harold Balazs.

7.37 **Moon Song,** 1971

George Tsutakawa

Silicon bronze; H 4.5 ft. × dia. 2.5 ft.
Memorial gift, Seattle Post-Intelligencer collection
Seattle Post-Intelligencer Building,
101 Elliott Avenue W

Moon Song is the first of three of George Tsutakawa's works with this spherical design. Another stands in the cafeteria of Seattle Central Community College on Capitol Hill. The third is located at Pennsylvania State University.

This fountain was commissioned as a memorial to Bobby McCallum, an award-winning columnist and reporter for the *Seattle Post-Intelligencer* from 1965 to 1969. The name *Moon Song* is not derived from its shape. Ms. McCallum's parents asked that it be given that name because Moon Child was a pet name they had for their daughter.

7.38 **Logging Mural** and **Logging in the Mountains,** 1948

Eustace Ziegler

Oil on canvas; each, H 8 ft. 9 in. × W 6 ft. 6 in.
Seattle Post-Intelligencer collection
Seattle Post-Intelligencer Building,
101 Elliott Avenue W

When the *Seattle Post-Intelligencer* built its former headquarters in 1948, it commissioned these two paintings by prominent Seattle artist Eustace Ziegler. When the new building was completed, Ziegler's paintings were moved to their present locations. A third, smaller painting, *Resting Lumbermen,* is in the newspaper's administrative offices.

These murals are typical examples of Eustace Ziegler's work, which are prized by museums and collectors. Along with Sidney Lawrence, Ziegler was one of the earliest painters of Alaska, but he also achieved considerable recognition for his scenes of the Pacific Northwest. Whereas Lawrence painted landscapes without human subjects, these two lobby paintings are typical of Ziegler's peopled landscapes and group figure subjects.

7.38 Logging Mural, Eustace Ziegler

7.39 **Ten Feet into the Future,** 1986

David Govedare

Aluminum; life-size
Martin Selig collection
3131 Elliott Avenue Building, on the south end

Ten Feet into the Future shows five joggers in silhouette. A careful look reveals that five different races or ethnic backgrounds are represented. The lead runner is an American Indian, symbolizing that American Indians were here before all other peoples and the artist's view that "in a spiritual sense" the Native American is leading the other peoples onward into the future. Others in the group are a black, an Asian, a Hispanic, and a Caucasian.

Ten Feet into the Future was commissioned by the Spokane Chamber of Commerce in 1986 and was placed in front of the Washington State Pavilion at British Columbia's Expo '86. The theme of that world's fair was transportation, and Govedare chose a play on words for his sculpture's title. The sculpture is derived from his much larger work at Spokane's Riverfront Park, which extends two city blocks and consists of forty runners.

After the conclusion of Expo '86, *Ten Feet into the Future* was purchased by Martin Selig, owner of the adjacent building. Its placement here is appropriate because the area is frequented by joggers who work in the neighborhood.

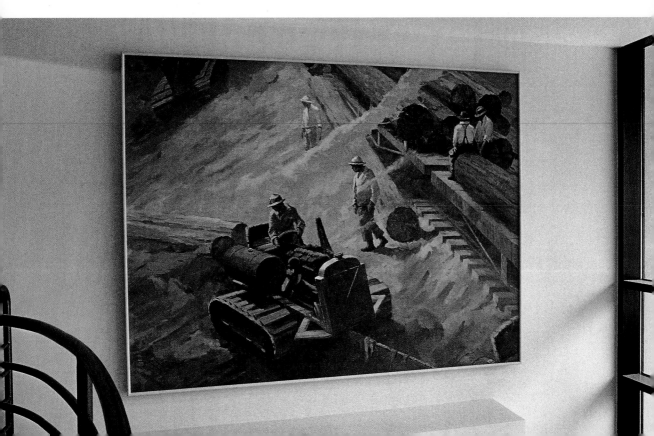

7.39 *Ten Feet into the Future,* David Govedare

7.40 **Adjacent, Against, Upon,** 1976
Michael Heizer

Granite boulders and concrete
*Seattle 1% for Art Program
and National Endowment for the Arts*
Myrtle Edwards Park, north of Pier 70

Michael Heizer's *Adjacent, Against, Upon* is one
of the most unusual and controversial artworks
in Seattle. Created in 1976, it was Heizer's first
public art commission and his most accessible
work at that time. It is a three-part sculpture
with each section consisting of a fifty-eight-ton
concrete base and a large granite boulder. The
boulders (two of which weigh approximately
fifty tons, with a third weighing thirty-five tons)
were chosen by the artist from quarries near
Skykomish, Washington. As the title of the work
suggests, one boulder is adjacent to its base,
another rests against its base, and a third rests
upon its base.

7.41 **Fencing treatment,** 1985
Carolyn Law

Metal fencing and mixed media
Seattle 1% for Art Program
Broad Street Electrical Substation,
Broad Street and Taylor Avenue N
(across Fifth Avenue from Space Needle)

Although probably missed by most drivers
rushing by in traffic, Carolyn Law's treatment of
the fencing around this drab electrical substation
adds energy and interest to the scene. On the
Thomas Street side, Law wove colors and lines
into the fencing to create a visual experience for
pedestrians. She describes the eighty-foot-long
design as "a pictographic and verbal definition
of how electrical power flows from the substation
to the consumer." Inside the gray fence on the
Broad Street side she added geometric shapes
of colored screen that are supported by hidden
cables, allowing a different "visual experience
from each angle." On its third side, Law had
portions of the concrete wall cut out to allow
viewing of the electrical equipment.

 This work was a collaborative effort of the
artist, City Light engineers, and the Seattle
firm of Arai/Jackson Architects.

7.40 *Adjacent, Against, Upon,* Michael Heizer

7.41 Fencing treatment, Carolyn Law

7.42 Family Watching TV, 1989

Richard Beyer

Cast aluminum; H 4 ft. 2 in. × L 4 ft. 9 in.
KING Broadcasting collection
KING Broadcasting Building,
333 Dexter Avenue N

Those entering KING's headquarters are first met outside by a mother and father, their son and daughter, and the family dog—all enjoying their evening watching television. Beyer's representation of the nonconformist in every group is the family cat, which sits on the edge of the chair and looks the other way. In addition to charming those who enter, Beyer's sculpture has the additional duty of inhibiting intruders, an attribute felt necessary because an angry citizen drove his car through the entrance several years before KING Broadcasting commissioned this sculpture. *Family Watching TV* replaced large concrete planters placed at the entrance after that attack.

7.43 Untitled fountain, 1981

George Tsutakawa

Stainless steel; H 25 ft.
KING Broadcasting collection
KING Broadcasting Building lobby,
333 Dexter Avenue N

George Tsutakawa's stainless steel fountain at KING Broadcasting is a continuation of his "rain fountain" theme, which was first used in his Design Center Northwest fountain (21.5). It is also a statement by the artist that all his fountains need not stand on a pedestal base. This twenty-five-foot fountain hangs from the ceiling.

With the use of dripping water through perforated stainless steel disks, Tsutakawa signifies the "great excitement in a very simple thing," the softly falling Seattle rain. We take it for granted; but Tsutakawa recognizes that whether the Seattle rain is falling in gray sheets or is a filter for the sun, it "has tremendous variation that is constantly affecting our lives." The movement of the water droplets as they leak through and bounce down through successive levels of his rain fountain can be likened to "rain on the lake or on a wet street on a bright day."

George Tsutakawa's fountain was presented to KING Broadcasting and all its employees by Priscilla Bullitt Collins, chairman of the board of KING and daughter of its founder, Mrs. A. Scott Bullitt.

7.43 Untitled fountain, George Tsutakawa

7.44 Bust of Dr. Mark A. Matthews, 1941

Alonzo Victor Lewis

Cast bronze; H 3.5 ft.
City of Seattle collection, memorial gift
Denny Park, facing Denny Way
between Ninth Avenue N and Dexter Avenue

This little-known sculpture was created the year after the death of Dr. Mark A. Matthews (1867–1940), one of Seattle's most colorful and active ministers in the first part of this century. Born in Calhoun, Georgia, he came to Seattle in 1902 to become pastor of the First Presbyterian Church and was welcomed by a 400-member congregation. When he died, that congregation, which included the downtown Seattle church plus branches at Green Lake, South Park, and Pleasant Valley, numbered 80,000. It was the largest Presbyterian congregation in the country.

Matthews's interests extended beyond church affairs. He crusaded against political and police corruption, started Seattle's first program to combat tuberculosis (which later developed into Firlands), and established the city's first kindergarten and nursery schools. Seattle's first juvenile court was created by his efforts, and as a practicing lawyer, he represented the underprivileged without charge.

7.45 The Construction Workers, 1982

Richard Beyer

Cast aluminum; approx. life-size
Wright Schuchart, Inc., collection
425 Pontius Avenue N at Republican Street

The area directly south of Lake Union is home to many small businesses but very little art. In the middle of it all is an imposing concrete office building. This is the headquarters of Wright Schuchart, Inc., and its operating divisions, which together make up one of the region's leading construction companies and real estate developers. Appropriately, the sculpture at its entrance depicts four construction workers.

7.46 Fountain, 1988

Jonn Geise

Welded silicon bronze; H 7.5 ft. × W 6 ft.
Commissioned by Trace and Associates
In front of Chandler's Crabhouse restaurant, off Fairview Avenue N, across from intersection of that avenue and Minor Avenue N

Jonn Geise emphasizes that his thoughts behind the design of this, his fourteenth fountain since 1965, are very involved and cannot be expressed briefly. The limited space here cannot eloquently describe his intentions, but a central theme is love, and the shape refers to two hearts. Geise added water "to make the shape pulsate and add sensuality." In addition, the water creates an umbrella shape, which the Seattle artist thought was an appropriate reference to this region.

7.44 Bust of Dr. Mark A. Matthews,
 Alonzo Victor Lewis

7.45 *The Construction Workers*, Richard Beyer

7.46 Untitled fountain, Jonn Geise

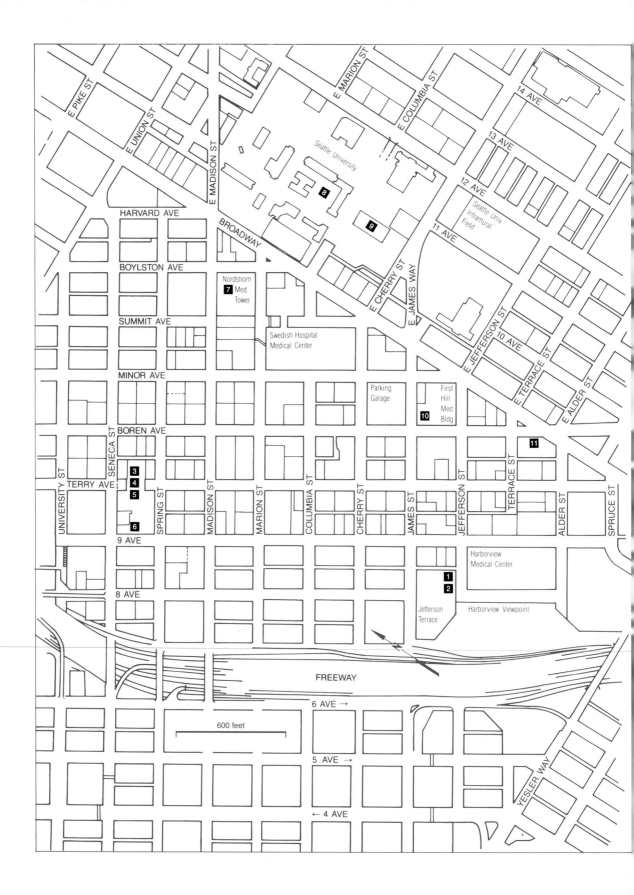

E PIKE ST

E UNION ST

E MADISON ST

E MARION ST

E COLUMBIA ST

14 AVE

13 AVE

12 AVE

Seattle University

8

9

Seattle Univ
Intramural
Field

11 AVE

HARVARD AVE

BROADWAY

BOYLSTON AVE

E CHERRY ST

E JAMES WAY

Nordstrom
7 Med
Tower

SUMMIT AVE

Swedish Hospital
Medical Center

E JEFFERSON ST

10 AVE

MINOR AVE

Parking
Garage

First
Hill
Med
Bldg

10

E TERRACE ST

E ALDER ST

BOREN AVE

SENECA ST

11

UNIVERSITY ST

3
4
TERRY AVE
5

SPRING ST

MADISON ST

MARION ST

COLUMBIA ST

CHERRY ST

JAMES ST

JEFFERSON ST

TERRACE ST

ALDER ST

SPRUCE ST

6

9 AVE

Harborview
Medical Center

1
2

8 AVE

Jefferson
Terrace

Harborview Viewpoint

FREEWAY

6 AVE →

600 feet

5 AVE →

← 4 AVE

YESLER WAY

Chapter 8

First Hill

All great art was made by, or on behalf of, a small minority. But this small minority must inspire confidence in the majority.

SIR KENNETH CLARK 1903–1983

My Garden, William Cumming *(see Swedish Hospital Collection, page 139)*

8.1 *Tall Shape*, Glen Alps

8.5 *Upon the Deep*, Charles Stokes

8.1 Tall Shape, 1962

Glen Alps

Aluminum; H 9 ft. 7 in. × W 4 ft.
Gift of Seattle Art Museum
Jefferson Terrace Retirement Home,
800 Jefferson Street, terrace at southeast corner

Tall Shape was created by Seattle artist and
University of Washington art professor Glen
Alps for display in a Seattle World's Fair exhibit
of innovative artworks. After the fair it was
purchased by the Seattle Art Museum, which
donated it to Jefferson Terrace in 1967.

As with his sculpture at the Seattle Municipal
Building (4.9), it was created by tracing a design
on a sheet of metal, cutting it out, and then
twisting and bending it into the final form.

8.2 Thomas Jefferson Memorial Fountain, 1969

James FitzGerald

Bronze; H 2 ft. × L 6 ft. 10 in. × depth 5 ft. 9 in.
Gift of Nellie Mitchell Frick
Jefferson Terrace Retirement Home,
800 Jefferson Street, entry court on south side

When Nellie Mitchell Frick, a prominent
suffragette and founder and first president of the
League of Women Voters (in 1920), died in 1960,
she left five thousand dollars to the Seattle
Foundation to purchase a work of art to honor
Thomas Jefferson. This fountain was created
in 1969 by Northwest artist James FitzGerald
for his own home, but he sold it to the Seattle
Foundation for placement here.

8.3 Garden for the Winds, 1983

Bill Hoppe

Acrylic, pencil, and ink on canvas;
H 3 ft. × L 15 ft. 4 in.
Virginia Mason Hospital collection
Virginia Mason Hospital lobby, 925 Seneca Street

Garden for the Winds is one of two major Bill
Hoppe paintings in a public place in Seattle, both
of which display his dynamic style of combining
swirling geometric shapes drawn and painted in
pencil, ink, and acrylic washes (see also 8.7).

Geometric shapes have been major characteristics
of his works since the 1960s, which have evolved
into ever more complicated structures.

Garden for the Winds was included in a series of
works Hoppe created for an exhibit at Marylhurst
College in Oregon. Hoppe compares each
painting in a series to a stanza of a poem and
seeks to create an environment with each series
(other titles in that series are *Morning Bird, Sun
Song, Bright Wings,* and *Frozen in Red*). Wind is a
common theme in his series. In a 1988 interview,
Hoppe stated that wind has always been an
important subject to him: "It holds an important
place in my life. . . . I have fond memories of it as
a child and I used to have a favorite place when I
was growing up in Wisconsin where there was
always wind. . . . When I was little I used to
think the wind was caused by moving trees. . . .
I don't intend to program meaning into my
paintings, but they do wake up meaning and
experiences in my life."

Here, Hoppe's attraction to the wind is
combined with references to a garden: triangular
pieces at the bottom of the painting seemingly
growing out of the earth. Also present are
references to the water and the subdued, natural
lighting found in the Puget Sound region.

8.4 Belzer and Carlson, 1973

Tom Holland

Epoxy paint on fiberglass;
each, H 7 ft. 4 in. × W 4 ft.
Virginia Mason Hospital collection
Virginia Mason Hospital lobby, 925 Seneca Street

Also at the entry of the Virginia Mason Hospital
lobby are two large abstract paintings by
Berkeley, California, artist Tom Holland.
Holland's goal was to come as close as possible to
creating "sheets of color hanging on the wall." He
thus painted on fiberglass panels riveted together
rather than on canvas stretched over wood
frames. Holland reports that if it had been
possible, he would have used only sheets of
paint. The paint was applied thickly enough to
create subtle relief designs. Each painting, one
blue and one red-orange, has a painted fiberglass
triangle attached to the upper right-hand corner.
The names of these two works have no
significance; at the time, Holland was randomly
choosing names from the Seattle telephone
directory as titles for his works.

8.5 **Upon the Deep,** 1976

Charles Stokes

Acrylic, Plexiglas; H 3 ft. × L 8 ft.
Virginia Mason Hospital collection
Virginia Mason Hospital, 925 Seneca Street

Up the stairs in the hospital lobby, behind the
reception desk is *Upon the Deep,* a unique acrylic
and plastic relief by Seattle artist Charles Stokes.
The subject is a woman swimming through
rippling water, a symbolic image, as it was
created as payment for cancer treatment Stokes
received at Virginia Mason in 1974.

Stoke's medium is unusual in any case, but
especially because he is a painter and this work is
a combination of painting and sculpture. He first
drew the design in charcoal on paper and covered
the work with a sheet of Plexiglas. He then
retraced every line repeatedly with clear acrylic
gel, slowly building up the surface to bas-relief.
When viewed at an angle, one can see the char-
coal lines beneath. When viewed from directly
in front, the charcoal lines seem to undulate.

8.6 *Otter with Flounder,* Tony Angell

The Consultation, Allan W. Lobb *(see Swedish Hospital
Collection, page 139)*

8.6 **Otter with Flounder,** 1977

Tony Angell

Carved steatite; H 17 in. × L 30 in. × W 17 in.
Virginia Mason Clinic collection
Virginia Mason Clinic lobby, 1100 Ninth Avenue

Tony Angell's *Otter with Flounder* is one of five
artworks in the Mason Clinic, which is just east
of Virginia Mason Hospital. This is a splendid
example of the artist's skillful carving style, which
has established him as one of the best wildlife
sculptors in the Northwest. The stone used here
is steatite, a hard type of soapstone.

The other artworks in the Virginia Mason Clinic's
lobby are Kenneth Callahan's *Floating World*
(1973), Paul Reed's *Gilport IX* (1972), Larry Zox's
Iodine Hoop (1977), and Dan Christensen's *Blue
Slide* (1979).

Swedish Hospital Collection

Blue, William Ivey *(see Swedish Hospital Collection)*

When major corporate art collections in Seattle are discussed, the names Seattle–First National Bank, SAFECO Insurance Company, and U.S. West Communications are most commonly heard. The Swedish Hospital collection is smaller but is one of the finest collections in the city and includes works by many of the region's most prominent artists.

Many pieces were given by grateful patients and friends. One was given by local artist William Cumming "in exchange for a new baby" (see page 135). *The Consultation,* a polished bronze sculpture created in 1975 by Dr. Allan W. Lobb, the hospital's former director, a noted surgeon, and an artist in his own right, was presented by hospital volunteers. Other pieces were purchased with funds donated for hospital decor.

The collection includes works by Mark Tobey, William Ivey, Guy Anderson, Kenneth Callahan, George Tsutakawa, Boyer Gonzales, Paul Horiuchi, John Franklin Koenig, Jacob Lawrence, William Cumming, Carl Morris, Frank Okada, Neil Meitzler, Louis Bunce, Kathleen Gemberling-Adkison, Alden Mason, Richard Gilkey, Joseph Goldberg, Peter Juvonen, Michael Daily, Keith Monaghan, and Donald Woodford. Unlike those of other corporations, most of the works in this collection are readily available for public viewing. The largest concentration of art is located in the hospital's main lobby at 747 Summit Avenue and in adjoining halls. Happily for the viewing public, each artwork is labeled, and viewing is encouraged.

8.7 **The Night Wanderer,** 1986

Bill Hoppe

Acrylic, pencil, and ink on canvas;
H 14 ft. 8 in. × L 28 ft.
Swedish Hospital collection, gift of Wright Runstad & Company
Swedish Hospital, Elmer Nordstrom Tower lobby, 1229 Madison Street

The Night Wanderer combines elements of Bill Hoppe's previous work with inspirations arising from a European trip and references to surrounding architecture. Elements also found in earlier paintings include images of "a clarion or a siren and an awakening in the night . . . and an inner complexity grappling a vector and, finally,

joy, exaltation, and acceleration." Combined here, they create what Hoppe describes as a "visual paraphrase of 'Zarathustra's Midnight Song,' from *Thus Spake Zarathustra,* by German philosopher Friedrich Wilhelm Nietzsche." A portion of that poem is included on a plaque next to the painting:

> O man! Take heed!
> What does the deep midnight say?
> I slept!
> I have awakened from a deep dream.
> The world is deep,
> And deeper than the day remembers.
> Deep is its suffering.
> Joy is deeper than heartache!
> Suffering speaks: Begone!
> All joy wants eternity,
> Wants deep, deep eternity.

Night Wanderer was commissioned shortly after Hoppe returned from a stay in London, where he heard a performance of Gustav Mahler's Third Symphony, which incorporates part of Nietzsche's poem. On the same trip, he became enamored with the brushstroke technique evident in the paintings of Peter Paul Rubens. "I saw his work at the National Gallery and I became very involved with the visual motion of the brushstrokes on the surface of his paintings . . . a sort of swirling, figure-eight texture. I had Rubens's painting in mind when I heard Mahler's Third and I was struck by the fact that the strings were overlapping. . . . They created overlapping visual acoustics that were the same as overlapping brushstrokes. . . . I like the idea of my painting referring to music. Sound and color do relate with one another."

Spring Landscape, Richard Gilkey *(see Swedish Hospital Collection, page 139)*

8.7 *The Night Wanderer*, Bill Hoppe

The Night Wanderer is the first painting Hoppe framed in what he described as a "saw-tooth, broken framing technique." "I had been thinking about it for some time, but this was the best opportunity to use it. . . . The architectural elements of the building relate well with it and it helps incorporate the painting into its surroundings." An earlier painting by Bill Hoppe can be seen in the lobby of Virginia Mason Hospital (8.3).

The nearby portrait of Elmer Nordstrom was painted in 1984 by Margaret Sargent. Nordstrom donated the funds necessary to build the Elmer Nordstrom Tower. He is one of the three brothers who ran the Nordstrom store chain after it was founded by their father. The stores are now run by the third generation of Nordstroms.

8.8 **Centennial Fountain,** 1989

George Tsutakawa

Silicon bronze; H 16 ft.
Seattle University collection
Seattle University quadrangle

Its pointed leaf-shaped forms, rather than the more typical rounded shapes of George Tsutakawa's other fountain-sculptures, make this work unique among his Seattle fountains. The abstract shapes, which the artist says are essences of natural shapes and represent no particular subject, intersect and rise vertically sixteen feet. Additional sculptural forms extend out into the fifty-foot-diameter pool when water from thirteen nozzles is shot against the curved bronze surfaces. A central nozzle also extends the sculpture vertically with a nine-foot plume of water. The total height of the bronze and water forms is approximately twenty-five feet, making it Tsutakawa's second tallest fountain-sculpture. The tallest is a 1974 work in Troy, Michigan.

This fountain was given to Seattle University by a group of private donors to commemorate the university's centennial.

North of the Tsutakawa fountain, in a glade on the north side of the Pigott Building, is a small fountain donated to the university by Henry and Mary Broderick in 1958. The fountain is of little artistic importance, except for the inclusion of James Wehn's twenty-seven-inch-high bust of Chief Seattle.

8.8 *Centennial Fountain*, George Tsutakawa

8.9 **Untitled mural,** 1967

Val Laigo

Mosaic; L 65 ft.
Seattle University collection
Seattle University, Lemieux Library
Reading Room

This mosaic mural is an energetic collection of scenes from the Bible and scenes of creation, war, good versus evil, death, and human creative talents. Laigo's subjects were inspired by a statement made to him by a Jesuit priest he once studied under. After explaining to the class that he was a gambling man, the priest concluded, "I'm not absolutely sure there is a God, but if there is, I'd hate to find out that I played my cards wrong." From that comment Laigo developed the theme of his work: "If there is no God the atheists cannot create Him. If there is a God the atheists cannot destroy Him. I hope there is a God."

8.10 **Murals,** 1988

Mara Smith and Kris King

Carved brick
First Hill Medical Building, corner of James Street
and Boren Avenue

These carved-brick murals were commissioned
for this building when it was built in 1988 and
depict scenes related to medicine, medical
treatment, and patient care. As with Mara Smith's
earlier, and larger, murals at Second Avenue and
Lenora Street (6.1), the bas-relief designs are
carved in separate panels before the clay is fired.

8.11 **Wall treatment,** 1989

Vicki Scuri

Cast concrete
King County Percent for Art Program
Boren Avenue Garage, Boren Avenue and
Alder Street

When plans for King County's Boren Avenue
Garage were unveiled, residents of adjacent
Hilltop House Retirement Center and other
neighbors raised concerns about the intrusive
nature of a concrete behemoth in their com-
munity. The King County Arts Commission
selected Seattle artist Vicki Scuri to create a design
and work on a design team with prime contractor
ABAM Engineering Contractors and consulting
architects Elaine Day La Tourelle and Associates,
in an effort to soften the building's harsh lines
and humanize its scale. Scuri added to its three
stories of outside walls horizontal, vertical, and
basketweave designs consisting of different tire
treads in precast concrete panels.

Scuri chose to give the building a unique
identity by referring to the building's purpose
and the industrial aspects of our society through
the use of ordinary tire treads, while at the same
time creating repeated organic-based designs
reminiscent of past cultures. "Treads are ordinary
and common," she explains, "but here they're
used to create patterns that connect us backward
in time to similar repeated designs of Mayan,
Egyptian, Chinese, and European cultures. The
patterns change as light plays upon them at
different angles. Sometimes they look like plants.
At others they look skeletal."

8.11 Wall treatment, Vicki Scuri

Lake Union

Portage Bay

Union Bay

University of Washington

NE PACIFIC ST

Univ Bridge

MONTLAKE BLVD NE

Montlake Bridge

HGWY 520

EASTLAKE AVE E

I-5

E BOSTON ST

E LYNN ST

BOYER AVE E

Univ of Wash Arboretum

Broadmoor Golf Course

E HOWE ST

Volunteer Park

6

10 AVE E

4 **5**

1 **3**

E HIGHLAND DR

Res

2

E PROSPECT ST

12 AVE E

15 AVE E

E ALOHA ST

E ROY ST

E MERCER ST

E REPUBLICAN ST

7

E HARRISON ST

8

E JOHN ST

E DENNY WAY

E MADISON ST

Lake Washington

Res

E OLIVE ST

15

9 **10** **11**

E PINE ST

14

BROADWAY

12

13

E UNION ST

BOREN AVE

Seattle University

E MARION ST

18 AVE E

19 AVE E

20 AVE E

23 AVE E

E CHERRY ST

E JEFFERSON ST

N

0.5 mile

I-90

Chapter 9

Capitol Hill

Thanks to art, instead of seeing a single world,
our own, we see it multiply until we have before us
as many worlds as there are original artists.

MARCEL PROUST 1871–1922

9.8 *Dancers Series: Steps*, Jack Mackie

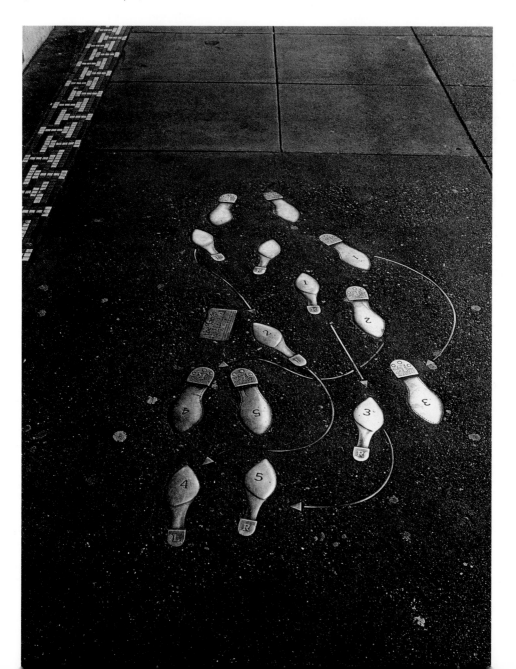

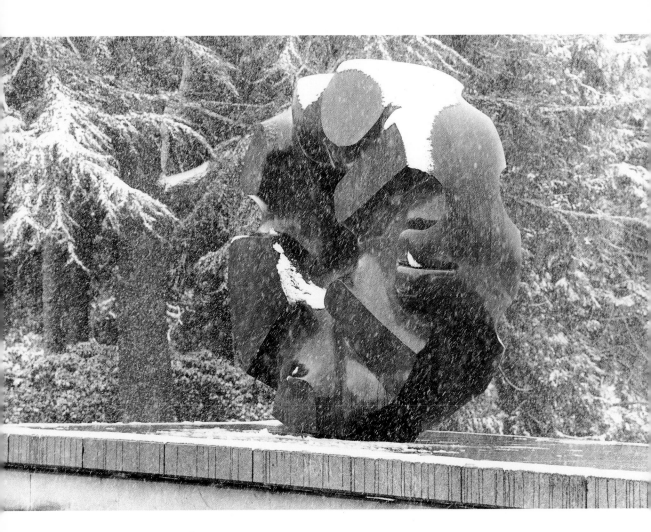

9.1 *Black Sun*, Isamu Noguchi

9.1 Black Sun, 1969

Isamu Noguchi

Black granite; dia. 9 ft.
National Endowment for the Arts and private funding
Volunteer Park, across street from
Seattle Art Museum

The design of Isamu Noguchi's *Black Sun* evolved from studies the artist made for his sculpture garden at Yale University's Beinecke Rare Book Library. There, he created a round, but less elaborate, white granite sculpture named *White Sun*. The design of *Black Sun* is more complex but also reflects Noguchi's reverence for stone as a sculptural material. Although highly polished and clearly man-made, many of its convolutions are similar to naturally eroded surfaces. The artist has remarked that stone is sculptural whether its shape is created by natural forces or human hands.

In 1969 Noguchi explained that in creating *Black Sun* he had "tried for a timeless feeling, a work that would seem both contemporary, yet with ties with the past. . . . I wanted the piece to have the energy and all the strength of the sun. After all, a circle is a basic form, but it can be dead unless you use it in some way. I wanted to make a sculpture that would seem alive and fluid; that would look different at different times. One that would seem to move, in a sense, as the sun moves, so there will always be a kind of dialogue between the real sun and the *Black Sun*."

Isamu Noguchi is one of the few American sculptors of international reputation whose works are displayed in Seattle. His second major work in this city is *Landscape of Time* (3.5).

Black Sun is the first artwork in Seattle commissioned by the National Endowment for the Arts, created by Congress in 1966 to foster and support all of the arts in the United States. Its Works of Art in Public Places Program was established to encourage local communities to debate the merits of public art and commission artworks for their public places. In 1968 the National Endowment funded one-half of the cost of *Black Sun*. The remaining portion was given by Dr. Richard Fuller, noted Seattle philanthropist and cofounder (with his mother, Mrs. Eugene Fuller) of the Seattle Art Museum.

The two camels at the museum's entrance are cast concrete replicas of marble tomb guardians that stood in front of the museum for decades. The originals were removed from the museum for restoration and reinstallation inside the museum's downtown building (see page 96).

9.2 Monument to Judge Thomas Burke, 1929

Hermon A. MacNeil and Carl F. Gould

Granite, marble, and bronze; central column, H 13 ft.
City of Seattle collection
Volunteer Park, southwest of Noguchi's *Black Sun* (steps descend from the sidewalk to a small pond; follow the path around the pond and walk a short distance to the west)

This little-known memorial is to a man who was Seattle's most famous citizen when he died in 1925. At the time of his death he was referred to as "the man who made Seattle."

Thomas Burke (1849–1925) arrived in Seattle in 1875 and served as a lawyer, judge, political leader, and diplomat. A founding member of the Seattle Chamber of Commerce, he was also a principal organizer of the 1909 Alaska-Yukon-Pacific Exposition. In his later years he was active in world affairs and human rights and worked to maintain strong and fair relations with Asia. In fact, he died in New York while giving an impassioned speech urging fair trade relations with Japan.

In 1872, when Seattle was without a railroad, Burke and a small group of businessmen began construction of a private rail line to connect Seattle with the transcontinental lines. The line never reached far enough, but Burke became well known to railroad magnate James J. Hill. Burke later became legal counsel for Hill's Great Northern Railroad and exerted considerable influence throughout the region as a friend and confidant of Hill.

While the granite column of Burke's memorial bears his profile in bronze, the rest of the memorial concentrates on symbolic references to his career. The column is flanked by two classical heroic figures: a Graeco-Roman Indian and Justice, the latter graced with a halo of feathers and bearing a crusader's sword. Words of praise are engraved in the granite around the entire

monument. On the left and right sides of the inlaid stone floor are two circles of inlaid marble. Their designs refer to Burke's intense interest in the Pacific Northwest's trade relations with Asia. In the western circle is a map of the west coast of the United States. In the eastern circle is a map of Asia. Both continents are flanked by the green marble waters of the Pacific Ocean.

The sculptures of this unique monument were created by Hermon A. MacNeil. The memorial was designed by Carl F. Gould, one of Seattle's most prominent architects at that time.

North of the reservoir, under a large tree in a glade between the reservoir and the Volunteer Park Conservatory, is an unusual cor-ten steel birdbath by Portland, Oregon, artist Lee Kelly. The cubical sculpture has a stylized yin-yang symbol on one side. The bath portion is coated with blue enamel. Nearby is a cor-ten steel bench. Kelly's sculptural birdbath was placed in this peaceful setting in memory of Heidi Peterson, a little girl who lived on Capitol Hill and was the victim of a still-unsolved murder in 1970.

9.3 **Rivalry of Winds,** 1932
Dudley Carter

Carved cedar; H 9 ft. × W 4 ft.
City of Seattle collection
Volunteer Park, behind Seattle Art Museum

Dudley Carter's *Rivalry of Winds* is one of those many older sculptures in Seattle that are almost totally forgotten and often, as in this case, deteriorating. Secluded behind the Seattle Art Museum, it depicts a Duwamish Indian legend concerning a rivalry between North Wind and South Wind over the lovely daughter of Mountain Beaver. She is the central figure. The rivalry ends with the scene depicted here. The warm South Wind (or Chinook wind in the Indian language) arrives in the spring and presents the daughter of Mountain Beaver with a basket of salal berries. He wins her away from the cold North Wind, the unhappy lower figure in the sculpture.

9.2 *Monument to Judge Thomas Burke,*
Hermon A. MacNeil and Carl F. Gould

9.3 *Rivalry of Winds,* Dudley Carter

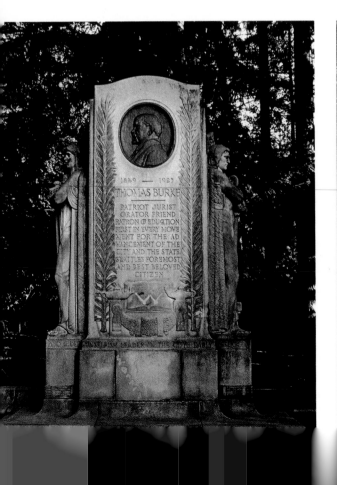

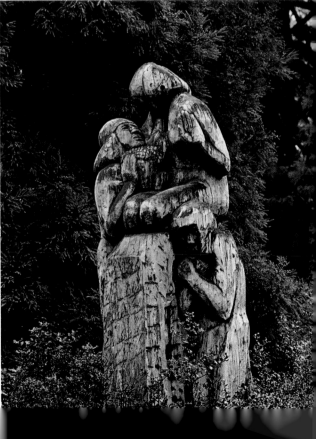

9.4 Monument to William H. Seward, 1909

Richard Brooks

Cast bronze on granite base; H approx. 19 ft.
Private funding, Alaska-Yukon-Pacific Exhibition commission
Volunteer Park, in front of Volunteer Park Conservatory

At the beginning of the century, the Seattle business community commissioned prominent New York sculptor Richard Brooks to create a statue of William H. Seward (1801–72). Seward was an influential politician in his day and was the driving force behind this country's purchase of Alaska from Russia in 1867, an idea his opponents dubbed "Seward's Folly." He also served as secretary of state from 1861 to 1868 in both the Abraham Lincoln and Andrew Johnson administrations. After extensive research and study of photos, Brooks created what Seward's descendants described as an excellent likeness of the man. The statue was completed in 1909, in time for placement at the Alaska-Yukon-Pacific Exposition on the University of Washington campus.

After the exposition closed, the Seward statue was "temporarily" moved to its present location to await final placement in the soon-to-be-completed Seward Park. Although the park was completed, Seward was never moved.

Seward is depicted standing next to a world globe and directly beneath him are the words "Let's make the treaty tonight." Not a profound statement, but reportedly exclaimed by Seward when Congress was getting close to a vote on the Alaska purchase treaty.

9.5 Homage in Green, 1982

Richard Spaulding

Etched glass; H 8.5 ft. × L 23 ft.
Gift of SAFECO Insurance Company
Volunteer Park Conservatory

Adjacent to the Seward statue is the city's Victorian-style greenhouse, which houses a splendid collection of tropical plants. The entryway is graced with a colored glass canopy created in Germany and Seattle by Richard Spaulding. The hand-blown German glass consists of a base of clear glass with a thin layer of rich green glass laminated to it. In the center are etched flowers—lilies, passion flowers, and convolvuluses (a kind of morning glory), which were popular in Victorian designs. On one side are English designs from before 1900. On the other are American designs dating after 1900. The entire work is framed in brass.

This addition was commissioned by the Friends of the Conservatory and installed as part of a renovation of the building in 1982. It was paid for by a grant from SAFECO Insurance Company.

9.6 Untitled sculpture, 1975

Lee Kelly

Cor-ten steel;
H 19 ft. × L 14 ft. × W 10 ft.
Seattle 1% for Art collection
Boren Park, Louisa Boren Viewpoint,
Fifteenth Avenue E and Garfield Street

This sculpture is composed of ten interlocking blocks of welded cor-ten steel that have rusted evenly to a rich brown color. A major attribute

9.4 *Monument to William H. Seward,* Richard Brooks

9.5 *Homage in Green*, Richard Spaulding

9.6 Untitled sculpture, Lee Kelly

of cor-ten steel is the fact that after rusting to a certain point it should not deteriorate further. The same material was used for Barnett Newman's *Broken Obelisk* at the University of Washington (12.10) and Doris Totten Chases's *Changing Form* on Queen Anne Hill (14.1). All of Lee Kelly's public sculptures are of welded metal. However, in recent years he has left the earth tone of cor-ten steel for the sheen of stainless steel (see 5.2 and 5.3).

This viewpoint is named after Louisa Boren Denny, the last survivor of that band of settlers who landed at Alki Point in 1851 and founded Seattle. The viewpoint was designed by the late Victor Steinbrueck.

At the southwest corner of Sixteenth Avenue E and E Aloha Street is a sidewalk mural by Seattle artist Charles Greening. As with his Gas Works Park *Sundial* (13.3) and *Meridian Gateway* (17.1), the mosaic is an assemblage of objects and designs. Most of the former were donated by area residents. The work was commissioned by the residents of PRAG house, a cooperative residence on the same corner, to repair the sidewalk and allow retention of the large tree on the corner. The city intended to cut the tree down because its roots would continue to break normal sidewalks.

9.7 **The Itinerant,** 1981

Richard Beyer

Cast aluminum; life-size
Private commission
Broadway and E Harrison Street, northeast corner

Richard Beyer's *The Itinerant* is a sculpture of a man sleeping on a bench. His head is covered by a newspaper, which the artist believes is a very good use for bearers of such bad news. Like so many of Beyer's works, this has the rough-cut surfaces created by his use of carved Styrofoam models, which he casts in aluminum. The sculpture was commissioned by local Broadway businesses and private individuals for placement in this pocket park. The park was designed by Louise Smith of Environmental Works.

9.8 **Dancers Series: Steps,** 1982

Jack Mackie

Bronze
Seattle 1% for Art Program
On Broadway, sidewalks from E Pine to E Roy streets (both sides)

At regular intervals on the east and west sidewalks along Broadway, between Pine and Roy streets, is a collection of inlaid bronze footprints and dance instructions designed by Seattle artist Jack Mackie (see page 145). Each of the eight groups depicts different dance steps, such as the rumba, the waltz, and the tango. Some dances, like the "Busstop" and the "Obeebo," are Mackie's inventions. Viewers are encouraged to participate and become part of the artwork by learning the dances.

One should note the treatment of the heels in the shoe imprints. For instance, parking tokens appear in those outside a parking lot. Coffee beans are in the heels of those in front of a grocery store, originally a Starbuck's coffee store. A stylized view of the downtown skyline appears in the heels for the "Busstop" dance.

Mackie was assisted in creating the dance steps by Seattle artist Charles Greening and worked with Makers, a Seattle urban design group, in placing them. The work, financed through Seattle's Urban Spaces Program with 1% for Art funds in cooperation with the Seattle Engineering Department, was part of a major facelift of the Broadway sidewalks completed in 1982.

9.9 **Wind Cradle,** 1976

Ali Baudoin

Stainless steel; H 11 ft. × W 10 ft.
Washington State Percent for Art Program
Seattle Central Community College, Broadway and Pine Street

Ali Baudoin's *Wind Cradle* consists of pillars of stainless steel that seem to wave in an ever-present breeze. This sculpture's design and name were in fact inspired by the forceful winds that often blow off Elliott Bay and up Pine Street past the college. Baudoin received the commission to create *Wind Cradle* after winning a competition arranged by the Washington State Arts Commission. At the time he was a graduate student in sculpture at the University of Washington.

The state purchased this work, Charles Smith's nearby sculpture (9.10), and a number of others inside the complex with one-half of one percent of the college's Phase Two budgeted construction costs.

9.10 **Untitled sculpture,** 1976
Charles W. Smith

Cor-ten steel; H 12 ft. × W 11 ft.
Washington State Percent for Art Program
Seattle Central Community College,
Broadway and Pine Street

This untitled work by University of Washington professor Charles Smith consists of geometric designs chosen for the simplicity of their forms. Smith emphasizes that such simplicity creates a work of ageless beauty. "I think in terms of sculpture being visual poetry or music with no words, and when you work with pure form and geometry, you not only create that feeling, the work also appears undated through the years. That is why I have worked with these shapes throughout my career and why I keep coming

9.9 *Wind Cradle,* Ali Baudoin

9.10 Untitled sculpture, Charles W. Smith

back to them." Smith took the same approach with *Study of Angles and Circles* in the University District (12.34).

Although the Broadway Performance Hall is open only during performance hours, it is worth mentioning that a large classical painting by Eustace Ziegler graces its lobby. Inside the college's main entrance is a large tapestry, created by college students in 1977 and incorporating cloth designs from all over the world. To the right, down the main hall, in the cafeteria, is a bronze fountain by George Tsutakawa. The fountain is very similar to his *Moon Song* (7.37).

9.11 **The Wyvern,** 1982
Richard Beyer

Painted cast aluminum; L 8 ft. × W 4 ft.
City and private funding
Bobby Morris Park (Broadway Playfield),
Eleventh Avenue, one-half block north
of Pine Street

Richard Beyer's cast aluminum *Wyvern* is the first of many works he has created for playgrounds throughout Seattle. This creature, a mythical winged animal resembling a dragon, is curled up with a bone in one paw and sleeping peacefully on a large log. The aluminum has been supplemented with brown paint and colored spots, an untypical addition to Beyer's works.

9.12 Neighbors, 1985

Diane Katsiaficas

Ceramic and wood
Seattle 1% for Art Program
East Police Precinct Station, Twelfth Avenue and E Pine Street

Neighbors: 1986 is meant to be a microcosm of the Capitol Hill community. Multicolored ceramic people and animals and wood cutouts of homes line the area under the main windows of the station. The homes imitate the various architectural home designs in the neighborhood. On the west wall the figures proceed up three porch steps. A window seat symbolizes a road through the community. A separate design swirls around the tan ceramic tile floor in front of the window seat. The design symbolizes the whirlwind activity of people in the community.

This project was another collaboration where the artist and the building architects worked together. Katsiaficas also worked with students from neighboring University Heights Elementary School and Sharples Middle School in creating and placing the two thousand figures. She was further assisted by artists Margi Beyer and Maggie Smith.

9.13 Purple Orchid and Iris, 1984

Ned Behnke

Vitreous enamel on steel;
H 4 ft. × L 6 ft. 8 in.; H 3 ft. 5 in. × L 4 ft. 11 in.
King County 1% for Art Program
Community Service Center for the Deaf and Hard of Hearing, 1609 Nineteenth Avenue E

9.12 *Neighbors*, Diane Katsiaficas

Ned Behnke's *Purple Orchid* and *Iris* are vitreous enamel on steel panels (the orchid mural is at the front entrance; the iris is in the courtyard on the building's west side). However, both retain the semblance of paint on canvas, Behnke's usual medium. Behnke worked with Dave Berfield, an expert in working with enamel on steel, in translating his skills as a painter into this medium. Berfield was also the technician for *Games*, Jacob Lawrence's Kingdome mural (1.17).

Purple Orchid, the larger of the two panels, has three orchid blooms, white with purple accents, set off by green fleshy leaves and a rich background of black enamel.

The single iris bloom on the smaller panel is primarily white and yellow but has red and green accents on the edges of each petal. It is supported by a green stem and stands against the same black background. Note in particular the brushstrokes visible at the edges of the iris petals, an unusual element in vitreous enamel artworks, where thick applications are more common.

9.14 *The Oracle of Truth,* James W. Washington, Jr.

9.14 **The Oracle of Truth,** 1987

James W. Washington, Jr.

Carved granite; H 5 ft. × L 6 ft. × W 3 ft.
Mount Zion Baptist Church collection
Mount Zion Baptist Church,
1634 Nineteenth Avenue E

Like many sculptures by James W. Washington, Jr., *The Oracle of Truth* is replete with his personal symbolism (see also 10.4). Here, Washington used numerous symbols to emphasize God's endowment of humanity "with the ability to reason on three levels of consciousness—physical, mental, and spiritual—with the motive coming from within. Man's desire to accept exterior motivation was his downfall and he became materialistically oriented." On the south side is a human figure, painted in greens and blues, with a dark red heart. On top is a lamb, which Washington uses to symbolize Christ.

Other symbols include a large circle encompassing a smaller one and a number 3, which symbolizes man and God within man and the fact that "all things were created out of three units; for instance . . . all colors are created from red, yellow, or blue; people have three natures: physical, mental, and spiritual." The equilateral triangle pointing up "stands for the three who bear record in Heaven: the Father, the Word, and the Holy Ghost." The flat stones surrounding the boulder are part of the sculpture and are incised with symbols.

A detailed explanation of Washington's design is not possible in this book. An explanatory booklet printed for the sculpture's installation may still be available from the church office.

Another of Washington's carved boulders is *The Obelisk*, located in front of Edmond Meany Middle School, 301 Twenty-first Avenue E. Created in 1970, it is the fifth in a series on the Creation.

9.15 Untitled mural, 1987

Gerald ("Chip") Morse

Enamel paint on concrete; L 140 ft.
Fratelli's Ice Cream Company
Fratelli's Ice Cream Building,
Nineteenth Avenue E and E Madison Street

This unusual mural is a tribute to the cows that give the world ice cream. Rather than paint only a pastoral scene of thirty-two grazing cows, artist Chip Morse (whose brothers own Fratelli's Ice Cream Company) has created a summary of twentieth-century art history by painting the cows in different styles. One can see a pointillist cow painted in the mechanical, neo-impressionist style of Georges Seurat. Another is a Picasso-like cubist work. There is a surrealistic scene with a cow serving as a window through which we see a man talking on the telephone. Jackson Pollock's drip style of painting is also represented.

Other than this mural, his only public work, Morse's artistic endeavors have been limited to the creation of a number of artistic (and popular) postcards. He is not a practicing artist and has reportedly moved to the East Coast, where he is teaching Spanish.

9.15 Untitled mural, Gerald ("Chip") Morse

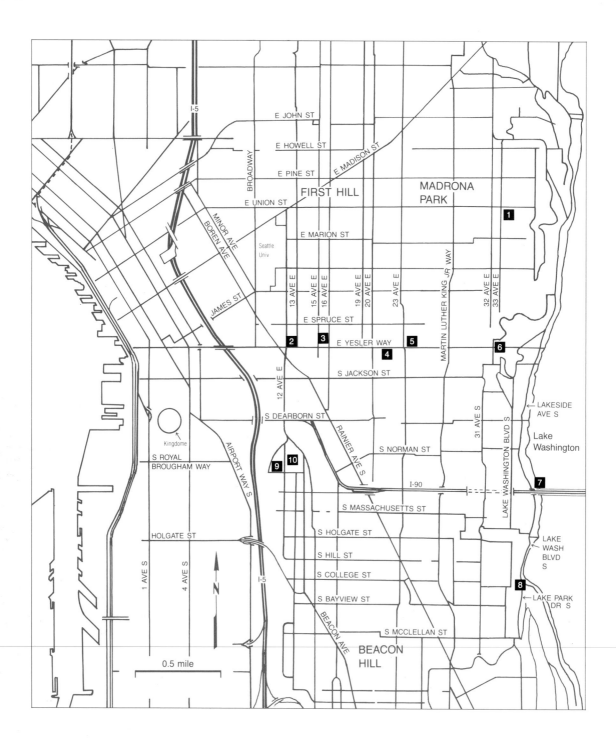

E JOHN ST

E HOWELL ST

E PINE ST

E MADISON ST

E UNION ST

FIRST HILL

MADRONA PARK

BROADWAY

MINOR AVE

BOREN AVE

E MARION ST

Seattle Univ

1

JAMES ST

13 AVE E

15 AVE E

16 AVE E

19 AVE E

20 AVE E

23 AVE E

MARTIN LUTHER KING JR WAY

32 AVE E

33 AVE E

E SPRUCE ST

2 **3** E YESLER WAY **5** **6**

4

12 AVE E

S JACKSON ST

S DEARBORN ST

Kingdome

RAINIER AVE S

S NORMAN ST

31 AVE S

LAKESIDE AVE S

Lake Washington

LAKE WASHINGTON BLVD S

S ROYAL BROUGHAM WAY

AIRPORT WAY S

9 **10**

7

I-90

I-5

S MASSACHUSETTS ST

HOLGATE ST

S HOLGATE ST

LAKE WASH BLVD S

S HILL ST

1 AVE S

4 AVE S

S COLLEGE ST

S BAYVIEW ST

N

8

LAKE PARK DR S

BEACON AVE

S MCCLELLAN ST

BEACON HILL

0.5 mile

Chapter 10

Central Area

Art which is not based on excitement is not art.

PAUL CÉZANNE 1839–1906

10.7 Portal of the Pacific relief, James Fitzgerald
*(photo courtesy of PEMCO Webster and Stevens Collection,
Museum of History and Industry)*

10.1 The Peaceable Kingdom, 1983

Richard Beyer

Cast aluminum; approx. life-size
Commissioned by the Madrona Community Council
Madrona Sally Goldmark Library,
Thirty-third Avenue E and E Union Street

Standing in front of the Madrona Sally Goldmark Library is yet another public sculpture by Seattle artist Richard Beyer. Here a pig and a mountain lion sit together on top of a large granite boulder. At the sculpture's base are a sheep and a wolf. Both are unlikely combinations of predator and prey, but they are symbols of the need for diverse groups to learn to live together harmoniously.

10.2 Coming of the Purifiers, 1977

Donald Barrie and others

Enamel paint on concrete; H 23 ft. × L 120 ft.
King County Arts Commission and private funding
King County warehouse, Thirteenth Avenue E and E Yesler Way

Donald Barrie's *Coming of the Purifiers* is his second large mural referring to an ancient Hopi Indian legend about the return to earth of supernatural beings called Purifiers. His first, *City*

in the Sky, was painted on the side of a building on Capitol Hill at Nineteenth Avenue and Mercer Street. That work, since removed, referred to man's building a city in the sky. After that is accomplished, the Purifiers will return to earth and reveal to humanity a deity.

This mural refers to the second part of the story. The earth is seen from 100 miles above Seattle. Floating in space above the city are spheres representing the Purifiers. Their designs range from simple, colored spheres on the left to detailed images incorporating native African, Asian, and South American art forms. Barrie chose to represent those cultures because of their prominence in this district. Change caused by supernatural visitors is not unique to Hopi legend, and Barrie's reference to other cultures reflects that fact. Such changes are alluded to in the mask bearing the word *change,* located in the mural's lower left-hand corner.

Assisting Barrie with this mural were Victor Kubo and Peter Urio, who supervised twenty Summer Youth Employment trainees. After being introduced to different creation myths and legends, each youth depicted a story in a circle on the mural's lower edge. To the right are symbols created as "signatures" for each trainee.

Coming of the Purifiers was commissioned by the King County Arts Commission. Additional financial assistance was provided by the Seattle Urban League, Arts Resource Services, KING Broadcasting, and Pioneer Masonry and Restoration, Inc.

10.1 *The Peaceable Kingdom,* Richard Beyer

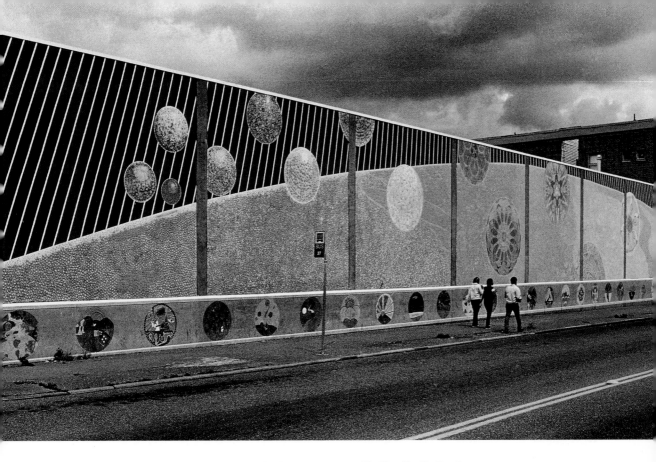

10.2 *Coming of the Purifiers*, Donald Barrie and others

10.3 *The New Family*, Ray Jensen

10.3 **The New Family,** 1970

Ray Jensen

Steel; H 3 ft. × W 2 ft.
Private funding
Medina Children's Service,
123 Sixteenth Avenue E (just north of Yesler Way)

At the entrance of the Medina Children's Service is a small sculpture of a man and woman walking with their small child. Although abstract and small, the work is monumental in its ability to create a scene of serene family life. All three hold hands and appear to be enjoying a stroll together. The sculpture is located in a small, protected garden entry, which adds to the serenity.

10.4 **My Testimony in Stone,** 1981

James W. Washington, Jr.

Carved granite; H 4 ft. × W 2 ft. × D 5 ft.
*Seattle and King County Arts commissions
and private funding*
Odessa Brown Children's Clinic,
2101 E Yesler Way

10.4 *My Testimony in Stone*, James W. Washington, Jr.

In *My Testimony in Stone*, Seattle sculptor James W. Washington, Jr., surrounds a large bird and its fledgling with symbolic references to his beliefs about life and the place of humans in the universe. Washington maintains that, to know our place, we must learn about ourselves and recognize that we are part of nature and the universe. "The functions of life forms may be different, but all life is one and the same. There is no difference."

A major idea of Washington's philosophy is that everything in the universe is created in threes. For instance, he explains, people have three natures: physical, mental, and spiritual. An atom has three parts: electron, proton, and neutron. There are three primary colors: red, yellow, and blue. This idea is symbolized on the sculpture's left side with an equilateral triangle. Inside the triangle are a circle and a dot. Washington points out that ancient people represented God with a circle. Like God, a circle has no beginning or end. The dot within represents humanity, standing within and part of a greater whole.

The artist's emphasis on three is again included with the nest and three eggs at the tail of the large bird. These symbolize the "three levels of consciousness" and the fact that all life emerges from an egg. Emergence from the egg is a recurring theme in much of Washington's sculpture.

With the carved square on the right toward the back, Washington departs from his emphasis on three. Its four corners refer to the four corners of the world, the compass directions, and the four elements—fire, water, air, and earth.

Wrapped around the front of the sculpture is a small pig, which may seem misplaced. Not so. Washington included it as a symbol of forbidden food, which pork is to some cultures. It symbolizes the fact that unwholesome or detrimental things in life are nevertheless part of life's experiences and we must be aware of them.

My Testimony in Stone is one of three Washington sculptures in a Seattle public place depicting the artist's philosophy (see 9.14). It was made possible by funding from the Children's Hospital and Medical Center and the Seattle and King County Arts commissions.

10.5 **Sojourner Truth** and **Frederick Douglass,** 1975

Eddie Ray Walker

Acrylic on canvas; each, 6 ft. × 6 ft.
Seattle Arts Commission, Artist in Residence Program
Douglass-Truth Branch Library,
Twenty-third Avenue S and E Yesler Way

This branch library was named after two of the most famous African Americans in this country's history, Frederick Douglass and Sojourner Truth, and both are depicted inside in large acrylic portraits by Eddie Ray Walker. Both were painted in 1975 after the Seattle Arts Commission selected Walker as its CETA artist in residence for that year.

Sojourner Truth, who lived from 1797 to 1883, was a slave in New York until that state abolished slavery in 1827. She took the name "Sojourner Truth" and dedicated herself to traveling throughout the country to speak the truth about slavery. She was recognized as one of the most effective speakers of the Anti-Slavery Society and was an inspiration to abolitionist forces. Although her appeals concentrated on slavery, she also became a leading figure in the women's suffrage movement.

Frederick Douglass was a businessman who became a leader in the abolitionist movement. Born a slave in 1817, Douglass escaped in 1838 and soon joined the movement to abolish slavery. He was a natural orator and was a forceful voice for abolition through both his lecturing and his newspaper, *Frederick Douglass' Paper.*

10.5 *Frederick Douglass*, Eddie Ray Walker

This large cedar sentry, which stands at the base of the hill at the end of E Yesler Way, is a Thunderbird, a mythical creature of Northwest Indian legends. Although its design was derived from traditional native forms, it is a contemporary rendering of a traditional Northwest native design. Lawney Reyes is one of many Native American artists of his generation who believes that traditional Indian styles should not merely be reproduced. Rather, he explains, "we are trying new ways to express ourselves while maintaining the inspiration of the tribe."

10.6 *Thunderbird*, Lawney Reyes

The main entrance of the Douglass-Truth Branch Library (one of several libraries given to the city in the early 1900s by American industrial mogul Andrew Carnegie) is graced by stained glass artwork by Richard Spaulding. Outside the library, on the corner, is an unusual carved pole named *Soul Pole*. It depicts 400 years of blacks in America. The work was carved by five students as a project for the Model Cities Summer Arts Festival in 1969 and given to the city by the Rotary Boys' Club.

On the southwest corner of the intersection, on the facade of Fire Station 6, are *Lightning Bolts*, anodized aluminum architectural decoration by Ellen Ziegler and Tom Askman. They were commissioned by the Seattle Arts Commission under the city's 1% for Art Program and installed in 1988 as part of a fire station renovation program (see 1.5). The work is backlit with neon lights.

10.6 **Thunderbird,** 1981

Lawney Reyes

Carved cedar; H 10 ft.
Private funding
Thirty-second Avenue S and E Yesler Way

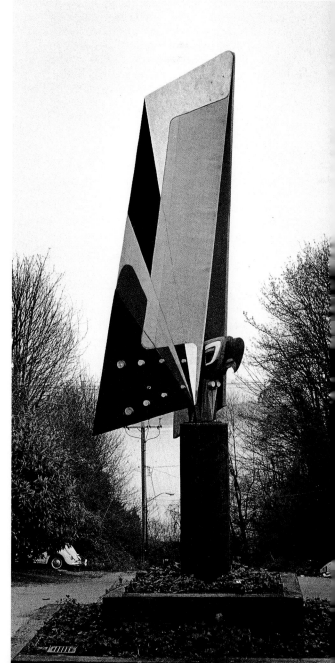

10.7 Portal of the Pacific reliefs, 1938 and 1988

James FitzGerald and James Schoppert

Concrete
Funded by Washington State
East end of the Mercer Island
(Lacey V. Murrow Memorial) Bridge tunnel

The concrete reliefs for Seattle's first floating bridge, those on the eastern face of the original south tunnel, were the first public art commission for sculptor James FitzGerald. FitzGerald became one of the region's most prominent artists and is one of the most represented artists in Seattle's public places. The large relief on the south side of the tunnel entrance is a design inspired by Northwest Indian art (see page 157). That on the north is an Oriental motif, complete with dragon. In between the two designs is a whale relief sculpture. Together, these designs refer to Seattle's role as a link between the United States and Asia.

The northern tunnel was constructed in 1988 and was supplemented with James Schoppert's contemporary reliefs. As with the FitzGerald designs, Schoppert used elements of Northwest Coast Indian forms. However, he chose to make his more contemporary and abstract, to "suggest the origins of the art, yet address the inherent aspects of change and adaptation Native Americans were accustomed to making." Schoppert also alludes to "Seattle's attitude of being progressive, not provincial, . . . and of supporting experimentation and new directions in the arts." His design also includes the words "Seattle—Portal to the Pacific." FitzGerald's design includes the words "City of Seattle— Portal of the North Pacific."

Unlike the original I-90 tunnel, the new tunnel under the Mount Baker area includes an upper level reserved for pedestrian and bicycle traffic. Its long yellow walls have been supplemented with ten murals painted by twenty local youths working under the city's Summer Youth Employment Program.

10.7 Portal of the Pacific relief, James Schoppert

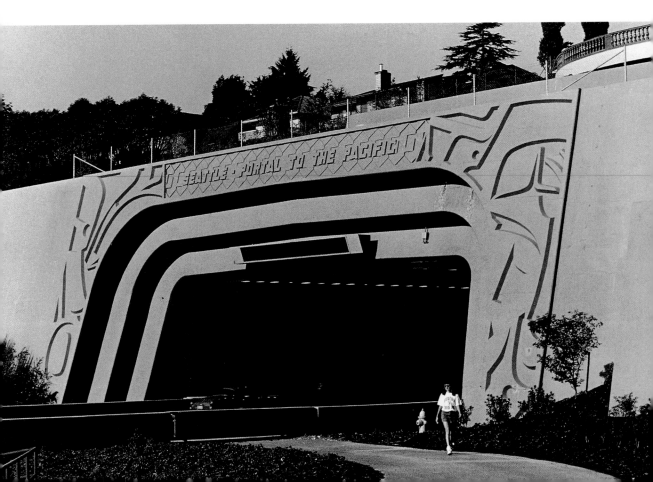

10.8 **Japanese lantern,** ca. 1911

Anonymous Japanese craftsmen

Carved granite; H approx. 18 ft.
Gift of the city of Kobe, Japan
Mount Baker Park, north end

This six-ton granite lantern was brought to Seattle from Kobe, Japan, in 1911. The lantern consists of five identical, but successively larger, pagodas standing atop one another. It was given to the city to commemorate visits between Kobe and Seattle as part of the Alaska-Yukon-Pacific Exposition in 1909. Kobe is now Seattle's "Sister City" in Japan.

At the other end of Mount Baker Park, on S McClelland between Thirty-fourth Avenue S and Lake Shore Park Drive S, is a collection of small artworks in the children's play area. Designed by Seattle artist Wendy Brawer, they include concrete play sculptures and ceramic inserts of leaves and handprints incorporated into the paths. These additions were made possible with Seattle 1% for Art funds and other gifts.

10.9 **East Is West,** 1981

Val Laigo

Mosaic; L, overall, 15 ft.; H, central section, 10 ft.; H, side sections, 8 ft.
Seattle Community Development Block Grants and private funding
José Rizal Park, Twelfth Avenue S and S Judkins Street, across from Pacific Medical Center (formerly the Seattle Public Health Hospital)

Val Laigo's mosaic mural at José Rizal Park consists of three two-sided concrete panels in which he has incorporated a collection of symbols referring to the Filipino community in Seattle and cultures that influenced the Philippines. "Rudyard Kipling said, 'East is East, and West is West, and never the twain shall meet,'" Laigo comments. "But that isn't so with the Filipinos. The two cultures did meet. The West came to us and we came to Seattle. All of that is referred to in this work."

On the east side, facing the street, one sees a fish in the right-hand panel, symbolizing the

10.9 *East Is West,* Val Laigo

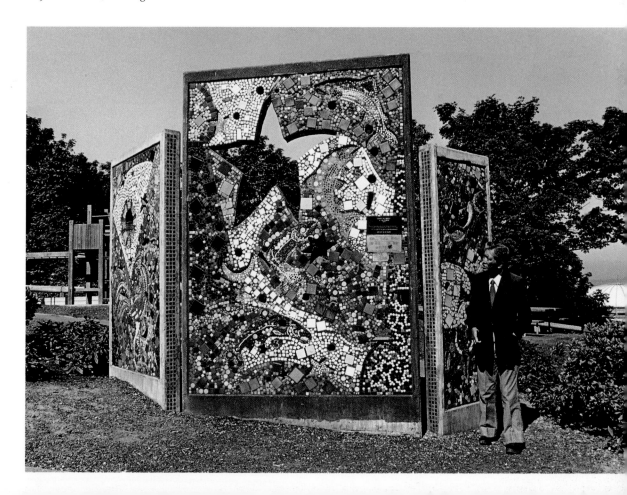

coming of Christianity to the Philippines. The nearby Spanish cross symbolizes Spain's introduction of Catholicism to the islands. The bull's head below symbolizes the Western cultures that came to the Philippines. On the left-hand side, Laigo used a rooster to symbolize the Malay Archipelago, which includes the Philippines. The Philippine sun shines above it, with its eight rays referring to the original eight Philippine provinces that fought Spain for independence.

In the larger, middle panel, Laigo incorporated fishes to refer to the Pacific Northwest and the future of its Filipino residents. Their arrangement imitates the Asian yin-yang symbol and symbolizes the continuity of life. "Fish spawn and die," Laigo explains, "but like all of us, they leave their offspring to continue with life."

On the west side, Laigo incorporated tiles and mirrors into a flurry of colors and reflections supplemented with symbols of the American "melting pot" of cultures. The star and crescent on the left refer to the Moslem faith; below is a Christian cross. In the middle a five-pointed star represents the United States, and below that are the Star of David and an eight-pointed Chinese star. To the right is the eight-rayed Philippine sun.

José Rizal Park was named after a revered Filipino scholar, artist, and patriot who urged Philippine independence from Spain in the late 1800s. He was accused of sedition and was executed in 1896 at the age of thirty-five. In death he became a martyr to the cause of Philippine independence.

10.10 Three paintings, 1937

Kenneth Callahan, with Hovey Rich and Julius Twohy

Oil on canvas; each, H 8 ft.
Historical Society of Seattle and King County collection
Pacific Medical Center lobby,
1200 Twelfth Avenue

The paintings in the lobby of Pacific Medical Center are part of a series of eleven created during the depression by prominent Northwest artist Kenneth Callahan with the assistance of two local artists, Hovey Rich and Julius Twohy. The paintings were commissioned for this hospital (then the Marine Hospital and later the Seattle Public Health Hospital) under the federal government's Works Progress Administration program. Ten were placed in the hospital's lobby.

The eleventh was retained by Callahan. The canvases, painted with the somber colors and heroic figures prevalent in many works of that time, depict seamen at work. They are far from Callahan's mature style of swirling, colorful microcosms of life.

The federal government, primarily through the efforts of Florence Pike, the hospital's general services officer, donated the ten lobby paintings to the Historical Society of Seattle and King County and eight of them were displayed for many years in the Fourth Avenue lobby of the King County Administration Building. They were removed in 1985 to the Museum of History and Industry. In 1986, again through the efforts of Florence Pike, three paintings (the two that had not been displayed since their removal from the hospital and the eleventh of the set, which Callahan donated to the historical society) were placed in the Pacific Medical Center lobby.

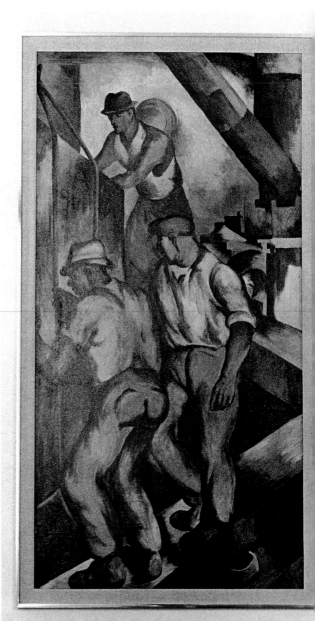

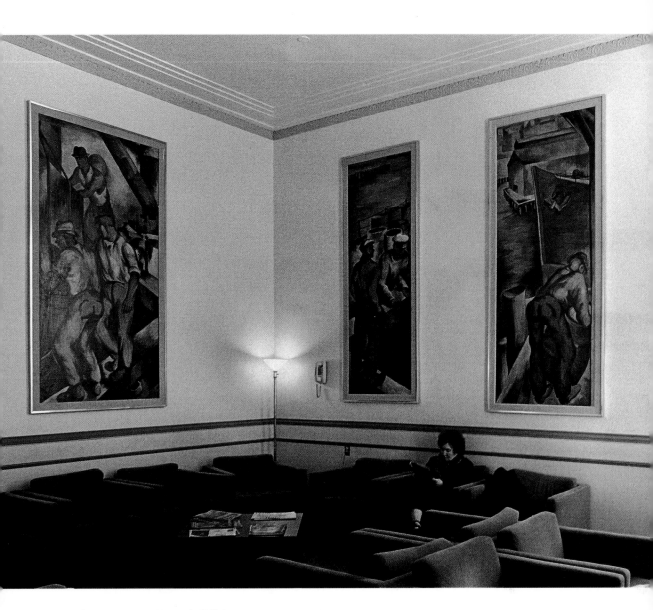

10.10 Three paintings, Kenneth Callahan

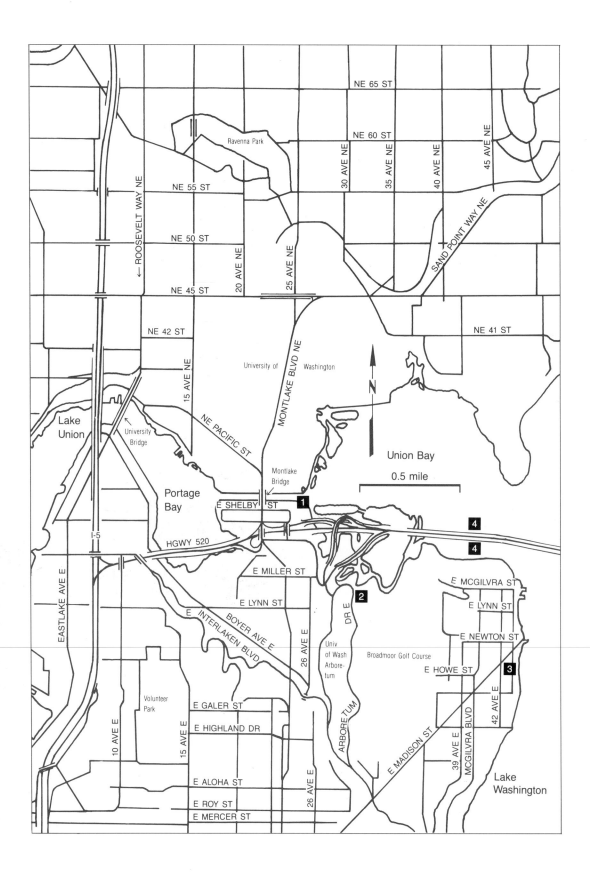

NE 65 ST

NE 60 ST

Ravenna Park

30 AVE NE

35 AVE NE

40 AVE NE

45 AVE NE

NE 55 ST

ROOSEVELT WAY NE

SAND POINT WAY NE

NE 50 ST

20 AVE NE

25 AVE NE

NE 45 ST

NE 42 ST

NE 41 ST

15 AVE NE

University of Washington

MONTLAKE BLVD NE

N

Lake Union

University Bridge

NE PACIFIC ST

Union Bay

0.5 mile

Montlake Bridge

Portage Bay

E SHELBY ST 1

4

I-5

HGWY 520

4

EASTLAKE AVE E

E MILLER ST

E MCGILVRA ST

BOYER AVE E

E LYNN ST

E LYNN ST

E INTERLAKEN BLVD

DR E

2

E NEWTON ST

26 AVE E

Univ of Wash Arboretum

Broadmoor Golf Course

E HOWE ST

3

Volunteer Park

10 AVE E

15 AVE E

E GALER ST

ARBORETUM

42 AVE E

E HIGHLAND DR

39 AVE E

MCGILVRA BLVD

E ALOHA ST

E MADISON ST

Lake Washington

26 AVE E

E ROY ST

E MERCER ST

Chapter 11

Montlake and Madison Park

It is through art, and through art only, that we can realize our perfection; through art and art only that we can shield ourselves from the sordid perils of actual existence.

OSCAR WILDE 1854–1900

11.2 Gates, George Tsutakawa

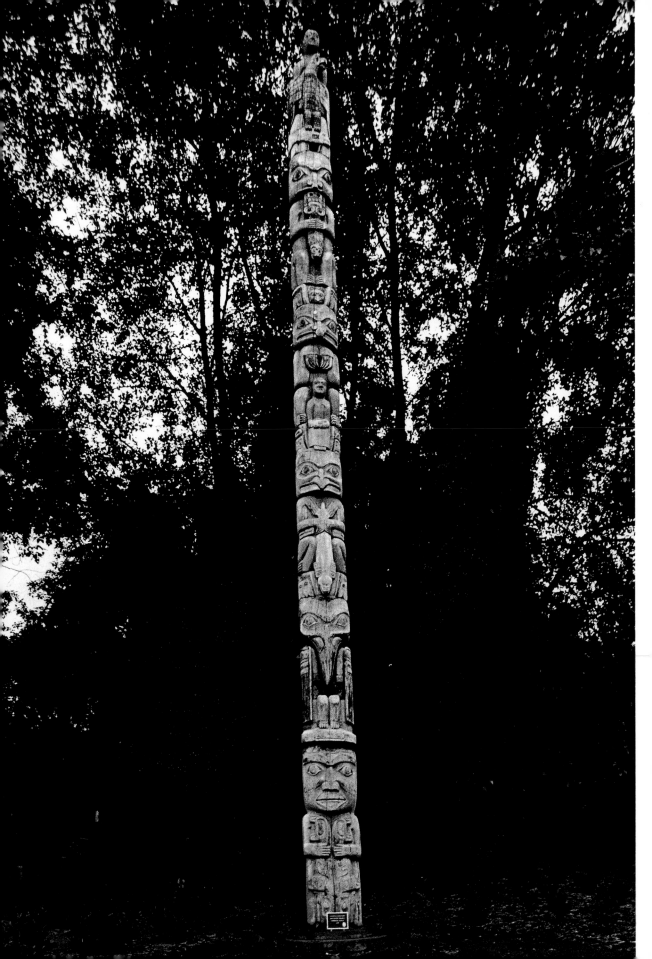

11.1 Totem pole, 1937

Chief John Wallace

Carved cedar; H 40 ft.
Private gift to the city
Montlake Cut, southeast edge off the east
end of E Shelby Street

This traditional Haida Indian totem pole was
carved in 1937 for a fish cannery in Waterfall,
Alaska, where it stood for many years greeting
returning fishermen. Years later, after the cannery
was closed, it was cut into pieces and sent to a
Seattle warehouse. It remained there for many
more years until it was sold at auction. The
purchaser was the Committee of 33, a group of
philanthropic Seattle citizens interested in im-
proving Seattle's aesthetic environment through
numerous gifts of artwork and landscape
improvements.

As is true with the well-known Pioneer Square
totem pole (1.1), this forty-foot creation tells an
ancient story. It is the "Story of North Island,"
involving a very old woman thought worthless by
her brother, chief of the Haida. When the chief
ordered his people to move to the west side of
North Island (in British Columbia), he ordered
that his sister be abandoned with no food or fire.
She asked the Spirits for help, and they sent
an eagle, which brought her food each day. But
then a bear began to steal the eagle's gifts. In
desperation the woman asked the Spirits for a
son to help her. A son was given and he killed
the thieving bear.

The son dreamed of a man who told him that
he and his mother must keep their eyes closed
throughout the next night regardless of the
commotion around them. They did so and awoke
to find themselves in a big house adorned inside
and out with carvings and totems. It was the first
carving ever seen by the Haida. The next day the
man of the dreams presented himself. He was
a Haida and taught them of a special medicine
to use when the tribe needed a good carver.

One of the Haida who received the man's
special medicine was Chief John Wallace, who
carved this totem pole. The pole's story is
depicted in the carved figures. The old woman
sits with the eagle at its top, and the rapacious
bear sits beneath her. The Haida man sits at the
pole's base, and the son sits with the eagle two-
thirds of the way up. The eagle is shown again
below, holding a seal that it brought for the
woman to eat.

South of Wallace's totem pole, on the exterior
northeast wall of the Museum of History and
Industry, to the left of the main entrance, is one
of many terra-cotta Indian heads that were prob-
ably created by Victor Schneider. It and several
others displayed in Seattle graced the upper
portions of the White-Henry-Stuart Building
in downtown Seattle. The building was demol-
ished in 1976 and replaced by Rainier Bank
Tower and Rainier Square.

Inside the museum are several large paintings
by Kenneth Callahan that are part of a set he
created in 1937 for the Marine Hospital on Beacon
Hill (see 10.10). On the museum's lower level is a
large (10 ft. × 24 ft.) fresco mural of the Seattle fire
of 1889 that was painted in 1953 by Rudolph
Zallinger, a prominent American painter from
Seattle, now largely forgotten by its citizens.
The mural was commissioned by the General
Insurance Company (now SAFECO).

11.2 Gates, 1976

George Tsutakawa

Silicon bronze; H 6 ft. × W 22 ft.
Private gift to the city
Arboretum Drive, entrance to the Arboretum
buildings up the road from the East Drive
entrance

Commissioned by Emma Stimson, a member
of the prominent Seattle lumber family, these
bronze gates (see page 167) are George
Tsutakawa's second sculptural gates. His first can
be seen at the Lake City Branch Library (19.9).

"In this design I incorporated all sorts of things
. . . pods, leaves, tentacles, and flowers—all
things in the Arboretum," Tsutakawa explains.
"It was made in the same method as the Lake
City gates, with bronze strips welded together.
It was tricky to build all those compound curves
and reverse curves. Reversing the curve and
making the wavy line is doubly difficult; but
it is doubly strong, too."

11.1 Totem pole, Chief John Wallace

11.3 **McGilvra's Farm,** 1980

Richard Beyer

Carved cedar and granite
Seattle Arts Commission and private funding
Madison Park

The animals throughout the children's play area at Madison Park are some of the many creations on view throughout Seattle by local sculptor Richard Beyer. The granite animals near the play tower include a large bear and its cub, which eye two nearby sheep guarded by a dog. Also included in Beyer's "farm" are a grazing horse and a group of beavers, which have just felled a tree. A short distance away is a large reclining cougar.

The play tower's cedar beams are embellished with carved cedar animal heads. Just east of the tower, at the top of an evergreen tree, are two carved wooden rats dancing merrily with one another.

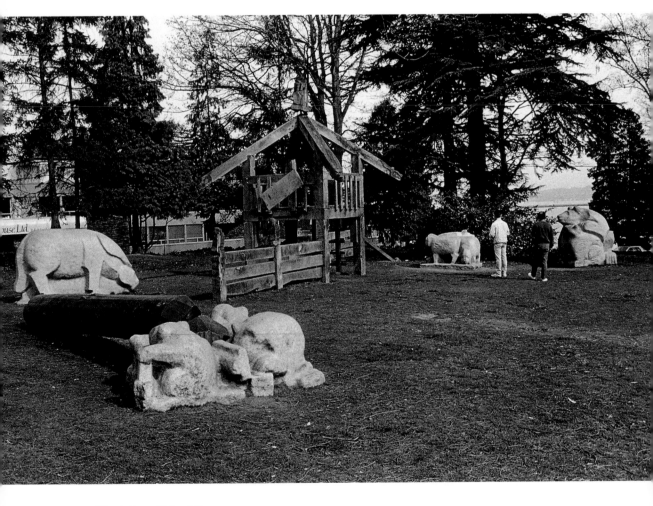

11.3 *McGilvra's Farm,* Richard Beyer

11.4 Nellie C. Cornish Memorial Sculptures and fountains, 1989

Parks Anderson

Gift of Pace National Corporation
West end of the Evergreen Point floating bridge, on Highway 520

Parks Anderson's most often seen sculptures welcome visitors into one of Seattle's eastern gateways and stand as a memorial to the late Nellie C. Cornish, a dedicated teacher and founder of what is now the Cornish College of the Arts. Each sculpture is topped with two gold-leaf-covered windmills, one above the other, that rotate in opposite directions. Each set consists of three fluted and curved windmill arms measuring four feet long. They are reminiscent of scientific wind-measuring devices. In the center of the top of each sculpture stands a small bear, balanced on a golden ball and balancing a smaller ball on its nose. This playful creature is invisible to traffic on the highway and is best seen from a boat with the aid of binoculars.

The windmills stand high atop four steel legs on a stepped concrete base. When the fountains are working, eight-foot-high streams of water shoot up at the base, and water cascades down the steps and over the base into Union Bay. They are lighted at night and create an eery spectacle of slowly rotating golden shapes.

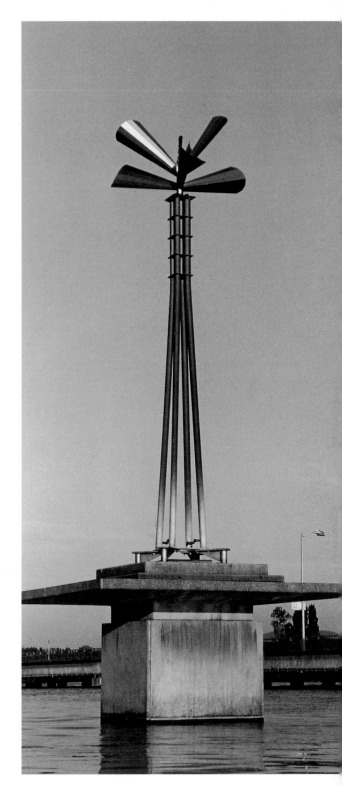

11.4 *Nellie C. Cornish Memorial Sculptures* and fountains, Parks Anderson (*photo by James M. Rupp*)

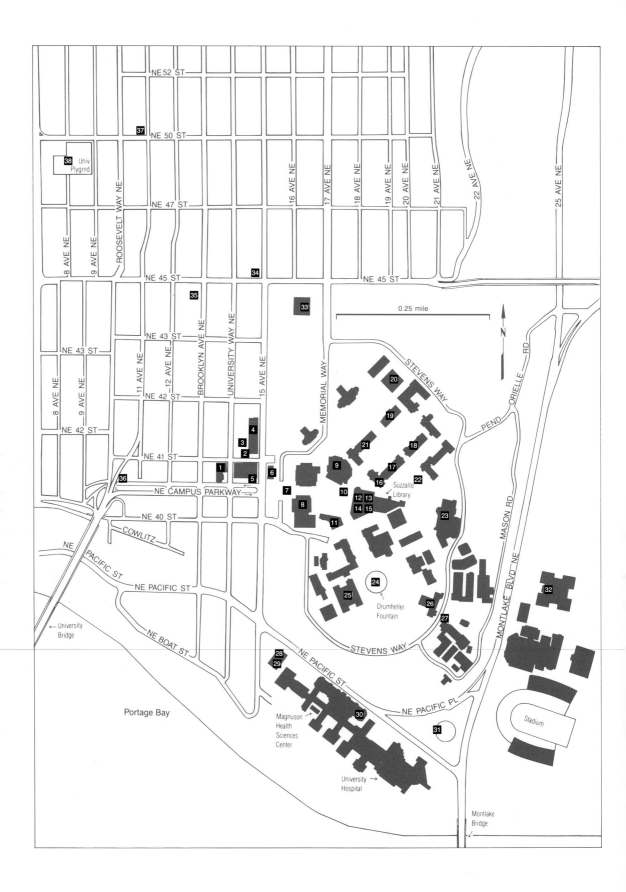

0.25 mile

N

NE 52 ST

NE 50 ST

37

Univ Plygrnd

38

NE 47 ST

16 AVE NE

17 AVE NE

18 AVE NE

19 AVE NE

20 AVE NE

21 AVE NE

22 AVE NE

25 AVE NE

8 AVE NE

9 AVE NE

ROOSEVELT WAY NE

NE 45 ST

NE 45 ST

34

35

33

Memorial Way

Stevens Way

PEND ORIELLE RD

NE 43 ST

NE 43 ST

NE 42 ST

NE 42 ST

NE 41 ST

11 AVE NE

12 AVE NE

BROOKLYN AVE NE

UNIVERSITY WAY NE

15 AVE NE

8 AVE NE

9 AVE NE

20

19

21

18

4

3

2

9

17

16

22

Suzzallo Library

1

10

5

6

12 13

7

14 15

8

11

23

36

NE CAMPUS PARKWAY

NE 40 ST

COWLITZ

24

Drumheller Fountain

25

26

27

MASON RD

32

NE PACIFIC ST

NE PACIFIC ST

NE

PACIFIC ST

NE BOAT ST

← University Bridge

Stevens Way

28

29

NE PACIFIC ST

MONTLAKE BLVD NE

Portage Bay

Magnuson Health Sciences Center

30

NE PACIFIC PL

31

Stadium

University → Hospital

Montlake Bridge

Chapter 12

University of Washington and Environs

Everything passes. Robust art alone is eternal.

THÉOPHILE GAUTIER 1811–1872

12.23 Detail from *University of a Thousand Years,*
Ernest R. Norling

12.2 *Bench for Meditation*, Brian Goldbloom

12.4 *Time Frame*, Steven Gilman

The University of Washington Collection

The University of Washington's collection surpasses that of many large cities and could be the subject of a separate book. The artworks range from the elaborate architectural decorations on Suzzallo Library to Barnett Newman's minimalist sculpture *Broken Obelisk*. No other place in the city has a more concentrated collection of architectural sculpture. As a general rule such sculpture is excluded from this book. However, because the many examples at the university can be seen easily in a small area and because so many of the artists are important names in Pacific Northwest art history, they are included here.

As with many office buildings in the city, paintings and small sculptures are displayed throughout some buildings. Only the readily accessible artworks are included in this chapter.

12.1 **Actor masks,** 1920s

Designed by Mark Tobey

Mosaic tile; H 2 ft. × W 1 ft.
University of Washington collection
Glenn Hughes Playhouse, southwest corner of NE Forty-first Street and University Way NE

At the theater's entrance are two small mosaic actor masks designed in the 1920s by the late Mark Tobey. They were once used by the Seattle Repertory Theatre, which used to be located here, and were featured in theater publications and advertisements.

Tobey's design was also used for the theater's neon sign, which still sits in the gable above the entrance. University of Washington art history professor Gervais Reed suggests that it is probably the only neon sign ever designed by the Pacific Northwest's most famous artist.

12.2 **Bench for Meditation,** 1982

Brian Goldbloom

Granite; H 2 ft. × L 11 ft. 4 in.
Washington State Percent for Art Program and University of Washington funding
Social Work, Speech, and Hearing Sciences Building, northwest corner of NE Forty-first Street and Fifteenth Avenue NE

Four large granite boulders placed in an arc form Brian Goldbloom's *Bench for Meditation,* which he created as a study in contrasts and contradictions. He sculpted the top portions to make the stone look "bent or wrinkled" and then polished those surfaces to contrast with the sculpture's rough edges. The work is a pleasant contrast to the angles of the neighboring brick and concrete buildings. Goldbloom did not begin with the idea of a bench and the sculpture evolved as a study of shapes and surfaces rather than a sitting area. However, the low, horizontal form lends itself to use.

12.3 **Sacred Bundles,** 1979

Guy Anderson

Painting, oil on paper; H 8 ft. × W 5 ft.
University of Washington collection, gift of SAFECO Insurance Company
Social Work, Speech, and Hearing Sciences Building, northwest corner of NE Forty-first Street and Fifteenth Avenue NE (in window above *Bench for Meditation*)

The forms and colors of this painting are typical of Guy Anderson's prominent style, which incorporates floating and swirling forms into a symbolic cosmos. Another work in this style is *Cultural Fragments* at the Opera House (7.30).

Sacred Bundles is one of two fine works at the university by Guy Anderson, a major name in Pacific Northwest art history. His other painting is *Secret Pastures* located in Meany Hall.

12.4 **Time Frame,** 1982

Steven Gilman

Basalt; H 7 ft. 3 in. × L 11 ft.
Washington State Percent for Art Program and University of Washington funding
Social Work, Speech, and Hearing Sciences Building, Fifteenth Avenue entrance

Steve Gilman's *Time Frame* is a column of roughly cut basalt that thrusts up from the brick patio beneath it as if pushed by tremendous geological forces. The work is situated as if the forces broke the column in two, leaving each end of the column firmly implanted in the earth. It is a stark contrast to the orderly brick and glass forms of the surrounding university building.

Time Frame was purchased by the university and the state through its Art in Public Places Program.

On the third floor of Schmitz Hall, across NE Forty-first Street from the Social Work, Speech, and Hearing Sciences Building, is a bronze bust of Dr. Martin Luther King, Jr., by Seattle sculptor Jeff Day. Created in 1984, the twenty-inch-high work is titled *Speaking Out*.

12.5 Dancer with Flat Hat, 1971
Phillip Levine

Cast bronze; H 6 ft. 6 in. × W 3 ft. 4 in.
University of Washington collection, private gift
West end of Fifteenth Avenue NE pedestrian overpass at Schmitz Hall

One of the most popular works on the campus is Phillip Levine's *Dancer with Flat Hat*, who seems to direct people down the stairs as she stands balanced on one foot. This is a larger version of one of Levine's favorite works, which was purchased by the Seattle Art Museum. The artwork reflects three of Levine's interests at the time: the dancer as subject matter, the portrayal of movement in sculpture, and the creation of a "certain ambiguity" of form and design.

Levine made this version for himself and included it in a Henry Art Gallery exhibit of art for public places. Members of the William G. Reed family saw the work there and bought it as a gift for the university. Mrs. Reed's grandfather was Horace C. Henry, the prominent philanthropist who gave the Henry Art Gallery to the university in 1927.

12.6 Architectural sculpture, 1927
Dudley Pratt

Cast stone
University of Washington, Henry Art Gallery

The Henry Art Gallery is less elaborately decorated than other facades from the same era on the campus, but it does have four cast stone figures at its corners and a decorative relief panel along its top. These were created by Dudley Pratt, whose sculptures also decorate Smith and Miller halls, the Engineering Building, Magnuson Health Sciences Center, and the nearby Administration Building. Pratt's four Henry Art Gallery figures represent the cradles of premodern art: Asia, Egypt, Greece, and medieval Europe. Encircling the building are the engraved names of fifty-three of history's great artists and architects.

12.7 George Washington Memorial Statue, 1909
Lorado Taft

Cast bronze; H 14 ft.
State of Washington and private funding,
Alaska-Yukon-Pacific Exposition commission
West of Meany Hall, overlooking
Fifteenth Avenue NE and NE Campus Parkway

The university's classical statue of George Washington is its first major artwork, and it was created by one of the country's leading sculptors

12.5 *Dancer with Flat Hat*, Phillip Levine

12.7 *George Washington Memorial Statue,* Lorado Taft

12.8 **Theater,** 1985

Jacob Lawrence

Vitreous enamel on steel;
H 4 ft. 3 in. × L 41 ft. 6 in.
University of Washington collection
University of Washington, Meany Hall lobby

After creating his first enamel on steel mural
in 1979 for Seattle's Kingdome (1.17), Jacob
Lawrence created several more for various lo-
cations around the country, including this mural
for Meany Hall, the university's performance
center. It is a collection of animated abstract
figures that he describes as representing theater
"in the broad sense" rather than particular
characters or plays. There are symbols
representing Shakespearean themes, acrobats,
"the drama of love (that's always a classic),"
comedians, and concerts ("there's a pianist in the
design").

The mural's colorful interlocking shapes and
spaces are typical of Lawrence's works. "I have
always been excited about color and the magic of
the picture plane," Lawrence explains, "seeing its
texture, its value and space, and seeing how it
functions. It's very exciting what you can do with
shifting space and lines and texture. . . . Ideally
I try not to have a background and a foreground
as such. I consider it a successful composition if
there is no definite background and foreground
but a continual back and forth movement. . . .
It gives a work a certain mystery, vitality, and
dimension. It's not static. I want it to continue
to move."

Theater was commissioned by many friends of
Jacob Lawrence and given to the university for
placement in Meany Hall.

of large statuary in the 1890s and early 1900s.
Lorado Taft was commissioned to create this
memorial to the state's namesake in 1905 through
the efforts of the local chapter of the Daughters of
the American Revolution (DAR). The fourteen-
foot-high statue was completed four years later.
The price for Taft's artwork was eight thousand
dollars, and when funds ran short, the DAR
asked the state's schoolchildren to donate no
more than five cents each. The children, and the
state government, donated enough coins to make
up the deficit.

George Washington originally stood at the
Seventeenth Avenue entrance to the university as
the welcoming attraction of the Alaska-Yukon-
Pacific Exposition. The statue was moved to its
present location in 1970.

12.8 Detail from *Theater,* Jacob Lawrence

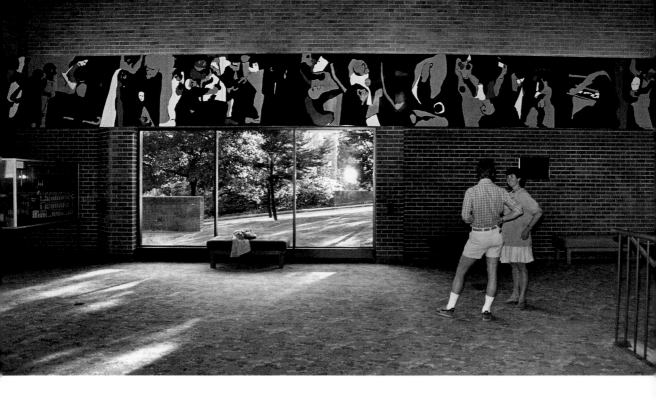

12.8 *Theater*, Jacob Lawrence

12.9 Untitled mural, Pablo O'Higgins

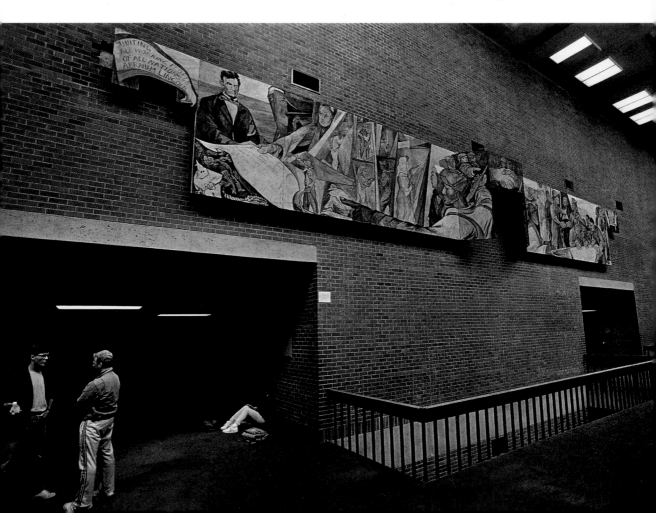

Meany Hall has a number of other major works by artists living in the Pacific Northwest. Windsor Utley's *Tribute to Beethoven,* painted in oil on canvas in 1960, was presented to the university by the artist in 1988 because of his fond memories of playing at Meany as a flutist in a local orchestra. It is an abstract representation of Beethoven conducting an orchestra. An untitled work by William Ivey and *Four Swimmers* by Michael Spafford are also on display. Both were purchased by the state of Washington through its Art in Public Places Program. Another major painting at Meany Hall is Guy Anderson's *Sacred Pastures,* painted in oil on linen in 1978. It is Anderson's largest work on display in Seattle's public places and was given to the university in 1987 by Washington Mutual Savings Bank.

Across from Meany Hall, on the second floor of the Odegaard Undergraduate Library, is a large bronze bust of Dr. Charles Odegaard sculpted by Everett DuPen in 1973. Odegaard was president of the university from 1958 through 1973, a period of tremendous growth for the institution. The bust was a gift of the university's Alumni Association and its Board of Regents.

12.9 **Untitled mural,** 1945

Pablo O'Higgins

Fresco mural; H 7 ft. × L 60 ft.
Gift of Seattle Local 541, Shipscalers,
Drydock and Boatworkers Union
University of Washington,
Kane Hall, second floor

This huge mural is one of the most unusual in the region and the only fresco in Seattle's public places. The work's theme, painted on the banner to the left, is "Uniting all working people of all nations." Its subjects relate to the past, the present (just after World War II), and the future.

This mural is painted in the manner of Mexican muralists Diego Rivera and José Clemente Orozco, who revived the ancient art of fresco painting. That medium, used by Michelangelo in his Sistine Chapel ceiling mural, requires application of paint to wet wall surfaces (usually plaster). The painting is thus incorporated into the wall.

Like so many of the Mexican murals, this one is a statement of the artist's political and social protest. It is a dated work to be sure, but a fine example of the style of the time. On the left-hand panel, Abraham Lincoln towers over a fearful Ku Klux Klansman. Franklin D. Roosevelt stands nearby, holding a scroll listing the four freedoms that should prevail worldwide—freedom of speech and expression, freedom of worship, freedom from want, and freedom from fear. The scroll also bears the initials of the Fair Employment Practices Committee (FEPC), a New Deal creation to combat discriminatory hiring practices. In the center panel are men of the time in military uniforms and workers' outfits. They surround two clasped hands, one black and one white. To the right is the artist's vision of the future, where men and women workers become inspired by the slogan "Build a free world. No masters. No slaves. Workers of the world unite!" and break the chains that keep them enslaved. In 1945 O'Higgins explained to a *Seattle Times* reporter that he was portraying "the struggle against racial

12.9 Detail from untitled mural, Pablo O'Higgins

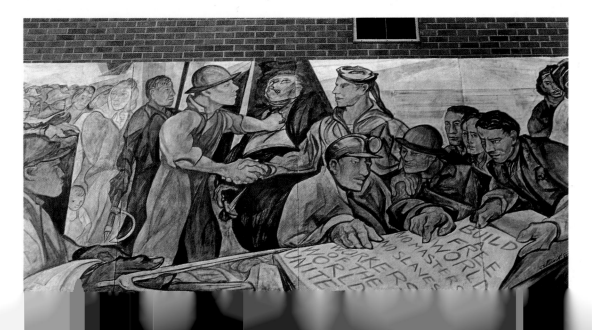

discrimination and the unity of international labor as one of the most important developments for future peace."

O'Higgins included many other symbols in his work and it is well worth studying. For many years it was not available for viewing. It sat in storage for twenty years after it was given to the university in 1955. It was located by MEChA, a Mexican American student group, which successfully lobbied to have the work restored and displayed. It was installed in Kane Hall in 1977.

12.10 **Broken Obelisk,** 1967

Barnett Newman

Cor-ten steel; H 25.5 ft.
Gift of Virginia Wright Fund
University of Washington, in front of Kane Hall

Broken Obelisk is one of only five sculptures created by the late Barnett Newman, who was primarily an abstract painter. It is considered Newman's most important sculpture and has been critically acclaimed as one of the great works of American sculpture. Newman's creation has a simple, yet dramatic, design with its inverted obelisk balancing on the apex of a pyramid. As with Tony Smith's *Moses* (7.11) and Ronald Bladen's *Black Lightning* (7.7) at the Seattle Center, *Broken Obelisk* is a minimalist work. The dignity of the form itself and its integration with its environment are considered paramount.

Unlike his colleagues in the minimalist movement, Newman did sometimes relate his work to inspirational themes. As a result, one New York critic surmised that *Broken Obelisk* alluded to the assassination of Martin Luther King, Jr. Another said it was inspired by the Six Day War in the Middle East in 1967. Barnett Newman himself said that the work "is concerned with life and I hope I have transformed its tragic content into a glimpse of the sublime." Confused, *New York Herald Tribune* critic Emily Genauer wrote that "the more minimal the art, the more maximal the explanation."

Broken Obelisk is the first of an edition of three conceived in 1963 and fabricated in 1967. The others are at Rothko Chapel in Houston and the Museum of Modern Art in New York. Prior to its purchase for the university, this particular piece was exhibited in New York at the Seagram Building and at the Metropolitan Museum of Art and in Washington, D.C., at the Corcoran Gallery.

12.10 *Broken Obelisk*, Barnett Newman

Broken Obelisk was given to the university in 1971 by the Virginia Wright Fund, established in 1970 by Prentice Bloedel, patriarch of a wealthy family with major lumber concerns in the Northwest. The foundation is named for his daughter (Mrs. Bagley Wright), one of the region's most active supporters of the arts.

12.11 **Architectural sculpture,** 1949

Dudley Pratt

Cast stone
University of Washington,
Administration Building

The twenty-four sculptures embellishing the parapets and borders of the university's Administration Building were Dudley Pratt's last works at the university. Each sculpture represents an academic discipline.

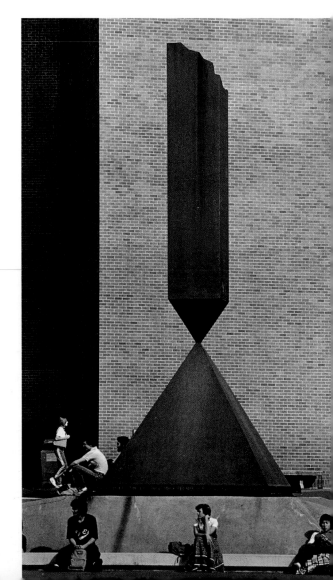

12.12 Architectural sculpture, 1926
Allan Clark

Terra-cotta and cast stone
University of Washington, Suzzallo Library

The most involved decorative work on any building at the University of Washington is that incorporated into the design of Suzzallo (accented on first syllable) Library. The Gothic main building has eighteen niches, each housing a four-and-a-half-foot terra-cotta figure, and three building portals housing heroic cast stone figures. All the figures were created by Tacoma artist Allan Clark and were his first commissioned works. The persons represented in the niches were chosen from a list of 246 nominees submitted to university faculty in 1923. Nominees had to be major contributors to human learning and culture. The chosen ones are, from left to right, Moses (holding the Ten Commandments), Louis Pasteur, Dante, Shakespeare, Plato, Benjamin Franklin, Justinian, Sir Isaac Newton, Leonardo da Vinci, Galileo, Goethe, Herodotus, Adam Smith, Homer, Gutenberg, Beethoven, Darwin, and Grotius. Below the great men are shields of major universities in North America

and Europe and Gothic lettering listing traditional areas of university study.

It is said that the Darwin sculpture would have been much more interesting had not President Henry Suzzallo thought Clark's proposed plan undignified. The plan was to have a lively little ape clinging to Darwin's right foot with one hand and thumbing his nose at passing *Homo sapiens* with the other.

Clark named the three cast stone figures above the library portals *Thought, Inspiration,* and *Mastery.* The model for *Mastery* was Charles C. May, a former university athlete who was the superintendent of buildings and grounds.

12.13 Circum-Octo, 1964
Jonn Geise

Steel; H 8 ft. × W 4 ft.
Gift of the Ford Foundation
Suzzallo Library, second floor of original building, outside Graduate Reading Room

Circum-Octo was Jonn Geise's first entry in the Seattle Art Museum's Northwest Annual Show

12.12 Architectural sculpture, Allan Clark

of regional art, and it won the show's award for sculpture. The Ford Foundation purchased it as part of its program to recognize American artists and presented it to the university.

Circum-Octo, which means "eight circles," consists of eight steel disks curved and rolled into a complex design. It is the artist's first work in his series of gnomon sculptures, named for the column that casts the shadow on a sundial. In 1977 he created a stainless steel gnomon sculpture now located near the Seattle Center (7.34). That work is outside and Geise has always regretted the fact that this earlier work, created when he could afford only steel, must remain indoors. Outside, the sun would create eight elliptical shadow patterns.

Through the main entrance of the original Suzzallo Library is the Graduate Reading Room,

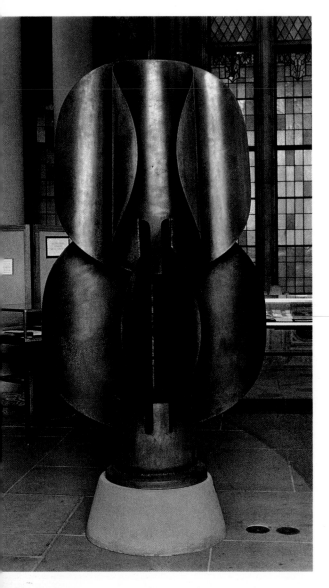

which extends the entire 241-foot breadth of the building. The vaulted Gothic ceiling is 65 feet high. The cornices of the oak bookshelves have extravagant carvings of flowers, fruits, trees, and shrubs native to Washington State. This 500-foot-long carved frieze was designed by the building's architects, the Seattle firm of Bebb and Gould. It was carved by H. L. Erickson.

The stained glass windows above are decorated with paper watermarks from the thirteenth through the seventeenth centuries.

12.14 **The Waiting Multitude,** 1967
Ray Jensen

Sheet copper; H 6 ft. 9 in. × L 17 ft. 6 in.
University of Washington, Suzzallo Library,
transom wall over entrance to card catalog area

When the library's new addition was built in 1963, Ray Jensen received a commission to create an interior sculpture. In 1967 he completed *The Waiting Multitude,* a fabricated sheet copper work. Its abstract design symbolizes the suffering of the people of the world. The masses, although fearful and anxious, are nevertheless a menacing threat as they await solutions and assistance to combat disease, famine, war, and overpopulation. Jensen has likened the two small projections on his work to children's arms pointing at university students, who may find the answers to our world's problems.

12.15 **Stained glass dividers,** 1967
Marianne Cassar

Glass and epoxy; H 8 ft. 4 in. × W 4 ft. 10 in.
University of Washington, Suzzallo Library,
plaza level near Circulation Department

Marianne Cassar's three stained glass dividers are examples of the dalle de verre method of creating glass windows or partitions. The technique uses thick (in this case, one-inch) slabs of glass held together with epoxy. The end result is a solid, deep field of color uninterrupted by the lead framing required with traditional techniques. Cassar was a pioneer in her work in this method. The dividers were commissioned for the library.

12.13 *Circum-Octo,* Jonn Geise

12.16 Architectural sculpture, 1932

John Elliott

Cast stone
University of Washington, Gowen Hall,
southwest wall, facing Suzzallo Library wing

Gowen Hall was built in 1932 and served the university for decades as its law school. The figures adorning the building are great figures in legal history, ranging from ancients such as Moses and Hammurabi, to great names in English law such as Blackstone and Coke, to modern greats Oliver Wendell Holmes and Benjamin Cardozo. Below each sculptural portrait is the subject's name.

12.17 Gargoyles, 1939

Dudley Pratt

Terra-cotta
University of Washington, Smith Hall

On the east end of Smith Hall, Dudley Pratt placed sculptures to represent human needs and emotions: family, love, shelter, food, rest, and laughter. On the northeast corner he installed various incongruous figures: an Oriental figure, an intellectual with his book, a World War I soldier complete with gas mask, and a "native" bongo drummer. Some theorize that Pratt intended these figures to stand for the knowledge of the Orient, the intelligent American democracy, the power of Europe, and the unknown of Africa. We don't know the answer, but Pratt was certainly having some degree of fun with the designs.

Two groups of curious figures grace the north side of Smith Hall. One group portrays Seattle's early history, and the other, life in Seattle in 1939, the year this hall was built. Among the former are Indians, totem figures, a fish, and a cougar. The more modern group includes what appears to be an architect or engineer holding a building in his hands, a mechanic with a gear and wrench, and a logger.

12.16 Architectural sculpture, John Elliott

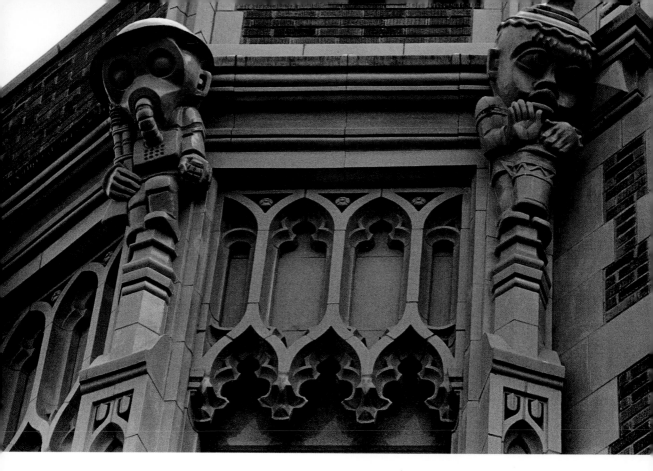

12.17 Gargoyles, Dudley Pratt

12.18 **Architectural sculpture,** 1920

Alonzo Victor Lewis

Terra-cotta
University of Washington, Miller Hall

The Miller Hall sculptures are a varied collection of subjects exhibiting no discernible overall theme. Although many seem to symbolize education—teachers and students and a mentor with his charge—elsewhere one can find Moses, Mercury, a woman playing a harp, a Chinese scholar, a carpenter sawing wood, and two gentlemen of the day sporting top hats.

12.19 **Architectural sculpture,** 1916

Designed by Carl F. Gould

Carved stone
University of Washington, Raitt Hall

Raitt Hall was originally the Home Economics Building, and the relief figures on its upper portions show women sweeping, washing

12.18 Architectural sculpture, Alonzo Victor Lewis

12.19 Architectural sculpture, designed by Carl F. Gould

clothes, and pursuing other activities involved with managing a home and family. To many, the figures are disturbing reminders of inequalities. Worse yet is the single male, who stands alone, the one figure working with only his mind. Regardless, the figures represent an outlook of the time and perhaps will someday serve as a historical reminder of restrictive roles.

These figures were designed by Carl F. Gould, the better-known half of Bebb and Gould, a Seattle architectural firm that designed a number of prominent buildings in Seattle, including many on the university campus.

12.20 **Fountain,** 1962

George Tsutakawa

Silicon bronze; H 37 in. × W 44 in. × depth 44 in.
Gift of Phi Mu Sorority
University of Washington,
Mackenzie Hall courtyard

Although often referred to as "Fountain of Reflection" or "Phi Mu Fountain," George Tsutakawa reports that he never gave this fountain a name. The same is true of many of his works, but names are often attached by owners or contributors. Tsutakawa points out that without water this is an interesting sculpture, but with the addition of water it becomes a multifaceted work. When the fountain is operating correctly, its center portion resembles a crystal ball into which viewers can look.

Tsutakawa's fountain was originally displayed at the Seattle World's Fair in 1962 and then returned to him. In 1967 Phi Mu Sorority purchased it and gave it to the university, and it was installed at the entrance of the new wing of Suzzallo Library. It was installed at its present location in 1988.

12.21 Architectural sculpture, 1920

Alonzo Victor Lewis

Terra-cotta
University of Washington, Savery Hall

Rather than decorate Savery Hall with gargoyles, Lewis chose to embellish it with a curious collection of figures representing occupations, sports, academic disciplines, and subjects from World War I. Figures on the west end represent boxing, tennis, crew, wrestling, golf, basketball, baseball, and track. The building's east side shows individuals in various careers—a mariner, an engineer, a miner, and a farmer—together with persons from academic disciplines and World War I military figures (including General John J. "Blackjack" Pershing).

same building is shown to the left. The columns shown in the mural are from the original building's front porch; they are now displayed on campus in the outdoor Sylvan Theater. The mural also depicts the construction of Denny Hall on the present campus. (See detail on page 173.)

Two noted citizens are also pictured: Edmond S. Meany, the university's well-known history professor for whom Meany Hall and a nearby hotel were named; and Gil Dobey, the University of Washington football coach from 1908 to 1916. Dobey's reign as coach saw fifty-eight wins, three ties, and no losses!

The title of this piece is reportedly a phrase used by Dr. Henry Suzzallo, the fifteenth president of the university, who served from 1915 to 1926.

12.22 Edvard Grieg, 1909

Finn H. Frolich

Cast bronze; H 13 ft., including pedestal
Alaska-Yukon-Pacific Exposition commission
University of Washington, International Grove, in front of Thomson Hall

This heroic bust was commissioned with funds donated by local Scandinavian groups in memory of Norwegian composer Edvard Grieg (1843–1907). Grieg, who was sometimes referred to as the "Chopin of the North," had died two years earlier. The sculpture was created by Finn Frolich, who was Director of Sculpture for the exposition. He also created the bust of James Hill (12.27).

12.23 University of a Thousand Years, 1949

Ernest R. Norling

Painted mural; H 15 ft. × L 24 ft.
Husky Union Building (HUB), second-floor lounge in original portion of building

This mural depicts the history of the University of Washington from 1861 to 1926. In the center background is the original Territorial University, located in what is now the section of downtown Seattle bordered by Fourth and Sixth avenues and Union and Seneca streets. Another view of the

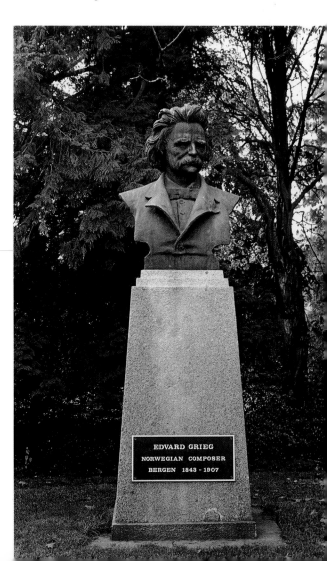

12.22 *Edvard Grieg,* Finn H. Frolich

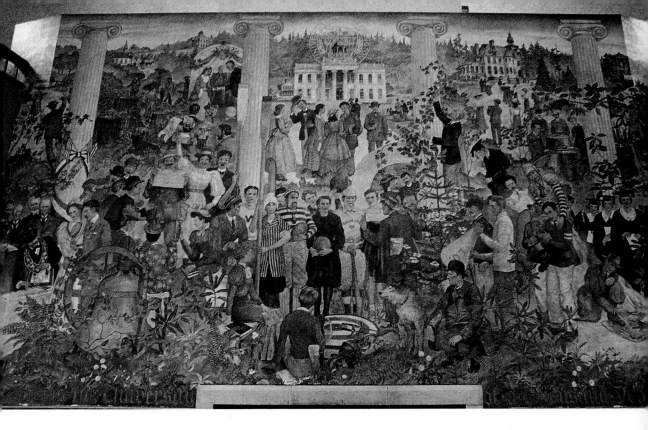

12.23 *University of a Thousand Years*, Ernest R. Norling

12.24 **Joseph Drumheller Fountain,** 1961

Lawrence Halprin & Associates

Gift of Joseph Drumheller
"Frosh Pond"

Frosh Pond was created for the Alaska-Yukon-Pacific Exposition of 1909, but its popular fountain was installed in 1961. The fountain was designed by Lawrence Halprin & Associates, an internationally known landscape architecture firm in San Francisco, which also designed Freeway Park in downtown Seattle. The fountain was given to the university by the late Joseph Drumheller to commemorate the university's centennial year. Mr. Drumheller, a prominent Spokane businessman, was president of the university's Board of Regents at the time.

12.25 **Untitled murals,** 1941

Robert B. Inverarity

Linoleum; each, H 8 ft. 9 in. × L 11 ft.
University of Washington, Bagley Hall entrance

The colorful murals in Bagley Hall were designed by Robert Inverarity as a part of the Washington Art Project of the Works Progress Administration of the 1930s. Bagley Hall is the chemistry building, and Inverarity's two murals depict Egyptian alchemy and modern chemistry.

12.26 **Research, Hand of Nature, and untitled sculpture,** 1948

Everett DuPen

Indiana limestone
University of Washington,
Electrical Engineering Building

At the building's entrance is *Hand of Nature,* a large hand carved in high relief holding a human figure, which DuPen chose to represent an atom. *Research,* located on the building's southeast corner, is a man holding a book and looking to the heavens for inspiration. The untitled panel at the entrance represents the human fear of natural phenomena, and not surprisingly for the date of this work, the figure used to convey this idea is female.

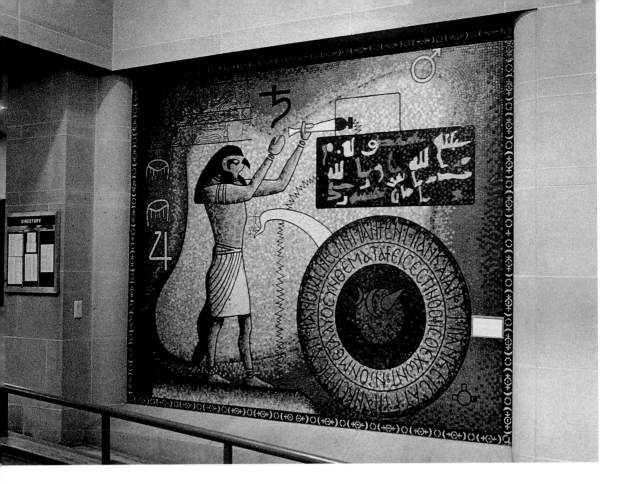

12.25 Untitled mural, Robert B. Inverarity

DuPen's choice of human figures as subjects was criticized by some as inappropriate for the Electrical Engineering Building. However, DuPen responds that "after all, man is the important thing, not vacuum tubes."

Everett DuPen was chairman of the Sculpture Department at the University of Washington when he created these sculptures. His carving assistant for this commission was George Tsutakawa, then a master's degree student at the university.

12.27 **James J. Hill,** 1909

Finn H. Frolich

Cast bronze; H 13 ft., including pedestal
Alaska-Yukon-Pacific Exposition commission
University of Washington, on Stevens Way, across the street from the Electrical Engineering Building

James J. Hill (1836–1916) was called the "Empire Builder" and was largely responsible for bringing the Great Northern Railroad to Seattle in 1893. He was one of the great industrial giants of the 1800s and formed several railroad companies, including the Great Northern, which he ran from 1893 to 1912. Hill's influence in this region was great because commerce and emigration from the East and Midwest increased with the expansion of his railroad empire. In addition, his sale of 900,000 acres of Washington timberland to his friend and neighbor Frederick Weyerhaeuser permitted creation of the Weyerhaeuser Timber Company, which has had important consequences for the Northwest.

This monument emphasizes many of Hill's accomplishments. The three-ton base is made of four blocks of granite: one from Canada, where Hill was born; another from Minnesota, where he lived; a third from Japan, which benefited from the wheat his railroads brought to the West Coast for shipment east; and the last from Washington State. Three bronze plaques decorate the base. The front one shows a train; another a steamship; a third a plowing farmer, one of many who came west on Hill's railroads. A fourth plaque, designed with the Seal of Washington, disappeared years ago.

12.26 Untitled relief sculpture,
Everett DuPen

On Stevens Way, south of the Hill bust and just beyond Rainier Vista, are Dudley C. Carter's carved red cedar entrance doors for the Winkenwerder Forest Sciences Laboratory. The doors are carved with designs of trees, mountains, and a log cross section.

Farther west and on the north side of Stevens Way across from the greenhouses is the university's medicinal herb garden. Its entrance is flanked by two wooden columns that should (unless vandals have returned) be topped by two sculptures of screaming monkeys. The original sculptures were carved of wood, but after one was stolen, concrete versions were created from the survivor. The artist is unknown.

An untitled cor-ten steel sculpture by Portland artist Lee Kelly stands in front of the university's Academic Computer Center at the corner of Brooklyn Avenue NE and NE Pacific Street. The work was commissioned by the university in 1978.

South of Lee Kelly's sculpture, at the entrance of the Marine Sciences Building (Brooklyn Avenue NE and NE Boat Street), are four colorful leaded stained glass windows by Seattle artist Dick Weiss. Each five-foot eight-inch-high panel is an abstract depiction of sea life. These are the artist's first works in a public place in Seattle. He has since created two large works at Sea-Tac Airport (22.1).

12.28 **Untitled,** 1982

Ludwig Schaffrath

Stained glass; H 16 ft. × W 7 ft.
Washington State Percent for Art Program
University of Washington, Hitchcock Hall,
entrance off pedestrian overpass

The entrance to Hitchcock Hall is up the overpass ramp at the second-floor level. At the building's entrance is a two-story stained glass window by Ludwig Schaffrath, one of West Germany's leading architectural glass artists. The white background of Schaffrath's design makes the work rather bland from the outside. However, viewed from the inside, it is a colorful display of twisting abstract shapes. The design was inspired by conversations Schaffrath had with a member of the university's biology department about biology and the spiral structure of the DNA molecule.

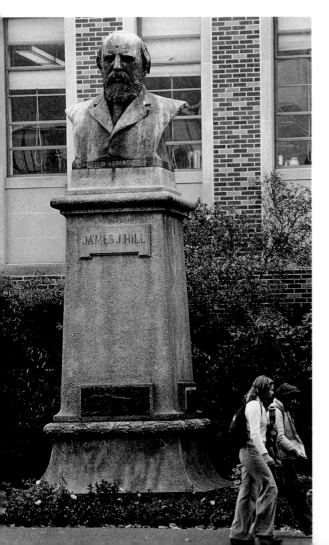

12.27 *James J. Hill*, Finn H. Frolich

12.29 **Vertebral Column,** 1982

John Rogers

Slip cast ceramic relief; H 5 ft. × L 31 ft.
Washington State Percent for Art Program
University of Washington, Hitchcock Hall,
entrance off pedestrian overpass

Hitchcock Hall is devoted to the study of bio-
logical sciences and John Rogers intended to
relate his design to biology, but not to anything
specific. A biology professor was delighted to
discover that the design is remarkably similar to
the foliated cell structure of oyster shells. Rogers
also designed his sculpture to take full advantage
of the lobby's abundant natural light. The mural
is primarily white with some pink tones during
most of the day. However, during a particular
time of the day, light from the skylight hits the
back side of the sections and creates a blush-
colored glow on the surfaces.

12.30 **Spirit of Medicine,** 1947

Dudley Pratt and Jean Johanson

Carved limestone
University of Washington, Magnuson Health
Sciences Center

12.29 *Vertebral Column,* John Rogers

Farther east from Hitchcock Hall on Pacific Street
is the Magnuson Health Sciences Center. On
a corner wall near the east end of the center is
a large bas-relief stone sculpture called *Spirit
of Medicine.* Its six main figures portray various
health care disciplines, including nursing,
pharmacy, and medicine.

Spirit of Medicine was created in 1947 and is
Pratt's last commissioned public work. Seattle
artist Jean Johanson was a student of Pratt's.

12.31 **The Tunnel Garden,** 1986

Richard Posner

Acoustic tile and wood
Washington State Arts Commission,
Art in Public Places Program
University of Washington,
Triangle Parking Garage, tunnel connecting
with University Medical Center

Seattle artist Richard Posner considers the
concrete tunnels connecting the University
Medical Center and Health Sciences complex
to be "pretty awful places." This tunnel is an
exception because it contains his simulated
"urban aviary." Posner lined the walls with a
latticework pattern of blue and white acoustic
tile and installed clear fir posts and beams and
ceiling latticework.

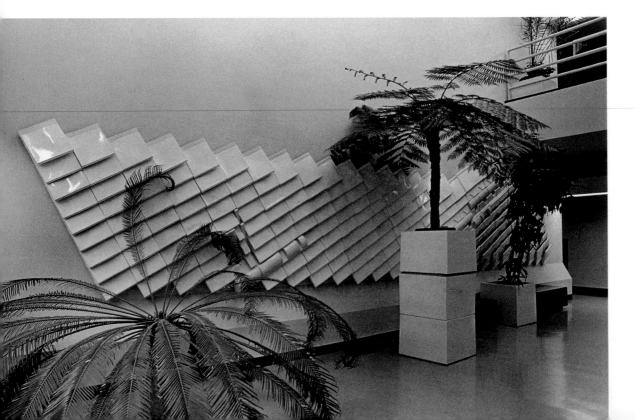

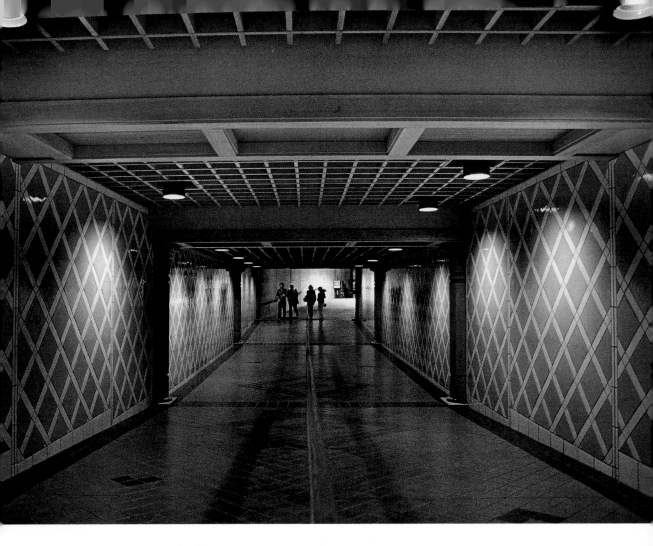

12.31 *The Tunnel Garden*, Richard Posner

A subtle and imaginative addition to this gardenlike setting is the uninterrupted playing of recorded birdsongs. The birds recorded are all indigenous to the Pacific Northwest. One nurse commented that she had not realized the bird calls were recorded until she walked through the tunnel late at night.

The Tunnel Garden was a collaborative effort between Posner and other artists and the Bumgardner Architects.

Future plans for the landscaped area above the garage include a large kinetic sculpture by Issaquah artist Parks Anderson. Anderson reports that the work will be larger than, but related to, his sculpture at Lakeside School (18.6) and will stand near the east-facing concrete wall, which has the University of Washington sign on it.

12.32 **Architectural relief,** 1968

Harold Balazs

Cast concrete; H 11.5 ft. × L 12 ft.
University of Washington,
Intramural Building entrance

This is one of two concrete friezes in Seattle by Spokane artist Harold Balazs (also see 14.5). According to the artist, this mural "is simply a combination of anthropomorphic and mechanical shapes." Balazs has long been fascinated with such combinations.

Balazs, a noted craftsman and sculptor in the Northwest, reports that he received one of his nicest compliments the night this work was installed. An elderly janitor working nearby inspected it and said, "You know, the nicest thing about it is that you can see it was made by hands."

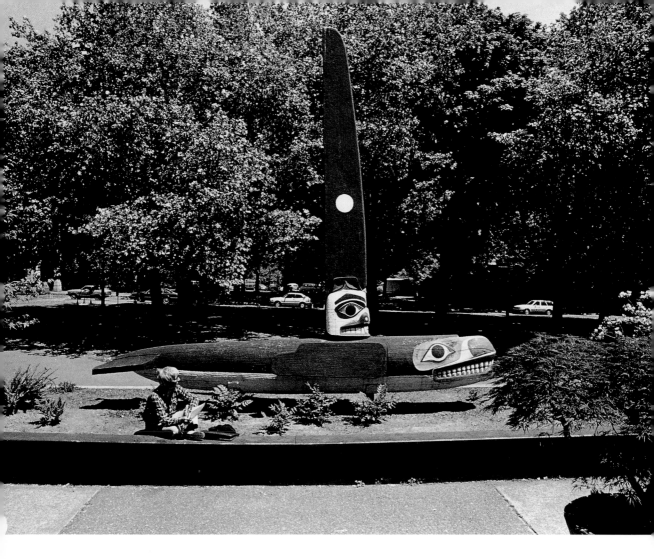

12.33 *Killer Whale*, Bill Holm

12.33 **Killer Whale,** 1985

Bill Holm

Carved cedar; L 18 ft.
Thomas Burke Memorial Washington State
Museum, entrance

This sculpture is a replica of a late nineteenth-century carving in the Haida Indian village of Howkan, Alaska, just north of the Queen Charlotte Islands. The original has rotted away, but its dorsal fin is part of the Burke Museum collection. Bill Holm created this work (and the two large totem poles nearby) as part of his duties as curator of Northwest Coast Indian art at the Burke.

The Burke Museum houses a treasure trove of Pacific Northwest Indian art. Many of the carved works were given by Anne Gerber, who collected them in British Columbia with her late husband, Sidney Gerber. An important non-Indian artwork inside the museum is the large stained glass *Peacock Window* in the Atrium Reading Room. It was designed around the turn of the century by the famous glass artist Louis Comfort Tiffany. The window was commissioned by Mrs. John (Eliza Ferry) Leary for her home on Capitol Hill. Her husband was a prominent lawyer and businessman who also served as mayor of Seattle. Mrs. Leary was the daughter of Elisha Ferry, the first governor of Washington Territory. Tiffany's twelve-panel window was given to the museum by the Episcopal Diocese and the James Kellogg family. The Leary's home is now the headquarters of the Episcopal Diocese.

Beyond the University

12.34 Study of Angles and Circles, 1969

Charles W. Smith

Steel; H 4 ft. 3 in. × L 10 ft. × W 3 ft. 6 in.
First Interstate Bank collection
First Interstate Bank Branch Office,
4501 Fifteenth Avenue NE

Study of Angles and Circles is one of two Charles Smith sculptures in Seattle's public places in which he uses pure geometric forms to create a complicated and timeless work (see also 9.10). Here he has cut and bent geometric shapes and transformed the metal into a seemingly delicate and light sculpture. The design does not fit into any sculptural school, and as a result, Smith has succeeded in creating a timeless quality in this piece.

12.35 SAFECO Fountain, 1972

George Tsutakawa

Silicon bronze; H 11 ft. 5 in. × L 11 ft. × W 11 ft.
SAFECO Insurance Company collection
SAFECO Plaza, NE Forty-fifth Street
and Brooklyn Avenue NE

George Tsutakawa's commissioned fountain-sculpture for SAFECO's office building consists of a group of pods (Tsutakawa calls them "clam shells") that surround a central stele. Water bubbles from the top dish to the pods, from which it pours out in sheets. At full capacity, 850 gallons a minute can be pumped through this fountain. To ensure that the winds whirling through the plaza do not blow water onto passersby, two wind velocity meters relay the wind velocity to the main water pump controls. When necessary, the water flow is automatically reduced or shut off completely.

Tsutakawa considers the setting for his SAFECO fountain to be one of the most appropriate among the extensive collection of his public works. It is placed apart from passing traffic, in a parklike setting surrounded by plants and the soft tones of a brick plaza with wood railings. The fountain's brick-and-tile base, designed by Tsutakawa, complements its environment.

In the SAFECO building's lobby are other major works by Pacific Northwest artists. They are part of a large collection that ranks as one of the region's foremost corporate art collections. The company sometimes changes the artworks on display, and it is worthwhile to go inside and inspect them. The SAFECO collection is also one of those rare collections for which identifying labels are provided.

12.34 *Study of Angles and Circles*, Charles W. Smith

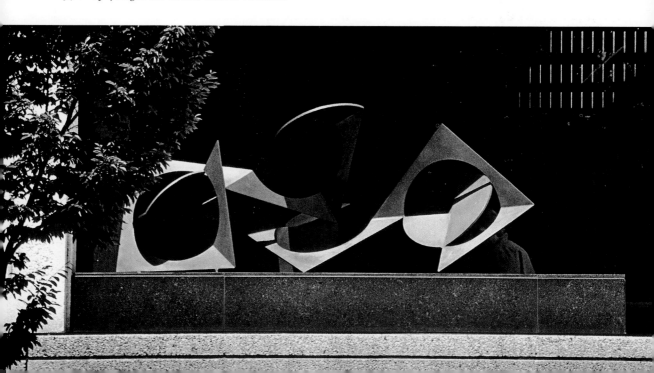

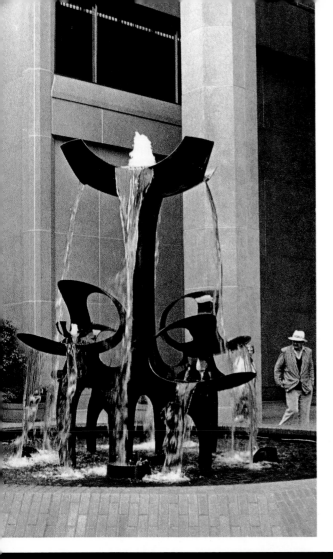

12.36 **Campus Parkway mural,** 1987

José Enrique Orantes

Painted wall mural; L 530 ft.
*Seattle Arts Commission, National Endowment
for the Arts, and private funding*
NE Campus Parkway, north side,
near Terry-Lander residence halls

The longest mural in Seattle is this colorful view
of Seattle designed by José Orantes. It consists
of a larger section within the University Bridge
underpass and a smaller section on one side of
the underpass. Orantes has depicted a lively,
somewhat comical view of the city from the sky,
including the Space Needle, Lake Union, and
the West Seattle Bridge.

 This mural is a splendid example of art created
at the instigation of the surrounding community.
The project was sponsored by the Greater Uni-
versity Chamber of Commerce and funded by
the Seattle Arts Commission and the National
Endowment for the Arts. Although the National
Endowment's public art program was established
to fund artworks actively supported by the
community, it has been criticized in cases where
one or only a few wealthy donors provide the

12.35 *SAFECO Fountain*, George Tsutakawa

12.36 Campus Parkway mural, José Enrique Orantes

12.38 *Sasquatch Pushing over a House,* Richard Beyer

support. Not so here. Creation of this mural was made possible through donations of time and money from many companies and individuals.

Orantes was selected to design this mural through a juried design competition. It is his first public artwork.

12.37 **Firefighters,** 1988

Tom Askman

Aluminum
Seattle 1% for Art Program
Fire Station 17, corner of NE Fiftieth Street and Eleventh Avenue NE

In the openings of the station's tower are aluminum silhouettes of firefighters which are part of a series created by Spokane artist Tom Askman (see 1.5). The silhouettes are on tracks. To allow work on the tower, they can be moved out of sight, so on occasion the silhouettes disappear for a time.

12.38 **Sasquatch Pushing over a House,** 1982

Richard Beyer

Cast aluminum and wood
City of Seattle collection
University Playground, NE Fiftieth Street and Eighth Avenue NE

At the west end of University Playground stands a green wooden house frame that is tilting precariously. The cause of its imminent destruction is a large Sasquatch straining to push it over. The Sasquatch, or "Big Foot," is a mythical human-bearlike creature said to roam the deep forests of the Pacific Northwest. Although a humorous scene, the sculpture is Beyer's poignant reference to the mass destruction of small homes in the area when the freeway was cut through.

Sasquatch Pushing over a House is one of several sculptures Beyer was commissioned by the Seattle Department of Parks and Recreation to create for children's play areas in the city (see 9.11 and 20.2).

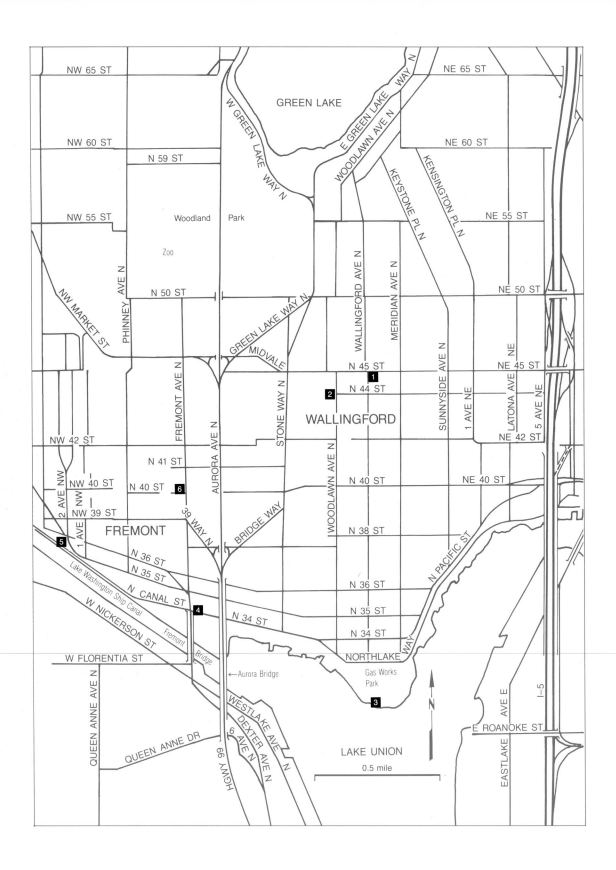

Chapter 13

Wallingford and Fremont

Art is the objectification of feeling.

Susanne K. Langer b. 1895

13.3 *Sundial*, Charles Greening

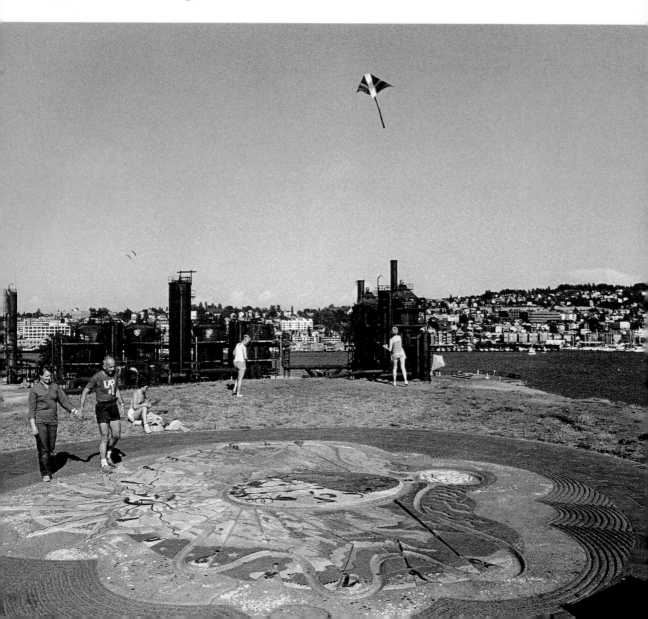

13.3 Details from *Sundial*, Charles Greening

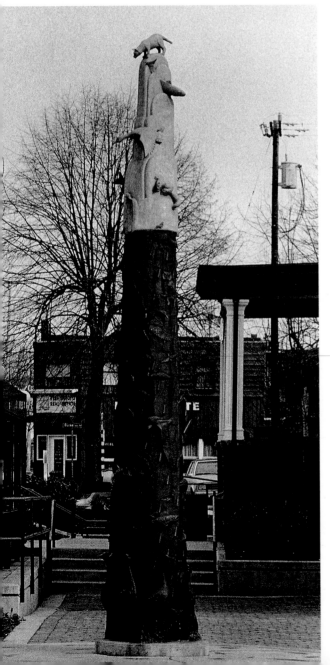

13.1 *Animal Storm*, Ronald W. Petty

Wallingford

13.1 **Animal Storm,** 1985
Ronald W. Petty

Bronze and cast aluminum; H 18 ft.
Funded by Wallingford Community Council
Wallingford Center, corner of N Forty-fifth Street
and Wallingford Avenue N

Petty, a resident of Wallingford, was told by
community leaders that the artwork for this
busy corner should reflect something about the
community. A native of Arizona, the artist has
always been impressed with the amount of
wildlife in Seattle. So, he chose the wildlife in the
area, including raccoons, Canada geese, cats, and
pigeons. Even slugs are included. To Petty's
delight, his work has been well received not only
by the community as a whole but also by blind
citizens, who have obtained much enjoyment
from inspecting the accessible, realistic
sculptures.

13.2 **Abraham Lincoln,** 1964
Avard Fairbanks

Cast bronze; H 3.5 ft.
Seattle Public Schools, private gift
Lincoln High School building,
N Forty-fourth Street and Woodlawn Place N

At the entrance to the auditorium of what used to
be Lincoln High School is a large bronze bust of
Abraham Lincoln created in 1964 in memory of
Margaret Fairbanks Garred, a former teacher and
advisor at that high school. It was donated by
her two sisters, Lulu and Esther Fairbanks, and
sculpted by her cousin, who was then dean of the
College of Fine Arts at the University of Utah.
The bust stands on a large base of Mount
Rushmore granite, brought to Seattle from
South Dakota.

13.3 **Sundial,** 1979
Charles Greening

Mixed media; dia. 27 ft.
Private gift to the city
Gas Works Park, on top of the hill

One of the largest sundials anywhere, and
certainly one of the most complex, is Charles
Greening's sculptural creation on top of the hill
at Gas Works Park (see page 197). Originally this
unique work was to be placed on the brick
promontory east of the hill. During the three
years it took to design it, park plans changed,
and it was finally placed at the top of the much-
used "kite-flying hill." There, people can stand at
specific points during the day and become part of
an accurate sundial.

"Making it work takes work," Greening ex-
plains, "and I've seen some people get frustrated.
But if you read the instructions (located near its
southern edge), it will tell you the time, even in
bright moonlight."

In brief, one determines the time by standing
in the center area on one of the bronze lines
where dates are listed. You then become the
gnomon, or column, of the sundial. Your shadow
will fall near one of the bronze numbers inset
around the dial. To accurately determine the time,
you add the number of minutes listed near your
feet (plus one hour during daylight savings time).

As is true of Greening's *Meridian Archway* at
Meridian Park (17.1) and his less complicated
mosaic at the southwest corner of Sixteenth
Avenue E and E Aloha Street on Capitol Hill,
this sundial abounds in surprises when studied
carefully. At one point is a bronze bear claw;
nearby is a brass button with an eagle on it. A
bronze turtle rests at another point and a ceramic
crab stands at another. The number 8 is sur-
rounded by a broken teapot. Copper nails
surround the 10; and 2, 3, and 4 have a little
bulldog's face, a sea urchin, and a sand dollar,
all in bronze.

An observer standing at the northernmost
point of the standing area will be stepping on
bronze reproductions of Charles Greening's bare
feet. At the south point are bronze reproductions
of the feet of the anonymous donor of this
artwork. At the 4:00 a.m. point, in a channel
often filled with rainwater, is a bronze replica
of the foot of the donor's dog.

Seattle artist Kim Lazare assisted Greening
in creating the sundial.

Fremont

Fremont is a lively little community with a large number of small artworks hidden in and about its business district. Only the larger works are featured in this chapter.

A collection of carved railing post decorations by Richard Beyer can be found on the west side of Fremont Avenue, half a block up from the Fremont Bridge. A large painting by Fremont artists stands nearby.

Remnants of *Reality Relics*, a 1981 project of Anita Fisk, can also be found in the area. Fisk was a Seattle Arts Commission Artist in the City that year and she placed at various, sometimes almost hidden, locations small bronze relics of everyday life. Many, including a bronze beer bottle near the bus shelter on the corner of N Thirty-fifth Street and Fremont Avenue N, have disappeared. As of 1987, three relics remained. Embedded in the traffic triangle on Fremont Avenue N is a bronze replica of the *Fremont Forum*, a neighborhood newspaper. East up Thirty-fifth Street, at the front steps of the Fremont Public Library, is a replica of the book *Changing: Essays in Art Criticism*, by Lucy Lippard. It is opened at pages 28 and 29, where the author discusses how art and the criteria for judging it change over time. (Inside the library are paintings by Susie Owens and Katherine Sharpe. Each shows a scene of Fremont.) A concrete square with "Black Hole" and "Star Wars" cards, both examples of "space cards" collected by children in the early 1980s, is located half a block west of the library.

A mural of swirling colors by Roger Wheeler covers the exterior wall of a building on N Thirty-fourth Street, midway down the block from Fremont Ave N.

Further exploration may yield other discoveries of little-known artworks. It will also yield worthwhile discoveries of interesting shops and restaurants.

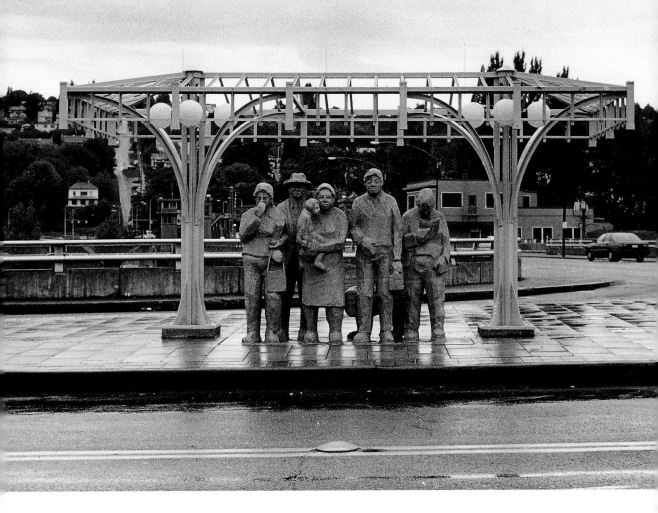

13.4 *People Waiting for the Interurban,* Richard Beyer

13.4 **People Waiting for the Interurban,** 1978

Richard Beyer

Cast aluminum; life-size
*Funded by Seattle Arts Commission
and local businesses*
N Thirty-fourth Street and Fremont Avenue N

The symbol of Fremont and one of Seattle's most beloved artworks is *People Waiting for the Interurban,* the cast aluminum group of people standing in the triangle near the north end of the Fremont Bridge. The six figures by Seattle artist Richard Beyer stand under an aluminum pergola near where the Interurban train used to pass on its way between Seattle and Everett. The pergola was created by Peter Larson of Environmental Works, a Seattle design firm.

The figures waiting for their train are regular working-class people accompanied by a dog possessing a human face. A popular misconception is that the face is of a citizen active in Fremont affairs who opposed this sculpture as unrepresentative of the neighborhood. In fact the face was created by Beyer's assistant and was first intended to represent a narcotics agent, an occupation that was the subject of some discussion in the area in the 1970s. Ultimately, Beyer included the figure to represent the anonymous freeloader who will try to sneak on the bus. Community support for the piece is evidenced by the frequent adornment of the dog and its companions with donated clothes and with signs and balloons saluting birthdays and other events.

13.5 *Ross Creek 1875*, Paul Lewing

13.5 **Ross Creek 1875,** 1980

Paul Lewing

Ceramic tile mural; H 3 ft. 9 in. × L 13 ft.
Funded by Fremont Arts Council and others
Fremont Canal Park, west end of Canal Street
at Second Avenue NW

This mural is located on the edge of the Lake
Washington Ship Canal and depicts a view of the
area as it was in 1875, looking east from Queen
Anne Hill. At that time a waterfall existed where
the Fremont Bridge stands and Ross Creek ran
along the route of the ship canal. The idea to
create the scene was inspired by an old photo-
graph of the area that artist Paul Lewing saw
at the Museum of History and Industry.

Ross Creek 1875 was selected after a design
competition and was placed here through the
efforts, and funds, of many organizations,
including the U.S. Army Corps of Engineers
(which has jurisdiction over the edge of the
canal), the Fremont Public Association, the
Fremont Arts Council (through a federal block
grant), and the Seattle Parks and Recreation
Department, which maintains Fremont Canal
Park.

13.6 **Stairway art projects,** 1980

David Ostler, Ann Gardner,
Steven Roth, and Michael Sweeney

Mixed media
Funded by Seattle Arts Commission
Stairway at Fremont Avenue N and
N Fortieth Street

In several places in Seattle there are hill-climb
stairways for pedestrian access up steep hills.
This stairway in Fremont is reminiscent of San
Francisco because of the residences and gardens
that line both its sides. However, unlike San
Francisco's stairways, this stairway is decorated.
At the bottom of the stairway childlike pictures
have been drawn into the concrete. Some of the
lines are now accentuated with natural moss
growth. At the bottom and top of the stairway
are panels of ceramic shards and glass arranged
in horizontal designs along the edges of neigh-
boring gardens. In the middle level, the ceramic
panels have primitive art designs and faces.
Here, the concrete sidewalk is also decorated
with drawings of city scenes, again accentuated
with natural moss growth.

13.6 Stairway art project, David Ostler, Ann Gardner,
Steven Roth, and Michael Sweeney

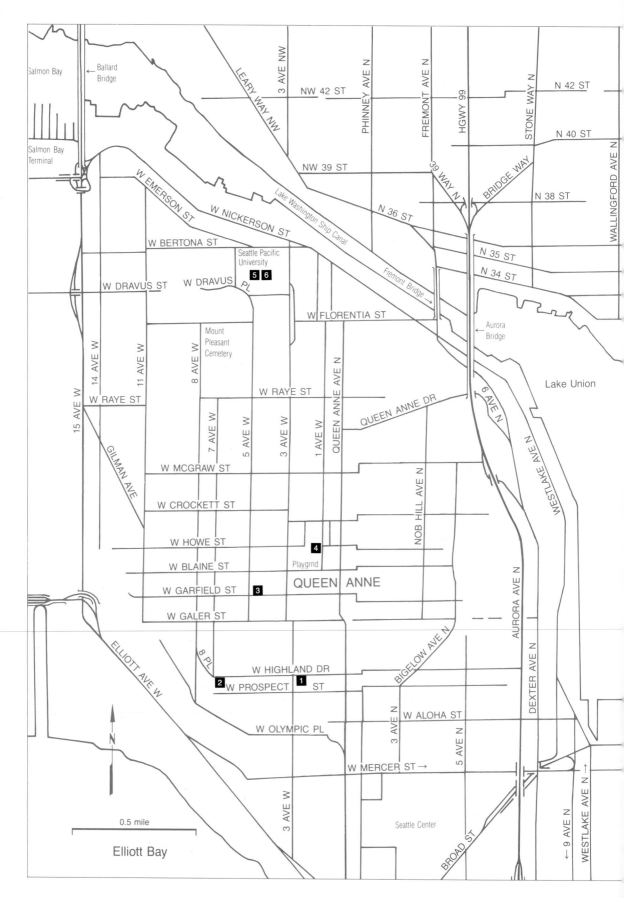

Salmon Bay

→ Ballard
Bridge

LEARY WAY NW

3 AVE NW

NW 42 ST

PHINNEY AVE N

FREMONT AVE N

HGWY 99

STONE WAY N

N 42 ST

N 40 ST

WALLINGFORD AVE N

Salmon Bay
Terminal

W EMERSON ST

W NICKERSON ST

Lake Washington Ship Canal

NW 39 ST

39 WAY N

BRIDGE WAY

N 38 ST

N 36 ST

W BERTONA ST

Seattle Pacific
University

5 6

Fremont Bridge →

N 35 ST

N 34 ST

W DRAVUS ST

W DRAVUS PL

W FLORENTIA ST

Aurora
Bridge →

Lake Union

15 AVE W

14 AVE W

11 AVE W

8 AVE W

Mount
Pleasant
Cemetery

W RAYE ST

QUEEN ANNE AVE N

W RAYE ST

7 AVE W

5 AVE W

3 AVE W

1 AVE W

QUEEN ANNE DR

6 AVE N

GILMAN AVE

W McGRAW ST

NOB HILL AVE N

WESTLAKE AVE N

W CROCKETT ST

W HOWE ST

4

W BLAINE ST

Playgrnd

AURORA AVE N

DEXTER AVE N

W GARFIELD ST

3

QUEEN ANNE

W GALER ST

ELLIOTT AVE W

8 PL

W HIGHLAND DR

BIGELOW AVE N

2 W PROSPECT 1 ST

N
↑

W ALOHA ST

3 AVE N

5 AVE N

W OLYMPIC PL

W MERCER ST →

9 AVE N

WESTLAKE AVE N

0.5 mile

3 AVE W

BROAD ST

Seattle Center

Elliott Bay

Chapter **14**

Queen Anne Hill

It is art that makes life, makes interest, makes importance for our consideration and application of these things, and I know of no substitute whatever for the force and beauty of its process.

HENRY JAMES 1843–1916

14.2 Detail from *Betty Bowen Viewpoint*

14.2 *Betty Bowen Viewpoint,* designed by Victor
Steinbrueck

14.2 Detail from *Betty Bowen Viewpoint*

14.1 Changing Form, 1971

Doris Totten Chase

Cor-ten steel; H 14.5 ft.
Gift of Mr. and Mrs. Albert Kerry
Kerry Park, on W Highland Drive

Changing Form (see page 8) is one of the most often photographed sculptures in Seattle. It was designed for this spot long before Mr. and Mrs. Albert Kerry, who donated the park to the city, commissioned Chase to execute her design. The resulting sculpture is the artist's first large commission.

"The park was there for years," Chase explains, "but it was an undeveloped strip with some rhododendrons. . . . I loved this piece and I designed it with a park in mind. It's an ideal space. . . . The piece fits, and people relate to it very well. More and more I believe that public sculpture should relate to the scale of the surrounding area. Too often nowadays it is just placed somewhere with no thought of scale."

As the name suggests, *Changing Form* is a kinetic sculpture, designed so a strong viewer could move the top section and change the sculpture's shape. Doing so has become a considerable, if not impossible, task as years of rain and moisture have worked at it.

East of Kerry Park, at Bayview Manor Retirement Home, which is a block down the hill from Highland Drive on Queen Anne Avenue N, are three large wooden sculptures by local carver Dudley Carter. They can be seen at the entrance driveway on the building's north side.

14.2 Betty Bowen Viewpoint, 1977

Designed by Victor Steinbrueck

Mixed media
Funded by the city and other sources
Marshall Park, south side of W Highland Drive at Seventh Avenue W

This small park at the west end of W Highland Drive contains works by some of the Pacific Northwest's major artists. The artwork is placed there in memory of their good friend Betty Bowen, who died in 1977. She lived a short distance away. Throughout her life, Betty Bowen used much of her energies and savings to encourage and help support unestablished local artists, many of whom became some of the region's most prominent. She was a Seattle institution noted for her vitality and interests and championship of causes ranging from historical preservation to environmental protection.

This outlook was designed by Seattle architect Victor Steinbrueck, who asked ten artists to submit sketches or paintings to transfer into concrete panels to line a path. Steinbrueck enlarged most of them and, with the assistance of Olympia Stone Company of Redmond, created the panels. From right to left, beginning after Steinbrueck's own panel naming the outlook, are designs of Margaret Tomkins, Mark Tobey, Harold Balazs, Kenneth Callahan, Morris Graves, Guy Anderson, Victor Steinbrueck, Charles Stokes, and Richard Gilkey. Steinbrueck and Balazs executed their own panels.

Steinbrueck endeavored to have each panel reproduce the original work as closely as possible. For instance, Kenneth Callahan's panel is an enlarged version of a small watercolor in gray tones with a small red blotch. Three subtly different gray-toned concretes were used, and the blotch was re-created with a small red stone.

Steinbrueck placed a granite sculpture by James Washington, Jr., at the eastern edge of the main path. It is carved in low relief and replete with symbolism typical of Washington's sculptures. The two birds with interlocking beaks emerging from the egg represent Gemini (the Twins), Betty Bowen's astrological sign. Other symbolic references appear on the work's base, including two arrows pointing up and down and representing the circle of life. An equilateral triangle refers to the "equality of everything." Washington included a circle, which has neither beginning nor end, as an ancient symbol for God.

Down the hill from the Tomkins panel is a small sitting area designed by Seattle artist Leo Kenney. The design includes a reproduction in concrete of Kenney's painting of concentric bands of color.

The artworks in the park are unobtrusive, just as Steinbrueck meant them to be. The works are there to admire, but they do not demand attention or block the view. The design of the park exemplifies his opinion that monumental art does not belong in parks. "The view is the wonderful thing," he explained. "The people come to see it, so why interfere with the view with art? They can look at this art if they want to, but it's not forced upon them."

14.2 Detail from *Betty Bowen Viewpoint*

14.3 *Quintet in D,* Richard Spaulding

14.3 **Quintet in D,** 1978

Richard Spaulding

Stained glass windows; each panel,
H 8 ft. 6 in. × W 3 ft. 4 in.
Funded by Seattle Public Library, Seattle Arts
Commission (Artist in the City Program),
and Seattle Public Library's Eugene E. Atwood Bequest
Queen Anne Branch Library,
400 W Garfield Street

From 1977 through 1979, Richard Spaulding
worked as artist in residence for the Seattle Arts
Commission and created stained glass artworks
for five of the city's branch libraries. All were for
library buildings donated to the city in the early
1900s by Andrew Carnegie. *Quintet in D* is the
first, the largest, and the most spectacular of the
Spaulding commissions. These five windows
(a quintet) total nearly 140 square feet of design
in twenty-one colors.

Spaulding spent fourteen years studying
classical music and sees great similarities between
people's responses to music and art. "Art, like
music, is nonverbal, and people respond to its
rhythm and sense of color. As with music, if
those qualities in an artwork are good, people
respond to it. If it's not, they walk away."

14.4 **His Point of View,** 1979

Michael Fajans

Painting on mirrored Plexiglas; H 4 ft. × L 16 ft.
Funded by Seattle Arts Commission
and Queen Anne Community Arts
Queen Anne Community Center,
First Avenue W and Howe Street

Inside the entrance of the field house is an
unusual mural by Seattle artist Michael Fajans.
Six human figures face the viewer and Fajans
calculated where each should stand in relation to
the architecture reflected in the mirror. He then
calculated where space should remain for the
viewer to become incorporated into the mural.
Additional reasons for using a mirror were to
create an illusion of a larger entryway and to
make the work less obvious and allow visitors
to discover it for themselves.

14.4 *His Point of View,* Michael Fajans

14.5 **Architectural relief,** 1962

Harold Balazs

Cast concrete
Seattle Pacific University, Weter Memorial
Library, 3317 Fifth Avenue W

Harold Balazs's architectural relief above the entrance of Weter Memorial Library is one of a series of his works in Seattle's public places where calligraphic or biological shapes are used. In his untitled sculpture at the Jackson Federal Office Building (3.3) and his bas-relief frieze for the University of Washington Intramural Building (12.32), Balazs created aesthetic collections of unrecognizable shapes. Here, the shapes are arranged in a similar fashion, but they are recognizable forms related to a specific theme: the evolution of writing. The panels depict writing from primitive cave painting to ancient Egyptian hieroglyphs, the Greek alphabet, Arabic script, and, finally, the printing press.

North of the Seattle Pacific University campus, down Third Avenue W and W Ewing Street, is the Metro Water Quality Laboratory. On the side facing the ship canal are nine aluminum wind vanes cut in the shape of salmon by Seattle artist Ronald Petty. They were commissioned in 1986 to lessen the architectural severity of the horizontal concrete beam on which they stand.

14.5 Architectural relief, Harold Balazs

14.6 Demaray Memorial Clock Tower, 1968

Ernest F. Schwidder

Cast concrete
Seattle Pacific University, Demaray Hall

Each of the three sides of the Demaray tower possesses concrete relief designs relating to the general themes of the liberal arts and life and religion through the ages to modern times. The west panel depicts the physical sciences, the south panel the social sciences, and the east panel the humanities. Designs in the upper sections of each allude to Christian themes. The panels were memorial gifts from friends of the university, and the tower clock was a gift of the class of 1966.

The designs on the west panel include an eye and a hand, which are biblical symbols of God; different scripts, including Egyptian hieroglyphics, Babylonian cuneiform, Greek, and Arabic numerals; and forms referring to biological sciences: a cell and a fish to represent fauna, a tree to allude to flora, a spiral to refer to matter, and a form representing a magnetic field to symbolize energy.

At the top of the south panel is a sunburst inscribed with Greek monograms for Jesus Christ. Below are figures alluding to human inventions and human ambitions. The north star in the center refers to the desire to explore, and the nearby fetus and skeleton refer to our travels through life. The lower forms allude to the history of humanity.

A descending dove and flamelike shapes at the top of the east panel symbolize the Holy Spirit, and forms below represent the spirit of humanity. The latter forms include Gregorian musical notations, different architectural shapes, and Egyptian hieroglyphs referring to "humanity" and "brotherhood."

Ernest Schwidder received both his B.A. and M.F.A. degrees from the University of Washington (1953 and 1955) and was chairman of the Seattle Pacific University art department when he designed these panels. They are fine examples of the liturgical designs that have become his specialty.

14.6 *Demaray Memorial Clock Tower*, Ernest F. Schwidder

Puget Sound

Shilshole Bay

NW 65 ST

NW 60 ST

BALLARD

AVE NW

39 AVE W

SEAVIEW

32 AVE NW

24 AVE NW

15 AVE NW

NW MARKET ST

Salmon
Bay

LEARY WAY NW

5 6 Daybreak Star 11 12 13
7 8 Arts Center 14 15
9 10

Hiram M. Chittenden
Locks

Salmon Bay

West Point

W COMMODORE

W LAWTON

WAY

W COMMODORE WAY

Ballard
Bridge →

Discovery Park

W GOVERNMENT WAY

GILMAN AVE W

Salmon Bay Terminal

3

Fort Lawton
Military
Reservation

W ELMORE ST

Discovery Park

W EMERSON ST

W MANOR PL

W EMERSON PL

W RUFFNER

W RUFFNER ST

MAGNOLIA

PERKINS LANE

W DRAVUS ST

Puget Sound

VIEWMONT WAY W

36 AVE W

34 AVE W

32 AVE W

28 AVE W

24 AVE W

21 AVE W

20 AVE W

THORNDYKE AVE W

15 AVE W

Interbay
Athletic
Field

Interbay
Golf Course

W RAYE
ST

W RAYE ST

4

W McGRAW ST

MAGNOLIA BLVD W

W ARMORY WY

2

N

Port of Seattle

Magnolia Bridge

0.5 mile

W GALER ST

16 AVE W

1

Smith Cove

Elliott Bay

Pier
91

Pier
90

Pier
88/89

Chapter 15

Magnolia Hill

Art is the most intense form of individualism
that the world has ever known.

OSCAR WILDE 1854–1900

15.9 *Man and Killer Whale*, Nathan P. Jackson

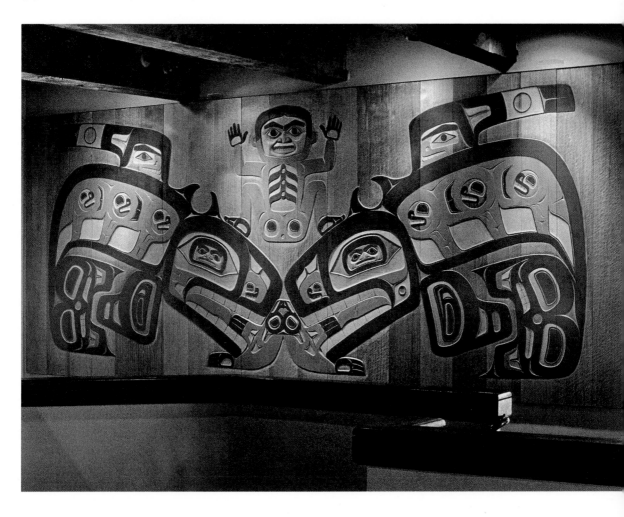

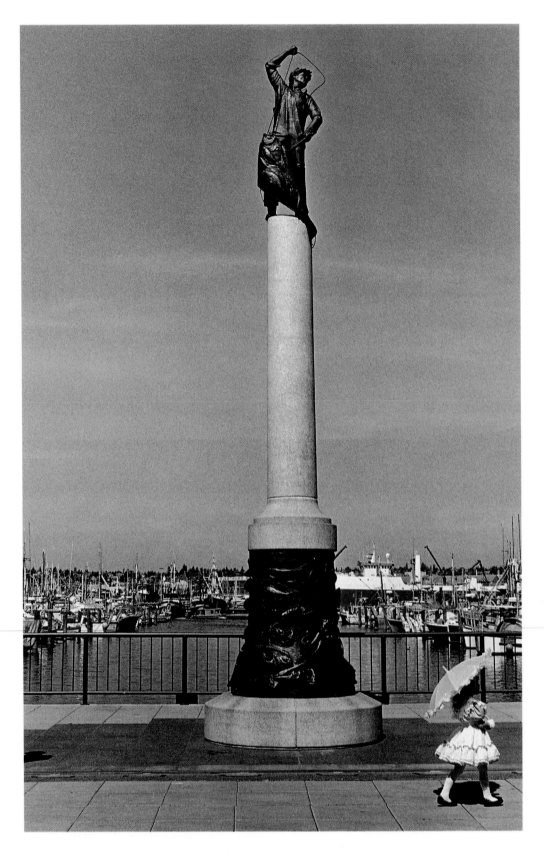

15.3 *Seattle Fishermen's Memorial*, Ronald W. Petty

15.1 Fishing Silhouette, 1981
Lewis ("Buster") Simpson

Galvanized steel
Washington State Percent for Art Program
In channel between Piers 89 and 90

Buster Simpson is noted for placing small sculptures in obscure places throughout the city. His *Fishing Silhouette* is a fine example, although it is unusual because it is a commissioned work, rather than an unsolicited placement by the artist. Simpson created a steel fisherman leaning back and fishing from the top of three pilings in the middle of the channel. The subject is supposed to have a fishing pole, and admirers often attach a fish-shaped windsock at the end of the line. Whether they are present depends on the sculpture's state of repair, which is often not good.

To find *Fishing Silhouette*, turn off Elliott Avenue W at Galer and follow the signs to the public fishing pier. Turn left off Galer onto Sixteenth Avenue W, the road next to the water's edge.

15.2 Step on No Pets, 1981
Linda Beaumont

Mosaic mural
Seattle 1% for Art Program
Animal Control Shelter, W Armory Way
and Fifteenth Avenue W

Linda Beaumont's *Step on No Pets* is a wall inside the west portion of Seattle's Animal Control Shelter, located below the Spay and Neuter Clinic on Fifteenth Avenue W. This mural is a two-sided work composed of ceramic shards, mirror fragments, tiles, and found objects. Dog and cat faces abound throughout the design, which also includes running guard dogs and a little group of tiny canines. Beaumont's mural is bordered by ceramic versions of crushed dog food cans. The mural is the result of the collaboration of the artist and the building's architect.

15.3 Seattle Fishermen's Memorial, 1988
Ronald W. Petty

Cast bronze and cast stone; H 30 ft.
Private funding
Fishermen's Terminal

Petty's *Seattle Fishermen's Memorial* was placed at Fishermen's Terminal to honor the many commercial fishermen from the Seattle area who have been lost at sea in their attempts to reap its harvest. The memorial has a classical design with its central bronze figure, eight feet four inches tall, standing on top of a tall polished cast stone column. A fisherman strains with a line and a gaff hook to haul in what at first glance appears to be a halibut, but closer inspection reveals designs of other regional fish incorporated into the larger fish. Petty used himself as the model for the fisherman because it was less expensive to do so and he felt it would bring bad luck to any fisherman who undertook the role.

The memorial's bronze base is decorated with thirty-two examples of sea life harvested by Seattle's fishing fleet and is encircled by strands of bronze kelp. Petty spent many hours of aquarium and library research studying the creatures depicted, knowing that fishermen would object if renditions were not anatomically correct. To the left of the memorial is a concrete wall with bronze plaques bearing the names of approximately 460 Seattle-area fishermen lost since 1900.

Fishermen's Memorial was commissioned with private donations collected by the Seattle Fishermen's Memorial Committee.

At the base of the circular security tower in the center of the Fishermen's Terminal buildings are designs of sea life sandblasted onto glass brick by Seattle artist Peter David. They were created in 1988.

15.4 **Hot Cha Cha,** 1988

Kenny Schneider

Stainless steel;
H 6 ft. 6 in. × L 4 ft. 8 in. × W 1 ft. 2 in.
Seattle 1% for Art Program
Fire Station 41, 2416 Thirty-fourth Avenue W

Schneider's stainless steel kinetic sculpture is a collection of seventy-seven identical firefighter puppets in a case. They stand in eleven rows, seven to a row, and dance at speeds determined by the viewer's turning of a brass wheel on the right. The design evolved from Kenny

Schneider's interest in the relationship between drawing and film, two media he has worked with extensively in his career. A film, he explains, can be a collection of drawings combined to make a moving image. In *Hot Cha Cha* the viewer turns a crank and motion is created, much like an antique movie projector. Schneider is pleased that his moving sculpture has been well received by the firemen who work near it each day. "Firemen are the last of the John Waynes," he concludes, "putting their lives on the line every day." Schneider's sculpture was commissioned by the city as part of a program for renovation of five fire stations in Seattle (see 1.5).

15.4 *Hot Cha Cha,* Kenny Schneider

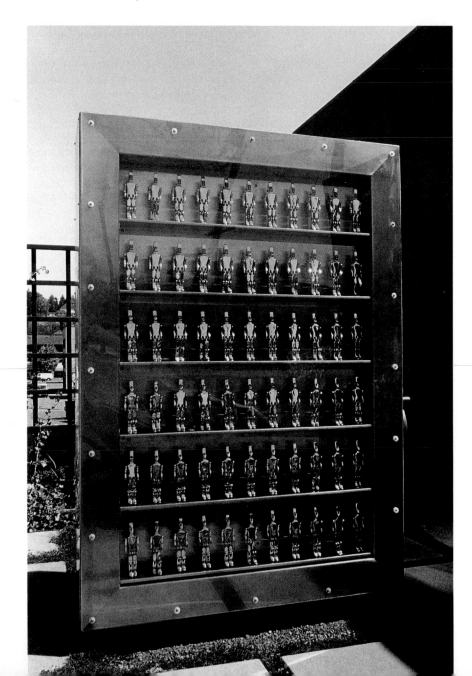

Discovery Park:
Daybreak Star Arts Center

In 1970 the U.S. Department of Defense declared 390 acres of its vast Fort Lawton Military Reservation on Magnolia Hill to be surplus. Soon after, various groups sought to have portions of the land devoted to their interests. Indian groups argued that part should be returned to them, the land's original owners, to be used as a much-needed cultural center. The Indians' idea was given little attention until approximately one thousand Indians from over forty tribes publicized their position by peacefully occupying a portion of the land. Their request was considered, and the United Indians of All Tribes Foundation obtained a ninety-nine-year lease on a portion of the park.

The Daybreak Star Arts Center, the first building of a planned Indian Cultural/Educational Center, was dedicated in May 1977. Designed by Lawney Reyes, a member of the Colville Confederated Tribes, the center is located within easy walking distance from the park's parking area and houses an impressive collection of large contemporary Native American artworks.

While collections of Northwest Indian and Alaskan native art are not uncommon in the region, the Daybreak Star collection is rare because although many pieces incorporate traditional forms, none of the interior works are copies of old designs. They are contemporary treatments of traditional subjects. Most of the interior works described in this chapter were commissioned with funds obtained through Seattle's 1% for Art Program and are on permanent loan from the city.

Outside the center are two carved Kwakiutl Indian sculptures, a sixteen-foot-tall totem pole and a ten-foot-tall human figure. Both stood on the north end of Vancouver Island when they were acquired by Seattle collectors Anne and Sidney Gerber over forty years ago. Much of the Gerber collection was given to the Burke Memorial Museum on the University of Washington campus. These pieces were presented to the center by Mrs. Gerber.

Near the stairway leading to the entrance of the building is one of the Indian heads attributed to Victor Schneider that graced the White-Henry-Stuart Building in downtown Seattle (5.5). It was presented to the center by Mr. and Mrs. Morris Alhadeff.

15.5 **Winter Loon Dance,** 1981
John Hoover

Carved and painted cedar; H 8 ft.
Daybreak Star Arts Center collection,
gift of Richard Pryor
Daybreak Star Arts Center

Winter Loon Dance is a contemporary sculpture influenced by Northwest Indian and Eskimo art and myths. The five dancing loons are combinations of bird and human with human

15.5 *Winter Loon Dance,* John Hoover

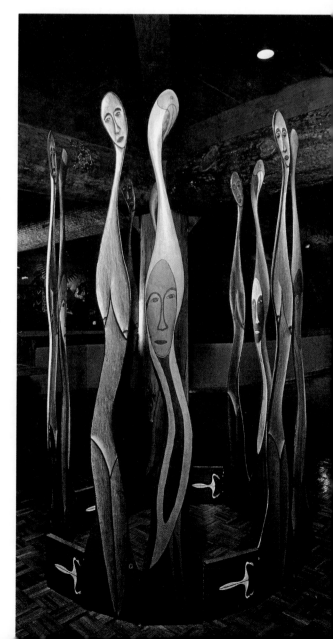

faces. That is a typical characteristic of the artist's work and refers to shamanistic beliefs of the Coast Salish Indians of Puget Sound. Shamans, Hoover explains, cure the sick by recapturing a patient's lost soul. To do so they must take the form of their spirit helper, a bird or an animal, and retrieve the lost soul if it flies away or goes under water. The loon is Hoover's favorite bird and he often uses it in his works. The five figures are female because the female is said to have greater contact with the spirit world. The carving is in low relief and outlined with a light coating of polychrome paint.

Comedian Richard Pryor visited Daybreak Star Arts Center in 1981 when *Winter Loon Dance* was being exhibited there. He was very taken with it and bought it for the center.

A second set of Hoover figures at the center, located in a conference room, is *Ancestor Spirit Boards*. It consists of six totem, or ancestor, figures with characteristics similar to those of *Winter Loon Dance*.

15.6 **The Underwater Panthers,** 1977

George Morrison

Redwood mosaic; H 8 ft. × L 20 ft.
Seattle 1% for Art Program
Daybreak Star Arts Center

This mosaic, created with pieces of natural and stained redwood, is a modern adaptation of a traditional birchbark and beadwork design of tribes in the Eastern Woodlands region of North America. The artist, George Morrison, is a member of the Chippewa tribe, an Eastern Woodlands people who lived on both shores of Lake Superior in what is now Michigan. Underwater Panthers are supernatural beings the Chippewa believed inhabited the lakes of the region.

15.6 *The Underwater Panthers,* George Morrison

15.7 *Epochs in Plains History: Mother Earth, Father Sun,*
the Children Themselves, T. C. Cannon

15.7 Epochs in Plains History: Mother Earth, Father Sun, the Children Themselves, 1977

T. C. Cannon

Acrylic and oil on canvas; H 8 ft. × L 20 ft.
Seattle 1% for Art Program
Daybreak Star Arts Center

This painting depicts religious and mythical epics of the Plains, Plateau, and Basin Indian cultural regions as well as the relation of the Indian people with the earth. In addition, Cannon portrays the changes in American Indian culture. The major figure is the woman, symbolizing Mother Earth. She is receiving in her outstretched hand animals, such as the all-important buffalo, to be placed on the earth to live with the Indian people. Father Sun stands glowing in the upper right-hand portion of the mural. Nearby, an Indian stands in modern dress. That Indian is the last figure in the artist's portrayal of his people's evolution: from roamer of the Plains on foot, to horse-riding hunter, to modern times. Note that the modern figure is playing a traditional Indian drum, a link with his heritage.

15.8 Tsimshian Legend of the Origin of Light, 1977

Roy Henry Vickers

Carved cedar panel; H 8 ft. × L 10 ft.
Seattle 1% for Art Program
Daybreak Star Arts Center

This modern depiction of an ancient legend is a superb example of an art form developed among the Pacific Northwest Indians. The Tsimshian were one of the principal people who developed this elaborate, two-dimensional style of low relief and incised carving highlighted with applied color. The subjects are most often stylized, symmetrical depictions of actual and mythological creatures. Raven, Bear, Wolf, and Killer Whale are just a few of the often seen representations. They are supernatural beings who take the form of the creature depicted. Thus, a story describing Raven's magical powers is not about a mere bird, but a magical being who came to earth in the form of that bird.

Whatever the subject, the common design is as if a three-dimensional image has been split in the middle and applied flat against a panel. The split

(left) 15.8 *Tsimshian Legend of the Origin of Light*,
Roy Henry Vickers; (right) 15.10 *The Earth Is Our Mother*,
Jimmie Carole Fife

head shown in this Tsimshian legend is that of
Wi-Gyt, a supernatural creature possessing a
number of magical powers, including the power
to fly with the wings of a raven. At the bottom of
the panel, below Wi-Gyt's head and held by his
black wings, is a square encompassing a red
circle. It represents the box in which the chief at
the head of the River Nass hid the sun from the
earth. Wi-Gyt retrieved the sun from the selfish
chief and returned it to the sky.

The figure above Wi-Gyt, surrounded by a red
arch representing the Daybreak Star, is a frog's
face, complete with red tongue and bulging eyes.

15.9 **Man and Killer Whale,** 1977

Nathan P. Jackson

Carved cedar; H 8 ft. × L 20 ft.
Seattle 1% for Art Program
Daybreak Star Arts Center

Nathan Jackson, a well-known artist in the
region, is a member of the Tlingit Indian tribe,
one of the Northwest's foremost woodcarving
people. In this work he has combined the
traditional characters of man and killer whales in
a contemporary design of his own (see page 213).
Characteristic of the native style, most spaces
within the figures are filled with seemingly
unrelated figures; for example, the eyes, blow-
holes, and tails of the whales each contain a
separate design.

The unpainted portions of Jackson's carving
are textured by surface adzing, which creates a
rippled effect. The adze is the primary wood-
carving tool of the regional tribes.

15.10 The Earth Is Our Mother, 1977

Jimmie Carole Fife

Oil on linen canvas; H 8 ft. × L 10 ft.
Seattle 1% for Art Program
Daybreak Star Arts Center

In *The Earth Is Our Mother,* Jimmie Carole Fife has depicted leaders of five dominant southeastern Indian tribes discussing their destiny. The figures, from left to right, represent the Choctaw, who were primarily located in southern Mississippi; the Creek, a confederation of tribes that lived in the Alabama-Georgia region; the Seminole, located in Florida; the Chickasaw, from northern Mississippi and Alabama, west of the Creek confederacy; and the Cherokee, located in Tennessee. These were the first tribes moved to Oklahoma by the U.S. government in the latter part of the nineteenth century. At the time, that area was officially referred to as Indian Territory. The white man "benevolently" named these five groups the Five Civilized Tribes because they codified their laws and formed governments modeled after those of the United States and European nations.

15.11 Deer Hunter, 1977

Robert Montoya

Acrylic on canvas; H 8 ft. × L 10 ft.
Seattle 1% for Art Program
Daybreak Star Arts Center

Robert Montoya's acrylic painting is the only work at the Daybreak Star Arts Center painted in the traditional style of a Southwest Indian tribe. This painting is done in the style of the Pueblo Indians of New Mexico. Montoya is said to be illustrating the strong religious significance placed by the Pueblo on the deer and the respect given toward an animal so necessary to sustain human life. Reference to the spiritual significance is made by the "prayer feathers" of eagle fluff placed on the heads of the deer. The feathers match those worn by the hunter. The words *soe-khuwa-pin* in the lower right portion of the painting are the artist's Indian name, "Fog Mountain."

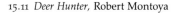

15.11 *Deer Hunter,* Robert Montoya

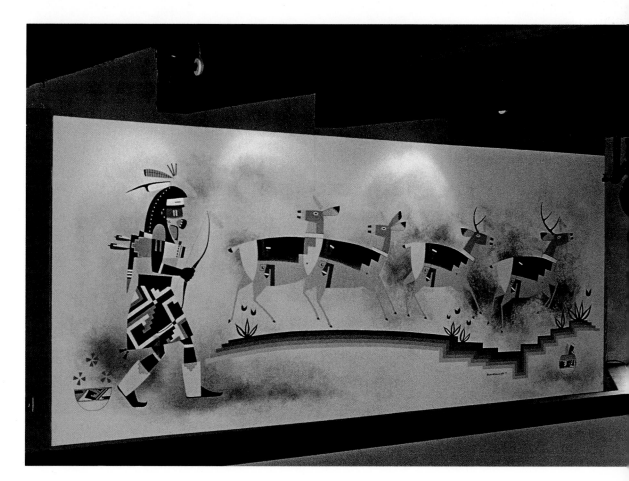

15.12 **The Masterpiece,** 1977

Robert Haozous

Carved mahogany; H 8 ft. × L 10 ft.
Seattle 1% for Art Program
Daybreak Star Arts Center

Carved into this mahogany panel are figures
representing three of the major Southwest
Indian tribes. On the left is a Pueblo Buffalo
Dancer from the New Mexico region. In the
middle is a Navaho Yeibei-chai Dancer from the
Arizona–New Mexico region. On the right is a
Mountain Spirit Dancer of the Apache, also
from the Arizona–New Mexico region. In the
background above the dancers is the audience.
Standing shoulder to shoulder, the group is a
varied collection of people except for the central
figure. One may assume it is Mickey Mouse,
an illogical addition to a fine carving.

15.13 **Buffalo Hunt,** 1977

Glen LaFontaine

Ceramic; H 8 ft. × L 10 ft.
Seattle 1% for Art Program
Daybreak Star Arts Center

This mural, composed of ninety ceramic squares,
depicts two Plains Indians hunting buffalo,
the main source of food and materials of the
American Plains region. The scene here shows
the predominant method of hunting before rifles
were introduced to the Indians. The two hunters
must ride close alongside their targets to get an
effective shot with their arrows.

15.12 The Masterpiece, Robert Haozous

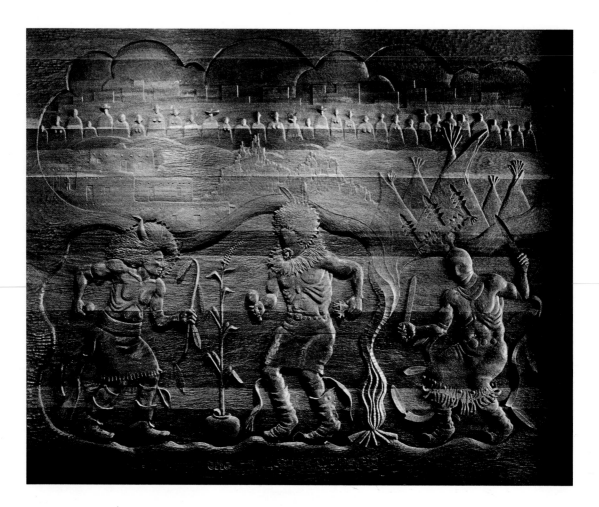

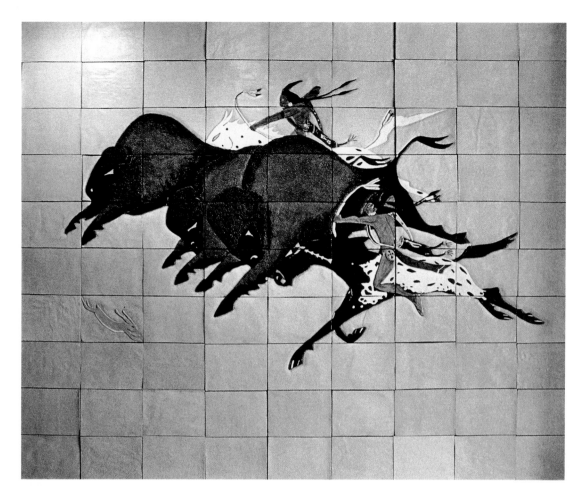

15.13 *Buffalo Hunt,* Glen LaFontaine

15.14 **Bear and Raven,** 1976

Marvin Oliver

Carved fir; each, H 8 ft. × W 7 ft.
Seattle 1% for Art Program
Daybreak Star Arts Center

Marvin Oliver originally designed these panels as
doors. However, the law required that metal bars
be placed across the front of the center's doors.
Rather than mar his designs with bars, Oliver's
creations were kept as decoration, and other
doors were purchased. The two decorative panels
have traditional Indian motifs of Bear and Raven/
Eagle.

15.15 **Longhouse,** 1987

Ron Coy Hilbert

Carved cedar; H 4 ft. 9 in. × L 12 ft.
Seattle 1% for Art Program
Daybreak Star Arts Center

Longhouse is a bas-relief depiction of a ceremonial
winter dance in an Indian longhouse, or smoke-
house. Among other things, such buildings were
used for religious and cultural celebrations and
events. The carving is very primitive and the
surface of the wood has been burned to give it
a rich brown color.

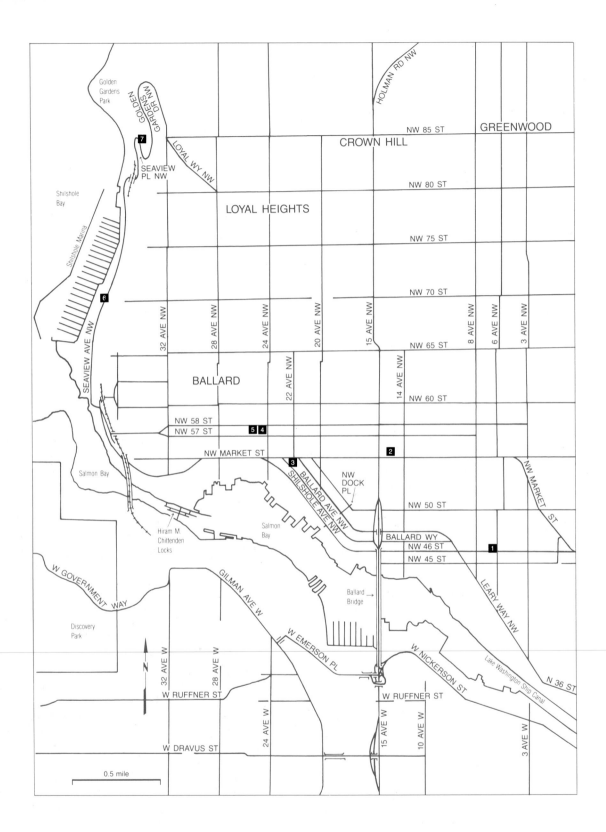

Golden Gardens Park

GOLDEN GARDENS DR NW

GOLDEN GARDENS NW

SEAVIEW PL NW

LOYAL WY NW

Shilshole Bay

Shilshole Marina

SEAVIEW AVE NW

HOLMAN RD NW

NW 85 ST — GREENWOOD

CROWN HILL

NW 80 ST

LOYAL HEIGHTS

NW 75 ST

NW 70 ST

32 AVE NW

28 AVE NW

24 AVE NW

20 AVE NW

15 AVE NW

8 AVE NW

6 AVE NW

3 AVE NW

NW 65 ST

BALLARD

22 AVE NW

14 AVE NW

NW 60 ST

NW 58 ST
NW 57 ST

NW MARKET ST

Salmon Bay

BALLARD AVE NW

SHILSHOLE AVE NW

NW DOCK PL

NW 50 ST

NW MARKET ST

Hiram M. Chittenden Locks

Salmon Bay

BALLARD WY
NW 46 ST
NW 45 ST

LEARY WAY NW

W GOVERNMENT WAY

GILMAN AVE W

Ballard Bridge

Discovery Park

W EMERSON PL

W NICKERSON ST

Lake Washington Ship Canal

N 36 ST

N

32 AVE W

28 AVE W

W RUFFNER ST

24 AVE W

15 AVE W

10 AVE W

W RUFFNER ST

3 AVE W

W DRAVUS ST

0.5 mile

Chapter 16

Ballard

*Now art should never try to be popular. The public
should try to make itself artistic.*

OSCAR WILDE 1854–1900

16.1 Untitled works, Barbara Noah

16.2 *Wall of Water*, Tom Yagle

16.5 *Of Sea and Life*, Howard Duell

16.1 Untitled works, 1985

Barbara Noah

Plexiglas and sign paint
Seattle 1% for Art Program
Canal Electrical Substation, NW Forty-sixth Street
and Sixth Avenue NW

Seattle City Light's Canal Electrical Substation
used to be a drab sight surrounded by chain link
fencing and including a nondescript building. In
1985 it was added to the list of substation renova-
tions by artist-architect design teams working on
1% for Art projects. The artist selected by the
Seattle Arts Commission to work on this project
was Seattle artist Barbara Noah.

Now the building is painted a lively color
and its upper windows frame silhouette images
created by Noah (see page 225). The substation
itself is a symbol of energy, so Noah's figures in
the windows on its four sides are symbols of
other forms of power. In the north windows the
figures symbolize the power of love. In the west
windows physical power is symbolized by hands
playing the game "Rock, Paper, Scissors." The
power of the law is symbolized in the south
windows by Blind Justice. The east windows
contain symbols of the powers of the mind and
money.

16.2 Wall of Water, 1980

Tom Yagle

Painted mural; H 25 ft. × L 130 ft.
Commissioned by private sources
Sunset Bowl, 1420 NW Market Street, west wall

Ballard's "salmon mural," as it is sometimes
called, was the result of a design competition
sponsored by the Ballard Chamber of Commerce,
administered by the Fremont Arts Council
(Ballard did not have its own), and funded by
Sunset Bowl and Burger King. Tom Yagle, a
graphic artist in Seattle, reports that his original
intention was to paint "just a big waterfall, but
this is Ballard and the people like fish so I added
some." The wall has since achieved landmark
status in the neighborhood.

16.3 Sidewalk relief sculptures, 1977

Donald W. Crabtree, Jack Ferrell,
Marvin T. Herard, Larry Tate,
and James Washington, Jr.

Mixed media
Seattle 1% for Art Program
Along Ballard Avenue between NW Market Street
and NW Dock Place

Part of a beautification project of Ballard's historic
section in the late seventies included the installa-
tion of sidewalk artworks. Some are difficult to
find and a few are no longer there. However, it
is an interesting neighborhood, and a walk on a
pleasant day will be enhanced by the remaining
five artworks.

The walk is best begun at the intersection of
Ballard Avenue and NW Market Street. On both
sides of Ballard Avenue are Marvin T. Herard's
artworks composed of precast concrete panels
in repeated semicircular designs.

Continuing down the east side of Ballard
Avenue, about midway between Market and
Twenty-second Avenue NW are two bronze
bas-relief panels by Larry Tate.

On the corner across Twenty-second Avenue
is a small red granite bas-relief sculpture by
James Washington, Jr., of a coelacanth, a
prehistoric fish thought for many years to
be extinct.

Two works can be found on Ballard Avenue
between Mount Vernon Place and Twentieth
Avenue. At the corner of Ballard Avenue and
Twentieth is *Catfish,* a three-part ceramic tile
mosaic by Jack Ferrell composed of one-inch-
square ceramic tiles, primarily in brown, white,
and gray tones. Four catfish swim through
the shallows of the sidewalk passing by water
lilies on their way north. On the opposite side
of Ballard Avenue, about half-way between
Twentieth and Mount Vernon Place, one can
see a cast iron bas-relief panel by Donald W.
Crabtree. The design of his untitled work is
based on a band saw.

16.4 Trees of Knowledge, 1963
Archie M. Graber

Laminated wood
Seattle Public Library collection
Ballard Branch Library,
5711 Twenty-fourth Avenue NW

Seattle artist Archie Graber's sculpture *Trees of Knowledge* alludes to the interrelation of knowledge from all civilizations through time. Numerous different types of wood from every continent were laminated together into three trees representing the past, the present, and the future. Each bursts with the growth of new knowledge and symbolizes the interdependence of civilizations upon one another.

16.5 Of Sea and Life, 1963
Howard Duell

Etched brass; H 6 ft. 6 in. × L 11 ft. 8 in.
Seattle Public Library collection
Ballard Branch Library,
5711 Twenty-fourth Avenue NW, inside courtyard

Howard Duell's *Of Sea and Life* is a combination of brass and water depicting scenes of aquatic life. A large brass fish is the central figure and a sheet of water cascades below it. Small schools of fish swim on either side of the sheet. The artwork is reminiscent of scenes one might see at the fish ladder at Hiram Chittenden Locks in Ballard, but Duell reports that he intended to depict sea life generally, not spawning fish.

16.6 Leif Eriksson, 1962
August Werner, Trygve Nakkerud, and others

Cast bronze; H 12 ft.
Gift to the city from private sources
Shilshole Bay Marina

Of all the heroic statues in Seattle, this twelve-foot statue of Leif Eriksson has the most unusual history. Although the entire credit for its creation is often given to the late August Werner, a music professor at the University of Washington, the work was in fact created almost by committee.

According to Trygve Nakkerud, president of the Leif Eriksson League in 1960 when it announced its intention to present a memorial to Eriksson to the city, a number of persons submitted designs for consideration. None of them were accepted. However, sculptor August Werner volunteered to create a design based on one of the proposals. Werner made some critical design changes. The league required a cross on Eriksson's chest and an ax in his right hand. "After all," Nakkerud explains, "the new unexplored region was called 'Vineland,' and we knew Eriksson must have had an ax to cut through the vines and undergrowth to reach the trees used to make pilings for his ship."

As with Douglas Bennett's *Christopher Columbus* (2.4), the design sparked considerable debate. Critics regarded it as too lifeless and undistinctive. After the design was finally accepted,

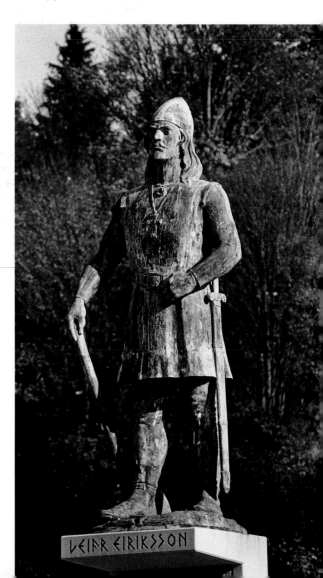

16.6 *Leif Eriksson*, August Werner, Trygve Nakkerud, and others

16.7 *Atala Kivlicktwok Okitun Dukik*, Lawrence Beck

Werner, Nakkerud, John Engan, and Einer Stende worked together under Werner's direction in Werner's dining room and sculpted a four-foot plaster model of the statue. That model was sent to Berkeley, California, where two foundry artists, Franco Vianella and Spara Anargyros, created what we now see. It stands on a base made of granite from Oslo, Norway.

Money for this statue was collected by the Leif Eriksson League from people throughout Seattle. It was dedicated on June 17, 1962, "Norway Day" at the Seattle World's Fair that year and also Icelandic Independence Day.

16.7 **Atala Kivlicktwok Okitun Dukik,** 1976

Lawrence Beck

Welded steel with automobile enamel paint; H 11 ft. 10 in. × L 18 ft.
Seattle 1% for Art Program
Upper Golden Gardens Park,
off Seaview Place NW

Made from flat sheets of steel, Lawrence Beck's bright yellow sculpture refers to his one-quarter Inuit (Eskimo) heritage. The long name is in Yukik, a Malemute dialect, and means "Just Like the Golden Shiny Money Moon." His sculpture also includes primitive drawings applied with a welding rod. Those figures, which the artist has named "Eskiglyphs," are spontaneous doodles ranging from simple designs to Eskimos fishing and hunting seals and walrus.

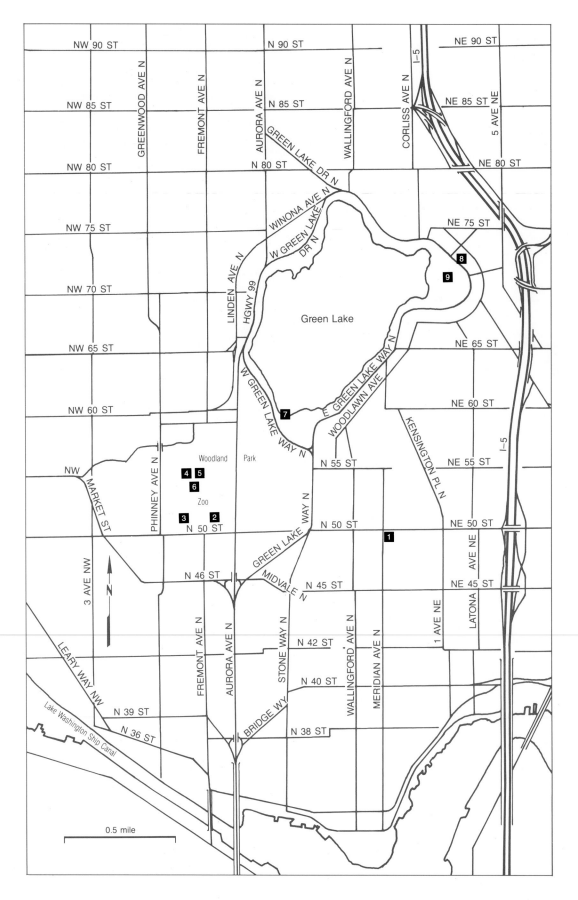

NW 90 ST • N 90 ST • NE 90 ST

GREENWOOD AVE N • FREMONT AVE N • AURORA AVE N • N 85 ST • WALLINGFORD AVE N • CORLISS AVE N • I-5 • NE 85 ST NE • 5 AVE NE

NW 85 ST

NW 80 ST • N 80 ST • GREEN LAKE DR N • NE 80 ST

WINONA AVE N

NW 75 ST • W GREEN LAKE DR N • NE 75 ST

8

LINDEN AVE N • **9**

NW 70 ST

Green Lake

NW 65 ST • NE 65 ST

HGWY 99

W GREEN LAKE WAY N • E GREEN LAKE WAY N • NE 60 ST

NW 60 ST • WOODLAWN AVE N • **7**

I-5

NW • Woodland Park • N 55 ST • KENSINGTON PL N • NE 55 ST

PHINNEY AVE N • **4** **5**

6

Zoo • **1** • NE 50 ST

MARKET ST • **3** • **2** • N 50 ST • N 50 ST • NE 50 ST

N 46 ST • GREEN LAKE WAY N • MIDVALE N • N 45 ST • NE 45 ST

3 AVE NW • LATONA AVE NE

1 AVE NE

FREMONT AVE N • AURORA AVE N • STONE WAY N • N 42 ST • WALLINGFORD AVE N • MERIDIAN AVE N

LEARY WAY NW • N 40 ST

BRIDGE WY

N 39 ST

Lake Washington Ship Canal • N 36 ST • N 38 ST

0.5 mile

Chapter 17

Green Lake and
Woodland Park

And the first rude sketch that the world had seen
was joy to his mighty heart,
Till the Devil whispered behind the leaves,
"It's pretty, but is it Art?"

RUDYARD KIPLING 1865–1936

17.4 *Seattle's Own Ark*, David Gilhooly

17.1 *Meridian Archway*, Charles Greening

17.2 Untitled sculptural mural, Alice Robertson Carr

17.1 Meridian Archway, 1981

Charles Greening

Stone and mixed media
Seattle 1% for Art Program
Meridian Playground, entrance at corner
of N Fiftieth Street and Meridian Avenue N

Meridian Archway is the most unusual entrance to
a public facility in Seattle. It consists of an arched
gateway and a walled switchback path con-
structed out of thousands of rocks. The rocks
include Mexican geodes, "Apache Tears" from
Arizona, fossils from the Oregon coast, river
rocks from the Cascades, eastern Washington
lava, and petrified sand dollars from San
Francisco's Golden Gate Park. There are also
petrified shells (one accompanied by a bronze
duplicate), bits of petrified wood, glass from
a Seattle glass factory, and large black rocks
gathered from the banks of the Toutle River
a short time before it was devastated by the
May 18, 1980, eruption of Mount Saint Helens.
Most of the large granite pieces are former
street curbs from downtown Seattle.

 Meridian Archway was created by Charles
Greening, the Seattle artist who created the sun-
dial at Gas Works Park (13.3). He points out that
Meridian Archway gets "more intense as you come
up the path or look down. . . . Some of it is like
a glacier, where everything is frozen and
sedimentary."

 The sedimentary layers abound with surprises
for the attentive explorer. A bronze religious
medallion is inset into the underside of the
arched entryway. It was cast from one of the
many plastic medallions that were found through-
out the Home of the Good Shepherd, the former
name of the building located in this park. A
collection of keys is inset near the medallion.
Elsewhere, drains that appear to be made of
pebbles are actually bronze. Rocks inset into walls
are comfortable seats. A piece of abalone shell
helps create a small "tidepool" on the top of one
wall.

 Although Greening reports that many neigh-
bors and friends helped construct it, the majority
of work was done with the help of two assistants
—Seattle artist Robert Williamson and a creative
friend, Mary Kern.

17.2 Untitled sculptural mural, 1924

Alice Robertson Carr

Cast concrete; H 5.5 ft. × L 23.5 ft.
Commissioned by the Lions Club
Woodland Park Rose Garden, at east end
of main zoo parking lot off N Fiftieth Street

A focal point of the Woodland Park Rose Garden
is the twenty-three-foot retaining wall facing the
pond at the garden's north end. Words on the
wall relate something of the garden's history, and
the central portion is a large bas-relief mural by
Alice Robertson Carr. The mural portrays a
serene, romantic scene featuring nine women,
seven of whom are dancing with silken scarves.
To the left a woman stands holding her infant
child while two deer graze in the foreground.
To the right a mother has placed her child on
the back of a benign lioness.

 Memorials adjacent to the sculpture explain
that the rose garden was conceived and designed
by the Seattle Rose Society and made possible by
the Lions Club, which also commissioned Carr's
mural.

17.3 Hiker Memorial Statue, 1926

Allen G. Newman

Cast bronze; H 14 ft.
Private funding
Woodland Park, southwest corner

The *Hiker* statue stands just beyond two six-inch
naval guns at the west end of the zoo's main
parking lot. It is a little-noticed memorial to
Americans lost in the Spanish-American War
(1898). The bronze figure is a "hiker," the term for
the foot soldier of that war. He and his comrades
are less remembered than the American cavalry,
the Rough Riders, who remain in America's
memory through publicity about Teddy Roosevelt
and his comrades.

 On the back of the statue's granite base is a
metal plaque cast from remains of the USS *Maine*,
the American battleship that mysteriously blew
up in Havana Harbor, Cuba, in 1898. That
occurrence was the immediate cause of the war.

 The *Hiker* is the only work in Seattle created
by New York artist Allen Newman.

17.4 **Seattle's Own Ark,** 1979

David Gilhooly

Redwood and ceramic; L 6 ft.
Seattle 1% for Art Program
Woodland Park Zoo, inside main gate,
just beyond PONCHO Theater

Seattle's Own Ark (see page 231) is a whimsical
vessel carrying animal passengers: a giraffe, a
beaver, a warthog, a snowy owl, a porcupine,

17.3 *Hiker Memorial Statue,* Allen G. Newman

and a hippopotamus. At the bow of the 1,000-
pound ark is "Frog Noah." The vessel's figure-
head is "Mer-Frog," whose tail can be seen at
the stern. All the animals are ceramic. The ark is
constructed of pegged redwood.

Gilhooly is a noted ceramicist whose works
have often featured animals, including those of
his "Frog World." Other frog subjects have been
Saint Anthony, Dionysius, and, last but not
least, "Moses Frog." Now a resident of Alberta,
Canada, Gilhooly has exhibited his creations
throughout North America as well as in Europe
and Japan. *Seattle's Own Ark* is his only work in
this city.

When installed, it was the first artwork placed
in the zoo in over forty years. The design was
selected as symbolic of the zoo, a place for fun
and enjoyment but also engaged in the serious
task of conserving and keeping safe the world's
animal species.

Near *Seattle's Own Ark,* on the east wall of
PONCHO Theater, is a carved-brick relief of a
bear. It is one of many artworks throughout the
city by Seattle artist Richard Beyer. He also carved
wooden benches and other brickwork around the
duck pond near the Children's Zoo.

Beyond the Children's Zoo, on the east side of
the savanna exhibit, is Larry Buckingham's *Jimi
Hendrix Memorial Savanna Overlook,* a raised and
patterned concrete lookout area created in 1982
in memory of the Seattle-born rock star.

17.5 **Gila Monster,** 1979

Betz Bernhard

Concrete and mosaic tile; H 3.5 ft. × L 5.5 ft.
Private funding
Woodland Park Zoo, Tropical House,
inside entrance

The zoo's Tropical House is filled with so many
interesting creatures that visitors often fail to see
the striking concrete reptiles at each end of the
building. To some degree that is intentional, as
they are there to be discovered.

To the left and around the corner from the
entrance, a six-foot-long gila monster emerges
from the wall. The sculpture is dedicated to Todd
Cameron Davis, a twenty-five-year-old student
who had been studying these lizards at the zoo
at the time of his death in 1978 in a mountain
climbing accident. It was commissioned by his
parents.

17.5 *Gila Monster*, Betz Bernhard

17.6 *Crocodile*, Betz Bernhard

17.6 **Crocodile,** 1980

Betz Bernhard

Concrete and mosaic tile; H 3 ft. × L 6 ft.
Seattle 1% for Art Program
Woodland Park Zoo, Tropical House,
adjacent to exit

Next to the exit a six-foot-long crocodile stands
with his head and tail extending beyond the
wall. Several frogs and fishes are fellow residents
in its concrete swamp. This crocodile was
commissioned two years after the gila monster
sculpture at the opposite end of the Tropical
House. Unhappily it has been damaged several
times by unsupervised children trying to swing
from its outstretched tail. It has been suggested
that the inattentive parents of such children be
fed to the live crocodiles. The matter is still
under consideration.

17.7 **Untitled kinetic sculpture,** 1981

R. Allen Jensen

Aluminum and steel; H approx. 32 ft.
Seattle 1% for Art Program
Green Lake Boating and Sailing Facility,
south end of lake (former location
of the Aqua Theatre)

On the northwest corner of a concrete remnant of
the demolished Aqua Theatre stands a long oar-
shaped aluminum rod counterbalanced with a
steel cylinder. The shape refers to the use of the
nearby boating and sailing facility, which houses
racing shells and sculls, popular rowing boats
used on the lake. The sculpture is painted the
same color as the surrounding blue railings, so
it is often missed. On days with sufficient wind,
viewers will see it move gently like a weather
vane.

17.8 **Homage to Hokusai,** 1979

Richard Spaulding

Stained glass
*Seattle Public Library and Seattle Arts Commission
(Artist in the City Program)*
Green Lake Branch Library,
7364 E Green Lake Drive N

Richard Spaulding's two-part stained glass
window above the entrance to the Green Lake
Branch Library is one of five stained glass
creations commissioned by the Seattle Arts
Commission for Seattle's branch libraries. These
fluid ripples of glass were created in honor of
Katsushika Hokusai (1760–1849), one of the
great masters of the Japanese woodblock print.
Hokusai is best remembered by westerners for
his woodblock print series of wave scenes.

This artwork is sometimes mistakenly called
"Homage to Hiroshige." Andō Hiroshige was an
equally famous master of woodblock art and a
contemporary of Hokusai.

17.8 *Homage to Hokusai,* Richard Spaulding

17.9 **Seven Figures,** 1988

Paul Marioni and Ann Troutner

Cast glass relief; H 5 ft. × L 26 ft.
Seattle 1% for Art Program
Green Lake Community Center,
7201 E Green Lake Drive N

The large window on the north end of the community center, which is part of the north wall of Evans Pool, consists of 216 individually cast glass tiles creating a scene of seven people swimming. The scene is supplemented with a wide assortment of fish, sea snails, and seashells and a small treasure chest. The piece can be viewed from inside with natural light (or headlights from the parking lot in the evening) or outside with light shining upon it or through it from inside the pool area. Light playing upon ripples and waves in the glass creates the illusion of motion as the viewer moves. The mural does not fill the entire window space. The remaining seven by twenty-six foot space is filled with tempered plate glass.

Each glass tile in *Seven Figures* was created from a unique carved-wax relief on wood, which was pressed into a special sand that retains intricate details. Molten glass was then poured into the impression. The glass tiles are held together with clear silicon so the design is not interrupted with framing. Spectrum Glass Company of Woodinville, Washington, underwrote the experimental phase of the casting development.

The main entryway on the north side of the community center is also graced with twenty-four cast glass tiles by Paul Marioni and Ann Troutner. Each tile has a ripple design of clear glass over a dichroic glass base. Dichroic glass was created by the U.S. Navy in World War II for use in signal lamps. It allows light to defract so glass appearing clear blue from head-on becomes yellow when viewed at an angle. Marioni reports that the effect "is magical, and when people look at it they can't figure out how it works."

17.9 *Seven Figures*, Paul Marioni and Ann Troutner

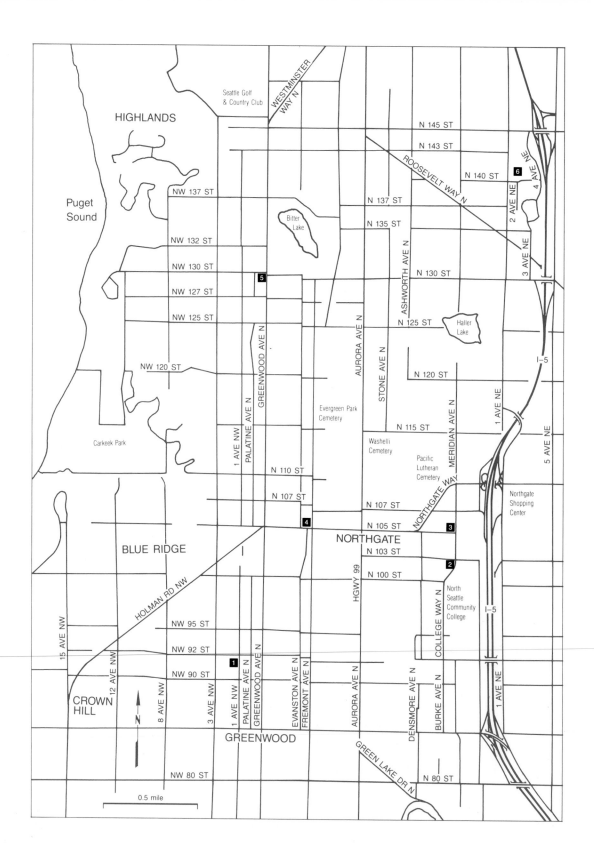

Chapter 18

Northwest Seattle

And each man hears as the twilight nears,
to the beat of his dying heart,
The Devil drum on the darkened pane:
"You did it, but was it Art?"

RUDYARD KIPLING 1865–1936

18.6 *Winds of Friendship,* Parks Anderson

18.2 *Khadi*, Paul Marioni 18.3 *Marker Series*, Mario Oblak

18.1 Untitled fountain, 1974

Jonn Geise

Sandstone
City of Seattle collection
Sandel Playground, NW Ninety-second Street
and First Avenue NW

Seattle artist Jonn Geise's fountain-sculptures are located around the wading pool at the north end of Sandel Playground. Made of sandstone blocks, they are continuations of a gnomon theme Geise has worked with throughout his career (see 7.34 and 12.13) that refers to the close relationship of the moon and the sun to one another and to the earth. The two elements stand opposite one another, the taller one representing the sun and the smaller one representing the moon. Both have circular cutouts of different sizes, and further contrast is achieved with the rough carved portions contrasting with the smooth sandstone. Water spouts out of each into the wading pool.

Northwest of the Geise fountain, outside the Seattle City Light North Service Center at 1300 Ninety-seventh Street, is a painted steel sculpture created by Donald W. Crabtree. The eight-foot-high creation was commissioned through the Seattle 1% for Art Program.

18.2 Khadi, 1984

Paul Marioni

Cast glass sculpture; H 8 ft. × L 17 ft.
Seattle 1% for Art Program
North Precinct Police Station,
10049 College Way N

This curved glass wall, which separates the lobby from the station's meeting room, has an irides-cent sheen on the lobby side. Close inspection reveals a woven design consisting of over 480, eight-inch-square tiles. All are identical cast glass designs, but each is turned ninety degrees from each of its neighbors. The result is sixteen different weave patterns from one mold; in the artist's words, "simplicity to the maximum." The special coloring was sprayed on when the glass was still hot.

Marioni's reasons for the design are interesting. The initial thought was that people visiting police stations are often distressed or at least frustrated. So, he wanted his work to have a calming influence. At the design stage, Marioni was reading the writings of Mohandas Gandhi and was impressed with the fact that the Indian spiritual leader was able to show a love for humanity without engaging in any organized religious practices. Weaving cloth and spinning yarn were Gandhi's ways of meditating and calming himself—this became the inspiration for Marioni's design and the piece is dedicated to Gandhi. The word *khadi* means "the act of weaving," and hence the name for Marioni's "woven" glass.

Khadi was incorporated into the station's design in a joint effort of the artist and the building's architects, the Seattle firm of Shavey Degrasse & Shavey. The glass flowerlike work in the garden just outside the station entrance is also by Marioni.

18.3 Marker Series, 1979

Mario Oblak

Cast bronze
King County 1% for Art Program
King County North District Multi-Service Center,
10501 Meridian Avenue N

Mario Oblak's *Marker Series* consists of four bronze sculptures dispersed on the lawn adja-cent to the Multi-Service Center. They look like four piles of rocks, and that is precisely what the artist had in mind when he created them. Oblak reports that these designs were inspired by piled stone sculptures he made in Rhode Island in the late 1970s. "I was going to different sites that appealed to me, like the ocean, where I'd build some and then leave them for people to look at and wonder about. Eventually the works would fall down. My idea has always been to make an interesting and appealing form that people would be able to just look at. The works have no message."

Oddly enough, these sculptures are quite simi-lar to piled rock markers constructed by Eskimos and Tibetans (Eskimos call them *inukshuk*s; Tibetans call them *obo*s), but Oblak was unaware of those creations until well after he made his own *Marker Series*. "I wasn't inspired by any of those forms, and it was really startling to see the Eskimo works and see that my thoughts weren't original."

These sculptures are much larger and their designs are more organic than Oblak's previous works. They are also his first public commission.

18.4 Untitled works, 1979

Andrew Keating, Sherry Markovitz, and Lewis ("Buster") Simpson, with windmills by Emil Gehrke and Veva Gehrke

Mixed media
Seattle 1% for Art Program
Viewland-Hoffman Electrical Substation, N 105th Street and Fremont Avenue

The collection of artworks at this Seattle City Light substation is the result of the city's first artist-architect collaboration for creating public artworks. Rather than commission works for the completed facility, the Seattle Arts Commission selected these three Seattle artists to work with Seattle architects Hobbs-Fukui Associates, Inc., to incorporate works at the design stage.

Central to the design are twenty-seven brightly painted windmills clustered inside a courtyard surrounded by a chain link fence and with a chain link tunnel on one side. These windmills were created by Emil Gehrke and his wife Veva in the little town of Coulee City, in eastern Washington. He started creating this unique folk art in 1965, at the age of eighty-one. Veva was painting them at the age of seventy-eight. Unfortunately, he died, at the age of ninety-five, before this project was completed.

The windmills are constructed from a wide range of discarded items, including a frying pan, an old boot, funnels, gears, a coffee pot, hard hats, dustpans, and an old posthole auger. To match the lively colors of the windmills, the artist team added colorful geometric shapes to the inside surface of the substation's concrete walls. In addition, certain parts of the City Light equipment were painted in different colors to illustrate the path of electricity through the substation. The artist team was also responsible for the comical signs in the area and the chain link armchair inside the fence.

This collaborative effort of artists, architects, and engineers has won numerous architectural and design awards and inspired two similar efforts for City Light substations. The Creston-Nelson Electrical Substation in south Seattle followed in 1982 (21.17) and the Canal Electrical Substation in Ballard (16.1) was completed three years later.

This substation was named in honor of the late Eugene Hoffman, a former superintendent of Seattle City Light.

18.5 Untitled paintings and carving, 1975

Marvin Oliver

Paintings on cedar and cedar carving,
Seattle 1% for Art Program
Broadview Branch Library,
NW 130th Street and Greenwood Avenue N

When the Broadview Library was built in 1975, two wall spaces above the entry were reserved for paintings by Native American artist Marvin Oliver. Painted in red and black on clear cedar, these works are typical of traditional Northwest Indian graphic design.

A more elaborate eight-by-six-foot work by Oliver is located to the left of the checkout counter. The two-dimensional cedar carving is accentuated with turquoise, red, and black paint.

18.6 Winds of Friendship, 1987

Parks Anderson

Anodized aluminum and stainless steel; H 23 ft.
Gift of Mr. and Mrs. Max A. Gurvich
Lakeside School, 14050 First Avenue NE

Winds of Friendship (see page 239) is one of the most unusual sculptures in Seattle because it is part of a set and its twin stands in front of Moscow School No. 20 in the Soviet Union. They were commissioned to emphasize the friendship between the schools and the people of the two nations. Both were simultaneously dedicated in the fall of 1988.

As is true of all of Anderson's kinetic sculptures, this work is wind-powered. Anderson prefers to use the force and power of the wind because it creates totally random movement in the rotation of the sculpture and the clockwise turning of its two independent S-shaped rotors, as well as randomly determining when and how fast it will move. *Winds of Friendship* is similar to a sculpture he created earlier for the home of Seattle art collectors Max and Helen Gurvich overlooking Lake Washington on Webster Point. That piece can be seen by boats traveling to and from Union Bay and from the Evergreen Point Floating Bridge.

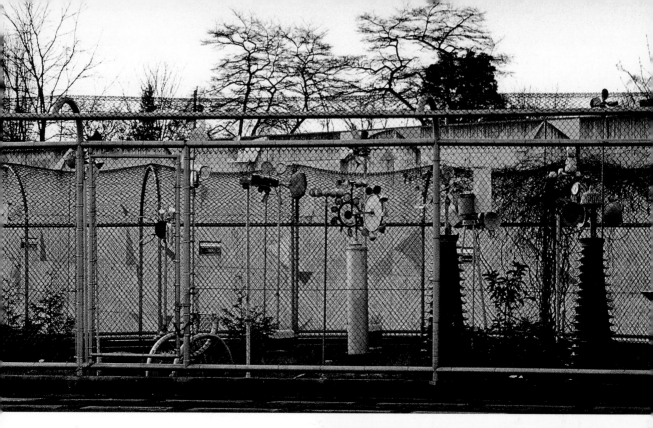

18.4 Viewland-Hoffman Electrical Substation

18.4 Windmill, Emil Gehrke and Veva Gehrke

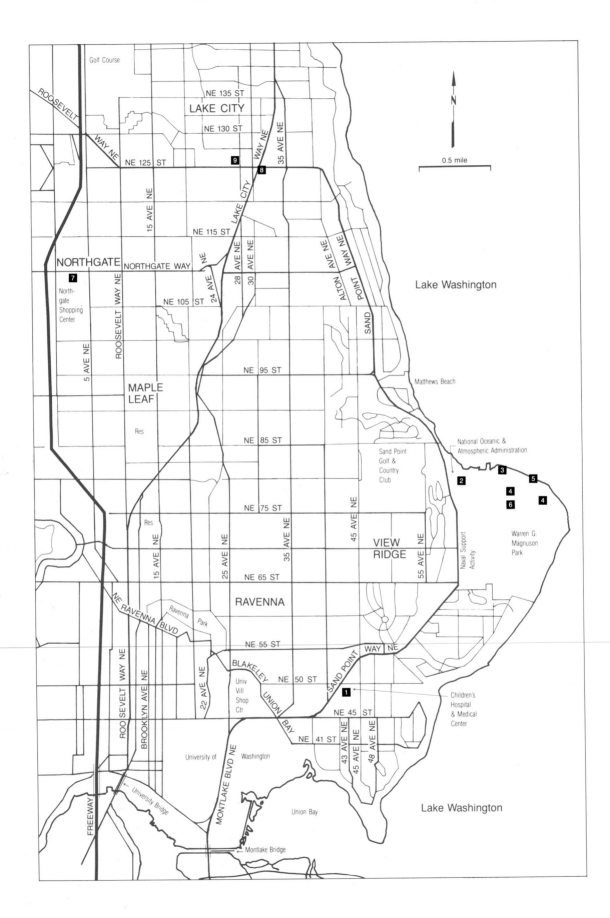

Golf Course

LAKE CITY

NE 130 ST

NE 125 ST

9

8

35 AVE NE

LAKE CITY WAY NE

ROOSEVELT WAY NE

15 AVE NE

NE 115 ST

NORTHGATE Northgate Way

7

North-
gate
Shopping
Center

ROOSEVELT WAY NE

5 AVE NE

NE 105 ST

24 AVE NE

28 AVE NE

30 AVE NE

ALTON AVE NE

SAND POINT WAY NE

Lake Washington

NE 95 ST

MAPLE
LEAF

Res

NE 85 ST

Sand Point
Golf &
Country
Club

Matthews Beach

National Oceanic &
Atmospheric Administration

2

3

5

4

6

4

NE 75 ST

Res

15 AVE NE

25 AVE NE

35 AVE NE

45 AVE NE

VIEW
RIDGE

55 AVE NE

Warren G.
Magnuson
Park

Naval Support
Activity

NE 65 ST

RAVENNA

NE RAVENNA BLVD

Ravenna
Park

22 AVE NE

NE 55 ST

SAND POINT WAY NE

ROOSEVELT WAY NE

BROOKLYN AVE NE

BLAKELEY

NE 50 ST

Univ
Vill
Shop
Ctr

UNION BAY

1

Children's
Hospital
& Medical
Center

NE 45 ST

43 AVE NE

45 AVE NE

48 AVE NE

NE 41 ST

University of Washington

MONTLAKE BLVD NE

Union Bay

Lake Washington

FREEWAY

University Bridge

Montlake Bridge

N

0.5 mile

Chapter 19

Northeast Seattle

Art! Who comprehends her? With whom can one consult concerning this great goddess?

LUDWIG VAN BEETHOVEN 1770–1827

19.6 *Sound Garden*, Douglas Hollis

19.1 Untitled sculpture, Maris D. Benson

19.3 *Viewpoint*, Scott Burton

19.1 Untitled sculpture, 1978

Maris D. Benson

Welded anodized aluminum;
H 6.5 ft. × L 14 ft. × W 8 ft.
Gift from PONCHO
Children's Hospital and Medical Center,
on the road leading up from Sand Point Way

Maris Benson's "building block" sculpture is a combination of two repeated shapes, the cylinder and the cone, which work together to create one sculpture. Although Benson was influenced by the minimalist movement of the 1960s, he chose not to depend on the monolithic form of minimalist sculpture. By 1979 he was working with the type of repeated-image design present in this work. "I'm interested in a serial kind of repeated image—shapes that work together, that are dependent on one another," Benson explains. "These volumes create a complicated composition, and if you remove any element, the piece will lose its visual presence and clarity."

Although this sculpture is composed of welded hollow forms, the forms are not welded to each other. They are held together by aluminum rods through their centers, which are fastened with large nuts. The resulting tension is part of the design.

Maris Benson's sculpture has been exhibited throughout the West Coast, but this work is his only public piece in the Pacific Northwest.

National Oceanographic and Atmospheric Administration

As part of the development of its new 114-acre Western Regional Center at Sand Point, the National Oceanographic and Atmospheric Administration (NOAA) established a program to incorporate commissioned artworks at the site. In 1980 it arranged for the Seattle Arts Commission to administer a process to select artists. The commission and the National Endowment for the Arts then nominated a selection committee to choose the artists.

That committee worked with NOAA, the project architects, and the surrounding community to select artists for the shoreline facility. The process was completed in July 1982 after reviewing over 250 proposals for artworks. The committee selected the design proposals of five nationally known artists: Siah Armajani, Scott Burton, Douglas Hollis, Martin Puryear, and George Trakas. Their design proposals were the subject of an exhibit and a symposium on public art held at the Seattle Art Museum in early 1983.

All five of these artists are known for emphasizing the relationship of their art to the surrounding environment. Robert Irwin, who placed a major work at Seattle's Public Safety Building (4.7), is another member of a group of American artists who take this approach to art in public places. Their art is in some respects similar to landscape architecture. Some of the artists distinguish their approach by the fact that they supplement the natural landscape with man-made materials. Others make no distinction.

This innovative project, the third largest public art program for the Department of Commerce (of which NOAA is a part), cost $250,000, which amounted to one-half of one percent of the center's construction costs.

The NOAA artworks are located along the northern shore of Sand Point and can be reached by entering the center off Sand Point Way at NE Seventy-sixth Street, a few blocks north of the entrance to Sand Point Naval Air Station. Park in the first area of parking lots and begin at Martin Puryear's *Knoll*. Then walk east to the stairway down to the lake level and the lakeshore path. Access is also available from the other end of the facility by walking through Warren Magnuson Park along the lakeshore. In that case, you will start at one of Siah Armajani's bridges and proceed up the hill to *Sound Garden* by Doug Hollis.

19.2 Knoll for NOAA, 1983

Martin Puryear

Concrete and aggregate; H 4.5 ft. × dia. 45 ft.
U.S. Department of Commerce collection
NOAA Western Regional Center

Martin Puryear's concrete and aggregate dome gently rises out of the surrounding area to a height of almost five feet and provides a sweeping view of the north end of Lake Washington. It consists of wide bands that coil around and meet at the dome's top with an Asian yin-yang symbol. Four concrete benches are placed around the sphere. Each is slightly curved to correspond to the knoll's shape.

19.3 Viewpoint, 1983

Scott Burton

Stainless steel, exposed aggregate, and boulders
U.S. Department of Commerce collection
NOAA Western Regional Center

The late Scott Burton's *Viewpoint* is located on a natural knoll above the water and serves as an extended terrace for viewing the northern shores. Large chairs made from granite boulders (dredged from Lake Washington to allow the large NOAA ships to moor) are provided for viewers to pause and enjoy the scenery. The scenery includes Burton's nearby terrace planters and monolithic garbage can encasements labeled "Oceanic" and "Atmospheric."

Burton received considerable recognition for his work with furniture as art. The stone chairs in *Viewpoint* are similar to a pair of large rough stone chairs in the collection of the Museum of Modern Art in New York.

The stone aggregate and stainless steel grid design of *Viewpoint* is central to the work and relates it to the grid design of the nearby building faces. That aspect of the design is Burton's attempt to lessen what he believed to be an intrusive effect of the architecture. "I don't like the buildings at all," he said in a 1983 interview. "I wanted to lessen their impact by relating them more to their surroundings."

Is Burton's work art or landscape architecture? "Landscape design is art with a place in it for people," he explained. "It enhances the viewer's experience, not just the artist's. . . . I want people to have their experiences enhanced. When you look at a painting, at a Picasso, you're looking at the artist's experience. . . . There is a need to project something more than the sensibility of the artist."

19.4 Bridges, 1983

Siah Armajani

Concrete and bronze
U.S. Department of Commerce collection
NOAA Western Regional Center

Down the path from Scott Burton's *Viewpoint* is one of two reddish-tinted footbridges by Minnesota artist Siah Armajani. The other is the last artwork on the NOAA path before reaching the fence dividing this site from Warren Magnuson Park. Both bridges consist of two blocks that rest upon a cylinder laid on its side. Inlaid in bronze on the lips of each cylinder, on the top edges of the bridge walls, and on the bridge decks are quotations from *Moby Dick*, Herman Melville's epic story of the sea. Armajani included the quotations to allude to NOAA's many duties in the world's oceans.

19.5 Berth Haven, 1983

George Trakas

Steel and wood
U.S. Department of Commerce collection
NOAA Western Regional Center

At shore level between one of Armajani's bridges and Hollis's *Sound Garden* is *Berth Haven* by New York artist George Trakas. The terraced, V-shaped levels of steel and hand-hewn logs and planks extend out to the water, providing visitors with easy access to the lake. *Berth Haven* was designed to blend in with its surroundings and connect the steep, inaccessible shoreline with the higher ground inland.

Trakas explains that in selecting the theme for this creation he "felt the urge to work on the shoreline and create something that would bring people close to the interface of land, sea, and sky in an intimate and integral way." His design incorporates existing clumps of wildflowers and grasses on the shoreline.

19.6 Sound Garden, 1983

Douglas Hollis

Steel, with ceramic block
U.S. Department of Commerce collection
NOAA Western Regional Center

The most widely acclaimed work in the NOAA collection is *Sound Garden* (see page 245) by California artist Douglas Hollis. It consists of twelve steel towers topped with structures resembling weather vanes. On one end of each apparatus is a vertical organ pipe. On the other is a wind vane that rotates the pipe toward the wind. Musical sounds are created as wind blows through the pipes of differing lengths, the framework of each tower, and the matrix of guy lines around them.

19.4 *Bridge*, Siah Armajani

19.5 *Berth Haven*, George Trakas

Sound Garden includes a path of triangular brick pavers that meanders up the rise in the land to metal benches in the grove of towers. Although placement of the towers, the benches, and the path are important elements of Hollis's design, sound is the major factor. Hollis points out that visiting *Sound Garden* on a windless day is not experiencing it. A five-mile-an-hour wind is enough to make "music," and as the wind velocity increases, the music will change.

The towers were built in pairs to increase the number of sound reverberations. Resulting sounds have been likened to the songs of humpback whales. Hollis first became interested in the phenomenon of wind-generated sounds while flying kites. In this work he intended only to make "melancholy" sounds, but he finds the comparison to whale songs appealing.

"These gardens are an oasis . . . in which you can escape from everyday life," he explained in a 1983 interview. "I don't know that I would tell anything about the work to people viewing it. . . . I think the work speaks for itself. I want to instill either an internal reaction in viewers or promote conversation. They should just relax and enjoy it."

19.7 Untitled pole sculpture, 1962
Dudley Carter

Carved cedar
Privately owned
Northgate Shopping Center,
entrance off Northgate Way

Looming above the entrance to the shopping center is a unique carved cedar pole by Seattle area artist Dudley Carter. It is not a Pacific Northwest Indian totem pole design. Rather, it is a combination of Carter's own designs and those of Pacific Northwest Indians and South Pacific peoples. The art forms used by those native cultures are a great influence on Carter's work.

19.8 Gateway, 1979
Michael Sweeney

Wire and concrete
City and community funding
Lake City Way NE,
north and south of NE 125TH Street

The three large boulders in the middle of Lake City Way were constructed by Whidbey Island artist Michael Sweeney as part of a program to beautify Lake City. Slicing into each is a painted steel blade that juts skyward from the top of each stone.

Sweeney's design refers to Lake City's image as a gateway from the city to the country. "Boulders," he explains, "conjure suggestions of wilderness and have been used throughout history to establish gateway points into cities. . . . The steel units (which arc toward the city) are derived from rectangular shapes inherent in the geometric character of city structures." The curve of each rectangle suggests nature's continual motion.

Using real boulders in *Gateway* could have presented a traffic hazard, so these are actually realistic constructions of wire and concrete.

19.9 Semicircular gates, 1967
George Tsutakawa

Silicon bronze; H 9 ft. × L 16.5 ft. at center
Seattle Public Library collection
Lake City Branch Library,
12501 Twenty-eighth Avenue NE

The entrance to the Lake City Branch Library has the first gates created by George Tsutakawa. He made them after his return from a European tour to study fountains, where he became fascinated with the many gates in Europe. By chance, upon his return he was asked if he would design some gates for the new library.

Unlike the heavy iron gates of Europe, Tsutakawa's designs are made of lighter and rust-proof bronze. They are constructed entirely of one-eighth-inch strips welded together into hollow frames.

On the inside of the gates, in the lower left-hand corner, are the letters T-U-B. "T" for Tsutakawa; "U" for Jack Uchida, a former Boeing engineer who has worked with Tsutakawa on each of the artist's major pieces; and "B" for Paul Billingsley, a young student who worked with the artist on this project.

Later gates by George Tsutakawa can be seen in the University of Washington Arboretum (11.2).

19.8 *Gateway*, Michael Sweeney

19.9 Semicircular gates, George Tsutakawa

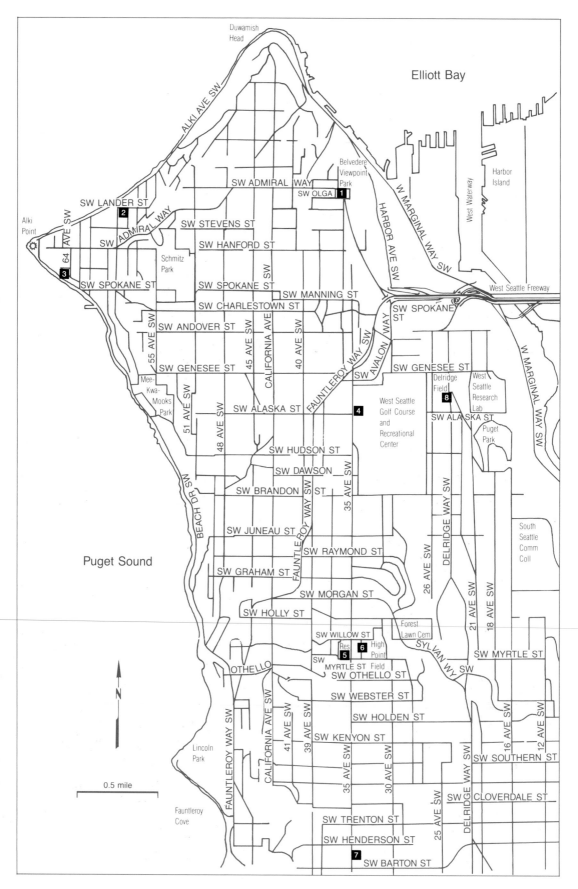

Duwamish
Head

Elliott Bay

ALKI AVE SW

Belvedere
Viewpoint
Park

SW ADMIRAL WAY

West Waterway

Harbor
Island

SW OLGA **1**

SW LANDER ST

2

SW ADMIRAL WAY

SW STEVENS ST

HARBOR AVE SW

W MARGINAL WAY SW

Alki
Point

64 AVE SW

SW
ADMIRAL WAY

SW HANFORD ST

Schmitz
Park

3

SW SPOKANE ST

SW SPOKANE ST

SW MANNING ST

West Seattle Freeway

SW CHARLESTOWN ST

SW SPOKANE ST

55 AVE SW

SW ANDOVER ST

45 AVE SW

CALIFORNIA AVE SW

40 AVE SW

FAUNTLEROY WAY SW

AVALON WAY

SW GENESEE ST

W MARGINAL WAY SW

Mee-
Kwa-
Mooks
Park

SW GENESEE ST

51 AVE SW

48 AVE SW

SW ALASKA ST

FAUNTLEROY WAY SW

SW ALASKA ST

4

West Seattle
Golf Course
and
Recreational
Center

Delridge
Field

West
Seattle
Research
Lab

8

SW ALASKA ST

Puget
Park

SW HUDSON ST

SW DAWSON

35 AVE SW

DELRIDGE WAY SW

South
Seattle
Comm
Coll

SW BRANDON ST

FAUNTLEROY WAY SW

SW JUNEAU ST

Puget Sound

SW RAYMOND ST

26 AVE SW

21 AVE SW

18 AVE SW

BEACH DR SW

SW GRAHAM ST

SW MORGAN ST

SW HOLLY ST

Forest
Lawn Cem

SW WILLOW ST

Res

5

6

High
Point

SYLVAN WY SW

SW MYRTLE ST

SW
MYRTLE ST

Field

OTHELLO

SW OTHELLO ST

SW WEBSTER ST

FAUNTLEROY WAY SW

CALIFORNIA AVE SW

41 AVE SW

39 AVE SW

35 AVE SW

SW HOLDEN ST

30 AVE SW

16 AVE SW

12 AVE SW

SW KENYON ST

SW SOUTHERN ST

N

Lincoln
Park

0.5 mile

DELRIDGE WAY SW

25 AVE SW

CLOVERDALE ST

Fauntleroy
Cove

SW TRENTON ST

SW HENDERSON ST

7

SW BARTON ST

252

Chapter 20

West Seattle

Art begins with resistance—at the point where resistance is overcome. No human masterpiece has ever been created without great labor.

ANDRÉ GIDE 1869–1951

20.5 *Seattle Underwater,* Carl F. K. Cheng

20.2 *Whale's Tail*, Richard Beyer

20.6 *Break Point*, Michael Kennedy

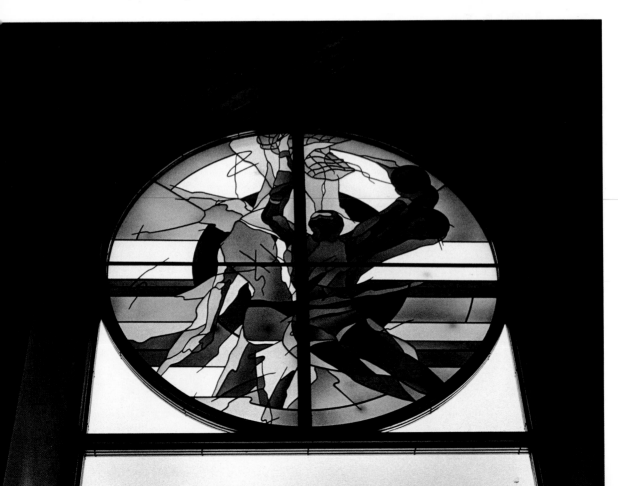

20.1 Totem pole, 1966

Michael D. Morgan
and Robert R. Fleischman

Carved cedar; H 20 ft.
Private gift to the city
Belvedere Viewpoint, SW Admiral Way,
north of SW Olga Street

This pole is a replica of one carved in 1901 by
Bella Coola Indians on the west coast of British
Columbia. That pole was given to the city by
J. E. Standley, a nearby resident and supporter
of Belvedere Viewpoint, and owner of Ye Olde
Curiosity Shop on the Seattle waterfront. Unlike
Seattle's Pioneer Square pole (1.1), the pole was
carved for sale and does not represent any story.
By 1966 the original pole had rotted and was
replaced with this one, carved by two Boeing
engineers who volunteered their time and efforts.
The design includes, from the top, a beaver, a
frog, a whale, and a bear.

20.2 Whale's Tail, 1982

Richard Beyer

Cast aluminum; H 6 ft. 9 in.
City of Seattle collection
Alki Playground, Fifty-eighth Avenue SW
and SW Lander Street (turn off Alki Avenue SW
onto Marine Avenue SW, which intersects
with SW Lander Street)

Whale's Tail is one of several sculptures by Richard
Beyer commissioned by the Seattle Department
of Parks and Recreation in 1982 for children's
playgrounds. Here, a large cast aluminum
whale's tail extends vertically into the air as it
plunges into the sea. Children love it. They can
stand on the flukes and survey the countryside,
or slide down and scamper beneath them.

A few blocks west of Beyer's *Whale's Tail*, next
to the beach off Alki Avenue SW and just across
from Sixty-first Avenue SW, is a small bronze
replica of the Statue of Liberty. It was presented
to the city of Seattle by Reginald H. Parsons and
the Boy Scouts of America in 1952. Mr. Parsons
was a prominent Seattle businessman. He lived
on West Highland Drive on Queen Anne Hill and
the yard to that home is now the Parsons Rose
Garden, another gift from the Parsons family to
the city.

20.3 Positive-Negative and Salmon Ladder, 1986 and 1988

Ronald W. Petty

Painted fiberglass; cast concrete
Metro collection
Metro Alki sewage treatment plant,
Beach Drive SW and Benton Place

Salmon Ladder is a collection of concrete salmon
cast in bas-relief at the southwest wall of Metro's
sewage treatment facility. Two years earlier, Petty
created *Positive-Negative* for placement on the
opposite side of the building. The two painted
fiberglass panels depict swimming salmon, in a
design that incorporates the yin-yang concept
used in Asian art. This earlier work can be viewed
by turning off Beach Drive SW and then going
left at either SW Wilton Court or SW Hinds
Street.

20.4 Totem pole, 1976

Robin Young

Carved cedar; H 17 ft.
Private gift to the city
West Seattle Recreation Area,
Thirty-fifth Avenue SW and SW Alaska Street

This totem pole was carved as part of Robin
Young's studies at Edmonds Community College
and was purchased and given to the city by the
West Seattle Chamber of Commerce. The artist is
a Sioux, a tribe of the north central United States
that did no totem pole carving. The figures are,
from bottom to top, Beaver, Raven, Whale (with
dorsal fin missing), and Thunderbird. It was
accented with red and black paint, which, with
the silver color of weathered cedar, gives the
pole an antique appearance.

20.5 Seattle Underwater, 1982

Carl F. K. Cheng

Plexiglas and water; H 6 ft. × L 12 ft.
Seattle 1% for Art Program
Myrtle Street Reservoir, on SW Myrtle Street,
between Thirty-fifth and Thirty-sixth avenues SW
(on the hill and just south of the blue water
towers) **(artwork to be removed in** 1991)

Carl Cheng's *Seattle Underwater* (see page 253) is one of the most unusual artworks in Seattle's public places and provides a unique view of the city through the prismatic and distorting effects of water and Plexiglas. The Plexiglas distortion (which is barely evident) was designed to direct the viewer's attention to the panorama beyond. The scene is further enhanced by bubbles rising from the bottom of the tank and appearing to come out of the distant buildings. The bubbles are rather comical disk- and ring-shaped little creatures of varying sizes that wiggle to the surface at computer-programmed intervals. The scene is accentuated at night with hidden lights at the top of the tank.

Seattle Underwater was installed as part of the Seattle Water Department's renovation of the perimeter of its Myrtle Street Reservoir. The reservoir is on the highest spot in Seattle, and Cheng chose to install this twelve-foot window in the surrounding chain link fence to allow a transformed view of the city.

20.6 **Break Point,** 1982

Michael Kennedy

Stained glass; dia. 7 ft.
Seattle 1% for Art Program
High Point Community Center,
6920 Thirty-fourth Avenue SW (one block east of the Myrtle Street Reservoir and water towers)

Michael Kennedy's colorful depiction of basketball players is located on the north side of the new triangular wing of the gymnasium. *Break Point* was commissioned by the Seattle Department of Parks and Recreation.

20.7 **Mother Reading with Child,** 1961

Charles W. Smith

Cast bronze; H 4 ft. 6 in. × W 2 ft. 10 in.
Seattle Public Library collection
Southwest Branch Library,
9010 Thirty-fifth Avenue SW

Mother Reading with Child is an abstract bronze wall sculpture showing a mother sitting on a chair with her legs crossed at the ankles, reading

to the child in her lap. The design is in an early style of Seattle artist Charles Smith and is radically different from his later geometric sculptures elsewhere in Seattle's public places (9.10 and 12.34).

20.7 *Mother Reading with Child,* Charles W. Smith

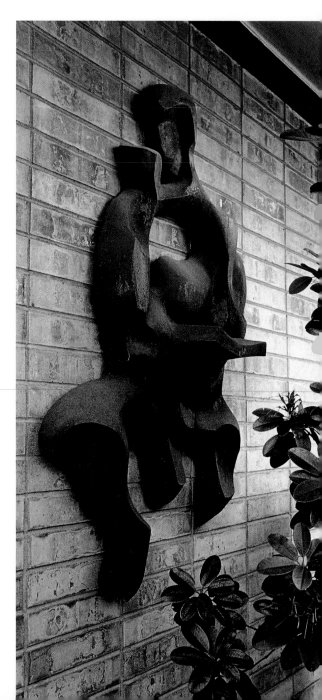

20.8 *The Boxers*, Paul Marioni

20.8 **The Boxers,** 1980

Paul Marioni

Cast glass; H 6 ft. × L 14 ft. 7 in.
Seattle 1% for Art Program
Delridge Community Center,
on Delridge Way SW, just north of the
intersection with SW Alaska Street

Paul Marioni's boxing scene at the Delridge
Community Center is composed of seventy-
eight squares of cast translucent glass. The two
opponents are fighting before a crowd of thirty-
seven spectators. Although each glass block
depicting spectators was cast from the same
mold, each face was fashioned individually to
make it unique. The squares are held together
with clear cement to give the scene a more
unified appearance, uninterrupted by the
strips used in leaded glass designs.

Before creating *The Boxers*, Marioni and others
spent eighteen months researching and experi-
menting with glass-casting techniques to perfect
a new technique to create such a large glass
mural. The end result is the first figurative cast
glass window made in the United States since
one was made for Rockefeller Center in 1929.

The Boxers is one of three cast glass artworks
by Marioni in Seattle's public places. In 1984 he
created *Khadi,* a large work for the Seattle Police
Department's North Precinct Station (18.2), and
in 1988 he and Ann Troutner created *Seven
Figures* for Evans Pool at Green Lake (17.9).

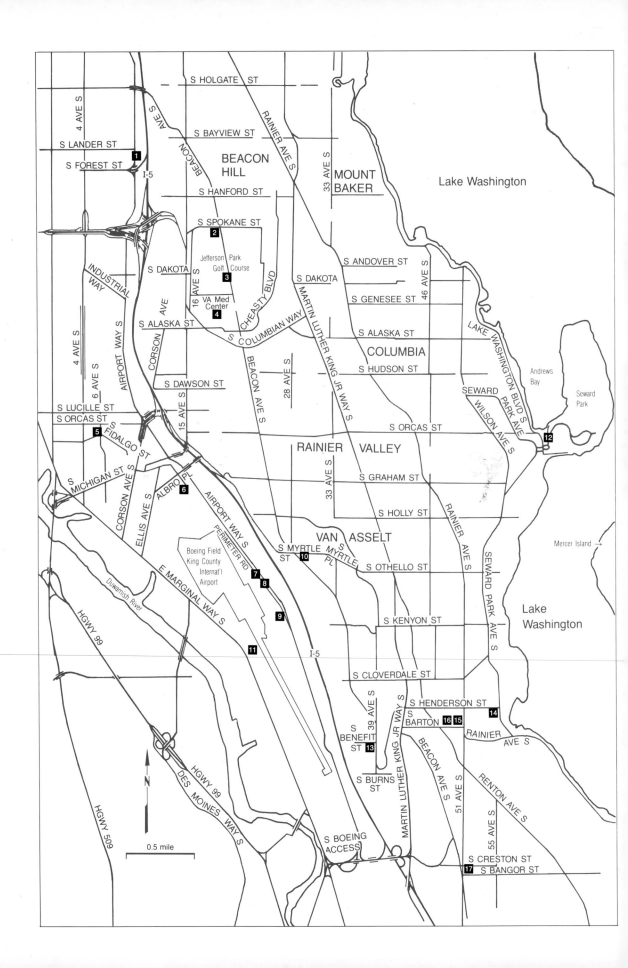

S HOLGATE ST

4 AVE S

S LANDER ST
S FOREST ST
[1]
I-5

BEACON
AVE

BEACON
HILL

S BAYVIEW ST

RAINIER AVE S

33 AVE S

MOUNT
BAKER

Lake Washington

S HANFORD ST

INDUSTRIAL
WAY

S SPOKANE ST
[2]

Jefferson Park
Golf Course
[3]

S DAKOTA

16 AVE S

VA Med
Center
[4]

CHEASTY BLVD

S ALASKA ST

CORSON
AVE

S COLUMBIAN WAY

MARTIN LUTHER KING JR WAY S

S DAKOTA

S ANDOVER ST

46 AVE S

S GENESEE ST

S ALASKA ST

COLUMBIA

S HUDSON ST

LAKE WASHINGTON BLVD S

AIRPORT WAY S

4 AVE S

6 AVE S

S LUCILLE ST
S ORCAS ST
[5]
S FIDALGO ST

S DAWSON ST

15 AVE S

BEACON AVE S

28 AVE S

S ORCAS ST

Seward
Park
Ave

WILSON AVE S

Andrews
Bay

Seward
Park

[12]

S
MICHIGAN ST

CORSON AVE S

ELLIS AVE S

ALBRO PL
[6]

AIRPORT WAY S

PERIMETER RD

Boeing Field
King County
Internat'l
Airport

S GRAHAM ST

33 AVE S

S HOLLY ST

RAINIER VALLEY

VAN ASSELT

S MYRTLE
ST
[10]

MYRTLE
PL

S OTHELLO ST

RAINIER AVE S

SEWARD PARK AVE S

Mercer Island →

HGWY 99

Duwamish River

E MARGINAL WAY S

[7]
[8]

[9]

[11]

I-5

S KENYON ST

Lake
Washington

S CLOVERDALE ST

HGWY 99

DES MOINES WAY S

N

0.5 mile

39 AVE S

S
BENEFIT
ST
[13]

MARTIN LUTHER KING JR WAY S

S HENDERSON ST
[14]

S BARTON [16] [15]

RAINIER
AVE S

S
BURNS
ST

BEACON AVE S

51 AVE S

RENTON AVE S

55 AVE S

HGWY 509

S BOEING
ACCESS

S CRESTON ST
[17] S BANGOR ST

Chapter 21

South Seattle

Art comes to you proposing frankly to give nothing
but the highest quality to your moments as they pass.

WALTER PATER 1839–1894

21.8 *Inukshuk,* Lawrence Beck

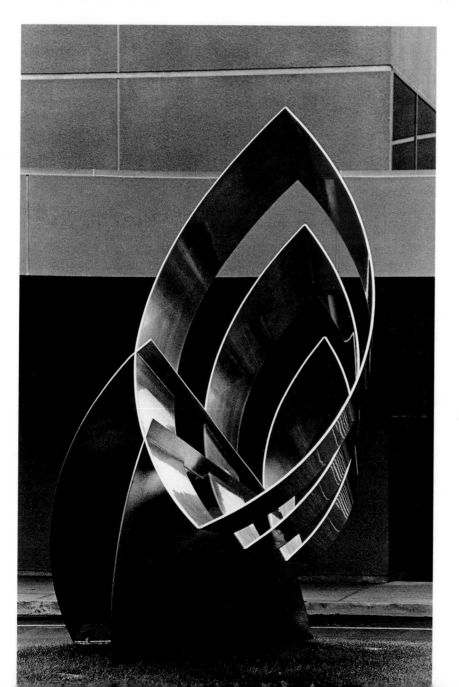

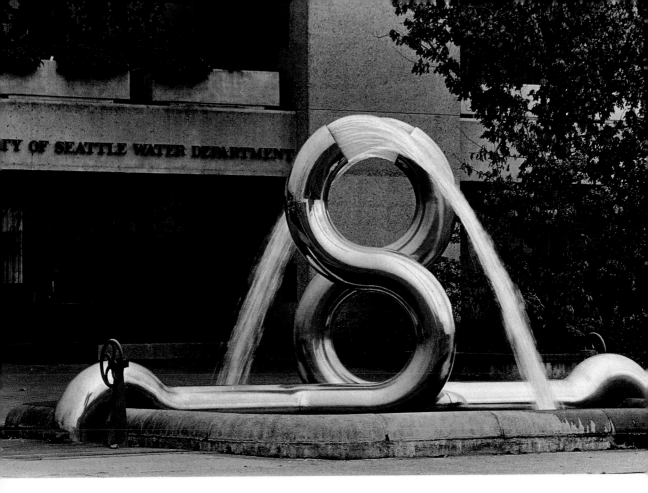

21.1 Untitled fountain, Ted Jonsson

21.2 Untitled sculptures, Ellen Ziegler

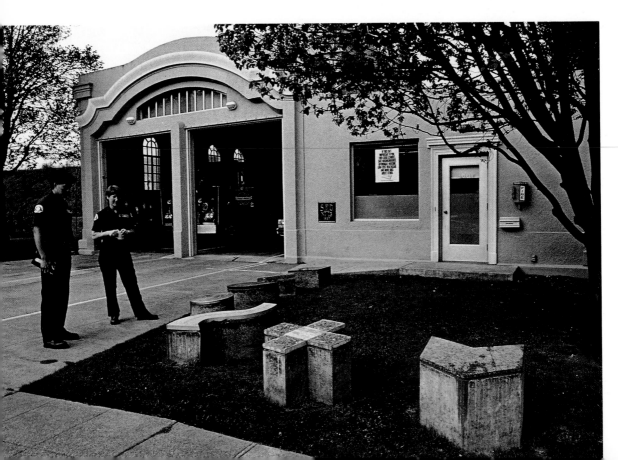

21.1 Untitled fountain, 1971

Ted Jonsson

Stainless steel; H 10 ft. × L 24 ft. × depth 5.5 ft.
City of Seattle collection
City of Seattle Water Department Operations
Control Center, 2700 Airport Way S

Ted Jonsson's fountain at the Seattle Water
Department's Operations Control Center is a
startling contrast to the industrial buildings along
Airport Way S. At first glance, the metal tubes
appear to be shooting forth solid columns of
water. This is the illusion Jonsson intended
to create. Solid columns of water would be
impossible given the size of the tubes and the
available water pressure. In fact, each column
of water is hollow. Jonsson reports that creating
the desired solid effect required considerable
experimentation.

Note how the water is not mere decoration but
is an extension and part of the sculpture. In this
respect his fountain is similar to those of George
Tsutakawa, whose approach to fountain design
had considerable influence on Jonsson's work.

In keeping with his view that art should elicit
responses, Jonsson intended the viewer to change
the water flow by turning the large valves on the
edge of the pool. However, that element of the
original design was never completed, and the
valves are inoperative.

This fountain was commissioned by the
Seattle Water Department and the Seattle Arts
Commission using funds set aside from the
building's construction budget. The selection
process was formulated in 1971, two years
before passage of the city's 1% for Art ordinance
(discussed earlier in A Historical Overview),
and became the prototype for future selections
by the city.

After receiving this commission, Jonsson
completed two other stainless steel sculptures:
Pantopol at Sea-Tac Airport (22.11) and *Torque*
on an upper patio of the First and Blanchard
Building, a condominium in downtown Seattle.

21.2 Untitled, 1988

Ellen Ziegler

Stone and metal
Seattle 1% for Art Program
Fire Station 13, 3601 Beacon Avenue S

Ellen Ziegler's unique creation on the lawn in
front of Fire Station 13 consists of seven stools
made of concrete columns, each of which is
topped with a different material and includes part
of a story of old Japan. The story concerns a
farmer on a mountain who had no time to get to
the people in the village below to warn them of
an approaching tidal wave. So he set his rice crop
on fire, and the villagers rushed up to help him
fight the fire. The wave devastated the empty
village, but four hundred lives were saved by
the farmer's action. In several cases the story is
referred to by the shape of the stool. For instance,
one stool is flame-shaped and another is wave-
shaped.

21.3 Sherwood Gillespie Memorial, 1915

Max P. Nielson

Cast bronze; H 5 ft. 7 in.
Private funding
Jefferson Park Public Golf Course,
in front of clubhouse on Beacon Avenue S

Dedicated in 1915, the small monument to
Sherwood Gillespie at Jefferson Park Public
Golf Course is one of the oldest works of art
in Seattle's public places. It consists of a granite
pedestal slightly over four feet high, flanked on
each side by small bronze drinking fountains and
topped by a small bronze statue of a young golfer
(now minus his club) who has just completed his
swing. The bowls of the drinking fountains are
encircled by bronze fish.

On the face of the pedestal is a medallion
with a bas-relief profile of Sherwood Gillespie
(1853–1912). A bronze medallion on the back
explains that the work was erected in memory of
Mr. Gillespie, an ardent golfer, who introduced
the idea of a municipal golf course for Seattle.

Max P. Nielson, who created this statue, also
created the bronze bas-relief Henry Yesler
memorial plaque, attached to the west side of
the King County Court House in downtown
Seattle (Third Avenue and James Street).

21.3 *Sherwood Gillespie Memorial*, Max P. Nielson

21.4 **The Veterans Lobby,** 1986

Richard Posner

Glass mural and mosaic
U.S. Veterans Administration,
Art in Architecture Program
Veterans Administration Medical Center lobby,
1660 S Columbian Way
(S Columbian Way and Beacon Avenue)

The Veterans Lobby encompasses the 900-square-foot main entry of the Seattle Veterans Administration Medical Center. The glass blocks on three sides of the entry have different textures and are arranged in a quiltlike pattern. Inside and to the left are two murals made of narrow stationary louvers of etched and painted mirrors.

These are also visible from the outside. At first glance the murals may seem to be designs composed of geometric shapes: the top one with black and white forms and the bottom one with orange and black. A closer look reveals that each mural presents a different scene depending on whether one views it from the right or left. From either angle, one sees a cheery blaze in a fireplace below with a picture above. Viewed from the left, the top mural shows three uniformed members of the armed forces, two men and a woman, with one soldier holding his sword aloft. From the right, the scene shows a farming couple with their chicken. He plows the field. She sows the seed.

Posner's design was inspired by the ancient Roman legend of Cincinnatus. Around 456 B.C., Rome was surrounded by the warring Aequians and defeat seemed imminent. Rome's senators sent for Cincinnatus and offered him a dictatorship to save the republic. Cincinnatus, who was found plowing his field, accepted the position and saved Rome, but refused all honors for his deeds. He returned to his farm, where he remained until the age of eighty, when he was called again to serve Rome and saved it from civil war. As one might expect, Cincinnatus was considered a model of Roman virtue.

The Veterans Lobby was a collaboration between Richard Posner and the building's architects, the NBBJ Group.

21.5 **Rain Fountain,** 1973

George Tsutakawa

Stainless steel
Private collection
Design Center Northwest, 5701 Sixth Avenue S

George Tsutakawa's *Rain Fountain* is his first departure from bronze for one of his fountain-sculptures. In addition, most of his other fountains have water bubbling or cascading over or spraying against the surfaces of the sculpture. Here, the water merely drips through successive stainless steel sieves until a column of water is created. Tsutakawa allows the water to fall "like a soft Seattle rain." "I like this work very much," Tsutakawa says. "I had always wanted to make a fountain using this concept. I did one for the Burien Public Library [14700 Sixth Avenue SW], but this one is the most successful. I haven't seen anyone else use this idea." Tsutakawa's third and largest rain fountain was created in 1981 for the lobby of the KING Broadcasting Building (7.43).

21.4 *The Veterans Lobby*, Richard Posner

21.6 **Ruby Chow Park dragon sculpture**

Chinese artisans

Carved marble
Gift to King County
Ruby Chow Park,
Stanley Avenue S and S Albro Place
(north edge of Boeing Field,
at the edge of Georgetown)
(not displayed in winter)

On top of the knoll at the northeast corner of
Ruby Chow Park is a classic Chinese design,
carved in marble and depicting the age-old

symbol among swirling clouds. The dragon is
one of the most prevalent symbols in traditional
Chinese art and symbolizes a wide variety of
characteristics and virtues, including imperial
power, beneficence, vigilance, and restraint
against greed. This carving was donated by the
family of Ruby Chow, the park's namesake, a
community leader who served three terms on
the King County Council. It was incorporated
into the park design by landscape artist Michael
McCafferty and by Richard Haag Associates, the
park's landscape architects. Dedicated in 1987,
Ruby Chow Park was the first collaborative artist-
architect design team project undertaken by the
King County Arts Commission.

21.7 Crystals, 1983

Valdis Zarins

Brass pipes; H 10 ft.
King County 1% for Art Program
King County International Airport (Boeing Field),
north end of terminal

This set of vertical brass pipes is described by
Zarins as a combination of sculpture and kinetic
art, which is an approach he has been working
with since 1968. Turned off, the work is simple
brass pipes; but when water is forced out of the
top of each pipe at the proper velocity, it flares
out, thus extending the metal with sculptural
shapes of water. The simple is made complex.

21.8 Inukshuk, 1980

Lawrence Beck

Stainless steel; W 8 ft.
King County 1% for Art Program
King County International Airport (Boeing Field),
in front of terminal

Lawrence Beck's two-ton *Inukshuk* (see page 259)
is part of a series of works that include in their
titles the Inuit (Eskimo) word meaning
"sculptural presence." Inukshuks are piled stones
that nomadic Eskimos used as markers of human
presence at a spot. According to its creator, this
work is whatever the viewer perceives it to be.
"Sculpture," he says, "is general and it will be
meaningless if you bring no awareness to it. You
will get the most out of it if you view it with some
understanding of modern art."

 This gleaming sculpture is similar to Beck's
stainless steel *Poktalaruk Inukshuk* located at
Highline Community College. That name means
"floating shape" in the Inuit language.

21.9 Double Concave Pentagon, 1985

Robert Maki

Cor-ten steel; H 10 ft.
Private gift to King County
7675 Perimeter Road (Boeing Field,
Portland Street and Perimeter Road,
south of airport terminal,
in front of American Avionics Building)

21.7 *Crystals*, Valdis Zarins

Robert Maki's *Double Concave Pentagon* is the
smallest of his works in Seattle's public places and
is an unusual design for this prominent Seattle
sculptor. Most of his works, such as his *Central
Plaza Sculpture* at Sea-Tac Airport (22.10), consist
of large intersecting and often horizontal planes.
Here, Maki has created a slim vertical plane
with no intersecting or adjoining surfaces. Maki
reports that the shape is "the void from another
sculptural concept" he has used in other
sculptures. "It comes from a black hole,"
he concludes, "an idea that intrigues me."

 Double Concave Pentagon was a gift to King
County from Jack Shannon, the president and
chief executive officer of Shannon Engineering,
a consulting firm located at the airport.

21.10 **Untitled mural,** 1983

Liza Halvorsen

Ceramic tile and sculpture; 225 sq. ft.
Seattle 1% for Art Program
South Precinct Police Station, 3001 S Myrtle Street
(east of Beacon Avenue)

When the Seattle Police Department South
Precinct Station was built in 1983, its design
included a large collection of tile salmon created
by Pacific Northwest artist Liza Halvorsen. The
central focus is a 225-square-foot mural that
extends along the wall above the reception desk
and wraps around the right side. Other salmon
swim along the edge of the reception desk.

On the west side of the entry one can see
salmon swimming from the outside into the
building, and on the east side they are leaving the
building, jumping over the drinking fountain as
they swim away. Additional fish swim through
the women's locker room, but that is not a public
place so viewers must be content with the
viewable collection.

In the reception area mural, Halvorsen's
salmon swim by island shapes through colors
reminiscent of nearby waters on rainy days. The
tiles were fired using the raku process, where
the glazed, fired clay is taken out of the kiln and
placed in combustible material such as sawdust.
The resulting chemical process creates crackled
surfaces and rich iridescent colors. The other
salmon in the station were made from brick clay,
a much more durable material.

Halvorsen's creation was inspired by sights
seen from her home on Lopez Island, eighty
miles north of Seattle in the San Juan Islands.
The mural is part of her series of ceramic works
depicting fish and aquatic life. Halvorsen's
thought was that the water scene and the grace-
fully swimming fish would be tranquil subjects
for a police station, where life can be hectic for
employees and visitors alike.

This artwork was commissioned by the Seattle
Arts Commission and was a design team project
with the building's architects, Arai/Jackson
Architects.

21.10 Untitled mural, Liza Halvorsen

21.11 **Gyro No. 1,** 1976

Robert George Becker

Painted steel; H 17 ft.
King County 1% for Art Program
King County International Airport Building,
8190 E Marginal Way S, on west side of airfield,
near observation tower

The creator of *Gyro No. 1* was also the architect
of the King County International Airport
Building. When the building was completed,
he recommended that a kinetic sculpture, using
wind in its design to fit the surrounding airfield
environment, be placed at its front. Becker's
proposal had the piece tipping on its horizontal
plane, but budget restrictions permitted only a
more simple turning design. According to airport
personnel, "In a south wind the piece turns like
a weather vane, but in a north wind it goes like
hell. We haven't figured out why."

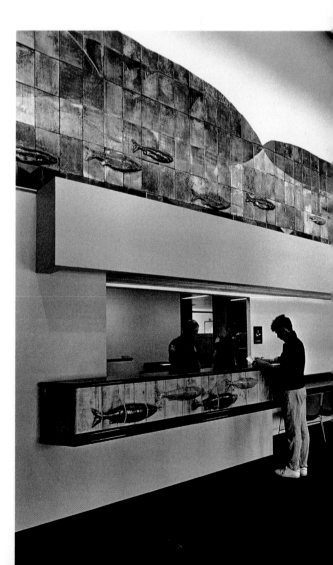

21.12 **Lanterns and Boulder,** 1976

Anonymous artisans

Carved granite
Private gift to the city
Seward Park, entrance

Standing at the entrance to Seward Park is a grouping of three traditional Japanese lanterns and an inscribed granite boulder. They were placed here in 1976 to commemorate the gift of 1,000 cherry trees from the citizens of Japan to the citizens of the United States. The trees were presented in honor of this country's bicentennial.

The lanterns were carved in Japan from Washington State granite and donated by the Japan-America Society, Japanese Community Service, and the Shunji Club of Seattle. The large central boulder was dedicated by Japanese Community Service and bears an inscribed duplication of calligraphy painted by Takeo Miki, the prime minister of Japan. Miki's message, which was rendered in Seattle by a local artisan, says, "Congratulations on the bicentennial of the United States of America's independence."

In the children's play area of the upper portion of Seward Park are three poles carved in 1977 by Seattle artist Richard Beyer. They are part of a large collection of Beyer sculptures in Seattle's public places.

21.13 **Common Ground,** 1982

Joe Wheeler

Sandstone and granite
Community funding
Benefit Playground,
Thirty-ninth Avenue S and S Benefit Street

Joe Wheeler's *Common Ground* is his statement that all beings share a spiritual "harmonious common ground" on earth. His design is a three-part grouping of dissimilar boulders gathered together in a unified whole. On the north side raw, jagged boulders are placed on steps. On the south side the boulders are smooth and stand on a ramp. In the center are two large sandstone columns. Wheeler explains that the vertical uprights "are like the split tower of a religious building or a great rock spire, cracked . . . by natural forces. It is open and inviting, revealing its secret." That secret, Wheeler concludes, is that one must "open up and listen to one's natural self. In this way, art functions as a catalyst."

The artist chose stone to illustrate his theme because "it has a cleanness and respectability" and leads the viewer to a spiritual feeling. The stone used here was collected from local quarries and selected for its durability and strength. The sandstone is the same type used for the State Capitol Building in Olympia and many of Seattle's downtown buildings.

21.13 *Common Ground,* Joe Wheeler

Wheeler wanted to create an "architectural feeling" with *Common Ground*. He has said that architecture "shapes our feelings and sense of well-being in life." It is, he concludes, "the very influential space people consistently enter and relate to."

Common Ground was commissioned by the Southeast Seattle Arts Council, a neighborhood group called South East Effective Development, residents of Beacon Hill, and the Seattle Arts Commission.

21.14 The Story of Clean Hands, 1982

Richard Beyer

Carved brick
Metro collection
Metro pumping facility, Seward Park Avenue at Henderson Street, exterior east wall

Richard Beyer wanted to include clean water in the theme of his design for the wall of this Metro facility because Metro was responsible for reversing serious pollution problems in Lake Washington. Beyer depicts the story of a man who had dirty hands but could not wash them because all of the available water was dirty. The man embarked on an arduous search for clean water. At the south end of the lake he fought off vicious alligators. Farther along the shore he encountered ferocious birds. When he finally reached clean water, he plunged his hands in to wash them and his hands fell off. Although this tale may be inconsistent with the story of Metro's successful efforts, it is a good example of Beyer's penchant for humor.

21.15 The Children, 1985

Richard Beyer

Cast aluminum; life-size
City of Seattle collection
Rainier Beach Branch Library,
9125 Rainier Avenue S

This sculpture of three children, a black, a white, and an Asian, sitting on a bench reading is by Seattle artist Richard Beyer. Around the edge of the bench are the words "Dedicated to Victor H.

Dickson, Educator, Friend and Caring Member of the Rainier Beach Community." Dickson was a very popular principal of Emerson Elementary School who died in 1983. His neighbors and friends in the community commissioned the sculpture to reflect his love for children and the arts. Beyer's sculpture was chosen after a community-sponsored competition.

21.16 Broken Wave and Clear Day, 1981

Emily Hall Morse

Collage murals
Seattle Public Library collection
Rainier Beach Branch Library,
9125 Rainier Avenue S

Emily Hall Morse's two murals for the Rainier Beach Branch Library were commissioned by the Seattle Public Library Board of Trustees with assistance from the Seattle Arts Commission. Both are collages created by applying an acrylic paint wash to canvas and then applying Japanese mulberry paper painted with casein and oil.

The designs of these murals are derived from nature, a subject which profoundly influenced Morse's work. *Broken Wave* is a nineteen-foot-long triptych with applied paper in shades of blue, red, and orange. *Clear Day* is a seven-foot-high vertical work with the same sky blue background but with applied paper painted black, yellow, and white, with blue and gray tones.

21.17 Untitled, 1982

Clair Colquitt, Ries Niemi, and Merrily Tompkins

Mixed media
Seattle 1% for Art Program
and Seattle City Light
Creston-Nelson Electrical Substation,
Fifty-first Avenue S and S Bangor Street

When Seattle City Light commissioned designs for its Creston-Nelson Electrical Substation, it sought those of artists as well as architects. As a result, this substation is a collaborative effort, with art by three Seattle artists incorporated throughout the facility.

21.16 *Broken Wave*, Emily Hall Morse

The entry gates on the south side, designed by Clair Colquitt, depict an electrical outlet with current emanating from each side. When opened, the gates plug into stainless steel and concrete gate stops that are renditions of three-way electrical connectors. The gates are flanked by two-foot-high aluminum light bulbs designed by Ries Niemi.

A pathway winds behind the substation and serves as the "electrical cord" connecting several light-bulb-shaped clearings. Each clearing has a sculpture whose theme relates to electricity and its use. Viewers can enter the pathway from the north side of the site or at the southeast corner. At the latter point, on the corner of the substation building, is a huge electric plug inserted into an equally large outlet. The cord extends into the concrete path, which winds up the hill.

Up hill is Clair Colquitt's *Electrical Abuse*, a tinted concrete depiction of an overloaded electrical outlet labeled "NO," which stands next to one being properly used and labeled "YES."

The next inset along the path originally had Merrily Tompkins's ceramic tile bust of inventor Nikola Tesla. Repeated attacks by vandals forced its removal.

Farther along the path is Ries Niemi's cast concrete, aluminum, and plastic sculpture, which represents the substation's transformation of high voltage to household current. It also serves as a bench. Three large cast-aluminum light bulbs, representing the substation's transformers, stand on a rectangular concrete pedestal. Three light switches are placed on the side of the pedestal. Between the pedestal and the bench is a smaller concrete base topped with fifteen aluminum light bulbs with switches.

Below the pathway one can also view black designs of electrical symbols interwoven into the substation's chain link fence. Merrily Tompkins refers to the pattern as "Navajo electric."

The Creston-Nelson substation project is the second of three artist-architect collaborations for Seattle City Light substations (see also 16.1 and 18.4). In this project, the artists combined their talents with those of Benjamin McAdoo Associates, a Seattle architectural firm. Except for the gates, the art was paid for by Seattle 1% for Art funds. The gates were purchased independently by Seattle City Light.

This substation was named after John Nelson, the popular superintendent of City Light from 1963 to 1971. Creston refers to neighboring S Creston Street.

21.17 Gate, Clair Colquitt 21.17 Fencing treatment, Merrily Tompkins

Chapter **22**

Sea-Tac Airport

*Art is a human activity having for its purpose the
transmission to others of the highest and best feelings
to which men have risen.*

LEO TOLSTOY 1828–1910

22.14 *Night Flight I*, Louise Nevelson

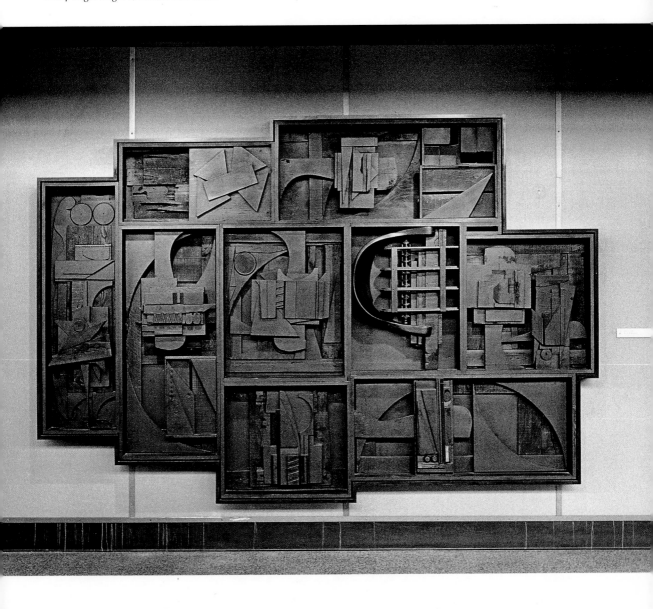

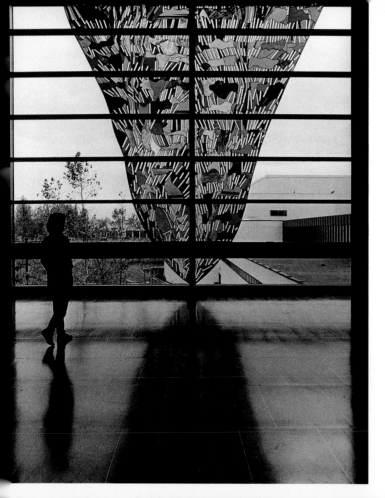

22.1 *For A. W.*, Dick Weiss

22.2 *Star Quarters*, Robert Rauschenberg

The Sea-Tac Airport Collection

In 1969 the Port of Seattle, which owns and operates Seattle-Tacoma Airport, budgeted three hundred thousand dollars for purchasing artworks for its newly remodeled terminal. The money came from revenue bonds, which were repaid with landing fees and airport rental revenues. Sixteen major pieces were selected by a nine-member committee that included local art collectors, museum directors, and airport architects.

The resulting collection is of museum quality and represents a wide range of artistic styles. Most of the works are by Pacific Northwest artists, but three internationally known New York artists—Frank Stella, Louise Nevelson, and Robert Rauschenberg—are also represented.

Since their purchase, the works in this collection have increased in value dramatically, a tribute to the good sense of the purchasing committee. One of the fortunate mysteries is the fact that, although the collection is unprotected, vandalism has been only a minor problem and the works stand relatively untouched for all to enjoy. Remodeling may result in the relocation of a few works, but they will remain in the main terminal esplanade behind the ticket counters.

Those interested in Pacific Northwest Indian designs are directed to the coffee shops in the airport's satellite terminals and the Northwest Shop in the main terminal. Duane Pasco, one of the country's leading Indian artists, has created outstanding carved wood reliefs.

The airport's Meditation Room, located above the Central Plaza and Robert Maki's sculpture, is a little-known space for public use. Designed for quiet reflection, it is graced with woven window coverings by Olympia artist Gloria Crouse, a fold-dye paper mural by Jennifer Lew and Richard Proctor, and a large photograph by Seattle photographer Johsel Namkung. The photograph was taken in 1968 on the ocean beach at Point of Arches on the northwest coast of Washington. The only light is that of the moon. The work is typical of the artist's nature photography; the beauty is that of a small scene that stands on its own regardless of the grandeur of its surroundings.

In 1988 the Port commissioned two stained glass windows for each end of the main terminal esplanade. Created by Seattle artist Dick Weiss, they are the first major artworks to be purchased for the airport since 1969 (22.1).

22.1 For A. W., 1988

Dick Weiss

Stained glass; H 22 ft.
Port of Seattle collection
Main terminal esplanade, south end

The imposing feature in the window at the south end of the main terminal esplanade is Dick Weiss's blue triangle of beveled stained glass. Weiss used an inverted triangle to create a delicately balanced, yet powerful image, and added to its vibrancy by using refracting beveled glass throughout its fourteen sections. His intention was to create "an uplifting, joyful feeling and refer to the positive aspects of man's power," in this case his ability to create something like today's aircraft "in such an amazingly short time." The work is named after the artist's mother, Ann Weiss.

Another large stained glass work by Dick Weiss was subsequently installed at the north end of the esplanade.

22.2 Star Quarters, 1975

Robert Rauschenberg

Serigraph on mirror-coated Plexiglas;
H 4 ft. × L 16 ft.
Port of Seattle collection
Main terminal esplanade, south end

In the early 1950s Robert Rauschenberg was one of America's leading attackers of abstract expressionism and became one of the founders of American pop art. His basic artistic premise is evident in *Star Quarters*—that the commonplace has aesthetic potential. Although paint on canvas is the traditional medium, Rauschenberg and his followers added materials such as rusty nails, rope, and cloth to their paintings. The resulting works are called "combine paintings."

Later, Rauschenberg began using a wider range of images and objects from everyday life: newspapers and magazines, commercial labels, photographs, and printed fabric. Much larger three-dimensional objects followed: dolls, cans, a baseball, and, in his most extreme case, an old stuffed goat encompassed by a tire.

In the 1960s he began experimenting with silkscreen transfers, and that technique was used in *Star Quarters*. The commonplace still appears. This work includes photographs of modern subjects such as a motorcycle, an astronaut, and

a fashion model. His theme of space and flight is emphasized with superimposed astrological symbols and the use of mirror-coated Plexiglas rather than canvas.

Star Quarters is the only work by Robert Rauschenberg in Seattle's public places.

22.3 **Infinity Column,** 1973

Jonn Geise

Neon tubing and Plexiglas;
H 7 ft. 10 in. × L 5 ft. × W 3 ft. 2 in.
Port of Seattle collection
Main terminal esplanade, south end

Jonn Geise's *Infinity Column* is one of the most popular works in the Sea-Tac collection. It consists of six curved, tubular neon lights in a dark glass case. The design becomes infinitely complex as the red, yellow, blue, and green bands reflect off the mirror-coated, one-way glass. Viewers see hundreds of the neon arcs stretching into the distance, and new designs appear as the piece is viewed from different points.

This work is part of a series of "infinity" sculptures Geise created in the sixties and seventies. "In 1966 I was trying to show light as energy in motion," Geise reports, "and I discovered what I could do with mirrors. I originally started with Leonardo da Vinci's studies of optics and measurements of light where he looked at gold mirrors through a small hole in a box. Transparent mirrors allow you to look in and make this type of sculpture possible."

22.4 **Tent Frame,** 1973

Paul Ripley Jenkins

Ebony, vermillion wood, ivory, and basswood;
H 6 in. × L 5 ft. × W 1 ft. 11 in.
Port of Seattle collection
Main terminal esplanade, south end

Tent Frame is the only work by Paul Ripley Jenkins in a public place in Seattle. It was created in 1973, one year before his untimely death from a brain tumor.

Tent Frame uses a theme Jenkins began working with after a 1971 trip to Morocco. While visiting Tangier, he became intrigued with the shapes created by awnings and tents in the marketplaces.

Here the sculpture is a finely crafted skeletal frame. In other works from this series he covered the frame with parchment to create billowing or insectlike shapes.

Jenkins was highly praised for his delicate, sometimes comical sculptural creations. This work, which sits on a base of joined basswood, is a fine example of his unique artistic talents and his superb craftsmanship.

22.5 **Untitled mural,** 1973

Tom Holder

Acrylic paint on canvas; H 5.5 ft. × L 42 ft.
Port of Seattle collection
Main terminal esplanade, south end

In this elaborate work, eight ribbons of bright hues grow out of the corner and progress down two adjoining walls as if waving in a gentle breeze. This mural is related to several paintings Tom Holder created for his graduate thesis in art in order to subtly comment on the contemporary trend of stripe paintings fostered by artists such as Frank Stella and Kenneth Noland.

22.3 *Infinity Column,* Jonn Geise

274

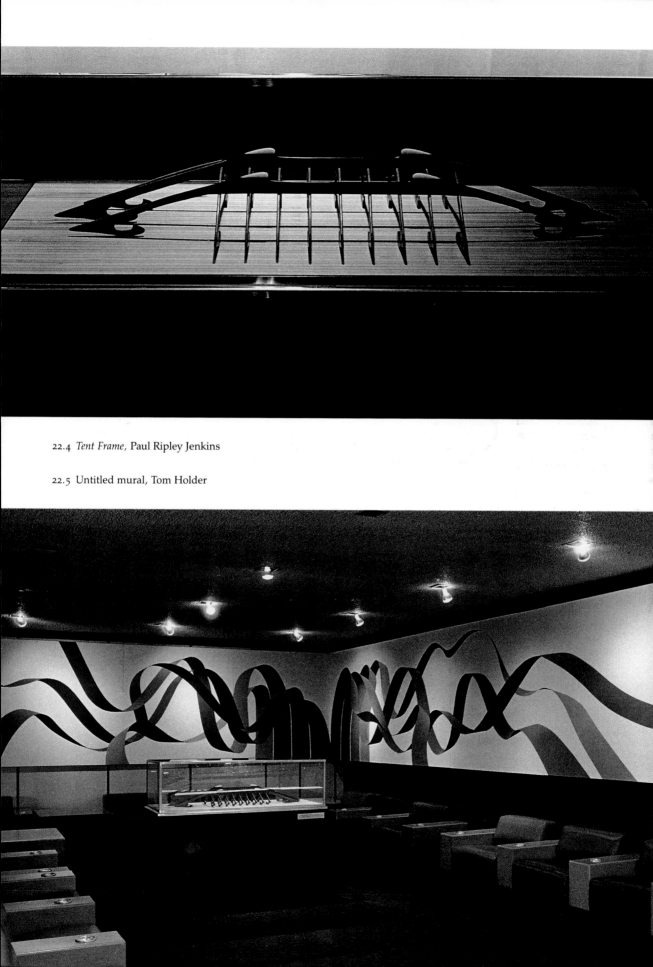

22.4 *Tent Frame*, Paul Ripley Jenkins

22.5 Untitled mural, Tom Holder

22.6 *Spectrum Delta II*, Francis Celentano

22.6 **Spectrum Delta II,** 1973

Francis Celentano

Acrylic paint on Masonite; H 9 ft. × L 46 ft.
Port of Seattle collection
Main terminal esplanade, south end

Francis Celentano's *Spectrum Delta II* is composed of 130 Masonite panels united to form a wall of vibrant optical effects. It is typical of his unusual style, with a dramatic orchestration of color arising from a simple but seemingly complex design. The wall appears to pulsate with red, orange, green, and violet hues surrounding a glowing section of yellow hues, a unique effect created by using an airbrush and painting the color spectrum vertically on panels. Every other spectrum panel was then inverted. The spectrum panels are separated by panels of cool blue, adding to the vibrancy of Celentano's design.

22.7 **Kalpa,** 1973

Christopher English

Acrylic on canvas; each, H 4 ft. × W 3 ft. 4 in.
Port of Seattle collection
Main terminal esplanade, south end

Kalpa consists of three paintings that are identical except for color. Each has a graceful line design that evokes biological, perhaps plant, forms.

22.8 **Noah on a Forty-Year Cruise,** 1982

Alden Mason

Acrylic paint on canvas; 6 ft. 9 in. × 6 ft. 9 in.
Port of Seattle collection
Main terminal esplanade, near concourse B

This large painting is an example of Alden Mason's unique style of creating textured paintings with squiggles of acrylic paint.

The undulating forms are created by applying paint directly from a squeeze bottle over a dark background. The work is a collection of vibrant, rich colors reminiscent of those used in pre-Columbian and other primitive painting, which Mason much admires.

Although previous series of works in this medium consist only of separate lines, this painting includes small abstract images. Mason's next step was to depart from the distinctly separate lines and create figures by stirring the applied lines together. An example of this later style is his *Seattle City Light Promenade* (3.9).

22.9 **Network IV,** 1973

James Seawright and Peter Phillips

Computer-controlled sound and light wall display; H 9.5 ft. × L 30 ft.
Port of Seattle collection
Main terminal esplanade,
opposite entrance doors 17 and 19

Network IV is a unique viewer participatory sculpture that encompasses the room. The light system on the main wall and the room's sound system are controlled by a computer that can be operated from the terminal in the center of the room. Left untouched, the design may be a lighted square floating across the thirty-foot-long wall. If two or three buttons at a time are pressed in different sequences, the squares may be joined or replaced by other alternating designs. The computers operating this high-tech creation are similar to those used in the airport for communications and security as well as operation of the satellite terminal transit system.

Most airport visitors are unsure about this work and are hesitant to touch the computer terminal. However, in creating *Network IV*, Seawright and Phillips not only wanted to emphasize that the flashing lights we see every day in signs and advertising can be an acceptable art form but also intended that viewers participate in their creation.

22.8 *Noah on a Forty-Year Cruise,* Alden Mason

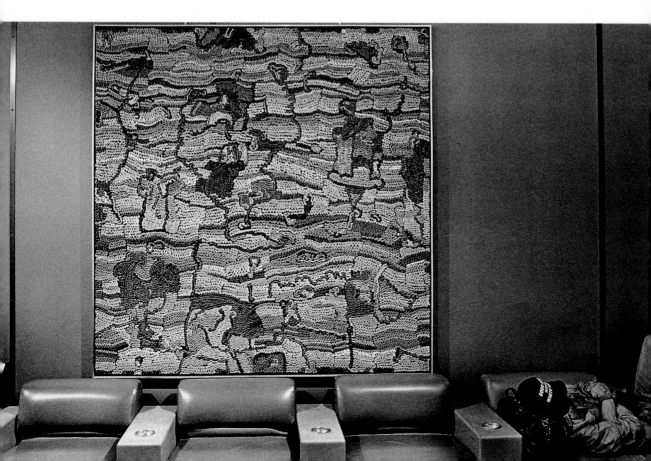

22.10 **Central Plaza Sculpture,** 1973

Robert Maki

Enameled aluminum;
H 11.5 ft. × L 32 ft. × W 21 ft.
Port of Seattle collection
Central plaza, opposite entrance door 21
from the street

Robert Maki's *Central Plaza Sculpture,* the largest
work in the Sea-Tac collection and one of his
largest sculptures, is a splendid study of his
approach to art. Rather than sculpt rounded,
natural shapes, such as those of Henry Moore
(see 4.13), or cubic works, such as those of Ronald
Bladen or Tony Smith (see 7.7 and 7.11), Maki is
concerned with the manipulation of flat inter-
secting geometric planes with which he creates
sculptural forms and voids. The sections of this
piece are all welded at right angles and create
seven parallel systems. The resulting shadows
and spaces and illusionary effects are all parts
of the sculpture.

"A compilation or series of views is part of
what's involved with the piece," Maki explains.
"From many angles the piece shifts from a flat
shape to a knife edge. . . . This is an experiential
piece and as I have worked with degrees of
closure and cantilever and created architecture
within architecture, the spaces have to be
experienced." Maki intended his sculpture to be
viewed from floor level and from the surrounding
balconies to allow "penetration of its different
levels" from the greatest variety of angles and
heights.

22.10 *Central Plaza Sculpture,* Robert Maki

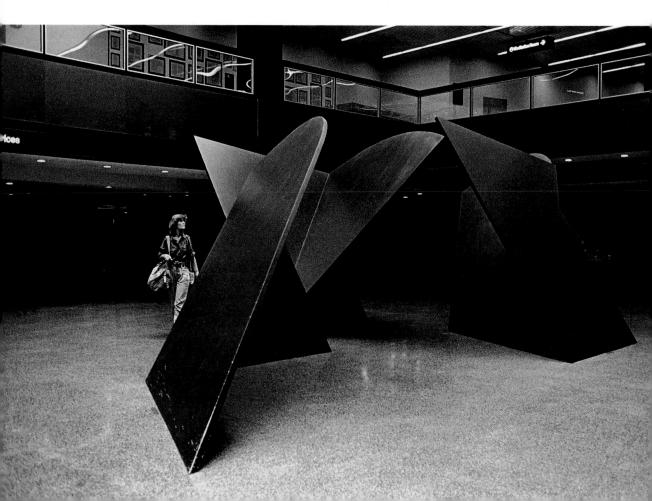

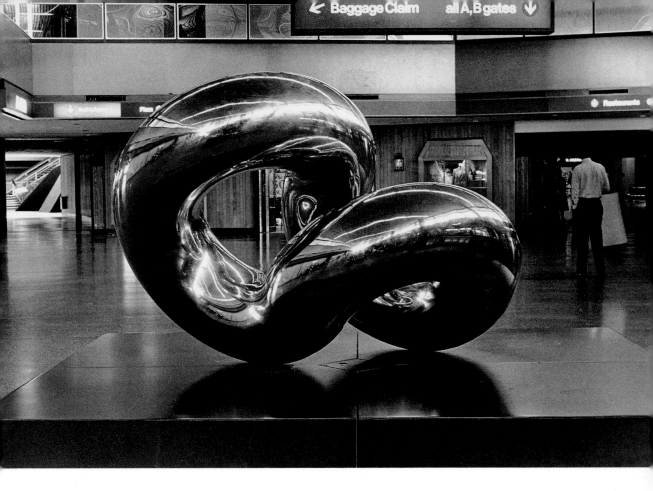

22.11 *Pantopol*, Ted Jonsson

22.11 **Pantopol**, 1973

Ted Jonsson

Stainless steel; H 3 ft. × L 6.5 ft. × W 4.5 ft.
Port of Seattle collection
Main terminal esplanade opposite terminal
entrance doors 23 and 25

Ted Jonsson's *Pantopol* is a smaller relative of his
stainless steel fountain on Airport Way S (21.1).
This creation is not a fountain, but its curvilinear
stainless steel tubing is reminiscent of the earlier,
more grandiose sculpture. He strived with both
to make a simple and direct, but scintillating,
visual statement.

With *Pantopol*, Jonsson intended to create illu-
sion by using a simple form with many surfaces.
"As with my Airport Way fountain, this initially
seems like a simple piece," he comments, "but if
you study it, it's a very complex piece made up
of essential forms, . . . curves, twists, and convex
and concave surfaces." The name *Pantopol* is a
combination of the Greek word *pan* for "all"
and the first part of the word *topology*, the
mathematical study of surfaces.

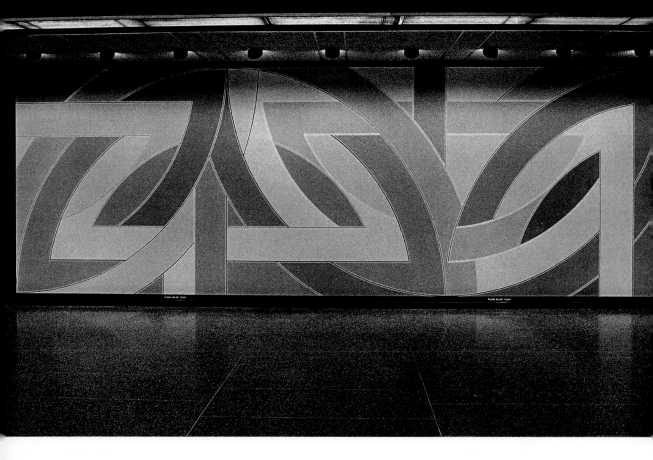

22.12 *York Factory A*, Frank Stella

22.12 **York Factory A,** late 1960s

Frank Stella

Acrylic on canvas; H 9 ft. × L 27 ft.
Port of Seattle collection
Main terminal esplanade,
adjacent to Ted Jonsson's *Pantopol*

In the 1960s and 1970s, American painting was progressing through a time of fervent change and extremes. One of the leaders of that era, along with artists such as Robert Rauschenberg and Andy Warhol, was Frank Stella. In the sixties Stella had become known for his use of geometric shapes and fluorescent colors to make large energetic canvases that often extended beyond traditional rectangular frames. Viewers were continually perplexed when they viewed his brilliant canvases, sometimes shaped like an L or a U, or even an arrow.

By 1967 Stella had moved from vibrantly colored polygon shapes and canvases to more subtle semicircles and circles on rectangular canvases. *York Factory A* is a fine example of his work during this period. It is part of his "Protractor Series," which lasted until 1971. Here, Stella used intersecting shapes to create a complex illusion of depth and movement. Although flat, the painting commands the viewer's attention with its illusory depth and directs the eye along its soft pastel intersecting lines. Typical of Stella's paints, the colors are regular commercial acrylic paints mixed to create distinctive shades.

Stella's approach to his paintings is to present the viewer with nothing more than a visual experience. There is, he has said, no sentiment and no message in his paintings. They are merely objects.

22.13 **Untitled sculpture,** 1973

John Wharton

Acrylic; H 9 ft. × L 5 ft. × W 5 ft.
Port of Seattle collection
Main terminal esplanade, north end

John Wharton's acrylic sculpture is composed
of two levels of clear acrylic shapes, each level
being the mirror image of the other. Intermittent
salmon-colored cubes provide the only color in
the sculpture and create the effect of a futuristic
board game.

22.14 **Night Flight I,** 1973

Louise Nevelson

Painted wood; H 6 ft. 9 in. × L 10 ft. 4 in.
Port of Seattle collection
Main terminal esplanade,
north of the Stella and Jonsson works

There are relatively few women in the history of
art who have acquired international reputations
as sculptors, but Louise Nevelson was unques-
tionably a leader of that group. *Night Flight I* is a
typical example of Nevelson's unique style, and it
is her only work on public display in Seattle (see
page 271). This artwork consists of nine separate
box sculptures containing various found items
that are united with an encompassing frame. The
objects include the back of a chair, pieces of
molding, precut disks, and a ravioli cutter.
Nevelson gave her work a sense of mystery with
a coat of her favorite color, "aristocratic black."
Nevelson's sculpture is not limited to its wooden
shapes. Rather, its shadows are integrated parts
of the whole. "Shadow is fleeting," she once
remarked. "I give it static life."

 Because of Nevelson's ability to combine
smaller assemblages into a harmonious whole,
her works have been likened to musical scores.
Like musical passages, each part can stand alone.
United, the parts create a composition of vitality
and movement.

 Nevelson's sculptures start with an initial
mental blueprint, but they are never meticulously
planned. They just evolve. In the film "Nevelson
in Progress," an interviewer asked her how
she thought of each design. "Darling," she
responded, "how do you eat a pear?"

22.13 Untitled sculpture, John Wharton

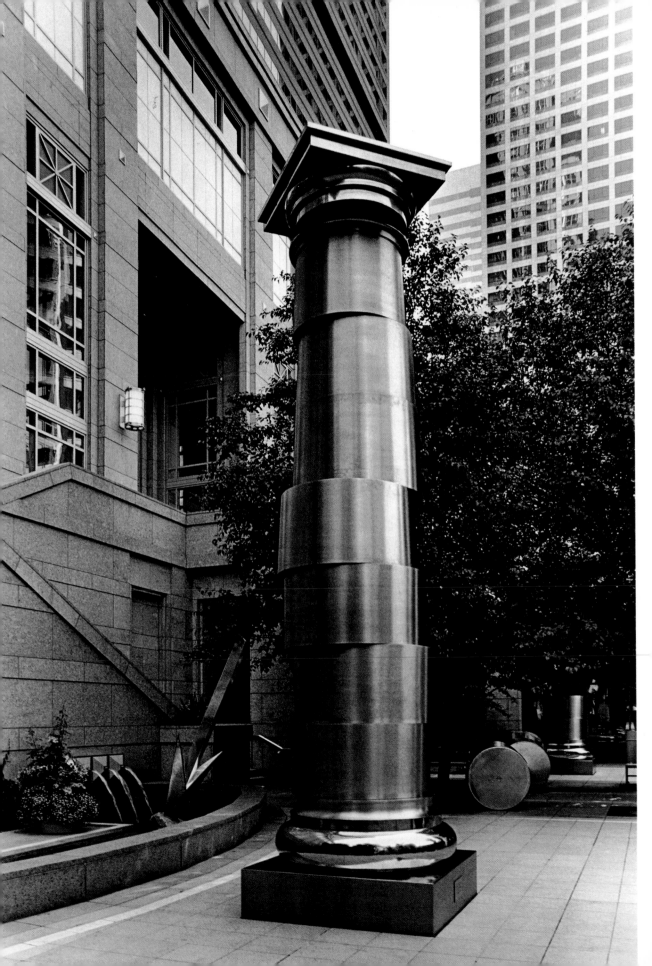

Afterword

Creating any book requires deadlines for completion of the final manuscript, photographs, and maps. In a book such as this, new artworks are installed between the deadlines and the publication date. *New Archetypes,* by Anne and Patrick Poirier, is an example of a work whose inclusion was prohibited by time constraints. This group of stainless steel sculptures is one of the newest additions to the Wright Runstad & Company collection. They stand in the Second Avenue plaza of the Washington Mutual Tower between University and Seneca streets. The artists liken the building to an immense, simplified column, "one of the oldest and most universal archetypes of sculpture." They explain that *New Archetypes* creates "a sort of archeological landscape of the present . . . in which a stroller will be able to evoke past or future voyages." The steel shaft symbolizes a momentary disturbance that could alter the perfection of these eternal archetypes.

Wright Runstad & Company has also installed *Etrusca,* a marble statue by Manuel Niri, in the lobby of its building at 1101 Second Avenue. The statue is one of many Niri works that evokes the *Venus de Milo* and classical Greek and Roman forms.

On the west and north sides of the building at the northeast corner of Second Avenue and Seneca Street are large bronze-colored wings by Seattle artist Ginny Ruffner. They were commissioned by Security Pacific Bank to mark the location of its art gallery on the ground floor. The sculptures are titled *Wings.*

The plaza of the AT&T Gateway Tower at 700 Fifth Avenue sports Parks Anderson's untitled sculpture (4.10). Within the building's public spaces one can see *Night and Day,* Peter Millet's three-part painted steel sculpture, and Gerard Tsutakawa's self-contained fountain. Both were commissioned by the building's developer. Inside the Key Bank lobby (in Gateway Tower) is Barry

New Archetypes, Anne Poirier and Patrick Poirier

Night and Day, Peter Millet

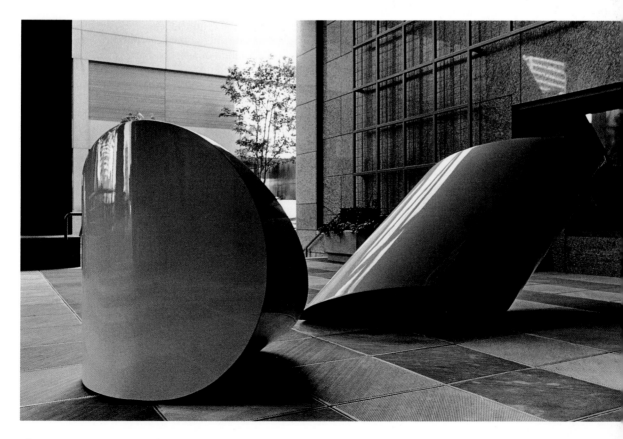

Herem's *Denominations*, a five-part, bronze-and-cedar depiction of a Northwest Coast Indian "copper," whole and in four parts. The copper represented wealth and social position; sometimes it was ceremonially broken or cut.

The Seattle Arts Commission has placed several new works in the Opera House at Seattle Center (Chapter 7), including *Protection (Variation)* a major work by Seattle artist Jody Isaacson. The fourteen-by-eighteen-foot combination of wood-blocks and woodcut reduction prints stands inside the lobby over the main doors. It replaced Lois Graham's *Sargasso Stir* (7.27), which was moved to another location in the Opera House.

A companion for Duane Pasco's Seattle Center totem pole (7.5) is David Boxley's thirty-foot-high Tsimshian "legend pole" located near the Flag Plaza Pavilion. The figures refer to the Northwest Coast Indian's connection to nature and, specifically, the salmon (in the top three figures), the legend of how mosquitos were created (featuring the "Cannibal Giant," second from the bottom), and a cedar carver (at the base), representing the importance of cedar to the native people.

In the University District (Chapter 12), a column of ceramic tiles by Robert Sperry has been installed adjacent to the SAFECO building on the corner of Brooklyn Avenue and NE Forty-fifth Street. It was commissioned by SAFECO in 1991. Visitors to the University of Washington Medical Center can enjoy an untitled landscape artwork commissioned by the Washington State Arts Commission and created by New York artist Mary Miss. Located in the glade southeast of the center, the work includes an array of metal fences, terracing, and nine irregularly shaped concrete pads placed together in the grass. The shapes are particularly interesting viewed from the hospital waiting rooms above.

New works in West Seattle (Chapter 20) include artworks at Weather Watch Park and a collection of large murals on the sides of commercial buildings. The park, located approximately one mile south of the Alki Point lighthouse, was created with privately donated funds by Seattle artist Lezlie Jane and other local artists. Jane included in her design a curved concrete bench inlaid with a bronze relief map of distant Olympic mountain peaks, brick pavers engraved with short sayings and the names of past and present West Seattle residents, and a column containing photographic images and topped with a weathervane. The West Seattle murals depict historical scenes of that area. Five are located in the Alaska Junction district at SW Alaska Street and California Avenue SW. They were made possible by private, city, and county funding.

In South Seattle (Chapter 21), major renovations of Franklin High School at 3013 S Mount Baker Boulevard resulted in an interesting collection of artworks commissioned by the Washington State Arts Commission. Near the entrance is a grove of sculpted keys by Seattle artist Clark Wiegman. They represent the unlocking of knowledge and Ben Franklin's famous electricity experiment with a kite and a key. Inside are bas-reliefs of human figures by Bainbridge Island artist Gayle Bard; four 10-foot-tall columns of artifacts from the original building by Auburn artist Marita Dingus; Seattleite Jim Pridgeon's groups of band instruments and athletic uniforms in the building's cupola that are viewable through a periscope; and two assemblages of old tools that Seattle artist Bill Whipple placed outside the vocational shop.

Other new artworks in South Seattle are Ginny Ruffner's creations at the South Park Community Center (8319 Eighth Avenue S). The painted steel archway is followed by a variety of games formed by bronze and colored concrete inlays in the walkway leading to the center. The inlaid designs include the solar system, Washington's five highest mountains, animal species found in Seattle, and five sports to play in the park. The walls of the center's locker rooms include ceramic tile handprints of neighborhood children. This collaboration of artist and architect was sponsored by the Seattle Arts Commission.

The work of a dozen schoolchildren, under the direction of artist Lupe Carlos III, can be seen in a fifty-foot mural on the side of the Rainier Vista Boys and Girls Club at 4610 Viburnum Court S. They painted a grand parade of themselves celebrating the fiftieth anniversary of the Seattle Housing Authority. Most of the young artists live in the Housing Authority's Rainier Vista community. The project was sponsored by the Pacific Arts Center and community groups.

New works are continually being commissioned or purchased by public and private entities for placement in building lobbies, plazas, parks, and other public places. They may not always rise to the level of Walter Pater's observation that "art comes to you proposing frankly to give nothing but the highest quality to your moments as they pass," but they are worthy of further study.

Biographies

Adams, Alice b. 1930

Alice Adams was born in New York City and now resides in the Bronx, New York. She earned a B.F.A. degree from Columbia University in 1953, after which she received a French Government Fellowship and a Fulbright Travel Grant and studied at L'Ecole Nationale d'Art Decoratif in Aubusson, France. She has received numerous other grants and fellowships, including a Guggenheim Foundation Fellowship (1981) and two National Endowment for the Arts Artist Fellowships (1978 and 1984). Adams has taught and lectured at many schools, including Princeton University (1978), Pratt Institute in New York (1979–80), and the Art Institute of Chicago (1980).

Alice Adams has exhibited her work primarily in New York, including several group showings at the Whitney Museum. Since 1977 much of her work has been devoted to sculpture for public places. She is one of the original five design team artists for Metro's downtown Seattle tunnel project (see 1.8) and designed artworks for the International District (1.13) and Convention Place stations (5.19).

Agam, Yaacov b. 1928

Yaacov Agam is a major, although now lesser known, figure in the kinetic art, or op art, movement of the 1960s. Born in Rishon-le-Zion, Israel (as Yaacov Gipstein), and raised in a deeply religious Jewish family (his father was a rabbi), Agam's approach to art is heavily influenced by Judaic philosophy (see 5.30). His artistic education was obtained at the Bezalel School in Jerusalem (1947–48), the Giedion Art School in Zurich (1949), and the Atelier d'Art Abstrait in Paris (1951). His 1953 exhibit of multifaceted kinetic painting/sculptures at the Craven Gallery in Paris first introduced the world to movable, contrapuntal, and transformable paintings, called "transformations" by some critics, which could be rearranged by the viewer. Later works incorporated optical illusion created by the movement of the viewer, rather than by the use of illusory shapes on a flat canvas, which is common in the more familiar op art works of Victor Vasarely. Although he spent the 1968 school year as a visiting lecturer at Harvard University, Agam has spent most of his career working in Paris, where he has lived for many years.

Alexander, Morrie 1916–73

Morrie Alexander was a master totem pole carver of the Lummi Indian tribe who was also noted for his efforts in teaching schoolchildren about Indian art. From 1971 until his death he was a visiting artist for the Washington State Cultural Enrichment Program, which commissioned him to carve a large pole for the Seattle Public Schools Administration Building (7.33). In 1973 Alexander was en route to the dedication of that pole, his only work in a public place in Seattle, when he was killed in a traffic accident. He carved other poles for the Pacific Science Center, the Washington State Capital Museum in Olympia, the Smithsonian Institution, and for display at Expo '70 in Osaka (later relocated to Tatayama, Japan). Morrie Alexander was also commissioned by the Bureau of Indian Affairs to carve a pole for Franklin Roosevelt and another for John Kennedy.

Alps, Glen b. 1914

Glen Alps was born in Loveland, Colorado, and received his artistic training at the Colorado State College of Education (where he received a B.A. degree), the University of Iowa, and the University of Washington (where he received a master's degree). He began teaching art at the University of Washington in 1945 and is now retired.

Although a well-known artist in this area, Alps gained international recognition for his work in printmaking and collages. His works in those media have been displayed throughout this country and Europe. The type of collage called the collagraph, which is now used throughout the world, was invented by Alps and his students in 1956 (see 4.9, 4.21, and 8.1).

Anderson, Guy b. 1906

Born in Edmonds, Washington, Guy Anderson is one of those Pacific Northwest artists who helped create what some now call the Northwest School of art. Except for a Tiffany Foundation Resident Scholarship in New York during 1929 and trips to California and Mexico in the 1930s, he has spent his life in the Pacific Northwest. He studied for a time with prominent painter Eustace Ziegler, but Anderson is primarily a self-taught artist.

Like many of the leading Northwest artists who began their careers during the first third of this century, he spent many years working for the Seattle Art Museum. Fellow employees and associates included Mark Tobey, Morris Graves, and Kenneth Callahan. At the time, these artists were considered the avant-garde of the thirties. They are now considered the masters of the period.

Anderson has exhibited on both the East and West coasts and his works are included in collections throughout the country, including the Metropolitan Museum of Art in New York and the National Museum of Art in Washington, D.C. (see 7.30 and 12.3).

Anderson, Parks b. 1942

Parks Anderson was born in Seattle and was educated at the University of Washington, where he earned a B.A. in microbiology in 1966 and an M.F.A. in sculpture in 1973. He has exhibited his sculpture throughout the region since 1965. Anderson works in a variety of sculptural media and has gained considerable recognition for his acrylic and cast plastic sculptures. His recent metal sculptures include 4.10, 11.4, and 18.6. In addition to his sculptures, he has also made biological models for use in hospital study and has illustrated a microbiology textbook.

Angell, Tony b. 1940

A native of California, Tony Angell came to Seattle at the age of seventeen—an artistic football player interested in nature and art with no intention of pursuing a career in art. Angell earned a B.A. (1962) and an M.F.A. (in English, 1966) from the University of Washington. He has no formal artistic training, but eventually his inclination toward art (he had been drawing continually since the age of fourteen) evolved into a full-time pursuit, supplemented by teaching and working in conservation programs. He is now considered one of the region's most talented nature artists (see 5.20 and 8.6). He has also gained considerable recognition for his illustrated books on mammals and birds.

Antonakos, Stephen b. 1926

Stephen Antonakos was born in Greece but has lived in the United States since 1930. He has been exhibiting neon sculpture since 1967 and has been included in exhibits throughout this country and in Europe. In addition to his work at Bagley Wright Theatre (7.12), Antonakos has created commissioned public sculptures for Southwestern Bell Telephone's Headquarters in Dallas, Texas; the Federal Building in Dayton, Ohio; Hampshire College in Amherst, Massachusetts; and the Tacoma Dome in Tacoma, Washington.

Armajani, Siah b. 1940

Siah Armajani was born in Iran and came to the United States in 1960 to attend Macalester College in Saint Paul, Minnesota (B.A., 1963). He has lived there ever since and became an American citizen in 1967. Armajani has exhibited regularly throughout the United States since the late 1960s. Many of his best-known artworks have been architectural commissions for offices, reading rooms, and libraries (see 19.4).

Artorez, Arturo b. 1940

Arturo Artorez was born in Mexico City and studied painting and sculpture at the San Carlos School of Fine Arts in Mexico City (1964–66). Artorez has lived and worked in Seattle since 1975. He exhibits his paintings annually in Seattle and elsewhere on the West Coast and in Mexico (see 6.6).

Askman, Tom b. 1941

Tom Askman was born in Leadville, Colorado, and is a graduate of the California College of Arts and Crafts, in Oakland, where he earned a B.A. degree in education in 1965 and a B.F.A. degree in 1966. He received an M.F.A. degree from the University of Colorado at Boulder in 1968. Since 1966 Askman has exhibited his work in numerous solo and group exhibitions in museums and galleries throughout the United States, including the Whitney Museum in New York (1973). Askman has also spent considerable time teaching and lecturing at various colleges and universities in the United States. A resident of Spokane, Askman was one of three artists who created artworks for refurbished Seattle fire stations in 1988 (see 1.5 and 12.37).

Bach, Caleb b. 1939

Born in Berkeley, California, Caleb Bach earned a B.A. degree in environmental design in 1962 from the University of California at Berkeley, where he specialized in furniture, textile, and ceramic design. After service in the U.S. Navy, Bach spent ten years working with the Central Intelligence Agency in Latin America and Europe. At the conclusion of that career, he decided to center his life around art. Since 1976 he has been chairman of the Art Department at Colorado Rocky Mountain School in Carbondale, Colorado.

Bach has exhibited his works in Colorado and New Mexico, but his showings are relatively rare. His two murals at the U.S. Court House in Seattle (4.24) are his only works on public display in the Pacific Northwest.

Balazs, Harold b. 1928

Born in Westlake, Ohio, Harold Balazs has lived in Washington since 1947. He is a graduate of Washington State University (earning a B.A. in 1951). The Mead resident has earned a reputation as an outstanding artist and craftsman. He has worked in almost every sculptural material and has completed numerous sculptures and architectural design commissions. Several examples of both can be seen in Seattle public places (1.15, 3.3, 5.10, 12.32, 14.5).

Barrie, Donald b. 1938

Donald Barrie was born in Juneau, Alaska, and obtained both his B.A. and his M.F.A. degrees from the University of Washington (1967 and 1973). In addition to painting, he has taught at various institutions in this region and in Alaska and Arizona, as well as at Antioch College in Ohio. He has exhibited in Seattle since 1970, and his commissioned works can be seen throughout this state and in Alaska (see 10.2).

Baudoin, Ali b. 1949

Ali Baudoin was born in Rochester, Minnesota, and earned a B.F.A. degree from the University of New Mexico in Albuquerque in 1974. He earned his M.F.A. from the University of Washington two years later. From Seattle he moved to Dallas, Texas, and has since created numerous sculptures for buildings and public places, primarily in Texas. He now resides in Santa Fe, New Mexico (see 9.9).

Beall, Jean Cory d. 1978

Jean Cory Beall, a former resident of Seattle, studied art at the California College of Arts and Crafts in San Francisco, the Parsons School in Paris, the Art Students League in New York City, and the University of Washington. She also studied mural painting in Mexico City at the Instituto Politecnico. Beall was an active muralist throughout the 1950s and created large murals for the Penthouse Theatre at the University of Washington and the Grand Ballroom of the Olympic Hotel. Both have been destroyed (see 3.10).

Beaumont, Linda b. 1950

Linda Beaumont received a B.F.A. in painting and ceramics from the University of Washington in 1974. She has exhibited her art throughout the state. When not pursuing such endeavors, she is a free-lance window designer (see 15.2).

Beck, Lawrence b. 1938

A Seattle native, Lawrence Beck is one-quarter Inuit (Eskimo) and often incorporates that heritage into his artwork. He received his artistic education, both graduate and undergraduate, from the University of Washington (B.A., painting, 1964; M.F.A., sculpture, 1965). In addition to sculpting, he has been an art instructor and a visiting instructor of art at Humboldt State University at Arcata, California, the University of Oregon, and Evergreen State College, Washington (see 16.7 and 21.18).

Becker, Robert George b. 1937

Robert George Becker is a practicing architect in Kirkland, Washington. He earned his B.A. degree in architecture from the University of Notre Dame in 1960 and, before moving to the Seattle area, worked as an architect and planner in Paris and Göteborg, Sweden. Becker has worked only occasionally in sculpture and painting, and *Gyro No. 1* (21.11) is his only public or commissioned sculpture.

Behnke, Ned 1948–88

Ned Behnke was born in Seattle and earned his M.F.A. degree from the Rochester Institute of Technology in 1976. During his art studies, he was moved by the works of Henri Matisse and Claude Monet; the latter's water lily paintings were a particular influence. Behnke created a considerable amount of work with a flower theme, two of which are *Purple Orchid* and *Iris* (9.13), his only works in a Seattle public place.

Bell, Bill b. 1928

Bill Bell is a native of Pittsburgh, Pennsylvania, and resides in Brookline, Massachusetts. After earning a B.A. degree in physics from Princeton University in 1949, he served in the army and then worked as a computer engineer and later as an aircraft pilot. Now a full-time creator of high-tech artworks, an example of which is his collection of sequential light bars in Metro's University Street station (5.7), Bell has placed commissioned artworks in the United States, Canada, and Japan and has exhibited in those countries as well as Brazil.

Bender, James b. 1951

James Bender was born in Summit, New Jersey, raised in Honolulu, and received his college education at the University of Puget Sound (1969–71) and the University of Washington (B.F.A., 1975). He began working in Northwest Coast Indian art at the University of Washington in 1975 and has studied under master carvers Bill Holm, Tony Hunt, and Duane Pasco. Bender's works have been exhibited primarily in the Pacific Northwest and are included in several prominent collections of Pacific Northwest Indian art. His largest pieces to date are two fifty-foot totem poles in Steinbrueck Park (5.27).

Bennett, Douglas b. 1920

Douglas Bennett was born in Stevensville, Montana, and is a graduate of the University of Washington School of Art (B.A., 1946) and the Art Center School in Los Angeles, which he attended from 1947 through 1951. Now retired and living in Port Townsend, Bennett had a successful career as an industrial and interior designer and as a sculptor. Although his only major large sculpture is *Christopher Columbus* (2.5), smaller works have been included in group exhibitions in museums throughout the United States, including the Metropolitan Museum of Art in New York. His modern furniture designs, for which he received considerable recognition, have also been exhibited extensively.

Benson, Maris D. b. 1942

Born in Latvia, Maris Benson came to the United States eight years later and was reared in Seattle. Benson earned a B.F.A. from the University of Washington (1967) and an M.F.A. from Southern Illinois University at Carbondale (1970). Since 1970 he has been a professor of art at Humboldt State University in Arcata, California. He now heads that university's sculpture department. Although Benson's works have been shown throughout the West Coast area, his untitled sculpture in Seattle (19.1) is his only public piece in the Pacific Northwest.

Bernhard, Betz b. 1952

Seattle sculptor Betz Bernhard is a native of Roslyn, New York. She received her art education at the Kansas City Art Institute (B.F.A., 1975) and the University of Washington (M.F.A., 1978). Bernhard has taught art at various institutions in Seattle, including the University of Washington, and at the Art Museum of South Texas. She now lives in Seattle (see 17.5 and 17.6).

Bertoia, Harry 1915–78

Born in San Lorenzo, Italy, Harry Bertoia studied art from 1937 to 1942 at the Arts and Crafts School in Detroit and the Cranbrook Academy of Fine Art in Michigan. He spent most of his career working near Philadelphia. By the time of Bertoia's death in 1978, he was well known as a sculptor and as a graphic and furniture designer.

Harry Bertoia's most famous work is probably the large (seventy feet long and sixteen feet high) sculptural screen created in 1954 for the Hannover Trust Building in New York. His only work in Seattle was commissioned by Seafirst Bank in 1968 (4.15).

Beyer, Richard b. 1925

Richard Beyer was born in Washington, D.C. He attended Columbia University (B.A., English and history, 1950) and then received an M.S. degree in education from the Putney-Antioch School of Teacher Education in Vermont. He later returned to Columbia University and pursued graduate studies in economics, which he continued at the University of Washington after moving to Seattle in 1957. A former Boeing employee, Beyer has been devoting all his time to sculpture since 1966 and has many sculptures in Seattle's public places. Many more of his sculptures appear in public places in western Washington and Oregon, two in Anchorage, Alaska, and a 1988 work in Tashkent, U.S.S.R. In 1989 Beyer moved from Seattle to Pateros, in Okanogan County, Washington.

Bishop, Jeffrey b. 1949

Jeffrey Bishop was born in Berkeley, California, and received his B.F.A. from Tufts University in 1973 and his M.F.A. from the University of Washington in 1977. In 1974 he received the Boston Museum School's James William Paige Traveling Fellowship. In 1982 he was awarded the Betty Bowen Memorial Award by the Seattle Art Museum. In 1983 he was the subject of a "Documents Northwest" exhibit at the Seattle Art Museum. Bishop has exhibited his unique works throughout the United States and is included in many of the region's major collections (see 5.12).

Bladen, Ronald b. 1918

Ronald Bladen was born in Vancouver, British Columbia, and has been an American citizen since 1956. He received his art education at both the Vancouver School of Art and the California School of Fine Arts in San Francisco. In 1960 he began exhibiting monumental minimalist sculptures and has since established himself as one of the important artists in that style of art. Because of the size of his works, he received relatively few public commissions until the early 1980s. Seattle's *Black Lightning* (7.7) was the first of four commissions he received in 1981.

Borofsky, Jonathan b. 1942

Jonathan Borofsky was born in Boston, Massachusetts, and received his artistic education at Carnegie-Mellon University (M.F.A., 1964) and Yale University (M.F.A., 1966). Borofsky has worked in a wide range of mediums, from sculpture and painting to video and installation art. He has exhibited his work throughout this country and in Europe and Japan. His work is included in major private and museum collections, the latter including the Whitney Museum of American Art and the Museum of Modern Art in New York. *Hammering Man* (see page 73) is his only work in a public place in Seattle. Borofsky lives in Venice, California.

Brooks, Richard 1865–1919

Sculptor Richard Brooks was born in Braintree, Massachusetts, and studied in Boston with T. H. Bartlett and in Paris with Jean Paul Aube and Antonin Injalbert at the Académie Colarossi. He had a notable career as a classical sculptor and exhibited in Paris and Washington, D.C. Brooks created major works for the nation's capital as well as for Boston and Hartford (see 5.22 and 9.4).

Burton, Scott 1939–89

Scott Burton was born in Alabama and raised in Washington, D.C. He studied painting with Leon Berkowitz and Hans Hoffman in the late 1950s. Afterwards he studied literature at Columbia University (B.A., 1962) and New York University (M.A., 1963). He began sculpting in the late sixties and exhibited his works in New York beginning in 1971. Burton exhibited in museums and galleries on the West Coast and throughout the United States and created public artworks in many locations in the United States (see 19.3) and Europe. Before his death in 1989, Burton's works were the subject of a museum exhibition seen in Düsseldorf, Stuttgart, and the Musée des Arts Décoratifs in Paris.

Calder, Alexander 1898–1976

Alexander Calder was born into an artistic family in Lawton (now part of Philadelphia), Pennsylvania. His mother was an accomplished painter and his father and grandfather were both sculptors (his grandfather created the famous statue of William Penn on the top of Philadelphia's City Hall). His earliest art studies were limited to drawing.

In the early 1920s he entered the Art Students League in New York and studied with the group of American painters that became known as "The Eight" or the "Ashcan School." In 1926 Calder went to Paris and began his career as a sculptor by carving wood and creating wire structures resembling three-dimensional drawings. He was soon befriended by the avant-garde artists and writers of the time and came under the influence of artists such as Joan Miro, Piet Mondrian, and Naum Gabo. Paris became Calder's second home, and his career was spent with homes on both continents (see 6.2).

Callahan, Kenneth 1905–86

Kenneth Callahan was born in Spokane, Washington, and spent his youth in Glasgow, Montana. A self-taught artist, he began painting as a teenager, inspired by the expansive outdoor scenes around him. At the age of twenty-one he had his first one-man show in San Francisco and thereafter exhibited regularly until his death in Seattle in 1986.

In the 1960s Callahan gained national recognition, with contemporaries Mark Tobey, Morris Graves, and Guy Anderson, as part of what some named the Northwest School of art. His work has been included in exhibits and collections of many of the nation's most prominent museums, including the Metropolitan Museum of Art and the Guggenheim Museum in New York.

During his long career Callahan had visiting teaching posts and artist-in-residence positions at several American universities and museums. From 1933 to 1953 he worked at the Seattle Art Museum and was its curator for fifteen of those years (see 7.17 and 10.7).

Cannon, T. C. 1946–78

T. C. Cannon was a nationally known Native American artist whose works have been included in exhibits throughout the United States. He was born in Lawton, Oklahoma, and lived in that state until 1966, when he began a year of study at the Institute of American Indian Art in Santa Fe, New Mexico. He subsequently studied at the College of Santa Fe and at Central State University, in Edmond, Oklahoma. Cannon's only work in a public place in Seattle is part of the collection displayed at Daybreak Star Arts Center (15.7). Cannon was part Kiowa and part Caddo Indian and at birth was given the name Pai-doung-u-day, which means "One Who Stands in the Sun."

Caro, Anthony b. 1924

Anthony Caro was born in London and received his college degree in engineering. In 1942 he studied sculpture at Regent Street Polytechnic and from 1947 through 1952 at the Royal Academy Schools in London. From 1951 to 1953 he was a part-time assistant to Henry Moore. He has since taught art on a part-time basis in England and spent the 1963 school year teaching art at Bennington College in Vermont.

Caro's sculptures have been exhibited throughout Europe and the East Coast of the United States and are included in the collections of numerous major American museums (see 5.29).

Carr, Alice Robertson b. 1899

Alice Robertson Carr was born in Roanoke, Virginia, and came to Seattle during her childhood. After graduating from Lincoln High School in 1919, she studied for a year in New York with A. Stirling Calder and George Bridgman. In 1921 she became an instructor at Santa Barbara School of Arts. Later in her career she studied with Antoine Bourdelle and Jose de Creeft, whom she subsequently married. Carr's only work in Seattle is the bas-relief at the Woodland Park rose garden (17.2). She also sculpted the artwork on a large memorial to Warren G. Harding that was later destroyed when the Woodland Park Zoo was expanded.

Carter, Dudley C. b. 1891

Dudley Carter was born in New Westminster, British Columbia, and spent his early years on the frontier. By the time he was fifteen years old, Carter had known only three white people other than his family. Because he grew up among the Indians and spent many of his adult years working in the region's forests as a logger, he chose as subjects for many of his sculptures Indian legends and woodland themes and rendered them in cedar, the same wood used by Indian artists.

Carter began working part-time as an artist in 1929. However, throughout his career he continued to work as a forest engineer and timber cruiser; he also operated a small cedar products business. He studied for a short time in Seattle with Dudley Pratt, but he was largely self-taught. In 1945 he taught sculpture at the University of Washington. Carter sculpts primarily with an ax.

Rivalry of Winds (9.3) was Carter's first major work. Later in the 1930s he carved *Goddess of the Forest* for the San Francisco World's Fair. It now stands in Golden Gate Park. Carter also created three carvings at the entrance of Bayview Manor on Queen Anne Hill (11 W Aloha Street). In 1962 he created the large pole at Northgate Shopping Center (19.7), and in 1978 he carved a major piece at Marymoor Park in Redmond.

Cassar, Marianne 1910–87

Marianne Cassar was an architectural designer who operated a stained glass studio in Seattle and created many commissioned works throughout the area. Her art was also placed throughout the United States as well as in Vancouver, British Columbia, and Europe. She was a pioneer in working in the "dalle de verre" stained glass style, which uses thick slabs of glass set in epoxy (see 12.15).

Cassar was born in Philadelphia and studied at both Juanita College and Eastern Seminary, located in Pennsylvania. She earned an M.F.A. degree from Colorado State University and pursued further studies at the Philadelphia School of Design and in New York City at the Art Students League. Cassar also studied privately in Europe and studied art education at the University of Washington. In addition to pursuing her career designing stained glass work, Cassar also taught art at the Honolulu Academy of Art and at public and private schools in Pennsylvania, Washington, and Hawaii. She died in Des Moines, Washington, in 1987.

Celentano, Francis b. 1928

Born in New York City, Francis Celentano received his B.A. degree in art from Washington Square College, New York University (1951), and his M.A. degree from the Institute of Fine Arts, New York (1957). After studying art in Rome in 1958 under a Fulbright scholarship, he returned to the United States and has since been teaching and painting. His works have been included in numerous prominent exhibitions throughout the country, including museum exhibits in New York's Museum of Modern Art and the Whitney Museum of American Art. Celentano has lived in Seattle and taught at the University of Washington since 1966 (see 22.6).

Chase, Doris Totten b. 1923

Born in Seattle in 1923, Doris Totten Chase studied architecture, and some interior design, at the University of Washington for two years. Although she did study under Jacob Elshin and Mark Tobey, Chase is by and large a self-taught artist. She began sculpting in 1960, at the age of thirty-seven, and received her first large sculptural commissions in the 1970s. Her first such commission resulted in *Changing Form* (14.1), one of Seattle's landmark sculptures.

In the early seventies Chase was commissioned by the Washington State Arts Commission to create a series of kinetic sculptures to be used in dance and performance. One of them is on display in Seattle's Intiman Playhouse (7.22). Chase has also created large works for Lake Park, Indiana; Atlanta, Georgia; and the Washington State Pavilion at the 1970 Exhibition in Osaka, Japan. The last work is now located at the Museum of Modern Art in Kobe, Japan.

Chase later moved to New York, where she has gained wide recognition for her work with video art, a medium Chase considers to be "artistic communication on a wider scale." A prominent New York art critic has described Chase as one of the "most precise talents in American independent cinema." Doris Chase now divides her time between Seattle and New York.

Cheng, Carl F. K. b. 1942

A native of San Francisco, Carl Fu Kang Cheng is a Los Angeles artist and a former artist in residence at the Los Angeles Institute of Contemporary Art. He earned a B.A. degree in industrial design from the University of California at Los Angeles in 1965 and an M.A. degree in sculpture and photography from that university in 1967, after which he studied for a year at the Folkwang Art School in Essen, West Germany. Cheng is a former instructor at the Otis/Parsons School of Art in Los Angeles and has taught sculpture at the University of California at Los Angeles. He is now a full-time sculptor and exhibits regularly in Los Angeles and has shown his works throughout the United States, as well as in Japan. *Seattle Underwater* (20.5) is Cheng's only work in a public place in Seattle.

Chevalier, Jack D. b. 1948

Jack Chevalier was born in Columbus, Ohio, and earned a B.F.A. degree in painting and printmaking at the Cleveland Institute of Art in 1975. In 1977 he earned his M.F.A. degree in painting at the University of Illinois, Champaign-Urbana. Since 1975 he has exhibited regularly in solo and group exhibitions in the Pacific Northwest and Midwest, and his works are included in corporate collections throughout the country. Chevalier has lived in Seattle since 1978 (see 7.32).

Chihuly, Dale b. 1941

Dale Chihuly was born in Tacoma, Washington, and earned a B.A. in interior design from the University of Washington in 1965. His artistic experimentation with glass began during his years at the university and continued with studies at the University of Wisconsin at Madison. He earned an M.S. from that university in 1967 and an M.F.A. from the Rhode Island School of Design in 1968.

Chihuly's career has included studies in Europe under a grant from the Tiffany Foundation and a Fulbright Fellowship, and teaching positions at various American institutions. He is artist in residence at the Rhode Island School of Design and is past director of that school's sculpture department. Chihuly is an important name in the international studio glass movement, which underwent a resurgence in the 1970s, and is the founder of the Pilchuck School in Stanwood, Washington. His works have been exhibited throughout the United States as well as in Canada, Australia, Japan, and Europe, including a one-man exhibit in Paris in 1986 at the Louvre's Musée des Arts Décoratifs (see 4.11).

Clark, Allan 1896?–1950

Allan Clark was born in Santa Fe, New Mexico, about 1896 (other sources say 1893 and 1898) and was raised in Tacoma. He attended what is now the University of Puget Sound and then studied sculpture at the Art Institute of Chicago and the Art Students League in New York. He then reurned to the Northwest and was soon recognized as an outstanding sculptor. His first commissions were architectural sculpture for the University of Washington's Suzzallo Library (12.12)

In 1924 Clark left the United States to accompany the second important expedition of Harvard University's Fogg Museum to the caves at Tun-Huang in northwestern China, which contain hundreds of Buddhist sculptures and frescoes. Clark was the expedition's illustrator. His drawings and later sculptures inspired by that trip were exhibited throughout the country with critical acclaim. He spent the rest of his career as a successful sculptor, and his work is included in several prominent museums, including the Museum of Modern Art in New York.

Colquitt, Clair J. b. 1945

Seattle artist Clair Colquitt was born in Detroit, Michigan, and studied both ceramics and sculpture at the University of Michigan in Ann Arbor, earning a B.S. in design in 1967. Two years later he earned an M.F.A. degree in ceramics from the University of Washington. He is a 1976 recipient of a National Endowment for the Arts Craftsman Fellowship and was a member of the art design team for the Creston-Nelson Electrical Substation (21.17). Colquitt's works have been shown regularly in Seattle since 1971.

Cumming, William b. 1917

William Cumming is a native of Kalispell, Montana, and grew up in Tukwila, Washington. Largely a self-taught artist, he began his career as a painter working on the WPA Federal Art Project in Seattle from 1938 to 1940. From that time on he has exhibited his paintings regularly in the Northwest. Cumming was the youngest member of the "Northwest School" of artists, whose members included Mark Tobey, Morris Graves, Kenneth Callahan, and Guy Anderson. In 1961 the Seattle Art Museum devoted an exhibition to his work, and he has had one-man exhibitions at numerous galleries since that time. In addition to an active career as a painter, William Cumming has spent many years teaching art, formerly at the Burnley School of Professional Art and presently at the Art Institute of Seattle. He has been represented by the Woodside/Braseth Gallery for the past several years.

Day, Jeff b. 1944

Jeff Day is a Seattle sculptor who has gained considerable recognition for his portrait sculpture, especially his busts of Dr. Martin Luther King, Jr. (one of which stands in the third-floor lobby of Schmitz Hall at the University of Washington), and rock star Jimi Hendrix. Born in Seattle, Day studied art for one year at the University of Washington and then spent many years studying under William Cumming. He has been showing his art locally since 1972.

Duell, Howard b. 1929

Howard Duell has been an instructor of art at Edmonds Community College since 1968. He taught at Everett Community College for three years before that. He was born in Philadelphia and earned a B.A. degree from Eastern Washington State College in 1955 and an M.F.A. degree from the University of Washington in 1957. In addition to *Of Sea and Life* (16.5), his other work in a public place in Seattle is a carved-brick bas-relief design on an exterior wall of the Bricklayers Union No. 2 building at 330 Fairview Avenue N.

DuPen, Everett b. 1912

Born in San Francisco, Everett DuPen received much of his art education at the University of Southern California and the Chouinard Art School in Los Angeles; he then earned a B.F.A. degree from Yale University in 1937. Afterwards he spent several years assisting sculptors in New York with works for the 1939 New York World's Fair.

Between 1938 and 1945 DuPen held teaching positions at the Carnegie Institute in New York City and Washington University in St. Louis, Missouri. In 1945 he became the chairman of the University of Washington Sculpture Department and remained at that post until 1980. Before retiring in 1983, DuPen headed the university's Division of Sculpture.

In addition to his works in Seattle's public places (4.8, 7.10, and 12.26), DuPen has created many sculptures for churches in the area. Another of his works is the large bronze fountain in front of the Washington State Library in Olympia.

Edwards, Garth b. 1950

A native of Stockton, California, Garth Edwards was raised in Portland, Oregon, and has studied at the University of Oregon and Portland State University, as well as the Pilchuck School in Stanwood, Washington. He is largely a self-taught artist and works in a variety of media, with emphasis on stained glass, enamel on steel, and cut steel. He used cut steel for his six-panel gate for the entrance to Metro's Pioneer Square station (1.8) and for panels next to the entrance gates of Portland's Civic Stadium. Edwards's works have been included in group exhibitions at the Smithsonian and the American Crafts Museum in New York, and he has several commissioned public works in the Pacific Northwest and Alaska. He is one of three artists who designed imaginative manhole covers that have been placed in downtown Seattle.

Elliott, John 1883–1971

John Elliott was an English silversmith who arrived in Seattle at the age of thirty-eight in 1921. In 1935 (with Albert E. Booth) and again in 1958, he created bas-relief panels for the Seattle City Light Building (3.11). Elliott was also known for his architectural sculpture, splendid examples of which are on Gowen Hall at the University of Washington (12.16). Elliott died in Seattle in 1971.

Epstein, Jacob 1880–1959

Jacob Epstein was born in New York City but settled in London in 1905 and later became a British subject. He obtained his artistic education at the Art Students League in New York and at the Ecole des Beaux-Arts in Paris. Epstein was a contemporary of Picasso, Brancusi, and Modigliani and joined them in their rejection of contemporary art forms and their free use of distortion and abstraction and elimination of nonessential detail. Regarded as one of the most important British sculptors of this century, Jacob Epstein's work included massive cubist figures, but he is most widely known for his expressionist portraits of famous subjects, including Winston Churchill, Albert Einstein, and Paul Robeson. However, most of his portraits were of unknown, common people who modeled for him, such as Pola Givenchy, a London scrubwoman who is the subject of *Resurrection* at the Intiman Playhouse (7.18). Jacob Epstein was knighted by Queen Elizabeth II in 1954 in recognition of his artistic contributions to the world.

Ericson, Kate b. 1955

Kate Ericson was born in New York City, where she now resides, and holds a B.F.A. degree from Kansas City Art Institute (1978) and an M.F.A. degree from the California Institute of the Arts (1982). She attended both those institutions with fellow artist Mel Ziegler and has worked and exhibited with him, primarily in New York, since 1980. Ericson was one of the five original design team artists of the Metro Downtown Seattle Transit Project and was the lead artist for the Pioneer Square station (1.8).

Ewing, Lauren b. 1946

Lauren Ewing was born in Fort Knox, Kentucky, and is presently head of the sculpture department at the Rhode Island School of Design. She holds a B.A. degree from Skidmore College (1968), an M.A. degree from Indiana State University (1971), and an M.F.A. degree from the University of California at Santa Barbara (1973). In addition to her teaching duties, Ewing pursues an active career as an artist and has established a national reputation for her work, the only example of which in a Seattle public place is *Endless Gate* at Seattle Center (7.1).

Fajans, Michael b. 1947

Michael Fajans was born in Philadelphia and in 1970 earned a B.A. degree in art and dance from Antioch College in Yellow Springs, Ohio. He subsequently taught art and dance at Antioch and then mural techniques at the University of Illinois. He had numerous public art commissions in Ohio and Illinois and has been creating murals throughout this state since 1975. Most of Fajans's work is for public display. He prefers not to paint for the enjoyment of only a select few (see 4.1 and 14.4).

Fife, Jimmie Carole b. 1940

Jimmie Carole Fife is a Creek Indian who was born in Dustin, Oklahoma. He earned his B.F.A. degree from Oklahoma State University in 1963, and during his college studies he spent two summers working under a Rockefeller Foundation grant at the Southwest Indian Art Project in Tucson, Arizona. Fife subsequently pursued postgraduate studies at several southwestern universities. Fife's work has been exhibited primarily in the southwest, where he has also pursued his art and taught in various institutions. His only art in a Seattle public place is located at Daybreak Star Arts Center (15.10).

FitzGerald, James 1910–73

A Seattle native, James FitzGerald was, among other things, an active sculptor, painter, craftsman, and designer in the Pacific Northwest. He obtained a degree in architecture from the University of Washington in 1935.

FitzGerald began his artistic career as a painter and in the late thirties worked in Kansas City as an assistant to Thomas Hart Benton. Afterwards he taught at the University of Washington and served as director of the Spokane Arts Center. After World War II, his career was devoted to sculpture. In addition to his works in Seattle (see Index) and Washington, FitzGerald created fountains for the U.S. Court House in Ogden, Utah, and at Princeton University.

Francis, Sam b. 1923

Sam Francis was born in San Mateo, California, and began his college career at the University of California at Berkeley, where he studied medicine and psychology and had no interest in painting. Francis first began painting in 1943 during an extended hospital stay. Afterwards he spent a year studying at the California School of Fine Arts in San Francisco; he then returned to Berkeley and earned B.A. and M.F.A. degrees.

Francis had his first one-man exhibition in this country in 1955, in Seattle at the Zoe Duzanne Gallery. He has since exhibited widely throughout the world, and his paintings are included in the collections of most major museums. His only work in a Seattle public place is one of his largest (4.14).

Frolich, Finn H. 1868–1947

Finn H. Frolich was born in Norway and was a student of noted sculptors August Saint-Gaudens and Daniel Chester French and was a graduate of the Ecole des Beaux-Arts in Paris. He served as the director of sculpture for the 1909 Alaska-Yukon-Pacific Exposition and created heroic busts of Edvard Grieg (12.22) and James J. Hill (12.27) for that event, both of which still stand at the campus. After the exposition, Frolich became the official sculptor for the 1915 Pan-American Exposition in San Francisco.

Finn Frolich lived in Seattle for some time and in 1908 was a co-founder of Beaux Arts Village on the eastern shore of Lake Washington. However, he lived for a much longer period in California, where he owned the Frolich School of Sculpture in Hollywood. He died in Los Angeles in 1947.

Gardner, Ann b. 1947

Born in Eugene, Oregon, Ann Gardner has studied ceramics and fine art at the University of Oregon and Portland State University. In 1984 she studied under a residency at the Koehler Art Center in Sheboygan, Wisconsin. Gardner has exhibited her glass and ceramic work in Seattle, Portland, San Francisco, and other locations on the West Coast (see 13.6).

Geise, Jonn b. 1936

Born in Wenatchee, Washington, Jonn Geise is a self-taught artist who has been a full-time sculptor since 1963. Before 1963 he spent five years as an apprentice architect with Seattle architect Stephen Richardson and the architectural firm of Naramore, Bain, Brady & Johanson (now called the NBBJ Group). A winner of numerous awards for his sculptures, he exhibits regularly in the Northwest and in Seattle, where he resides. Geise has had commissioned works placed in Seattle, Bothell, Eugene, Oregon, and Anchorage, Alaska (see 7.34, 7.46, 12.13, 18.1, 22.3).

Gerber, Georgia b. 1955

Georgia Gerber was born in East Orange, New Jersey, and obtained her undergraduate education at Brucknell University in Lewisberg, Pennsylvania. She earned her M.F.A. from the University of Washington in 1981. Although Gerber lives on Whidbey Island, she is better known in Portland, where she created a life-size bronze baby elephant for the Portland Zoo and twenty-five life-size animals for the Portland Tri-Met transit system (see 5.26).

Gilhooly, David b. 1943

David Gilhooly was born in Auburn, California, and received his B.A. and M.A. degrees at the University of California at Davis in 1965 and 1967. He subsequently taught at the University of California at Davis, San Jose State University, the University of Saskatchewan, and York University in Toronto. Gilhooly is now a resident of California. Ceramic works by Gilhooly have been exhibited throughout North America as well as in Europe and Japan (see 17.4).

Gilkey, Richard b. 1925

Richard Gilkey was born in Bellingham, Washington, and has lived in the Northwest most of his life. Although always interested in drawing, he did not become an artist until after World War II, when he returned to Seattle and fell under the influence of Morris Graves, Mark Tobey, and Guy Anderson, major figures in what many refer to as the Northwest School of American art. He is considered a major talent of the generation following those artists.

Largely self-taught, Gilkey traveled extensively throughout Europe to study paintings by the masters. In 1958 he was awarded a Guggenheim Fellowship and painted landscapes in Ireland for six months, followed by further travel and study in Europe. His work has been exhibited widely throughout the Northwest and has been included in numerous exhibits of artists from this region (see 5.8).

Goldbloom, Brian b. 1950

Brian Goldbloom is a native of North Bend, Oregon, and earned his B.F.A. degree from the University of Oregon in 1974. Thereafter he pursued further studies in sculpture at the University of Oregon and has spent his career as a full-time sculptor engaged primarily in creating commissioned works. He has created sculpture for public places in several Washington cities, including Auburn, Bellingham, Bremerton, and Spokane. He has exhibited his works in Seattle, as well as in Los Angeles and Oregon. In addition to *Bench for Meditation* (12.2), Goldbloom created a granite sculpture at the James Street entrance of Seattle's new Metro tunnel (1.8).

Gould, Carl F. 1873–1939

Carl Gould was born in New York and graduated from Harvard University in 1898. He then spent three years studying in Paris at the Ecole des Beaux-Arts. Gould practiced architecture on the East Coast for several years (including work with McKim, Mead & White in New York) and arrived in Seattle in 1908. In 1914 he became the first chairman of the University of Washington's Department of Architecture, which he helped establish, and served in that capacity until 1926.

Gould was the better known half of Bebb and Gould, a Seattle architectural firm that designed a number of buildings in Seattle, including the Seattle Art Museum and, on the University of Washington campus, the Henry Art Gallery, Suzzallo Library, and Hutchinson, Raitt, Savery, Miller, and Gowen-Smith halls. Gould and his firm also played a major role in the plan of the University of Washington campus, major features of which are the library and the Liberal Arts Quadrangle (see also 1.7, 9.2, and 12.19).

Govedare, David b. 1950

A native of Berkeley, California, David Govedare trained as an architect in California at Hancock Junior College, in Santa Maria, and California Polytechnic State University School of Architecture, in San Luis Obispo, where he received an Associate of Arts degree in 1970. He worked as an architect in Santa Barbara before moving to Spokane, Washington, where he now lives, and began working full time as a sculptor in 1974. In addition to his aluminum artwork near Seattle's waterfront (7.39), Govedare has created sculptures for public places in Washington, California, and Idaho. His works are included in private collections throughout the United States and in Canada and Mexico.

Graber, Archie M. 1924–84

Archie Graber was born in Bloomfield, Montana. He earned a B.F.A. from the Minneapolis School of Art and later studied at Montana State University and in Europe, where he studied with Oskar Kokoschka in 1953 and 1955. Graber came to Seattle in 1959 to create his first public work in the city (5.11; see also 16.4). He created several artworks and fountains in the Pacific Northwest as well as a fountain in Fairbanks, Alaska. When not creating sculpture, he pursued a successful career as an artist in the advertising departments of several local businesses.

Graham, Lois b. 1930

A native of Kewanee, Illinois, Lois Graham earned her B.A. from Knox College in 1952 and subsequently studied with Paul Burlin at Washington University in St. Louis. She also studied under Nathan Oliviera and Lothar Schall, followed in the late seventies with master classes taught by abstract expressionist painter Jack Tworkov. Now a Bellevue resident, Graham is regarded as one of the region's important abstract expressionist painters. Her works were the subject of a retrospective exhibit in 1984 at the Bellevue Art Museum, and she has exhibited throughout the Pacific Northwest and in Los Angeles, Chicago, and Houston.

Lois Graham received the Seattle Arts Commission Honors Award in 1984 and the Bellevue Arts Commission Achievement in Arts Award in 1986 (see 7.27).

Graham, Robert b. 1938

Robert Graham was born in Mexico City and received his artistic education at San Jose State College (1961–63) and San Francisco Art Institute (1963–64). He subsequently gained recognition as a pop artist, and since the sixties, his works have been featured in galleries and museums and are included in public collections throughout the United States as well as in London and Europe. He is considered by many to be one of the best American realist sculptors (see 3.14).

Greening, Charles b. 1949

Charles Greening was born in Shreveport, Louisiana, and has lived in the Pacific Northwest since 1967. He earned his B.A. degree in sculpture from the University of Washington in 1973. Now a Seattle resident, Greening is best known for his mixed media sundial at Gas Works Park (13.3) and his later *Meridian Archway* (17.1).

Haas, Richard b. 1936

Richard Haas was born in Spring Green, Wisconsin. A great influence in his life was his exposure to Frank Lloyd Wright's work at Wright's home, called Taliesin, where his uncle was chief stonemason. However, rather than use that inspiration to pursue a career in architecture, Haas chose to pursue a career in painting. He received his undergraduate education at the University of Milwaukee (B.A., 1959) and earned an M.F.A. from the University of Minnesota in 1964. Haas has become one of the nation's leading muralists and has been painting architectural illusions on building walls since 1974 (see 3.13).

Halvorsen, Liza

Liza Halvorsen received her arts education at the University of Washington, where she graduated with a B.F.A. degree in 1973. She has been exhibiting her ceramic work (see 21.10) for many years throughout this area and has also exhibited at the Renwick Gallery of the Smithsonian Institution in Washington D.C. She is presently a resident of Lopez Island.

Hamrol, Lloyd b. 1937

Lloyd Hamrol was born in San Francisco and earned his B.A. in art at the University of California at Los Angeles in 1959, where he also earned his M.A. in 1963. Presently a professor of art at the University of California at San Diego, Hamrol has worked on numerous site projects throughout the country (see 6.4).

Hansen, Gaylen b. 1921

Gaylen Hansen was born in Garland, Utah. He received his artistic training at the Otis Art Institute in Los Angeles (1939–40) and at the Art Barn School of Fine Arts and the Art Center in Salt Lake City, Utah (1940–44). He received his M.F.A. from the University of California at Los Angeles in 1953.

In 1957 Gaylen Hansen became a member of the Art Department at Washington State University in Pullman; he remained there until his retirement in 1982. Hansen has been exhibiting his works in galleries and museums since 1959 and has become recognized nationally for his unique painting style (see 3.7). Hanson resides in Palouse, Washington.

Haozous, Robert b. 1943

Robert Haozous is a prominent Native American sculptor who is part Chiricahua and Navajo. Now a resident of Santa Fe, New Mexico, he studied at Utah State University and then earned a B.F.A. degree from California College of Arts and Crafts in Oakland in 1971. Although his only work in a public place in Seattle is carved wood (15.12), Haozous is also known for his works in stone, steel, and bronze. He is best known in the southwestern United States, but his sculptures have been exhibited throughout the United States, as well as in Switzerland and France.

Hassinger, Maren b. 1947

Maren Hassinger is a native of Los Angeles and earned a B.A. degree (in visual art) from Bennington College in Bennington, Vermont, in 1969 and an M.F.A. degree (in fiber structure) from the University of California at Los Angeles in 1973. She has subsequently received several awards, including two National Endowment for the Arts Artist Fellowships. Hassinger has been creating public sculptures, primarily in Los Angeles and New York, since 1978 and has created plaza planters and tree grates for Metro's Downtown Seattle Transit Project (see 1.8 and 5.19). In addition to public settings, her art has been included in many group exhibitions in California and New York. Hassinger now lives in Long Island City, New York, and is an adjunct professor of art at Hunter College in New York City.

Hayes, Randy b. 1944

Randy Hayes was born in Jackson, Mississippi, and received his B.F.A. degree from the Memphis Academy of Arts in 1968 and did postgraduate work at the University of Oregon the following year. Although he has been painting for many years, recognition of Hayes as one of the foremost artists of his generation in Seattle has come only recently. A typical example of his painting style can be seen at the Seattle Center (7.9). Randy Hayes regularly exhibits his work in Seattle, where he resides.

Heizer, Michael b. 1944

Born in Berkeley, California, Michael Heizer is an artist of international reputation and is considered a leader of that school of art that uses nature itself, with little or no embellishment, as the medium for sculpture. In the early 1960s he studied painting at San Francisco Art Institute, followed by a move to New York, where he continued to paint. In 1967 he directed his attention to "earth-art" sculptures, which were deep trenches, shallow cuts, and depressions in remote desert areas of Nevada. His reputation was based on such creations until 1976, when he broadened his sculptural subject matter to include works such as Seattle's *Adjacent, Against, Upon* (7.40). After creating this work, he gained many other commissions throughout the country, including a related work of boulders on aluminum bases in Miami. IBM commissioned Heizer to create a granite and water sculpture in front of its headquarters in New York City. He also has a major sculpture in downtown Los Angeles.

Michael Heizer now lives and works in both Nevada, where he continues his desert earthworks, and New York. He has recently achieved considerable recognition for combining art with earth reclamation projects.

Holder, Tom b. 1940

Tom Holder was born in Kansas City, Missouri, and began studying painting at San Diego City College. He earned a B.A. degree from California State University in San Diego in 1965 and an M.F.A. from the University of Washington in 1969. In 1971 Holder became a member of the faculty of the University of Nevada at Las Vegas. Holder has exhibited his work throughout the western United States (see 22.5).

Holland, Tom b. 1936

Born in Seattle, Tom Holland has studied at Willamette University (1954–56), the University of California at Santa Barbara (1956–57), and the University of California at Berkeley (1957–58). In 1975 he received a National Endowment for the Arts sculpture grant and in 1979 was awarded a Guggenheim Fellowship grant. Since 1960 Holland's work has been the subject of exhibits and has been included in group exhibitions throughout California, as well as in New York, St. Louis, and Seattle (see 8.4). He is represented in many museum collections throughout the country, including the Museum of Modern Art, the Whitney Museum of American Art, and the Guggenheim Museum in New York. Holland lives in Berkeley, California.

Hollis, Douglas b. 1948

Born in Ann Arbor, Michigan, Douglas Hollis received his artistic education at the University of Michigan (B.F.A., 1970). Since that time he has pursued a career as a sculptor and has been a frequent lecturer and teacher at various American institutions. His *Sound Garden* at Seattle's NOAA facility (19.6) is one of several wind-generated sound sculptures he has created. Earlier works include *Wind Organ* for the Lawrence Hall of Science at the University of California at Berkeley, *Wind Harp* in San Francisco, and an untitled work for the 1980 Winter Olympics at Lake Placid, New York.

Holm, Bill b. 1925

Bill Holm is a native of Roundup, Montana, and earned both his B.A. (1949) and his M.F.A. (1951) degrees from the University of Washington. His education included study with the late Dr. Erna Gunther, who was director of the Thomas Burke Memorial Washington State Museum, on the University of Washington campus.

Bill Holm was curator of Northwest Coast Indian art at the Burke museum from 1968 until 1985, when he became adjunct curator. He is a noted authority, author, and lecturer on Northwest Coast Indian art and culture (see 12.33).

Hoover, John b. 1919

Born in Cordova, Alaska, John Hoover spent the first part of his adult life working as a fisherman and a shipwright. In 1950 he began to study painting and in the early sixties he began sculpting in traditional Northwest Indian styles. In the 1960s he also studied art in Seattle at the Leon Derbyshire School of Fine Arts. He has since exhibited throughout the United States, establishing himself as an important Native American artist. His first sculpture exhibit, in 1965, ended with the purchase of all forty-one pieces by the U.S. Bureau of Indian Affairs. With the exception of three that were given by President Lyndon Johnson to visiting dignitaries, those works are now displayed in Bureau offices throughout the country.

In the midseventies Hoover began working in the low-relief style for which he is primarily known (see 15.5). All of his works are carved red cedar. In addition to exhibiting, Hoover has served as artist in residence at the Institute of American Art in Santa Fe, New Mexico (1972), and as an instructor at Northern Arizona University in Flagstaff (1979).

Hoppe, Bill b. 1945

Bill Hoppe was born in Portage, Wisconsin, and earned a B.A. from St. John's University in Collegeville, Minnesota, in 1967. He began exhibiting his paintings in Seattle in 1972 during his graduate studies at the University of Washington, where he earned his M.F.A. degree the following year. He has served as a visiting professor of art at Reed College (1974–76) and as artist in residence at Lewis and Clark College (1977–78), in Portland, Oregon. In 1981 Hoppe was awarded a National Endowment for the Arts Individual Artist Fellowship. His work is included in major public and private collections throughout the Pacific Northwest and is exhibited in both Seattle and New York, where he now resides. Two fine examples of Bill Hoppe's painting can be seen in Seattle public places (8.3 and 8.7).

Horiuchi, Paul b. 1906

Paul Horiuchi was born in Kawaguchi, Japan, and as a youth studied sumi brush techniques. His family came to the United States in 1922, and Horiuchi became an American citizen six years later. He moved to Seattle in 1946 and has lived here ever since.

In his early years in Seattle, Horiuchi became friends with artist Mark Tobey, a major figure in Pacific Northwest art. The two developed a close friendship fostered by a mutual interest in Zen philosophy and Japanese art.

Horiuchi began painting watercolors in the early fifties as more of a hobby, but his works were soon in some demand. By 1956, he had become inspired by the beauty of outdoor posters in Seattle's International District that had been frayed by wind and rain. As a result, he began working with collages as his principal art medium. He was the subject of a one-man exhibition at the Seattle Art Museum two years later (see 5.16 and 7.3).

Horiuchi's work has been exhibited and collected throughout the world. His many honors include award of the Sacred Treasure Fourth Class from Emperor Hirohito of Japan in 1976.

Inverarity, Robert b. 1909

Robert Inverarity was born in Seattle and studied locally with Mark Tobey, Kazue Yamagishi, and Blanding Stone. From 1937 through 1941 Inverarity was a director of art projects for the Works Progress Administration (WPA), after which he worked as an artist for the U.S. Navy and then for Boeing. He received his formal artistic education after all of those experiences, earning his B.A. from the University of Washington in 1946 and his M.F.A. and Ph.D. in 1947 and 1948 from Fremont University.

After receiving his graduate degrees, Inverarity embarked on a career as a museum administrator, directing the Museum of International Folk Art in Santa Fe, New Mexico; the Adirondack Museum in Blue Mountain Lake, New York; and the Philadelphia Maritime Museum.

Inverarity spent many years studying the art and culture of Northwest Coast Indians (see 12.25) and has written and lectured on the subject extensively. He now resides in La Jolla, California.

Irwin, Robert b. 1928

Robert Irwin was born in Long Beach, California, and received his artistic education at both the Otis Art Institute and the Jepson Art Institute in Los Angeles. He subsequently taught art at the Chouinard Art Institute in Los Angeles and the University of California at Los Angeles and at Irvine.

Irwin began his artistic career as an abstract expressionist painter. However, by 1970 he had abandoned the more traditional forms of art and is now one of the leaders in the creation of public artworks that use the landscape as part of the design. In addition to his one work in Seattle (4.7), Irwin has other well-known commissioned works at the San Francisco Airport, the University of California at San Diego, and O'Hare Airport in Chicago.

Ishii, Sonya b. 1952

A native of Honolulu, Hawaii, Sonya Ishii received a
B.F.A. degree from the University of Oregon in 1978
and from 1981 through 1984 pursued graduate studies at
the College of Architecture and Urban Planning at the
University of Washington. Ishii spent most of her
career creating commissioned public artworks, which
can be seen in Washington, Alaska, and Massachusetts.
She was one of five artists who served on the design
team for the Metro tunnel project in downtown Seattle
and has designed some of the artwork for the
International District station (1.13). She resides in
Chapel Hill, North Carolina.

Ivey, William b. 1919

A Seattle native, William Ivey has remained here
most of his life. He received his artistic training at the
Cornish School of Allied Arts (1937–41) and, after
service in World War II, at the California School of Fine
Arts in San Francisco (1946–48), where he studied with
Mark Rothko, Clyfford Still, and Ad Reinhardt. Ivey
returned to Seattle in 1948 and has received numerous
awards for his abstract expressionist paintings,
including a Ford Foundation Purchase Award and a
Rockefeller Fellowship. His works have been exhibited
throughout the United States and in both Europe and
Japan. He was given one-person exhibitions at the
Seattle Art Museum in 1964 and 1974 and a major
retrospective at the Henry Art Gallery in 1989 (see 7.21).

Jackson, Nathan P. b. 1938

A member of the Chilkoot-Tlingit tribe, Nathan P.
Jackson is a native of Tenakee, Alaska, and now resides
in Ketchikan. Although Jackson spent several years
studying art at the Institute of American Indian Arts
in Santa Fe, New Mexico, he is primarily a self-taught
carver and has been a full-time artist since 1964. He
has also taught Native American art at many schools
throughout Alaska and has served as a consultant on
projects involving North Coast Indian art, including the
1982 exhibit "Maritime Peoples of the Northwest Coast,"
at the Field Museum of Natural History in Chicago.
In 1985 Jackson carved a twenty-foot totem pole during
the American Festival at the Museum of Mankind in
London, England. Nathan Jackson's work has been
exhibited throughout the Pacific Northwest and Alaska
and his commissioned works have been placed
throughout Alaska, as well as in New York, Seattle
(15.9), Kobe, Japan, and at Harvard University.

Jenkins, Paul Ripley 1940–74

Paul Ripley Jenkins was born in Torrington, Wyoming,
and received his artistic education at the Art Institute of
Chicago (B.F.A., 1962) and the University of Michigan
(M.F.A., 1964). He became an associate professor of art
at the University of Washington in 1964 and remained
there until his death. Although he began his career as a
painter, sculpture began dominating his career in the
mid-1960s. Jenkins's work is included in the collections
of both the Seattle Art Museum and the University of
Washington's Henry Art Gallery, as well as the Port of
Seattle collection at Sea-Tac Airport (22.4).

Jensen, R. Allen b. 1935

R. Allen Jensen is a native of Denver, Colorado, and
since 1973 has been a tenured associate professor at
Western Washington University, where he began
teaching in 1969. He holds an associate of arts degree
from Everett Junior College (1956), a B.A. in education
from the University of Washington (1960), and an
M.F.A. degree in painting from Washington State
University (1962). Jensen has been exhibiting his
paintings, drawings, and sculptures in group and
solo exhibitions at galleries and museums, primarily
in western Washington, since 1967. One of his
sculptures can be seen in Seattle at Green Lake (17.7).

Jensen, Ray b. 1929

Ray Jensen was born in Seattle and earned a B.A.
degree in sculpture from the University of Washington
in 1953. In 1956 he obtained an M.F.A. from Cornell
University. Jensen is a former instructor at the Cornish
College of the Arts and the Bush School as well as the
University of Washington. He presently teaches at
Bellevue Community College, where he is chairman
of the Art Department (see 4.20, 7.29, 10.3, 12.14).

Johanson, Jean b. 1911

Jean Johanson was born in Seattle and earned her
B.A. from the University of Washington in 1934. After
graduating from college, she spent two summers work-
ing with renowned sculptor Alexander Archipenko.
While at the university, Johanson was a student
of Dudley Pratt, and in 1947 she worked with him
to create limestone reliefs for the University of
Washington (12.30).

Jones, Fay b. 1936

A Seattle resident, Fay Jones was born in Boston,
Massachusetts, and earned her B.F.A. degree from
the Rhode Island School of Design in 1957. Her unique
style of painting, an example of which can be seen in
the Metro station at Westlake Mall (5.25), has earned her
a considerable following in the Seattle area, where most
of her work is exhibited and collected. Her paintings
have also been included in group and solo exhibitions
elsewhere in Washington, as well as in Oregon and
California.

Jonsson, Ted b. 1933

Ted Jonsson is a California native who began his artistic
career as a painter. His degree from the University of
California at Davis (B.A., 1957) was in painting, but
he changed to sculpture while attending the University
of Washington. He received his M.F.A. from the
University of Washington in 1964. A resident of
Seattle, Jonsson has been an art instructor at Highline
Community College (1968–78) and at Humboldt State
University in Arcata, California. He is a full-time
sculptor and has exhibited in Seattle and New York.
In addition to works in the Pacific Northwest, Jonsson
has sculptures in public places in Falls Church,
Virginia, and Baltimore, Maryland (see 21.1 and 22.11).

Katsiaficas, Diane

A resident of Seattle for thirteen years, Diane Katsiaficas was educated at Smith College and the University of Washington. She has been an art instructor at the University of Washington, Bellevue Community College, and the Pacific Arts Center in Seattle. She is now an associate professor of art at the University of Minnesota (see 9.12).

Keating, Andrew b. 1948

A native of Bryn Mawr, Pennsylvania, Andrew Keating received a B.A. in studio art in 1970 from Hobart College, Geneva, New York, and received his M.F.A. in painting at the University of Washington in 1974. Although his only work in a Seattle public place is a collaborative design for Seattle City Light's Viewland-Hoffman Electrical Substation (18.4), Keating's medium is painting and he is considered by many to be one of the foremost artists of his generation in the region. He has exhibited his works in solo and group exhibitions throughout the Northwest, beginning in 1975, as well as in New York and Los Angeles.

Kelly, Lee b. 1932

Lee Kelly was born in McCall, Idaho, and has lived and worked in Portland, Oregon, since 1945. He received his art education at Vanport College in that city (1949–51) and at the Portland Art Museum (1954–59). Although he has been a visiting professor of art at Reed College in Portland and an instructor at Mount Angel College in Mount Angel, Oregon, most of Kelly's career has been spent as a full-time sculptor.

Kelly has exhibited regularly in the Northwest and is one of the most widely represented artists in the region's public places. He has also created sculptures in California, Texas, Virginia, New York, and Washington, D.C. (see 5.2, 5.3, 9.6).

Kennedy, Michael b. 1948

Born in Fairbanks, Alaska, Michael Kennedy is an architectural glass designer in Seattle who has created numerous public and commercial commissioned works throughout the Pacific Northwest and Alaska. He has also completed residential stained glass commissions throughout this country and Europe. Other than studying for a brief period at Pilchuck School, under noted stained glass artist Ludwig Schaffrath, Kennedy is a self-taught artist (see 20.6).

Kepner, Rita b. 1944

Rita Kepner was born in Binghamton, New York, and studied at Elmira College in Elmira, New York, and at Harpur College at the State University of New York—University Center at Binghamton. A sculptor, she has exhibited throughout the northeastern United States and in Seattle and Vancouver, B.C. Kepner lived in Seattle in the 1970s and received considerable attention while she created a large granite sculpture in Westlake Mall in downtown Seattle. The finished piece was to be placed in the mall, but it was placed in storage and has not been displayed since. Kepner's only work on display in a public place in Seattle is *In Transition Is Unity* (4.23).

Kirkland, Larry b. 1950

Born in Port Hueneme, California, Larry Kirkland is a resident of Portland, Oregon, who is known for his large hanging sculptures designed for architectural spaces. Kirkland graduated from Oregon State University in 1972 with a B.S. degree in environmental design and in 1974 earned an M.F.A. degree in design from the University of Kansas. He has served as a member of the design faculty at the University of Kansas (1972–74) and as an associate professor of art at Oregon State University (1974–76).

A 1982 recipient of a National Endowment for the Arts Fellowship, Kirkland has been creating large commissioned ceiling sculptures since 1979 and has placed works throughout this country as well as in New Zealand, Singapore, and Malaysia. His only work on public display in Seattle is in the lobby of the Sheraton Hotel (5.13).

Kohn, Jay b. 1942

Born in Chicago, Jay Kohn received his artistic education at the University of Wisconsin at Milwaukee (B.A. in art and education) and at Madison (M.F.A. in painting and sculpture). He has been exhibiting regularly in the Pacific Northwest since his arrival in Seattle in 1976. Kohn's works are included in numerous Seattle and Midwest collections (see 2.7).

LaFontaine, Glen b. 1949

Glen LaFontaine is a Seattle native who now resides in Portland, Oregon. He is a Cree Indian and received his formal art education at the Institute of American Indian Arts in Santa Fe, New Mexico, from 1968 to 1970 and at the Rhode Island School of Design in Providence from 1970 to 1973. LaFontaine has been exhibiting his art since 1967 in the northwestern and in the southwestern United States. His only work in a Seattle public place is at Daybreak Star Arts Center (15.13).

Laigo, Val b. 1930

Born in the Philippines, Val Laigo has lived almost all of his life in Seattle. With the exception of a two-year period of study in Mexico, he received his artistic education in Seattle, culminating with an M.A. in painting from the University of Washington in 1964. Laigo has taught art at Seattle University since 1967, where one of his major murals is accessible for public viewing (8.9; see also 10.9).

Law, Carolyn b. 1951

Carolyn Law was born in Morgantown, West Virginia, and earned her B.A. degree from Georgetown University in 1972. She spent the following year working extensively with intaglio and lithography at the metal plate lithography workshop at Kalamazoo Art Center in Kalamazoo, Michigan. Law received an M.F.A. from the University of Washington in 1974. A printmaker and sculptor, Carolyn Law has exhibited primarily on the West Coast and has run several workshops in this area on printmaking techniques. Her fencing treatment for the Broad Street Electrical Substation (7.41) is her first large-scale public commission and her only work in a public place in Seattle.

Lawrence, Jacob b. 1917

Jacob Lawrence was born in Atlantic City, New Jersey. At the age of thirteen he moved to the Harlem district of New York City, which at that time was a thriving and culturally rich community. Lawrence became interested in art at an early age and throughout the thirties he studied with many of the major black artists of the time. He studied with Charles Alston at the Harlem Art Workshop in 1932 and then under Alston and Henry Bannarn at a WPA Harlem Art Workshop from 1934 to 1937. From 1937 to 1939 he studied with Anton Refregier, Sol Wilson, Philip Reisman, and Eugene Moreley under a two-year tuition scholarship at the American Artists School.

Lawrence became recognized as a talented and innovative artist and has had a successful career as an artist and teacher. He has taught at Pratt Institute and the Art Students League in New York and has been an artist in residence at Brandeis University. He was a professor of art at the University of Washington from 1971 until 1986, when he became professor emeritus.

Works by Jacob Lawrence are included in the collections of major museums around the world, and his art is widely exhibited (see 1.17 and 12.8). He has received numerous awards, including membership in the prestigious fifty-member American Academy of Arts and Letters.

Levine, Phillip b. 1931

Born in Chicago, Phillip Levine obtained his M.F.A. at the University of Washington in 1961. Except for various temporary teaching and lecturing positions in the Pacific Northwest, he has devoted his career to sculpture. Levine has many works in public places throughout the state, including two in Seattle's public places (7.35 and 12.5). His artwork is included in many public and private collections on the West Coast and also in Asia and has been exhibited in many individual and group shows.

Lewing, Paul b. 1947

Born in Middletown, Ohio, Seattle artist Paul Lewing was brought up in Missoula, Montana, and holds both a B.F.A. (1969) and an M.F.A. (1972) degree from the University of Montana. He moved to Seattle in 1972 after spending one quarter teaching at the University of Wisconsin at Parkside, in Kenosha, Wisconsin. Thereafter he served as chairman of the ceramics department at the Factory of the Visual Arts in Seattle, and is currently teaching part-time at Highline Community College as well as participating in area ceramic workshops. Lewing has spent his artistic career working in ceramics and concentrates primarily on commissioned tile art for residences and commercial spaces. In addition to his mural in Fremont Canal Park (13.5), Lewing also created the decorative tile along the Fifth Avenue wall of the United Methodist Church in downtown Seattle.

Lewis, Alonzo Victor 1886–1946

Alonzo Victor Lewis was born in Logan, Utah. He received his artistic education in Butte, Montana, studying with western artist E. S. Paxson, and he later attended the Chicago Art Academy. Lewis came to Seattle in the 1920s, where his first public commissions were terra-cotta figures for buildings at the University of Washington (see chapter 12).

Although he became a well-known sculptor in this state (see 7.14 and 7.44), his reputation did not spread far beyond the Pacific Northwest and little is written about him. His other major work in this area is the war memorial on the grounds of the state capitol in Olympia.

Liberman, Alexander b. 1912

Alexander Liberman was born in Kiev, Russia. After the 1917 Russian Revolution, his family moved to England, then Paris. He graduated from the Sorbonne in Paris in 1930 and subsequently studied architecture as well as welding and other construction techniques relating to sculpture. Although now known primarily as a sculptor, Liberman is a recognized painter and photographer. Since 1962 he has also worked as editorial director of Conde Naste Publications in New York, publisher of *Vogue, Vanity Fair,* and *Mademoiselle.* His only public work in this region is *Olympic Iliad* at Seattle Center (7.2).

McCracken, Philip b. 1928

Philip McCracken was born in Bellingham, Washington, and has spent most of his life in the rural environment of nearby Guemes Island. He is a 1954 graduate of the University of Washington, where he received a B.A. in sculpture. His education included study at that university under George Tsutakawa, Everett DuPen, and Charles Smith, and working as an assistant to noted British sculptor Henry Moore in the summer of 1973. McCracken has exhibited widely throughout the United States, primarily in New York and Seattle, and his work is included in many prominent private and museum collections, including the Whitney Museum of American Art in New York and the Phillips Gallery in Washington, D.C. (see 1.14, 3.2, 3.4).

Mackie, Jack b. 1946

One of Seattle's most active public (rather than studio) artists, Jack Mackie is a native of Princeton, New Jersey. His college education is limited to three and a half years at Western Washington University, where he majored in sociology and psychology. In 1969, Mackie left college and embarked on a career in art, much of it related to art in urban design. He has been involved in several novel projects in Seattle. One is the series of bronze dance steps along Broadway Avenue on Capitol Hill (9.8). Another (a collaborative effort with Buster Simpson and Paul and Deborah Rhinehart) consists of tree plantings, sidewalk enhancements, and benches along First Avenue between Virginia Street and Denny Way (see introduction to chap. 6). Mackie was also one of the five artists on the design team for the Metro tunnel in downtown Seattle (1.8), as well as an artist for its Convention Place (5.19) and Westlake stations (5.25).

McMahon, Gene Gentry b. 1941

A native of Jacksonville, Florida, Gene Gentry McMahon earned a B.A. degree (in English, 1967) as well as B.F.A. (1976) and M.F.A. degrees (1978) from the University of Washington. She was the recipient of Ford Foundation grants in 1977 and 1978. Her paintings have been included regularly in group and individual exhibits in the Seattle area since 1976 and have also been part of group exhibitions in several western states. McMahon's works are included in many public and private collections, including Metro's collection of commissioned artworks for its Downtown Seattle Tunnel Project (5.25).

MacNeil, Hermon A. 1866–1947

Born in Everett, Massachusetts, Hermon A. MacNeil graduated from Massachusetts State Normal School in 1886 and subsequently studied in Paris for two years with Henri M. A. Chapu at the Julien Academy. He spent another two years studying under Jean A. J. Falguière at the Ecole des Beaux-Arts. After completion of his studies, he returned to the United States, where he became a nationally known sculptor.

MacNeil received numerous important commissions throughout the country, and he created major works for the expositions at Chicago, Paris, Buffalo, and Panama. He also sculpted the design used on the U.S. quarter from 1916 to 1932. One of MacNeil's larger sculptures is *The Coming of the White Man* in Portland's City Park. His only work in Seattle is the *Monument to Judge Thomas Burke* on Capitol Hill (9.2).

Much of MacNeil's career was spent teaching art; he held positions at Cornell University, the Art Institute of Chicago, the Pratt Institute in New York, and the American Academy in Rome.

Maki, Robert b. 1938

Robert Maki was born in 1938 in Walla Walla, a small city in the southeast portion of Washington. He received his undergraduate education at Western Washington State College (B.A., 1962) and received his M.F.A. degree four years later at the University of Washington. Maki taught sculpture at the university from 1966 to 1968 and has since lectured at several colleges and universities in the United States. He has been exhibiting regularly in the western United States since 1967 and is regarded as one of the Northwest's leading sculptors. Maki has received many public commissions, including one at Highline College and another at the Washington State Department of Transportation Administration Building in Olympia (see 5.24, 21.9, 22.10).

Marioni, Paul b. 1941

Paul Marioni is a nationally known artist specializing in glass. He was born in Cincinnati, Ohio, and received his B.A. in English and philosophy from the University of Cincinnati in 1967. He has taught glass sculpture at many schools throughout the United States and in many foreign countries. Besides locally, Marioni's works have been exhibited at the Smithsonian Institution in Washington, D.C., the Corning Museum in Corning, New York, and the Museum of Contemporary Crafts in New York City.

In 1980 Paul Marioni created *The Boxers* (20.8), the first figurative cast glass window made in the United States (see also 17.9 and 18.2).

Markovitz, Sherry b. 1947

Sherry Markovitz was born in Chicago and received a B.A. in ceramics and education from the University of Wisconsin in 1969 and an M.F.A. in printmaking from the University of Washington in 1975. Her paintings, drawings, and sculpture have been included in group exhibitions in galleries and museums throughout the United States and in solo exhibits in Seattle and New York. Her animal sculptures, often decorated with intricate beadwork, have gained her considerable recognition and were the subjects of the Seattle Art Museum "Documents Northwest" exhibit of her work in 1987. Markovitz has lectured extensively on art and art issues and has taught at the University of Washington and the Cornish Institute (see 18.4).

Mason, Alden C. b. 1919

Alden Mason was born in Everett, Washington, and earned his M.F.A. from the University of Washington in 1947. He joined the art faculty of the University of Washington in 1949 and taught painting there until retiring in 1981. Now a full-time painter, Mason is considered one of the region's important artists and has exhibited regularly in the Pacific Northwest since 1958, beginning with a solo exhibition at the Seattle Art Museum. He has received numerous awards and commissions throughout his long career, and his works are included in major West Coast collections (see 3.9 and 22.8).

Mee, Nancy b. 1951

Born in Oakland, California, Nancy Mee earned a B.A. from the University of Washington in 1974. She also studied for a year at the American Center for Art and Artists in Paris. Throughout the seventies her career was centered on printmaking, and her work was included in numerous group exhibits in the Pacific Northwest, as well as exhibits in California, New York, and Philadelphia. She is the 1988 winner of the Seattle Art Museum's Betty Bowen Memorial Award.

Mee's emphasis in the eighties has been glass sculpture, and her creations have gained her considerable recognition as an innovative artist in that medium. In 1982 she created *Transition of Venus*, a sculpture commissioned by the Seattle Sheraton Hotel (5.18).

Montoya, Robert b. 1947

Robert Montoya, a Pueblo Indian, is a native of Santa Fe, New Mexico, where he is a successful architect. He earned a B.F.A. degree in architecture from the University of New Mexico in 1969, and from 1970 through 1972 pursued graduate studies in city and regional planning at that university under an American Indian Ford Foundation Fellowship. Montoya has been painting and exhibiting his unique blend of traditional and contemporary Indian styles since 1970. His only work in a Seattle public place is at Daybreak Star Arts Center (15.11).

Moore, Henry 1898–1986

Henry Moore studied at the Royal College of Art in London and eventually taught there in the 1920s. He first began exhibiting his sculpture in 1926, and by the midthirties had become an innovative leader of modern British sculpture. He also achieved considerable fame with his drawings, especially those of civilians living in London bomb shelters during the German bombardment of that city in 1940.

From midcentury until his death in 1986, Henry Moore was the acknowledged dean of British sculpture and one of the most innovative and prominent figures in the history of modern art. In recognition of his accomplishments he was knighted by Queen Elizabeth. His many works are included in collections throughout the world. His only work in a Seattle public place is *Three-Piece Sculpture: Vertebrae* (4.13).

Morris, Hilda b. 1911

Hilda Morris was born in New York and studied in New York City at both the Cooper Union School of Art and Architecture and the Art Students League. In the late thirties she moved to Spokane, Washington, and worked at the Works Progress Administration Art Project at the Spokane Art Center. The project's director was painter Carl Morris, whom she later married. She has lived in Portland, Oregon, since 1941.

Hilda Morris has exhibited both sculptures and paintings regularly throughout the West Coast and her works are included in major West Coast collections. She has several large commissioned sculptures in Oregon, as well as one at the Rochester Memorial Art Museum in Rochester, New York (see 4.12 and 7.28).

Morrison, George b. 1919

George Morrison is a member of the Grand Portage Chippewa Indian tribe and has been exhibiting his abstract expressionist works since 1948. He was born in Grand Marais, Minnesota, and from 1939 to 1943 he was trained at the Minneapolis School of Art (now College of Art and Design). For the next three years he studied at the Art Students League in New York City. From 1952 to 1953 he studied in France at the University of Aix-Marseille in Aix-en-Provence under a Fulbright scholarship. He has held teaching positions at various universities in the Midwest and East Coast and is currently a professor at the University of Minnesota. The artist's redwood mosaic *Underwater Panthers* (15.6) is his only public work in Seattle.

Morse, Emily Hall 1906–88

Emily Hall Morse was a Seattle artist and teacher who received her art training at the Boston Museum of Art, the Art Students League in New York City, the Phillips Gallery in Washington, D.C., and the School of Fine Art at Radcliffe College. Although she began her artistic career as a sculptor, she is known in this region for her painting/collages, which she began exhibiting in the late 1960s (21.16).

Moss, Bill b. 1923

An internationally known artist/tent designer, Bill Moss was born in Detroit and studied painting at the University of Michigan, Ann Arbor (1941), the Layton School of Art in Milwaukee (1943–45), and Cranbrook Academy of Art in Bloomfield Hills, Michigan (1946–48). For many years after that he worked as an illustrator, designer, and consultant for Ford Motor Company, but in the 1950s he began experimenting with painting on tents, rather than canvas, and then he began creating tents as usable sculpture. Moss now resides in Camden, Maine, where he works as artistic director for his company, Moss, Inc. He has been an instructor at the Haystack Craft School, Arizona State University, and the University of Michigan at Ann Arbor. Moss has received several prestigious awards for his designs, and his works have been included in a wide range of exhibits, including those at the Museum of Modern Art in New York, the Smithsonian in Washington, D.C., and the Musée des Arts Décoratifs at the Louvre.

Namkung, Johsel b. 1919

Johsel Namkung was born in Korea and came to Seattle in 1947. At that time he was an accomplished singer and music teacher and began graduate study in singing at the University of Washington. Photography was an experimental interest during Namkung's first years in Seattle, but by 1956 he was devoting all his time to the subject. In 1957 he apprenticed with Chao-Chen Yang, a well-known Seattle photographer and expert in color photography.

Although best known for his nature photography, which has been exhibited widely and is included in museum and private collections throughout the Pacific Northwest, Namkung has also had a successful career as a scientific photographer. From 1961 to 1981 he was the scientific photographer at the University of Washington. He is now retired from the university and pursues photography full time. Namkung's large black and white photograph *Point of Arches* can be seen in the Meditation Room of Sea-Tac Airport (chapter 22). Many of his color photographs have been placed in the elevator lobbies of the Seattle Sheraton (see chapter 5).

Nevelson, Louise 1900–88

Born in Kiev, Russia, Louise Nevelson began seriously studying art at the age of thirty-two and first sold a work (to someone other than a friend) in her late forties. Ten years later she began experimenting with creating sculptures from discarded wooden objects found lying about. She called her creations "assemblages," and by the late 1950s she was successfully establishing herself as a major talent.

Nevelson was one of relatively few internationally known woman artists and was a major figure in the history of modern sculpture. A typical example of her sculpture is *Night Flight I* at Sea-Tac Airport (22.14).

Newman, Allen G. 1875–1940

Allen Newman was born in Kingston, New York, and was trained at the National Academy of Design. He became a well-known sculptor of statues and memorials and spent his career working in New York. Most of Allen's works are found on the East Coast. His only sculpture in Seattle is the *Hiker Memorial Statue* (17.3).

Newman, Barnett 1905–70

Barnett Newman was born in New York City and studied at the City College of New York (B.A., 1927) and the Art Students League. His early life was not devoted to art. He worked in his father's clothing manufacturing business, taught art as a substitute high school teacher in New York, and later studied ornithology at Cornell University. In 1950 he began devoting himself to art and continued to do so until his death at the age of 65 in 1970.

Newman was primarily an abstract painter and is considered one of the most influential artists of the 1960s. Although his sculpture *Broken Obelisk* (12.10) was a relatively rare venture into that medium, it is considered by many to be one of the great works of modern American sculpture.

Noah, Barbara b. 1949

Barbara Noah received her B.A. degree from Mills College in Oakland, California, in 1971 and an M.F.A. degree from Pratt Institute in Brooklyn, New York, in 1975. She has been a visiting lecturer of art at the University of Washington and has lectured at the University of California at Los Angeles and California State University at Long Beach. She is now a resident of Seattle (see 16.1).

Noguchi, Isamu 1904–88

Isamu Noguchi was born in Los Angeles of a Japanese father and an American mother, and his work was influenced by a combination of his parents' cultures and his cosmopolitan education. Between the ages of two and fourteen, he lived with his parents in Japan. He later studied at Columbia University and subsequently worked with American realist sculptor Gutzon Borglum (who carved Mount Rushmore). By 1927 Noguchi had moved to Paris, where he became the assistant to sculptor Constantin Brancusi. From Brancusi he learned the value of simple forms and polished surfaces and was exposed to the works of Brancusi's contemporaries, notably Alberto Giacometti and Alexander Calder.

Noguchi returned to this country in the 1930s and continued his artistic endeavors while earning income through furniture and product design. In his book *History of Modern Art*, H. H. Arneson states that by the 1930s, "Noguchi was the most advanced American sculptor working in the United States (with the exception of Calder, who commuted)" (p. 436). His reputation as an innovative sculptor grew dramatically from the late 1940s and he was still actively working when he died in New York at the age of 84. In 1987 President Ronald Reagan presented him with the National Medal of Arts in recognition of his outstanding artistic achievements. Two major Noguchi works can be seen in Seattle's public places (3.5 and 9.1).

Norling, Ernest R. 1893–1974

Ernest R. Norling was a widely known painter, illustrator, and wood carver who lived in Seattle most of his life. Born in Pasco, Washington, he grew up in Ellensburg and graduated from Whitman College in Walla Walla in 1915. He received his artistic education in Chicago and New York and was an artist in Hollywood before arriving in Seattle in the 1930s.

Norling wrote two books on artistic perspective and wrote the 1971 *Encyclopaedia Britannica* section on that subject. *Perspective Made Easy*, written in 1939, is a classic text on the subject. Norling also illustrated a number of popular children's books written by his wife. In addition to his mural at the University of Washington (12.23), Norling's 1941 mural, *American Youth and Freedom*, can be seen at Colman Pool in Lincoln Park (8603 Fauntleroy Avenue SW).

Oblak, Mario b. 1949

Born in Buenos Aires, Argentina, Mario Oblak is an American artist who received his undergraduate artistic education at the University of Puget Sound (B.A., 1973) and the University of Washington (B.F.A., 1975). He earned his M.F.A. degree from the Rhode Island School of Design in 1977. He now lives in Seattle. Before receiving the commission for his *Marker Series* (18.3) from the King County Arts Commission, Oblak had exhibited in numerous cities in New England and the Pacific Northwest.

O'Higgins, Pablo 1904–83

Pablo O'Higgins (whose parents named him Paul Esteban O'Higgins) was born in Salt Lake City, Utah, and received most of his artistic education in Mexico. In the 1920s he studied in that country under Diego Rivera, a leader in reviving the art of fresco mural painting and a leader of the Revolutionary Artists League of Mexico. O'Higgins agreed with Rivera's political views, became a member of that organization, and pursued his interests with study in the U.S.S.R. from 1931 to 1932. When O'Higgins was commissioned to paint his Seattle mural (12.9), he was an established artist in Mexico whose works were exhibited in that country and New York City.

Okada, Frank b. 1931

Frank Okada was born in Seattle and earned a B.F.A. degree from the Cranbrook Academy of Art in Michigan in 1957. Following his graduation he studied in New York on a John Hay Whitney Fellowship, then in Japan on a Fulbright Fellowship, and then in France on a Guggenheim Fellowship. A former professor of art at the University of Oregon, Okada is an important abstract expressionist painter who has exhibited regularly throughout the western United States and in group exhibitions elsewhere in this country and in France and Japan (see 7.20).

Olanna, Melvin b. 1941

Melvin Olanna was born in Shishmaref, Alaska, and brought up in a typical Eskimo environment of subsistence hunting. He is one of the few Eskimos of his generation making a living as a contemporary sculptor, and his work reflects a contemporary approach to traditional subjects he has been exposed to throughout his life. Although as a child Olanna saw much primitive-style painting created by local natives, he became attracted to modern sculptures, such as those of Henry Moore, that he observed in books. Olanna is not formally educated but was schooled by various sources in Alaska, Oregon, and New Mexico. He exhibits his sculptures regularly in Seattle, and his art is included in many major private and corporate collections.

Oliver, Marvin b. 1947

Marvin Oliver is a Native American of Quinault and Isleta Pueblo heritage. He was born in Seattle and holds a B.A. degree from San Francisco State University (1970) and an M.F.A. degree from the University of Washington (1973). Oliver has taught at several community colleges in the region and from 1976 to 1980 was an adjunct lecturer at the University of Washington's School of Art. He is currently an instructor in the university's American Indian Studies Program. Oliver is one of the best-known Native American artists in the Pacific Northwest and has exhibited frequently in Seattle and New York (see 5.27, 15.14, 18.5).

Orantes, José Enrique b. 1953

A native of El Salvador, José Orantes was raised in Guatemala after the age of seven. From 1974 through 1978 he studied at the Escuela Nacional de Artes Plasticas in Guatemala, where he specialized in painting and sculpture. During the last year of his studies he served as resident sculptor at the National Museum of Anthropology in Guatemala. Orantes is known as a painter, and his largest work to date is his 530-foot-long *Campus Parkway Mural* in Seattle (12.36). He has been exhibiting his works in Washington, primarily in the greater Seattle area, since 1979. Orantes is now a Seattle resident and became a U.S. citizen in 1988.

Padelford, Morgan b. 1902

Morgan Padelford was born in Seattle and earned both his B.A. (1924) and his M.F.A. (1925) degrees from the University of Washington. His short career as an artist in Seattle was devoted to painting, primarily portraiture. Padelford taught art for a few years at the University of Washington. In 1929 he left the city to teach at Scripps College in Claremont, California. Padelford remained there until 1935, when he began a long career in Los Angeles as a color consultant in the motion picture industry. He now lives in Pasadena, California (see 3.1).

Pasco, Duane b. 1932

Duane Pasco was born in Seattle but raised in Alaska, where he was heavily influenced by regional Native American art and culture. In the late sixties, before regional native arts and culture had experienced their resurgence, Pasco began painting and carving in the traditional Pacific Northwest native style. Although not a Native American, Duane Pasco has become a leading master artist and teacher of native art and culture of the Northwest. A resident of Poulsbo, Washington, he has been a full-time artist and teacher since 1967.

Pasco has exhibited regularly since 1969 and his works are included in major private and public collections throughout the country. He has several large commissioned works in Seattle's public places. Four carvings stand together in Occidental Park (1.3), a totem pole can be seen at Seattle Center (7.5), and many of his works are located at the Northwest Shop and the satellite terminals of Sea-Tac Airport. Commissioned works by Pasco can also be found in Canada, Japan, Singapore, Norway, and Congo.

Pepper, Beverly b. 1924

Beverly Pepper was born in New York City. At the age of eighteen she earned her B.A. degree in advertising and design from the Pratt Institute in Brooklyn. Between 1946 and 1949 she studied at the Art Students League in New York City and then in Paris with André Lhote and Fernand Léger. A strong influence in her artistic approach was the work of Constantin Brancusi, who worked in Paris during her years there. Pepper was a painter from 1949 until 1960, when she turned to sculpture, her predominant medium since then.

Pepper has resided in Italy and New York since 1951 and exhibits regularly in Europe and the United States. She is regarded by many as one of the most important sculptors of the day and her works have been included in major European and American exhibitions as well as in museum collections on both continents (see 3.6).

Petty, Ronald W. b. 1939

Ronald W. Petty was born in Casa Grande, Arizona, and received his formal artistic education at the Arizona State University School of Art from 1959 to 1961. He has worked as a carpenter and sculptor in the southwestern United States, Alaska, and the Pacific Northwest. He now resides in Seattle. Petty has created several large works in Seattle's public places (see 13.1, 15.3, 20.3).

Point, Susan b. 1952

Susan Point is a Coast Salish artist raised on the Musqueam Reserve on Vancouver Island, British Columbia. She is primarily a self-taught artist, having taken only a four-week course in jewelry making when she was twenty-nine, and is one of a handful of contemporary artists engaged in reviving the art of the Coast Salish people. She is best known for her work as a painter, printmaker, and silver and gold engraver. Point created one of five tree grate designs commissioned for Metro's street improvement project (1.8). In an unusual departure from her previous work, it is a classical design of acorns and oak leaves, unrelated to Coast Salish art.

Posner, Richard b. 1948

Richard Posner was born in Los Angeles and was educated at California State University at Chico (B.A., 1973) and the California College of Arts and Crafts (M.F.A., 1976). Posner's works have been exhibited throughout the United States and Europe since 1976 and are included in public and private collections in this country, Europe, and Japan (see 12.31 and 21.4).

Pratt, Dudley 1897–1975

Born in Paris, Dudley Pratt was raised in Boston and educated at Yale University. After being awarded the Prix de Rome, Pratt studied in Italy and later in Paris with Emile-Antoine Bourdelle. By 1927 he had moved to Seattle and had begun teaching art at the University of Washington. Pratt remained at the university until 1942. During that time he was a frequent exhibitor and received many awards for his works (see 4.6, 12.6, 12.11, 12.17, 12.30). His students at the university became some of the important artists and architects of this region. George Tsutakawa, Minoru Yamasaki, Paul Hayden Kirk, and Perry Johanson are just a few of his former students. Pratt died in Mexico in 1975.

Puryear, Martin b. 1941

Martin Puryear is a resident of Chicago, where he is assistant professor of art at the Circle campus of the University of Illinois. He was born in Washington, D.C., where he attended the Catholic University of America and earned a B.A. in 1963. After studying wood craftsmanship in Sierra Leone (while in the Peace Corps) and printmaking and sculpture at the Swedish Royal Academy of Art in Stockholm, he returned to the United States and attended Yale University. He earned an M.F.A. in sculpture from Yale in 1971.

Puryear has pursued a successful career as a sculptor and educator and continues to exhibit regularly, primarily in the Midwest and on the East Coast. His work is included in the Museum of Modern Art and the Whitney Museum of American Art in New York. Puryear has created several large public commissions, including *Knoll for NOAA* in Seattle (19.2).

Ramsay, Heather b. 1953

Born in Oak Park, Illinois, Heather Ramsay is a self-taught artist who has been living in Seattle since 1974. She has been exhibiting sculpture here since 1979 and has worked in a variety of sculptural media, much of it on a miniature scale (past works have included diminutive furniture and buildings). In addition to nonfunctional sculpture, Ramsay also creates sculptural jewelry, boxes, and clocks. Her largest clock to date is *Pendulum Clock,* located on Fifth Avenue and Pine Street (5.25).

Rauschenberg, Robert b. 1925

A native of Port Arthur, Texas, Robert Rauschenberg is considered by many to be one of the most, if not the most, important painters in the creation of American pop art. His artistic education included study at the Kansas City Art Institute and School of Design (1946–47), Académie Julien in Paris (1947), Black Mountain College in North Carolina (with Joseph Albers) (1948–49), and the Art Students League of New York (1949–51). In 1955 Rauschenberg established himself as a major innovative artist by exhibiting what he called combine paintings, in which he combined painting and various objects affixed to the canvas. At first they were simple collage elements, such as photographs, newspaper clippings, or prints. He later began using such items as clocks, spoked wheels, and a functioning wireless set. The extreme example was his 1959 work *Monogram,* in which Rauschenberg attached to a painted and collage base a stuffed ram encircled by a car tire. The artist later began using images silk-screened onto canvas or, in the case of *Star Quarters* at Sea-Tac Airport (22.2), onto mirrored Plexiglas.

Reyes, Lawney b. 1935

Lawney Reyes is a member of the Narrow Lakes Band of the Colville Indian Nation and was born on the Colville Indian Reservation in Washington State. Although he holds degrees in fine arts and interior design from the University of Washington, he attributes his love of sculpture more to his years as a student in the art program at the Chimewa Indian School on the Colville Indian Reservation. Reyes has been exhibiting his sculptures since 1967 in the Pacific Northwest, Washington, D.C., Oklahoma, and Arizona and is a well-known contemporary Indian artist. His contemporary approach to traditional Indian design can be seen in his sculpture *Thunderbird* (10.8).

Reyes is an active member of the Native American community and helped establish the Indian Cultural/ Educational Center at Discovery Park. He designed its Daybreak Star Arts Center (see chap. 15).

Rez, Anton 1896–1963

Anton Rez was born in Hungary and studied architecture at the University of Budapest. He never became an architect, and his work in this country was devoted to creating stained glass windows as head of the stained glass window department of W. P. Fuller & Company in Seattle. Works designed by Anton Rez are included in many churches on the West Coast.

Rez married the daughter of Joshua Green, the founder of Peoples Bank (now U.S. Bank of Washington). The late Joshua Green, Jr., reported that some of Rez's later windows were designed on the Green family's pool table in what is now known as the Stimson-Green Mansion on First Hill.

Richardson, Amanda b. 1957

Amanda Richardson is a native of Truro, Cornwall County, England, and received her arts education at the Penzance Art School (1973–74), the Falmouth School of Art (1974–75), and Goldsmith's College at London University, where she earned a B.A. degree in embroidery and textiles in 1978. After much experimentation during her studies, Richardson invented a unique technique for creating textile tapestries, which she used to create *Sandstone Cliff* in downtown Seattle (5.23). Richardson has exhibited her work often in galleries in England, New Mexico, and California and has large commissioned works in England, Italy, and St. Paul, Minnesota. She settled in the United States in 1986 and now lives in Friday Harbor, on San Juan Island.

Rodin, Auguste 1840–1917

Auguste Rodin was a revolutionary artist of the latter half of the nineteenth century who helped begin the "post-realistic" era of modern sculpture. He was born in Paris in 1840 and was shunned by the art establishment of the time until he was forty because his work was a revolt against the sculptural technique and idealistic or sentimental subject matter of the time. Many considered his work too realistic, even vulgar, for depicting ordinary figures in unclassical poses with accurately rendered musculature. In other works Rodin was criticized for leaving his clay seemingly unfinished and "scarred," lacking the smooth surfaces typical of classical sculpture (see 5.4).

Rodin argued against sculpture as mere reproduction and his innovation resulted in wide acclaim in his later years. He was hailed as the father of modern sculpture. At the 1900 Exposition in Paris an entire building was devoted to the display of his works. He was showered with tributes and in 1904 became president of the International Society of Sculptors, Painters and Engravers.

A year before his death, in Paris in 1917, Rodin agreed to will his estate to France if it would provide him with financial support and make his home a museum after his death. Both sides kept their bargain and the Musée Rodin is a splendid tribute to the man and his art.

Rogers, John b. 1951

John Rogers is a native of Vancouver, Washington, who lives in Portland, Oregon. He earned a B.S. degree from Portland State University in 1973 and then spent a year working at the Contemporary Craft Gallery in Portland. Since 1978 he has been a full-time sculptor and works in a wide range of media, primarily on wall reliefs and floor designs. He has one work in a Seattle public place (12.29) and has created works in Alaska and Texas as well as many others in the Pacific Northwest.

Rosati, James b. 1912

Born in Washington, Pennsylvania, James Rosati's first career was as a violinist. From 1928 to 1929 he played violin with the Pittsburgh String Symphony. But by 1934 his fascination with sculpture had become so strong that he embarked on a career as a sculptor. He spent four years working full time as a sculptor for the Works Progress Administration art project in Pennsylvania. In 1944 Rosati moved to New York and formed a close association with innovative artists of the time, primarily Willem de Kooning, Franz Kline, and David Smith. He taught art at the Pratt Institute in New York, and from 1960 to 1973 he was a professor of sculpture at Yale University.

Rosati is now considered one of the more important American sculptors of this century and is represented in major collections throughout the United States. Prior to the installation of *Loo Wit* (4.25) at the Holiday Crowne Plaza Hotel, Rosati completed a major piece for the new east wing of the National Gallery in Washington, D.C.

Sato, Norie b. 1949

Norie Sato was born in Sendai, Japan, and earned a B.F.A. degree in printmaking from the University of Michigan in 1971. In 1974 she earned her M.F.A. degree in printmaking and video from the University of Washington. Sato has exhibited both video art and paper works throughout the United States. In the latter medium, she has been widely praised for her unique style, which is inspired in part by phosphorescent video images (see 5.17).

Sato's creations are included in the collections of the Solomon R. Guggenheim Museum in New York, the Brooklyn Museum, the Philadelphia Museum of Art, and the Seattle Art Museum. In 1983 she was the recipient of the Seattle Art Museum's Betty Bowen Memorial Award. In 1984 she had a solo "Documents Northwest" exhibit at the Seattle Art Museum. Sato resides in Seattle.

Schaffrath, Ludwig b. 1924

Ludwig Schaffrath is a native resident of Alsdorf, West Germany, and is considered one of the leaders of the post–World War II renaissance of stained glass art. He received his artistic education in Schlüterschule, a private art school in Alsdorf (1946–47), and then as assistant to Professor Anton Wendling in the architecture department of the Technische Hochschule in Aachen, West Germany (1947–54). From 1954 to 1985 Schaffrath was a free-lance artist and teacher and taught master classes on stained glass art in the United States, Australia, Great Britain, and Japan. Since 1985 he has been professor of painting and architectural art at the Staatlichen Akademie de bildenden Künste in Stuttgart, West Germany. His only work in a Seattle public place is a large window at the University of Washington (12.28).

Schneider, Kenny b. 1939

A resident of North Miami Beach, Florida, Kenny Schneider was born in Ellenville, New York, and graduated from the University of Miami (B.A., 1960). He is largely a self-taught artist, but in the summer of 1963 he attended the Sommerakademie für bildend Kunst in Salzburg, Austria, and was able to study with Oskar Kokoschka. Schneider has worked in a wide range of art media, including drawing, painting, sculpture, and film and has exhibited his work in group and solo exhibitions in New York, Florida, and California (see 15.4).

Schoppert, Robert James b. 1947

Now a resident of Seattle, Schoppert was born in Juneau, Alaska, and holds a B.F.A. in sculpture and printmaking from the University of Alaska at Anchorage (1978) and an M.F.A. in sculpture from the University of Washington (1981). Since 1973 Schoppert has been an art consultant and teacher in Alaska and has created numerous commissioned works in that state. He has exhibited regularly since 1974, primarily in Alaska and on the West Coast, and his works are part of collections throughout the country. Schoppert's only work in a Seattle public place is his relief design at the entrance to the I-90 Mount Baker tunnel (10.9).

Schwartz, Martha b. 1950

Martha Schwartz was born in Philadelphia and obtained her undergraduate education at the University of Michigan (B.F.A., 1973). A landscape architect, Schwartz earned a master's degree in landscape architecture from the University of Michigan (1976) and spent 1977 studying in the landscape architecture program at Harvard University Graduate School of Design. Her career includes a term as artist in residence at Die Villa Romana in Florence, Italy, in 1983.

Schwartz has exhibited her landscape architectural designs throughout the United States and has been responsible for several commissions in this country that combine landscape, art, and architecture. Since 1986 she has been a member of a landscape architecture firm in San Francisco that she co-founded (see 4.4).

Scuri, Vicki b. 1953

Born in Santa Rosa, California, Vicki Scuri is a Seattle artist who has spent much of her career working with graphic art. She is one of the five artists to serve on the design team for the Metro tunnel project in downtown Seattle and contributed graphic designs for two of the stations (5.7 and 5.25; see also 8.11). Scuri earned a B.A. degree from the University of California at Berkeley in 1975, and in 1977 she studied in Paris at the Atelier 17 under Master Printer S. W. Hayter. In 1980 she earned an M.F.A. degree in printmaking from the University of Wisconsin, after which she served as an assistant professor of art at Whitman College, in Walla Walla, Washington, a post she held until 1985. Scuri's work has been included in exhibitions throughout the United States, and her work has been the subject of exhibitions or installations in Seattle since 1982.

Shaw, Benson b. 1950

Benson Shaw is a 1972 graduate of Colorado College in Colorado Springs, where he earned a degree in physics. In 1976 he earned a master's degree in sculpture and art history from the University of New Mexico in Albuquerque. He has exhibited in the western United States since that time and has works in collections in Denver, Colorado Springs, and Seattle (see 4.5).

Shimomura, Roger b. 1939

Roger Shimomura was born in Seattle and holds a B.A. degree (1961) from the University of Washington and an M.F.A. degree (in painting, 1969) from Syracuse University in New York. He has also studied at the Cornish School of Allied Arts in Seattle (1964) and Stanford (1967) and Cornell (1968) universities. Shimomura has exhibited his works in individual and group exhibitions throughout the country, starting in 1965, and his paintings are included in collections throughout the United States (see 5.25 and 7.19). He now teaches drawing, painting, and performance art at the University of Kansas in Lawrence, Kansas, where he has lived since 1969.

Simpson, Lewis ("Buster") b. 1942

Buster Simpson was born in Saginaw, Michigan, and graduated from the University of Michigan, where he earned a B.A. in sculpture and design in 1963 and an M.F.A. in 1969. A Seattle resident, he has been exhibiting in the Pacific Northwest since 1975 and has had works included in individual and group exhibitions throughout the country. Simpson has been an active designer and creator of art for public places beginning with his role as an artist-consultant for Seattle's Viewland-Hoffman Electrical Substation (18.4; see also 5.1 and 15.1). He was subsequently chosen to create public sculptures in Boston, Portland, and Cleveland and a master use plan for a 900-acre park in Oakland County, Michigan. Simpson has gained considerable recognition for his placement of many small uncommissioned works in Seattle's public places. His varied career has also included working as a director, consultant, and designer for public art projects and workshops in the United States.

Singleton, Susan b. 1948

Susan Singleton is a Seattle native and earned an M.F.A. from the University of Washington. Much of her career has been devoted to textile design, but she incorporated that medium into sculpture and has created many commissioned artworks for placement in office buildings. As is true of her wall sculpture *Alihtan* (5.9), Singleton endeavors to bring natural rustic materials into office building environments of shiny stone and metal. She has been exhibiting her work in Seattle since 1974 and has had works placed throughout the United States.

Smith, Charles W. b. 1922

Charles Smith was born in New York City and has been working and teaching at the University of Washington since 1948. He is a graduate of the Pratt Institute in New York (1948) and obtained his B.A. in sculpture from the University of Washington in 1955. In 1956 he earned an M.F.A. from Cranbrook Academy of Art, in Bloomfield Hills, Michigan. Smith does not exhibit his art and has devoted most of his career as a sculptor to creating commissioned works, many through design competitions. He has won competitions and placed works in public places in the Seattle area (see 9.10, 12.34, 20.7), Beaverton, Oregon, and several cities in Alaska.

Smith, Mara b. 1945

Mara Smith is a native of Houston, Texas, who first came to her present home in Seattle in 1984 to carve the brick murals on the U.S. West Communications Building on Second Avenue and Lenora Street (6.1; see also 8.10). Smith earned her B.A. degree in 1968 and her M.F.A. degree in 1980 from Texas Women's University in Denton, Texas, and from 1969 to 1975 she was a crafts instructor at the University of Florida in Gainesville. In 1975 she began her graduate studies at her alma mater and two years later began her studies in carving wet brick. Mara Smith has since created over 125 murals (totaling 2.6 miles) throughout the United States.

Smith, Tony 1912–80

Born in South Orange, New Jersey, Tony Smith was first educated as an architect. In the late 1930s he studied at the New Bauhaus in Chicago and then worked in various capacities on several Frank Lloyd Wright projects. After embarking on an artistic career, Smith became known in the art world as a teacher and intellectual rather than as a practicing artist. However, in 1960 he began devoting his time to sculpture and created his first metal sculpture two years later, when he was fifty. Smith soon became a leader (some critics say *the* leader) in minimal art and is now considered one of America's major modern sculptors. A fine example of his work is *Moses,* located at Seattle Center (7.11).

Spafford, Michael C. b. 1935

Michael Spafford was born in Palm Springs, California, and received his college education at Pomona College (B.A., 1959). He earned an M.A. from Harvard University a year later. Spafford then spent three years painting and exhibiting in Mexico City. From 1965 to 1966 he studied under a Louis Comfort Tiffany Foundation grant, followed by two Prix de Rome Fellowships during the period 1967 through 1969. Spafford has taught painting and drawing at the University of Washington since moving to Seattle in 1963. Michael Spafford is regarded as one of the region's premier artists and has exhibited widely throughout the area (see 1.16 and 7.31).

Spaulding, Richard b. 1947

Richard Spaulding was born in Detroit, Michigan. He holds a B.A. in Spanish literature from Western Michigan University (1972), and his art studies include work at the Pilchuck School in Stanwood, Washington, and the Pratt Fine Arts Center in Seattle. He began working with stained glass in the late 1970s and *Quintet in D* (14.3; see also 9.5 and 17.8) was only his second large work. He has since established himself as a prominent modern stained glass artist. A prominent influence in Spaulding's work is his fourteen years of training in classical music. He has described the process of creating his art as similar to making music, largely instinctive rather than intellectual. Richard Spaulding has lived in New York City since 1982.

Sperry, Ann

Ann Sperry is a New York sculptor who was born in the Bronx, New York. She received a B.A. degree from Sarah Lawrence College, where she learned welding from Theodore Roszak, one of the country's important abstract sculptors. Sperry has exhibited her work in one-person and group exhibitions in the New York area and Seattle and has various works in public collections in the United States. *Seattle Garden* (5.28) is her only public work in the Northwest.

Sperry, Robert b. 1927

Robert Sperry was born in Bushnell, Illinois, and received his art education at the Art Institute of Chicago (B.F.A., 1953) and the University of Washington (M.F.A., 1982). A Seattle resident since 1950, Sperry taught ceramics at the University of Washington and was chairman of its ceramics department from 1960 until his retirement in 1982. Sperry now devotes his time to his art, which has been included in exhibitions throughout this country and in Europe and Japan (see 4.2 and 5.14). In 1984 he was awarded the Gold Medal of the International Society of Ceramics.

Stahly, Francois b. 1911

Francois Stahly was born in Constance, Germany, and began studying art during his youth in Switzerland. His first public sculpture was created for the 1937 World's Fair in Paris, six years after he had completed his studies with Aristide Maillol, one of the great French sculptors.

After lecturing at Harvard and teaching at the University of California at Berkeley, Stahly came to Seattle in 1961 as a visiting professor at the University of Washington. His stay in Seattle reportedly had a great impact on him. As evident in his fountain at Seattle Center (7.13), he was interested in vertically oriented works. The totem poles he saw in the Pacific Northwest further inspired him, and this approach can be seen in later bronze and stone fountains.

Steinbrueck, Victor 1911–85

Born in North Dakota in 1911, Victor Steinbrueck came to Seattle two years later. He began college studies at the University of Washington when he was only sixteen and graduated with a degree in architecture. He subsequently had a successful career as a professor of architecture at the university, serving many years as chairman of the School of Architecture. In addition to teaching, Steinbrueck published numerous articles and sketchbooks, including popular books on the Pike Place Market and Seattle.

Fighting to save the Pike Place Market was one of many civic causes in which Steinbrueck was actively involved. He also had an influential role in promoting the renaissance of Pioneer Square and the creation of Gas Works Park. In addition to Steinbrueck Park, near the Pike Place Market (see comment after 5.27), he also designed Louisa Boren Viewpoint on Capitol Hill and Betty Bowen Memorial Viewpoint on Queen Anne Hill (14.2). Professor Steinbrueck also helped design Seattle's Space Needle.

Stella, Frank b. 1939

Frank Stella was born in Malden, Massachusetts, and earned an A.B. degree from Princeton University in 1958, after which he moved to New York, where he continues to live. Stella has devoted his life to painting and is regarded as one of this country's leading innovative artists in the 1960s. He is referred to by some critics as a post-painterly abstractionist, distinguished in part by the fact that the painted shapes are geometric and flat with clean, definite boundaries. A fine example is his painting at Sea-Tac Airport (22.12).

Stella has lectured and taught at various institutions, including Yale and Brandeis universities, and has served as artist in residence at Dartmouth College and visiting critic at Cornell University.

Stokes, Charles b. 1944

Charles Stokes was born in Tacoma, Washington, and received his B.A. degree from the University of Washington in 1967. He earned his M.F.A. degree in painting from the University of Oregon in 1969. Stokes was a faculty member of Seattle's Cornish Institute from 1969 to 1985. He has also held visiting instructor positions at the University of Oregon, Evergreen State College, and Dartington College of Arts in England.

Stokes has been exhibiting his work in the Pacific Northwest since 1965, and his work has been the subject of, or included in, museum and gallery exhibitions throughout Washington and is part of many of the region's major public and private collections. In 1974 Stokes's art was included in the Smithsonian Institute's exhibit "Art of the Pacific Northwest." In 1975 he became the first recipient of the Seattle Art Museum's Betty Bowen Memorial Award, which is given annually to an outstanding local artist.

The only work by Charles Stokes in a public place in Seattle is his painting-sculpture *Upon the Deep* (8.5).

Stumer, Mildred

Mildred Stumer was a native of Olympia and received her art education at the California School of Fine Arts and the Art Students League in New York. Stumer came to Seattle in 1923 and opened a studio but spent only a few years here before leaving to work and study in New York and Paris. She returned to Olympia in the 1930s (see 3.1).

Sweeney, Michael b. 1940

Born in Cherokee, Iowa, Michael Sweeney earned a B.A. from the University of Washington in 1965 and an M.F.A. from the University of Kentucky in 1967. Since then his works have been featured or included in exhibits in New York and the Pacific Northwest. Although he was part of the team that created the stairway art projects in Fremont (13.6), his sculpture *Gateway* (19.8) is his only major work in a public place in Seattle.

Taft, Lorado 1860–1936

Lorado Taft was born in Elmwood, Illinois, and graduated from the University of Illinois in 1879. After studying at the Ecole des Beaux-Arts in Paris from 1880 to 1883, he opened a studio in Chicago, where he spent the rest of his career. From 1886 to 1907 he was an instructor at the Art Institute of Chicago and continued to lecture there until 1929. Taft was also a frequent lecturer at the University of Chicago and an adjunct professor at the University of Illinois.

Taft is recognized as an influential force in Midwest sculpture. Although best represented in the Midwest, one of his more prominent works is the Columbia Fountain at Union Station in Washington, D.C. His only work in Seattle is the statue of George Washington at the University of Washington (12.7). Taft also gained a reputation within his field as a lecturer and writer. His best-known book is the first history of American sculpture, which was published in 1903.

Tobey, Mark 1889–1976

Born in 1889 in Centerville, Wisconsin, Mark Tobey studied briefly at the Art Institute of Chicago but was largely a self-taught painter. After moving to Seattle in 1923, he acquired a deep interest in Asian art and philosophy, which influenced much of his work. He was the undisputed leader of what some refer to as the Northwest School of art and was very influential in the development of younger associates such as Morris Graves, Guy Anderson, and Kenneth Callahan.

In 1960 Tobey left Seattle forever and spent the rest of his life in Basel, Switzerland. In 1961 he became the first American artist to have a retrospective exhibit at the Louvre's Musée des Arts Décoratifs in Paris. In 1962 his works were shown in a major retrospective at the Museum of Modern Art in New York. The most prominent artist from this region (see 7.24 and 12.1), Mark Tobey was once described by *New York Times* art critic John Canaday as "the dean in absentia of American painting."

Tomkins, Margaret b. 1916

Margaret Tomkins was born in Los Angeles and earned both a B.A. (1938) and an M.F.A. degree (1939) from the University of Southern California. In 1939 she moved to Seattle to become assistant professor of art at the University of Washington and soon joined the group of "Northwest School" artists, such as Tobey, Graves, Callahan, and Anderson, as she and they developed their individual artistic styles. The first of her many solo exhibitions was held at the Seattle Art Museum in 1941, and her works have been exhibited widely. Tomkins's paintings are also included in the collections of both the Whitney Museum of American Art and the Metropolitan Museum of Art in New York, as well as the Art Institute of Chicago. She now resides on Lopez Island.

Unfortunately Tomkins's contributions to art in Seattle's public places are limited to a sculptural screen (4.22) created with her husband, James FitzGerald, and her work completing his last fountain after his death in 1973 (2.6).

Tompkins, Merrily b. 1947

A native of Everett, Washington, Merrily Tompkins received her college education at the University of Washington (1966) and Central Washington State College (1967–69). Her art has been included in many group exhibitions in galleries and museums throughout the United States and in several one-person exhibitions in Seattle since the early seventies. In 1982 Tompkins was one of three artists who incorporated works into the design of Seattle City Light's Creston-Nelson Electrical Substation (21.17).

Trakas, George b. 1944

George Trakas was born in Quebec, Canada, and received his artistic education at Brooklyn Museum Art School (1964–67), the Art Students League and the New York University Institute of Fine Arts (attending both in 1967), and New York University (B.S., 1969). His works have been widely exhibited in galleries and museums throughout the United States since the early 1970s (see 19.5).

Troutner, Ann b. 1958

Ann Troutner was born in Safford, Arizona, and earned her B.A. degree in fine arts from Pitzer College in Claremont, California, in 1979. She later studied at the Pilchuck School in Stanwood, Washington, and at the Penland School of Crafts in Penland, North Carolina. Troutner began her career as a scientific illustrator and photographer, but after five years in that field she began working full time with glass as an art medium. She has taught at several institutions, most recently the New York Experimental Glass Workshop in New York City. Troutner is presently working in Seattle with her husband, Paul Marioni. The Marioni-Troutner team has created several large cast glass commissions, including *Seven Figures* at the Green Lake Community Center (17.9).

Tsutakawa, George b. 1910

George Tsutakawa was born in Seattle and received much of his precollege education in Japan. He graduated from the University of Washington in 1937, where he earned B.A. and M.F.A. degrees. Tsutakawa has been an important member of the Pacific Northwest art community all his adult life and is a recognized sculptor and painter whose works have been exhibited widely. He was a member of the University of Washington art faculty from 1945 to 1980, and is now professor emeritus.

Tsutakawa's fountain-sculptures have been commissioned for public places throughout the United States, in Canada, and in Japan; he is one of the most widely represented artists in Seattle's public places. His work is collected in this country and included in many foreign collections, including that of the Japanese royal family.

Tsutakawa, Gerard K. b. 1947

Gerard K. Tsutakawa is the son of George Tsutakawa and was born in Seattle. He has watched his father work with bronze since the late 1950s and became his assistant in 1970. He has worked on all of George Tsutakawa's commissions since that time. Gerard Tsutakawa began his own sculpting in 1979 and has worked primarily with metals (see 1.9).

Utley, Windsor 1920–89

Born in Los Angeles, Windsor Utley was a Seattle artist, teacher, and musician who was trained as a flutist at the University of California at Los Angeles, the University of Southern California, and Pomona College. His formal education in painting was limited to summer art classes at UCLA in 1938, although he later received guidance from his good friend Mark Tobey. In 1947 Utley shifted from music to painting as his primary career, and over his lifetime he developed a rhythmic and dynamic style that arose from his desire to compose with the painted canvas. A good example of his work is *Tribute to Beethoven,* in the lobby of the University of Washington's Meany Hall. Utley's paintings have been exhibited throughout the Seattle area and in New York, and have been included in exhibits at the Henry Gallery at the University of Washington, the Guggenheim and Brooklyn art museums, and the Pennsylvania Academy of Fine Arts.

Windsor Utley also taught art at the Helen Bush School and the Cornish College of the Arts in Seattle. He headed the art department at Cornish from 1955 to 1959. Utley died in Seattle in 1989.

Van Slyke, Michelle G. b. 1945

Michelle Van Slyke was born in Roanne, France, and was educated at the Sorbonne in Paris and the University of Heidelberg in Germany. Her education culminated in a degree as a foreign language interpreter. In 1966 she moved to the United States and resided in Los Angeles, where she began creating large woven sculptures. In 1971 Van Slyke moved to Bainbridge Island, where she now resides. Her works are included in local collections and she has several public works on the West Coast, including one at the Spokane Public Library. Since 1980 she has been working with enameled steel cutouts, the technique she used for *Fish at Play* in Seattle (7.36). Van Slyke rarely exhibits in this area but exhibits regularly in San Francisco.

Vickers, Roy Henry b. 1946

A Tsimshian Indian, Roy Henry Vickers is a well-known carver and graphic artist in Canada who was born in the village of Greenville, British Columbia. Although he engaged in formal study for a limited time at the University of Victoria, his initial studies of Indian art and culture were self-directed while he worked at various jobs. In 1973 he began devoting his full attention to those interests and studied for two years at the Gitanmax School of Northwest Indian Art in Hazelton, British Columbia. He is well regarded as a contemporary artist who works with traditional Indian styles, a fine example of which is on display at Daybreak Star Arts Center (15.8).

Wallace, Chief John 1861–1952

Chief John Wallace of the Haida tribe was a much-admired craftsman whose works can be seen at the Burke Memorial Museum at the University of Washington, the New York City Museum, and the west entrance of the Department of the Interior Building in Washington, D.C. He is also remembered as a performing artisan at the 1939 San Francisco World's Fair, where he created totem poles in an ongoing exhibit (see 11.1).

Warashina, Patti b. 1940

Patti Warashina is a Seattle resident and one of the country's major contemporary ceramic artists. Born in Spokane, Washington, she received her formal art education at the University of Washington, where she received a B.F.A. degree in 1962 and an M.F.A. degree in 1964. She is presently a professor of art in the university's ceramics department. Warashina has exhibited widely throughout the United States, with regular exhibits in Seattle and New York. Her whimsical, sometimes surreal ceramic sculpture is included in many prominent collections as well as in most surveys of contemporary ceramic art. A splendid example of her art is *A Procession*, located in the lobby of the Seattle Opera House (7.25).

Warsinske, Norman b. 1929

Norman Warsinske is a well-known interior designer and sculptor in Seattle. He received a B.A. in interior design and sculpture at the University of Washington in 1958. Prior to that he received a B.A. in journalism at the University of Montana (1949) and studied jewelry design at the Kunstwerkschule in Darmstadt, Germany (1953). A sculptural screen at University Unitarian Church, 6556 Thirty-fifth Avenue NE, was his first sculpture commission (see also 4.28).

Washington, James W., Jr. b. 1909

Born in Gloster, Mississippi, James W. Washington, Jr., has lived and worked in Seattle since the mid-1940s. He began his artistic career as a painter and studied locally with Mark Tobey, Glen Alps, and Harry I. Freund. In 1956 he began sculpting, influenced by an earlier trip to Mexico and exposure to primitive Mexican sculptures. Washington has exhibited extensively throughout the United States. His stone sculptures can be seen in several public places in Seattle (see Index).

Wegner, James b. 1923

James Wegner was born in Saginaw, Michigan, and received his master's degree in art from Michigan State University. He was living in Seattle when he created *Alice* (4.19) for the Seattle Public Library and was a designer and carver of architectural ornaments and signs.

Wehn, James A. 1883–1973

James Wehn, Seattle's first sculptor, was born in Indianapolis and came to Washington Territory in 1889. He learned to sculpt when he returned to Indianapolis at the age of fifteen, where he studied as an apprentice sculptor for five years. Upon his return to Seattle, he created architectural ornamentation at the Salmon Bay Brass and Iron Foundry, which his father owned. He later served as the first chairman of the University of Washington's Sculpture Department.

During his long career, Wehn created a number of Chief Seattle sculptures. The most famous is the Tilikum Place statue, which he completed in 1912 (6.5). In 1909 a copy of the bust of that statue was placed on a horse watering fountain in Pioneer Square (1.2), and in 1910 he installed a replica of that bust at the Renton Fire Station. In 1958 a larger bronze head was installed at the *Broderick Fountain* at Seattle University (see comment after 8.8).

Wehn designed the seal for the city of Seattle, which includes a profile of Chief Seattle. A large bronze replica of that seal stands above the doorway of the Public Safety Building in downtown Seattle on Third Avenue between James and Cherry streets.

Weiss, Dick b. 1946

Dick Weiss is a native of Everett, Washington, whose career as a glass artist started in 1976, eight years after graduating from Yale University with a B.A. degree in psychology. While working as a railroad switchman in Everett, he took an evening class in stained glass art, and his interest soon blossomed into a full-time career. He exhibits regularly in Seattle, where he now lives, and his works are included in many government and private art collections as well as those of the Corning Museum of Glass in New York and the Victoria and Albert Museum in London. Two of his largest works can be seen at Sea-Tac Airport (22.1)

Werner, August 1893–1980

August Werner was born in Bergen, Norway, where he obtained a bachelor's degree in agriculture before moving to the United States as a young man. After arriving in this country he began a career in music and from 1932 to 1964 was a professor of music at the University of Washington. Werner was also a painter and sculptor and was primarily responsible for sculpting the Leif Eriksson statue at Shilshole Bay (16.6). Other works by Werner include the large statue of Christ at Gethsemane Lutheran Church at Stewart Street and Sixth Avenue in downtown Seattle, as well as a commissioned work placed in Washington, D.C., and one in Åbo (Turku), Finland.

Wesselman, Tom b. 1931

New York artist Tom Wesselman was born in Cincinnati, Ohio, and received his college education at Hiram College, in Hiram, Ohio, and the University of Cincinnati, where he received a B.A. in psychology in 1956. He subsequently studied at the Art Academy of Cincinnati (1954–56) and the Cooper Union in New York City (1956–59). Wesselman is one of the leading pop artists and has exhibited extensively throughout this country, Canada, and Europe, in individual and group shows, since he first began exhibiting in 1961. His paintings are included in major museums and collections throughout the world. Although his place in art history is as a painter, Wesselman has created many sculptures throughout the past decade. His largest to date is *Seattle Tulip,* a commissioned work in downtown Seattle (3.8).

Whipple, Bill b. 1947

A native of Worcester, Massachusetts, Bill Whipple earned a bachelor of fine arts degree in 1970 from the University of Washington and has been exhibiting his sculpture regularly in Seattle since 1975. He has also shown his work in Bellevue and Portland, Oregon. A Seattle resident, Whipple has executed several commissioned works in the Pacific Northwest, including the large clock at the corner of Fifth Avenue and Pine Street in downtown Seattle (see 5.25).

Wright, G. Alan 1927–82

G. Alan Wright received much of his art education in Hawaii at the Honolulu School of Art and the Honolulu Academy of Arts. He was a successful sculptor in the Northwest from the time he first began exhibiting in the late 1950s and was well known for his sculptures of birds and animals (see 7.4). In a 1968 review, *New York Times* art critic and author John Canaday commented that Wright's sculptures are more than mere zoological structures or ornamental forms: "they reduce the personality of each of his creatures to its essence." G. Alan Wright died in Seattle in 1982 at the age of 55.

Yagle, Tom b. 1947

Tom Yagle is a Seattle native who earned his B.A. degree from Seattle University in 1969 and has since pursued a career as a graphic artist and designer. From 1976 through 1979 he was a Peace Corps volunteer in Fiji, where he worked as a graphic artist. Shortly after his return he painted his *Wall of Water* mural in Ballard (16.2).

Zach, Jan b. 1914

Born in Slany, Czechoslovakia, Jan Zach received his artistic eduation at the Superior School of Industrial Arts and the Academy of Fine Arts, both in Prague. He first came to the United States in 1938 to work at his country's pavilion at the New York World's Fair. After Germany's occupation of Czechoslovakia in 1939, Zach remained in New York. In 1941 he moved to Brazil, where he taught and sculpted for eleven years. He taught sculpture at the Banff School of Fine Arts in Alberta, Canada, from 1951 to 1953 and then settled in Victoria, B.C., where he opened a school of painting and sculpture. In 1958 he became head of the sculpture department at the University of Oregon, where he remained until his retirement in 1980. Zach's works are included in public and private collections in the United States, Canada, and Brazil (see 3.12). He now lives in Vernita, Oregon.

Zallinger, Franz 1894–1962

From the thirties until his death, Franz Zallinger was a prominent painter and photographer in Seattle who was well known for his paintings of Pacific Northwest logging scenes, landscapes, outdoor life, and industries. He was born in Salzburg, Austria, and received his art training from Fritz Kraus in Vienna and at the School of Fine Arts in Selb, Bavaria (now West Germany). During World War I he was imprisoned by the Russians in Siberia and spent two years as a painter decorating public buildings. After the war he worked as an artist and sign painter in Manchuria and China until immigrating to Seattle in 1923. In Seattle, he operated a professional photography and portrait studio for many years and exhibited his paintings at the Seattle Art Museum. Zallinger painted several large works for regional hotels and theaters, and two of his few remaining paintings on public display are located in the Vance Hotel (5.21).

Zallinger, Rudolph F. b. 1919

Rudolph Zallinger is the son of Franz Zallinger and was born in Irkutsk, Russia. After studying at the Cornish School in Seattle, he attended Yale University, where he received B.F.A. (1942) and M.F.A. degrees. He received early recognition in 1949 when the National Academy of Design awarded him the Pulitzer Art Scholarship, based partly on his sketches for a 1,760-square-foot fresco mural in the Great Hall of Reptiles at the Peabody Museum of Natural History at Yale University. He served as artist in residence at the Peabody, where he painted the reptile mural, and as professor of art at Yale. Zallinger is a nationally known painter, illustrator, and educator, and his paintings have been exhibited widely throughout the United States. His work includes illustrations for *Life* magazine's popular books *The World We Live In* and *The Epic of Man,* and a 1970 six-cent postage stamp, *The Age of Reptiles.* In 1953 Zallinger painted the Seattle fire mural, which is still on display at the Museum of History and Industry in Seattle.

Zarins, Valdis b. 1939

Valdis Zarins was born in Latvia (now a republic of the U.S.S.R.). He received his M.F.A. degree from the University of Washington in 1966 and subsequently became a professor of sculpture at California State University in Chico. He remained in that position until 1980, when he returned to the Seattle area. Zarins has exhibited his sculpture in galleries and museums throughout the United States. He now resides in Renton, Washington, and devotes his time to sculpture (see 21.7).

Ziegler, Ellen b. 1949

A Seattle resident, Ellen Ziegler was born in Los Angeles and holds a B.A. degree in humanities and fine arts from Antioch College (1971). After completing her college studies, she studied North Indian classical music at the Ali Akbar College of Music in San Rafael, California (1971–73), and then traveled in India with her teacher on a musical tour. Over the past ten years Ziegler has centered her attentions on creating site-specific artworks in the Seattle area. She has received numerous awards for her work, including a Rome Fellowship in 1987 from the Northwest Institute of Architecture and Urban Studies. In addition to the works featured in this book (1.6 and 21.2), Ziegler has created markers and gateways at the Ravenna Eckstein Community Center (6535 Ravenna Avenue NE) that describe world records for the long jump, triple jump, and pole vault, as well as "sportgoyles" for the center's gymnasium.

Ziegler, Eustace 1881–1969

Born in Detroit, Eustace Ziegler left that city at the age of twenty-seven to manage an Episcopal mission in Cordova, Alaska. He eventually became an Episcopal priest, but he also gained a reputation as a fine painter. By 1920 his urge to paint had become irrepressible, and he spent that year studying art at the Yale School of Art. Although he moved to Seattle permanently in 1924, he visited Alaska regularly and spent the rest of his life painting scenes of that region and the Pacific Northwest.

Eustace Ziegler was a leading figure in the Seattle art world throughout his life. He was a frequent exhibitor and supported himself and his family through sales of his paintings and commissions to illustrate several books published in Alaska and Seattle. His solvency merited a headline for a 1947 *Seattle Times* interview that read "Ziegler, An Artist Who Eats Regularly."

Along with Sidney Lawrence, Ziegler was one of the earliest painters of Alaska, and his works are prized by museums and collectors. While Lawrence painted landscapes without human subjects, Ziegler often painted "peopled" landscapes and groups of figures (see 7.38).

Ziegler, Mel b. 1956

Mel Ziegler was born in Campbelltown, Pennsylvania, and holds a B.F.A. degree from Kansas City Art Institute (1978) and an M.F.A. degree from the California Institute of the Arts (1982). He attended both those institutions with fellow artist Kate Ericson and has worked and exhibited with her, primarily in New York, since 1980. A resident of New York City, Ziegler collaborated with Ericson on designs for Metro's Pioneer Square station in downtown Seattle (1.8).

Sources and Suggested Reading

aterial for this book was compiled from too many sources to list all of them here. In addition to interviews with many artists, information was obtained through research in the files of the Seattle Arts Commission, the King County Arts Commission, the Seattle Art Museum, the Seattle Public Library, and the University of Washington libraries. Microfiche copies of the *Seattle Times* and the *Seattle Post-Intelligencer* from 1900 to 1987 were additional sources of information. The following list provides sources readers may wish to consult for more detailed information about artists and artworks included in this guide.

Books

Arnason, H. H. *History of Modern Art*. Englewood Cliffs, N.J.: Prentice-Hall, 1968.

Bagley, Clarence B. *History of Seattle from the Earliest Settlement to the Present Time*. Chicago: S. J. Clarke Publishing Co., 1916.

Cheney, Sheldon. *Sculpture of the World: A History*. New York: Viking Press, 1968.

Elsen, Albert E., ed. *Rodin Rediscovered*. Washington, D.C.: National Gallery of Art, 1981.

Fleming, Ronald Lee, and Renata von Tscharner. *Place Makers: Creating Public Art That Tells You Where You Are*. New York: Harcourt Brace Jovanovich, 1987.

Garfield, Viola E. *The Seattle Totem Pole*. Seattle: University of Washington Press, 1980.

Graham, Colin. *Philip McCracken*. Seattle: University of Washington Press, 1980.

Guenther, Bruce. *Fifty Northwest Artists*. San Francisco: Chronicle Books, 1983.

——————. *Guy Anderson*. Seattle: Francine Seders Gallery, 1986.

Hanford, C. H. *Seattle and Environs, 1852–1924*. Chicago: Pioneer Historical Publishing Co., 1924.

Holm, Bill. *Northwest Coast Indian Art: An Analysis of Form*. Thomas Burke Memorial Washington State Museum Monograph no. 1. Seattle: University of Washington Press, 1965.

Johnson, Michael R. *Kenneth Callahan: Universal Voyage*. Seattle: University of Washington Press, 1973.

Keithahn, Edward L. *Monuments in Cedar*. Seattle: Superior Publishing Co., 1963.

Kreisman, Lawrence. *Art Deco Seattle*. Seattle: Allied Arts of Seattle, 1979.

Lucie-Smith, Edward. *Late Modern: The Visual Arts since 1945*. New York: Oxford University Press, 1975.

Melville, Robert. *Henry Moore, Sculpture and Drawings, 1921–1969*. New York: Harry N. Abrams, 1970.

Morgan, Murray. *Skid Road: An Informal Portrait of Seattle*. New York: Viking Press, 1960.

Municipality of Metropolitan Seattle (Metro). *Artifacts: Public Art in Seattle's Underground*. Seattle: Metro, 1988.

National Sculpture Society. *Contemporary American Sculpture*. 1929.

Noguchi, Isamu. *A Sculptor's World*. New York: Harper and Row, 1968.

O'Doherty, Brian. *American Masters: The Voice and the Myth*. New York: Random House, 1973.

Read, Herbert. *A Concise History of Modern Sculpture*. New York: Frederick A. Praeger, 1964.

Reed, Gervais (with Jo Nilsson). *Art in Seattle's Public Places: Five Urban Walking Tours*. Seattle: Seattle Public Library, 1977.

Reichart, Jasia. *Yaacov Agam*. London: Methuen, 1966.

Rose, Barbara. *American Art since 1900: A Critical History*. New York: Frederick A. Praeger, 1967.

Sale, Roger. *Seattle Past to Present*. Seattle: University of Washington Press, 1976.

U.S. General Services Administration. *Art in Architecture Program*. Washington, D.C., 1979.

Wheat, Ellen Harkins. *Jacob Lawrence, American Painter*. Seattle: Seattle Art Museum, 1986.

Williams, C. A. S. *Outlines of Chinese Symbolism and Art Motives*. New York: Dover Publications, 1976.

Woodbridge, Sally B., and Roger Montgomery. *A Guide to Architecture in Washington State*. Seattle: University of Washington Press, 1980.

Exhibition Catalogs

Anthony Caro: Sculpture, 1960–1963. London: Whitechapel Art Gallery, 1963.

Art of the Pacific Northwest, From the 1930s to the Present. Washington, D.C.: Smithsonian Institution Press, 1974.

Chihuly, A Decade of Glass. Bellevue, Wash.: Bellevue Art Museum, 1984.

Eustace Ziegler, A Retrospective Exhibition. Anchorage: Anchorage Historical and Fine Arts Museum, 1987.

Guenther, Bruce. *Documents Northwest: The PONCHO Series, Jeffrey Bishop*. Seattle: Seattle Art Museum, 1983.

Hart, Jean. *The Sculptures of Paul Ripley Jenkins*. Quarto Number Two. Seattle: Henry Art Gallery, University of Washington, 1974.

International Exhibition Catalog. New York: Solomon R. Guggenheim Museum, 1971.

James Rosati, Recent Works. New York: Marlborough Gallery, 1977

Johsel Namkung: An Artist's View of Nature. Seattle: Seattle Art Museum, 1978.

Northwest Traditions. Seattle: Seattle Art Museum, 1978.

Northwest Visionaries. Boston: Institute of Contemporary Art, 1981.

100 Masterpieces of American Painting from Public Collections in Washington, D.C. Washington, D.C.: Smithsonian Institution, 1983.

Pacific Northwest Artists and Japan. Osaka: National Museum of Art, 1982.

Tobey's 80: A Retrospective. Seattle: Seattle Art Museum and University of Washington Press, 1970.

Waldman, Diane. *Transformations in Sculpture.* New York: Solomon R. Guggenheim Museum, 1985.

William Ivey: Three Decades of Painting. Seattle: Henry Art Gallery, 1989.

Wright, Virginia. *William Ivey: An Exhibition of Paintings.* Seattle: Seattle Art Museum, 1975.

Articles

Aronson, Margery. *"Olympic Iliad* Arrives." *Northwest Arts,* 17 August 1984.

"Art for People's Sake" (Randy Hayes). *Seattle Arts,* February 1985.

"Artist Benson Shaw's Eight-Panel Relief Sculpture Installed Here." *The Arts,* June 1984.

Bell, Daphne Enslow. "Seattle's Own Ark." *Seattle Arts,* December 1978.

——————. "Artwork Turns the Corner at Third and Bell" *(Gyrojack). Seattle Arts,* March 1979.

——————. *"Nine Spaces, Nine Trees* to Be Dedicated." *Seattle Arts,* July 1983.

——————. "Five Artworks for NOAA." *Seattle Arts,* November 1983.

Berkson, Bill. "Seattle Sites." *Art in America,* July 1986, 68–135.

Chin, Sue. "Seattle Walls Project, Integrating Art and Architecture." *Seattle Arts,* February 1981.

——————. "My Testimony in Stone." *Seattle Arts,* October 1981.

Gregor, David. "Windows of the Spirit: The Art of Richard Spaulding." *Alaskafest Magazine,* June 1980.

Guenther, Bruce. "The Eccentric and Personal Vision of Gaylen Hansen." *The Arts,* July 1986.

Hastie, Louise. *The University Report* (University of Washington), Autumn 1978.

Hess, Thomas B. "Breakthrough with Tanks" (Alexander Liberman). *New York Magazine,* 6 June 1977, 70–72.

Joseph, Nancy. "Each Rock Has a History" *(Meridian Gateway). Seattle Arts,* May 1981.

——————. "Fish Swim in Police Station" (Liza Halvorsen). *Seattle Arts,* August 1983.

——————. "The Weaving of Light" *(Khadi). Seattle Arts,* July 1984.

Kendall, Sue Ann. "A Fish-Eye View of the City Skyline" *(Seattle Underwater). Seattle Arts,* February 1982.

——————. "Two-stepping on Broadway." *Seattle Arts,* April 1982.

Kohn, Jay. "The Aquarium Project." *Seattle Arts,* July 1980.

Mann, Joan. "Public Art Chronology." *Private Visions/Public Places* (Bellevue Art Museum), 1987.

——————. "Looking Back in Search of the Future: Some Thoughts on the Long Local History of Public Art." *PASSAGE* (Seattle and King County arts commissions), Spring/Summer 1987, 4–13.

"Murals, Whirligigs, Tunnel at Viewland/Hoffman Substation." *Seattle Arts,* June 1979.

Peck, Janice. "Arts Activists and Seattle's Cultural Expansion, 1954–1965." *Pacific Northwest Quarterly* 76 (July 1985): 82–94.

Reed, Gervais. "George Tsutakawa: A Conversation on Life and Fountains." *Journal of Ethnic Studies* 4 (1) (1976): 1–36.

"The Right Red Neon for the Wright Green Theatre." *Seattle Arts,* October 1983.

Rose, Barbara. "A Monumental Vision" (Beverly Pepper). *Vogue,* December 1987, 484–535.

Rose, Kenneth. "Booze and News in 1924: Prohibition in Seattle" (Mark A. Mathews). *PORTAGE* (Historical Society of Seattle and King County), Winter 1984, 16–22.

Rupp, James M. "The Rosati Finally Arrives." *Northwest Arts* 13 (June 1980): 10.

Severn, Jill. "A Demonstration of Artistic and Electrical Energies Working Together" (Creston-Nelson Substation). *Seattle Arts* 5 (June 1982).

Tomkins, Calvin. "Like Water in a Glass." *New Yorker,* 21 March 1983, 92–97.

"Totem Pole Gift to the City Tells Haida Legend" (John Wallace totem pole). *Seattle Arts,* June 1983.

Wright, Virginia. "Painter William Ivey Is One of Most Important 'Eclipsed' Artists of the Pacific Northwest." *The Arts,* February 1982.

General Reference Books

American Craftsmen's Council. *Architectural Craftsmen of the Northwest.* American Craftsmen's Council, 1960.

Falk, Peter H., ed. *Who Was Who in American Art.* Madison, Conn.: Sound View Press, 1985.

Fielding, Mantle. *Dictionary of American Painters, Sculptors, and Engravers.* Greens Farm, Conn.: Modern Books & Crafts, 1974.

Press, Jacques Cattell, ed. *Who's Who in American Art.* 17th ed. New York: R. R. Bowker Co., 1986.

Sollid, John. *Index to Washington Artists.* Seattle: Spring Rain Press, 1974.

University of Washington. *Comprehensive Guide to the Manuscripts Collection and to the Personal Papers in the University Archives.* Seattle, 1980.

Index